Art History for Filmmakers

BLOOMSBURY ACADEMIC
Bloomsbury Publishing Plc
50 Bedford Square, London, WC1B 3DP, UK
1385 Broadway, New York, NY 10018, USA
29 Earlsfort Terrace, Dublin 2, Ireland

BLOOMSBURY, BLOOMSBURY ACADEMIC and the Diana logo
are trademarks of Bloomsbury Publishing Plc

First published in Great Britain 2016 by Fairchild Books
Reprinted by Bloomsbury Academic 2019, 2020, 2021 (twice)

A catalogue record for this book is available from the British Library.

Library of Congress Cataloging-in-Publication Data
McIver, Gillian.
Art history for filmmakers / Gillian McIver.
pages cm
ISBN 978-1-4725-8065-8 (paperback) -- ISBN 978-1-4725-8066-5
(epdf) 1. Art and motion pictures. 2. Painting--History. I. Title.
N72.M6M39 2016
700.9--dc23
2015020639

ISBN: PB: 978-1-5013-6230-9
ePDF: 978-1-4725-8066-5
eBook: 978-1-4742-4620-0

Series: Required Reading Range

Typeset by Roger Fawcett-Tang
Printed and bound in Great Britain

To find out more about our authors and books visit
www.bloomsbury.com and sign up for our newsletters.

To my wonderful family.
Gillian McIver

Art History for Filmmakers
The Art of Visual Storytelling

Gillian McIver

BLOOMSBURY ACADEMIC
LONDON • NEW YORK • OXFORD • NEW DELHI • SYDNEY

CONTENTS

PART 2

CHAPTER FOUR
SEX AND
VIOLENCE
114

CHAPTER FIVE
HORROR
138

CHAPTER SIX
LANDSCAPE
156

CHAPTER SEVEN
HEROES AND
HEROIC ACTS
182

CHAPTER EIGHT
MODERN
MOVEMENTS
198

CONCLUSION
HOW CAN WE USE
ART HISTORY IN
FILMMAKING?
232

APPENDIX
242

INTRODUCTION

HOW DOES ART HISTORY RELATE TO CINEMA HISTORY?

At its simplest, art history is the history of painters and paintings, or paintings together with other art forms such as sculpture, from prehistoric times (more than 50,000 years ago) up to the present. It is the story of the development of Western visual culture; more recent interpretations of art history also include the story of how non-Western cultures affect and transform Western visual culture. It is the story of how the "canon" of artistic excellence was established. It is the story of great personalities, whose innovations and imaginations created significant works. Cinema history is often also structured in a similar way: a history of directors and their films; history of film cultures; history of national film industries; history of the development of film technologies; and so on.

However you decide to tell art history, it is a history stretching back more than 7,000 years, while cinema has a history of less than 150 years. Cinema "plugs into" art history because both cinema and painting are visual art forms, and cinema uses the imagery and symbolism that have been developed over the course of millennia.

Art history shows how humankind continually grapples with big ideas: man's relationship with God, human social relationships, reality versus ideals, social position, fantasy and imagination, good versus evil, nightmares and fears, nature and the natural world—all have been, and continue to be, explored through visual art.

0.1
The Third Man, 1949
Dir. Carol Reed
The "cinematic" in film. Composition and lighting create atmosphere that enhances the story by visually suggesting the tension and suspense necessary for drama.

Why Is Art Important?

All art, including film, may have a biological function. According to research at the University of Toronto, appreciation of art may be a natural process of the human brain. Researchers found that looking at art biologically triggers pleasure, pain, expectations, or other emotions. The results suggest that viewing paintings may not only engage the systems involved in perceiving visual representation and object recognition, but also may structure our underlying emotions and internalized cognitions. So art may be much more important to our human lives than simply being attractive, or decorative, or entertaining.

How Is Art History Useful for Filmmakers?

Most people today are more familiar with the moving image than they are with paintings. Even those who are very knowledgeable about painting cannot escape the fact that the motion picture has been the dominant popular art form since the early twentieth century. When discussing paintings, often the word *cinematic* crops up for certain painters or paintings. What is this concept, "cinematic"? The word is often thrown around, but has no precise meaning; yet because we are so familiar with cinema, we intuit that it means a picture that is "like cinema": dramatic, narrative, intriguing. A cinematic picture is one that presents a moment in time, in which we can imagine the before and after: a freeze-frame rich in drama with a sense of suspense.

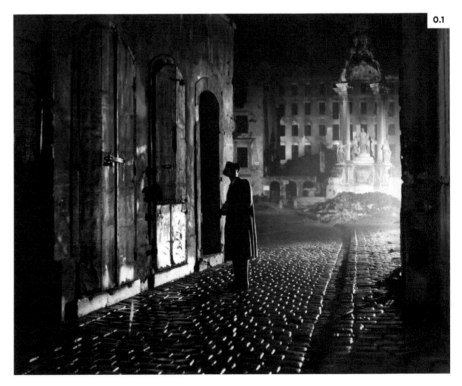

0.1

"WHEN I DON'T FEEL IN THE MOOD
FOR PAINTING, I GO TO THE MOVIES
FOR A WEEK OR MORE. I GO ON A
REGULAR MOVIE BINGE."
—Edward Hopper, painter[1]

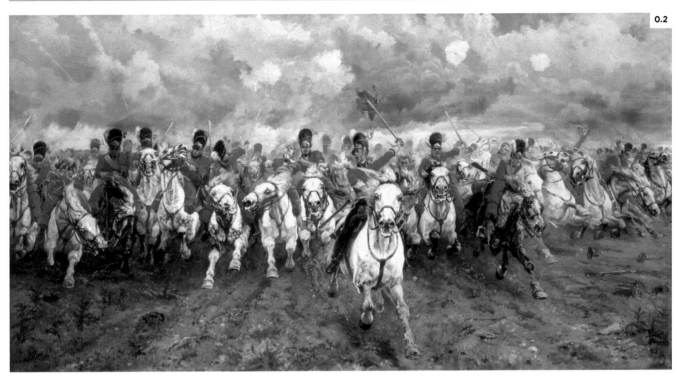

0.2

"IN A SENSE, PAINTERS AND
CINEMATOGRAPHERS ARE CUT
FROM THE SAME GENETIC STRAIN."
—Sherwood "Woody" Omens, ASC,
cinematographer[2]. Omens studied
painting before he switched to
filmmaking.

0.2
Scotland Forever, 1881
Artist: Lady Elizabeth Butler (1846-1933)
The "cinematic" in painting. The cavalry surges
forward, toward the viewer, almost hurtling
out of the frame. The excitement is palpable,
and the picture almost seems to vibrate with
action. We are invited to engage, not simply to
observe. Notice how white and red are used in
the composition to create a sense of unity in
the mass of figures: white brings clarity and red
attention. We will consider color symbolism and
its cultural specificity in Chapter 1.

How the "Cinematic" Can Be Found in Art

A cinematic picture is one that gives an intimation or suggestion of a story or narrative; there is a clear sense of *mise en scène*, composition, lighting, and (sometimes to a lesser extent) tonality or color, which puts us in the frame of mind of a motion picture. The cinematic can be found in art when we notice that a picture has certain qualities that are shared with cinema: a dramatic moment, a sense of something happening, a striking composition.

Cinema and much pre-twentieth-century painting are about storytelling. Visual storytelling creates (by design) an intended effect within the viewer. It lends weight to the narrative development and engagement with the overall story by suggesting to viewers that they might consider a particular scene through a particular visual (cultural, genre, etc.) filter. However, we need to remember that a story is driven by its narrative construction, and can survive as a story being told in many visual ways. This can be seen when we consider the different adaptations that have been made of classic novels; for example, *Wuthering Heights* was adapted in 1939 by William Wyler, in 1992 by Peter Kosminsky, and in 2011 by Andrea Arnold, among others. Luis Buñuel made a Spanish language version in Mexico in 1954, Yoshishige Yoshida set his 1988 adaptation (*Arashi Ga Oka*) in feudal Japan, and several Bollywood versions have also been made. Allowing for the license that adaptations normally take, the story is largely the same in all these films, but they employ very different ways of conveying the story visually.

Filmmaking is imaginative, but to some extent is always bound up with the need to make things appear believable.

The past is a territory that cannot be purely imagined, yet we have few guides to know what it actually looked like. Painting can help give an idea of how past times looked. What is especially convenient is that a painting filters reality, so the image of the past—a stately king, a group of peasants, a sixteenth-century interior—already indicates what are the key significant elements that the viewer's eye should look at. Often production designers and cinematographers use paintings as a starting point for recreating the past or imagining new worlds.

But we need to remember that painters and filmmakers interpret the world. They observe it closely and then refine it to the most significant details deemed necessary. This is as true of trying to represent the past as imagining the future.

This book talks about art using the language of film, and demonstrates that the link between the two is strong and unbreakable. It provides a succinct and clear introduction to the history of art, illuminating the historical background of image making and showing how this feeds both directly and indirectly into filmmaking. Throughout the text, both linear and thematic approaches are taken; the emphasis is always on the experience of looking and watching, rather than following academic schools of thought. By using both the language of film and the language of fine art, and comparing the two, the book offers filmmakers a deeper appreciation of art and its value to cinema. The book will be useful to those doing degree-level study in film and also to those preparing to enter the profession of filmmaking, whether in cinematography, directing, production design, or art direction.

Ways of Looking at the History of Art

Art history can be recounted as a series of movements, grouping together artists under historical categories such as Impressionism, Mannerism, Expressionism, and so on. The limitation with this approach is that it excludes artists who cannot be fitted into these categories. These movements are usually defined by critics and art historians, not by the artists themselves. The tendency to categorize by movements also applies occasionally to cinema, so we have Italian Neorealism, Golden Age Hollywood, the Nouvelle Vague, and so on.

Alternatively, one can see art history in terms of historical periods, such as the Early, Middle, and High Renaissance, the Reformation and Counter-Reformation, the Baroque, followed by the Rococo, the Romantic era superseded by the Industrial Revolution, and onward. This approach serves to locate art within specific defined historical periods, which can be convenient for relating the production of art to other historical processes, such as political movements, wars, scientific or technological inventions, social and intellectual developments. However, the limitation of this approach is that it can lead us to almost forget the imaginative element in the production of art.

Sometimes the history of art is told as the story of great artists. The first recognized historian of art is Giorgio Vasari, who wrote *The Lives of the Most Excellent Painters, Sculptors, and Architects* (1550), in which he talked and gossiped about the artists he knew, and recounted what was known about others. Despite its errors, the book is still in use today, and Vasari's contribution to understanding the history of art as a story of "great artists" is still influential.

This approach has certainly been useful for filmmakers, leading to the production of a number of films (of varying quality) that portray the lives of important artists. While all of these films take liberties with their subject matter, some of the more successful ones are *Nightwatching* (2007) by Peter Greenaway, about Rembrandt; *The Girl with the Pearl Earring* by Peter Webber, about Vermeer; *Frida*, Julie Taymor's biography of Frida Kahlo; and *The Wolf at the Door* by Henning Carlsen, about Gauguin. Vincent van Gogh has been portrayed many times, but one of the best is still *Lust for Life* (1956) by Vincente Minnelli. However, there are obvious limitations in this approach: the "great man" theory of history places a great deal of onus on choosing artists with exciting lives. Of course the tempestuous life of Caravaggio—who was something of a villain—is more titillating than the life of Claude Monet or Thomas Gainsborough, but that doesn't tell us much about their paintings.

Traditional art histories see art as a process of influence: painters are influenced by what the previous generation of painters was doing. This linear view assumes that painters always build on the influences of the past. It can be very useful for organizing large bodies of information, but often these categories can be too broad to explain or understand serious differences between artists' approaches.

The history of movements or historical periods or great artists is less useful to the filmmaker seeking to understand the art of the past. The same can be said of the canon of art history—that virtual list of "the greats" that identifies who are the important artists and the important paintings. The problem with this canon is that it changes from era to era. Painters deemed important in one period fall out of taste and are relegated to the museum basement in another. However, that does not mean that their work is not interesting, or that it was not influential at the time it was painted. Conversely, sometimes artists who did not achieve any status in their lifetimes have been discovered by later generations and lionized (van Gogh being the classic example). The canon, therefore, is less useful when trying to understand visual culture in a broader sense.

Somewhat more useful might be the story of art as a quest for "the real" or, alternatively, a story about the visual imagination. This book focuses on the history of art as a history of painting the "cinematic" image. We will look at a carefully chosen selection of paintings created at different periods in human history, noticing how the visual imagination changes and evolves, as we consider how these images might prove valuable to the contemporary filmmaker.

THE IMAGE-SOUND RELATIONSHIP

In-depth discussion of the image-sound relationship is outside of the scope of this book; for this topic, we recommend Michel Chion's book *Audio-Vision: Sound on Screen* (1994).[3] However, we can observe that "the cinematic" in painting can be thought of as implying sound: that is, in many pictures, the implication of sound and movement is there in the still image. To take one example, in the painting *Liberty Leading the People* (1830) by Eugène Delacroix (see p. 187), notice that the mouths of some of the people in the picture are open, shouting. Notice the smoke, from gunshot and cannon fire. And the size of the crowd, how noisy that must be. The picture is still and silent, but it implies movement and sound. As another example, look at the cover image, *Gas* (1940) by Edward Hopper. As we gaze at the still, quiet gas station at twilight, we can imagine the sounds of crickets in the grass, birds, and perhaps even the blare of a radio from the gas station cabin. A cinematic picture stimulates the audial imagination as well as the visual.

A BRIEF LINEAR (TRADITIONAL) HISTORY OF ART

Prehistory

Ancient History

Before we proceed, it is useful to offer a very basic, traditional, linear history of art that will allow you to look up and discover more about the artists you become interested in.

The earliest evidence of what we might call art has been found in Sulawesi, Indonesia, and has been dated as around 40,000 years old. But prehistoric art has been found in every region of the world—in South America, in Europe, and especially in Africa. Clearly the desire to make art is part of what makes us human.

The caves at Lascaux in France and Altamira in northern Spain contain the best-known examples of prehistoric painting and drawing. Typically, the cave paintings show realistic and finely detailed renderings of animals, whereas depictions of humans tend to be stylized and even sometimes abstracted.

We can begin with the art of ancient Mesopotamia and Egypt, and the tomb and temple paintings and friezes that have survived. In Egypt, these normally illustrate scenes from the Egyptian *Book of the Dead*, connecting them to the lives of the persons buried in the tomb, or illustrate the activities of the Pharaoh, gods, or goddesses. This is the official art of ancient Egypt, the art of the state and the state religion, and it is noticeable for its extremely stylized imagery.

From Egypt, traditional art history then moves to Greece, particularly Athens, and the development of Greek sculpture and architecture. Here we can see the beginnings of a quest for *realism* and the creation of lifelike sculpture. The Romans, who conquered Greece and Egypt as well as the entire Mediterranean territory and north Britain, largely copied Greek art.

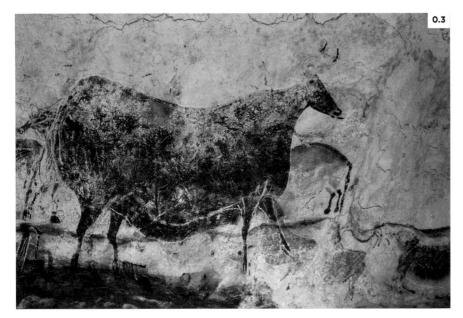

0.3

0.3
***Great Black Bull*, Lascaux Caves, France, c. 17,000–15,000 BC**
Artist: unknown
The Lascaux caves in southwestern France are famous for cave paintings. Estimated to be 17,300 years old, the paintings depict large animals, and some humans. Fossil remains in the area dating from the period show that the same animals were present.

The Medieval Period

The medieval period is a little bit problematic for art historians because Western art histories traditionally ignored Byzantine and Coptic art and that of the Islamic world, concentrating instead on the art of Western Europe; this is currently being rectified. In all cases, we can see that, regardless of its provenance, medieval art is almost entirely religious in nature.

In Japan, by contrast, secular art was alive and well. By the 12th century (late Heian period) the e-maki or illustrated narrative handscroll was established as a significant art form. Many traditional art histories exclude Japanese and other non-Western art from the discussion of this period, but it offers an interesting contrast and important broader perspective.

The Renaissance

It was Vasari who identified the Renaissance, which he described as a "rebirth" of classical ideals: resurrecting philosophies, arts, and sciences of ancient Greece and Rome and bringing them into Christian Western Europe. The real story is bit more complicated than that, but Vasari was correct to identify the great outpouring of painting that began in Florence in the fourteenth century. The Renaissance period is notable for the development of a highly realistic linear perspective. There were three main centers of art in Italy: Florence, Venice, and Rome. The other principal region for Renaissance art is the Netherlands in the early fifteenth century. We associate the Italian Renaissance with artists such as Fra Angelico, Botticelli, Raphael, Leonardo da Vinci, and Michelangelo, while in the Netherlands we note Jan van Eyck and the development of oil paint.

The Baroque

As many books will tell you, the Renaissance then gave way to the Reformation and the schism of the Western Christian church into Catholicism and Protestantism. This led to the Baroque era, from the very end of the sixteenth century to the beginning of the eighteenth. The period from 1500 to 1700 is possibly the most important era for the development of painting. Many painters we will be looking at in this book date from this period: Bronzino (1503–1572), Titian (c. 1488/1490–1576), Caravaggio (1571–1610), Rubens (1577–1640), Vermeer (1632–1675), Rembrandt (1606–1669), and Velázquez (1599–1660). Theirs is painting of high drama, marked by significant developments in lighting, composition, realism, color, and technique.

However, traditional art history often did not discuss how this was also the period of European expansion, which brought art and artifacts from Asia and the Americas to Europe. This was the period where slavery was expanded, and great wealth was created in parts of Europe. European art begins to reflect these huge cultural changes.

FURTHER VIEWING

The Dark Ages: An Age of Light is a documentary by ZCZ Films presented by Waldemar Janusczak that explores the dynamic art of the Vikings, the Visigoths, and early Islam, opening up a hitherto unknown visual culture that could enhance and enrich historical drama.

Rococo and Neoclassical

The Baroque may (or may not) give way to something called the Rococo; art historians argue whether Rococo even existed in painting (though it is commonly acknowledged in architecture and the decorative arts). Eighteenth-century art is ornate, colorful, and highly decorative, full of humor and wit, based on an appreciation of nature and landscape. Toward the end of the eighteenth century, Greek or Roman classicism became popular yet again. We certainly see this in architecture: this is the period when the White House and the Capitol building in Washington, DC, were designed along neoclassical lines. In painting, French art came to dominate, with painters like Nicolas Poussin (1594–1665) and Claude Lorrain (1600–1682) in the early period, then Antoine Watteau (1684–1721), Jacques-Louis David (1748–1825), and Jean Auguste Ingres (1780–1867); but English and American painters also began to emerge, including Thomas Gainsborough (1727–1788), John Singleton Copley (1738–1815), and Benjamin West (1738–1820). The first American art schools were founded in Mexico (1781, the Academy of San Carlos) and the USA (1805, the Pennsylvania Academy).

The Industrial Age

By the nineteenth century, France was the preeminent artistic culture, though there was significant painting in the German-speaking regions and, for the first time, in Britain and America. Artists, wherever they came from, normally spent a period of time in Italy, soaking up the Italian landscape, the classical remains, and of course the glories of Italian Renaissance and Baroque painting, which crammed the region's museums and religious buildings. By this time there was a great contrast between Italy, which was still predominantly agricultural, and the increasingly industrial regions of the north of Europe. Artists went in a startling number of different directions. Nineteenth-century art includes conventional large-scale dramatic history paintings and religious paintings and an abundance of portraits, but also Orientalist works created by artists who fled from Europe to North Africa, the Middle East, and beyond for inspiration. Some artists decided to include the industrial landscapes (Georges Seurat's *Bathers at Asnières* is one example), while others took refuge in *faux medievalism* and fantasy. Russia began to emerge as a nation of great realist painters, producing Ilya Repin, Isaac Levitan and Ivan Aivazovsky, but also Léon Bakst (1866–1924) who revolutionized costume and stage design. Artists from other parts of the world began to arrive in Europe (usually France or Italy) to study art, such as the Uruguyan realist Juan Manuel Blanes (1830-1901). But the most dramatic transcultural influence was the enthusiasm for Japanese art, particularly prints by Ando Hiroshige (1797-1858) and Katsushika Hokusai (1760-1849), that swept late 19th century Europe, and comprehensively affected Western art.

Twentieth-Century Modernism

The twentieth century is notable for two significant developments in the history of visual culture: the cinema, which brought movement to visual images (and later the inclusion of sound), and the development of nonrepresentational painting—that is, painting that is not a picture *of* something, but is instead what Pablo Picasso called "painting about painting." Here we see Abstraction, Abstract Expressionism, Minimalism, conceptual art, and so forth. It can be argued that the development of cinema and photography meant that painting became less dominant as a form of visual culture and had less responsibility to represent the world as it is. However, the twentieth century also gave us representational painters such as L. S. Lowry and industrial Lancashire (*Coming from the Mill*, 1930), Edward Hopper and his pictures of urban America (*Nighthawks*, 1942), Andrew Wyeth's American landscapes (*Christina's World*, 1948), David Hockney's evocations of 1960s California (*A Bigger Splash*, 1967) and Gerhard Richter's meditations on recent German history (*October 18, 1977*). In the twentieth century, the art world opened up to include significant artists from Latin America, Asia, Africa, and the Middle East, such as Diego Rivera (1886–1957) and Frida Kahlo (1907–1954) (Mexico), Fernando Botero (b. 1932) (Colombia), Abdel-Hadi El-Gazzar (1925–1966) (Egypt), and Saloua Raouda Choucair (b. 1916) (Lebanon). African Americans also came to prominence, among them Jean-Michel Basquiat (1960-1988). Before the twentieth century, social attitudes and the social structures of artistic production meant that few female painters were well known; exceptions included Artemisia Gentileschi (1593–c. 1656), Élisabeth Vigée-Le Brun (1755–1842), Suzanne Valadon (1865–1938), Lady Elizabeth Butler (1846–1933), and Mary Cassat (1844–1926). In the twentieth century, women were recognized as important painters making significant contributions to the art form, among them Käthe Kollwitz (1867–1945), Natalia Goncharova (1881–1962), Sonia Delaunay (1885–1979), Georgia O'Keeffe (1887–1986), Dorothea Tanning (1910–2012), and Bridget Riley (b. 1931).

Looking at art history from the perspective of cinema entails acknowledging that cinema was adopted across the world immediately following its invention. Different countries and cultures adapted cinema to their own storytelling, often influenced by Hollywood and European cinema but equally influenced by their own visual culture. We can see this in the history of (for example) Japanese, Chinese, and Egyptian cinema, where the visual art of these cultures is embedded in their films, and contributes to their interpretation of 'the cinematic.' Egyptian art and cinema are both strongly symbolic, for instance; the ghost story can be found depicted in Japanese art from earliest times, and continues to be popular in cinema.

It is important when studying "world" cinema to consider the visual culture of the producers, including their art history.

TOWARD AN "ALTERNATIVE" HISTORY OF ART

Part 1

The history of art is a repository of images and ideas that is available to the filmmaker. By becoming familiar with painting, you have access to a huge archive of visual culture to draw from, be inspired by, or learn from.

The aim of this book is to identify key artists or artworks from all periods that demonstrate "the cinematic" in their work and who are valuable for filmmakers to study, to learn about, or be inspired by. Many notable artists, important movements, and good artworks will be left out of this account because we are focusing on what is more immediately useful for filmmakers. Each chapter will discuss an aspect of art history and its relevance to cinema. The book is divided into two sections: Part 1 establishes the link between art and cinema and develops the concept of the "cinematic" in art. Part 2 is made up of shorter chapters that look at specific directions, genres, and tendencies in cinema and art.

1. Visual Culture and Storytelling

Chapter 1 introduces the idea of narrative in art. Paintings often tell stories, from recounting the progress of a hunt in the Lascaux caves to the journey of the soul after death in the Egyptian tomb paintings or a well-known legend such as Perseus and Medusa. The chapter looks at the various forms of narrative paintings through history. It also looks at one of the most powerful tools in art: color. What is the history of color and its arrangement? How did the discovery and use of different pigments influence how people felt about color? How did color symbolism come to affect cinema?

Cinema has sometimes been referred to as "painting with light." In Chapter 1, we will also see how painting established the primacy of lighting. How did lighting come to drive the narrative of a painting, as well as a film? How did composition and *mise en scène* develop? How did optical tools aid the process of development, and how did these lead eventually to the evolution of cinema? The chapter will look in detail at the paintings of Caravaggio, Rembrandt, and Vermeer, who can be seen as forerunners of cinema in the way they used light and shade (Caravaggio), optics (Vermeer), and composition (Rembrandt).

2. Realism in Visual Art

Chapter 2 will look at the idea of representing the real. What is realism in art? Since the ancient Greeks, we have been interested in trying to represent the "real" world, but this always creates conundrums. How far should verisimilitude go? Trying to depict the real also raises the question of representation. We will see how painting created enduring assumptions about gender and race in visual culture that have carried over into cinema. The case study at the end of this chapter looks at how the science of optics contributed to the painter's quest for "the real," as well as leading to the eventual development of the camera.

3. Beyond Realism

Chapter 3 discusses how artists came to represent the not-real. How and why does art go beyond realism? We will explore the realm of imagination through the art of myth and fantasy. Artists have been tasked with depicting Heaven and creating imaginary worlds populated by mythic characters. The chapter will look at the dreamlike paintings of Giorgio de Chirico, Arnold Böcklin, and Henry Füssli, as well at the dream sequence in film. But art also explores the unconscious mind, and the chapter looks at the Surrealism of Salvador Dali, René Magritte, and Jan Svankmajer. This section concludes with an examination of the astonishing films of Emeric Pressburger and Michael Powell, and the talented artists with whom they worked.

4. Sex and Violence

Chapter 4 will look at genre, and how painting established visual motifs and styles for genre films. We are used to films that portray sexuality, and to romantic comedy, but most of the sex and gender tropes we find in cinema were formed long ago by painting. Violence in film is frequently controversial, but some of the best-known artworks are much more graphically violent than any movie: we will look at the different versions of *Judith Slaying Holofernes* as well as the films of Martin Scorsese.

5. Horror

Similarly, all our ideas about horror appeared first in painting. Chapter 5 examines the different subgenres of the horror film: supernatural horror, religious horror including demons and devils, dragons and reptilian monsters, and brutal body horror were each prefigured in paintings, such as Hieronymus Bosch's *Garden of Earthly Delights* (c. 1480–1505), and Titian's *The Flaying of Marsyas* (c. 1575). The case study looks at the films of Mexican film director Guillermo del Toro and the influence on his work of Spanish artist Francisco de Goya.

6. Landscape

In Chapter 6, we will see how painting created visual motifs and styles for expressing our feelings about landscape through an exploration of the sublime. What were artists seeking when they started painting the landscape? What set American landscape painting apart? Why was the American western so popular? The case study looks at the genre of the road movie.

7. Heroism

How do we recognize a hero? How did artists develop the visual language of the "hero" character? Chapter 7 considers portrait painting and history painting as the basis of our conception of the hero in cinema. The case study of Quentin Tarantino's *Django Unchained* starts by examining the fashionable portraiture of English painter Thomas Gainsborough.

8. Modern Movements

Modern art developed alongside cinema, and both have consistently influenced each other. Chapter 8 looks at how in the twentieth century painting developed in parallel with cinema, and the interrelationship between the two. Expressionism is one early-twentieth-century art movement that fully encompassed both visual art and cinema, but art and cinema continue to influence each other right to the present. The chapter looks at several modern movements in art and their relationship to cinema, including more "difficult" art trends such as Minimalism and Abstraction, and investigates how they have been interpreted in cinema.

In Chapter 8 we also examine cultural developments to see how non-Western art invigorated Western art. In particular, we look at Japanese art and its broad influence on both painting and graphic arts. We will see how the popularity of Japanese art ultimately led to the feature animation of Walt Disney.

1 Townsend Ludington, *A Modern Mosaic: Art and Modernism in the United States* (University of North Carolina Press, 2000).
2 *Cinematographer Style* (2006). Directed and produced by Jon Fauer. DVD, color, 86 mins. In English. Distributed by Docurama Films.
3 Michel Chion, *Audio-Vision: Sound on Screen*, translated by Claudia Gorbman (Columbia University Press, 1994)

HOW TO USE THIS BOOK

All of the pictures discussed in this book are available online, allowing you to look up the image as you read the book. A search engine should help you find the image, but for the best quality it is often better to go directly to the official collection website. A list of online collections, artists' websites, and other resources can be found in the appendix at the end of the book. Each chapter has suggestions for further reading.

CHAPTER ONE
VISUAL CULTURE AND STORYTELLING

Our experiences are, and always have been, strongly visual. For extended periods of human history, literacy was limited to certain sectors of the population, and spoken words and visual images were the main means of communication. The temple paintings, friezes, and sculptures of ancient Greece and Egypt, the splendid altarpieces and architectural designs of the Italian Renaissance churches—these were just as important to worshippers as words. Secular art such as portrait painting, the drama of history painting, and the bourgeois appreciation of landscape pictures communicate the beliefs, values, and dilemmas of their age.

The very long history of visual art frames the way that we see things today: how we understand beauty and sensuality, bravery and heroism, good and evil, is strongly influenced by the way these have been represented in art. Over the course of the twentieth century, cinema has not only availed itself of this visual culture but has also made its own contributions.

This chapter will introduce some key points in the history of art, from the development of image-based storytelling to the technological challenges of composition and perspective, lighting, and the application of color pigments to create images that can inspire awe and, above all, communicate.

"CINEMA IS A LANGUAGE OF IMAGES, FORMED BY LIGHT AND DARKNESS, AND BY THE INTERNAL ELEMENTS OF COLORS, THROUGH WHICH STORIES MUST BE INTERPRETED."
—Vittorio Storaro, cinematographer (Writing with Light, 1992)

NARRATIVE AND STORYTELLING IN ART

COLOR AND NARRATIVE

KANDINSKY'S COLOR THEORY IN PAINTING AND IN CINEMA

PERSPECTIVE AND COMPOSITION

LIGHT

CASE STUDY: PETER GREENAWAY AND DUTCH PAINTING

EXERCISES, DISCUSSION QUESTIONS, FURTHER VIEWING, AND FURTHER READING

NARRATIVE AND STORYTELLING IN ART

Narrative as Human Culture

Films are stories; filmmaking is storytelling. Storytelling is one of the oldest human activities. In the era of human history before written language, human storytelling was represented visually. From the cave paintings of Europe to the rock carvings of South America, visual narratives that tell stories proliferated. Filmmaking is simply one of the most recent manifestations of the human desire to tell stories. Filmmaking seems to have solved the ancient problem of bringing together visual representation, traditionally done through art forms such as painting, and time-based representation, traditionally done through art forms such as reciting or reading the written word. Cinema allows stories to be told visually over time. Although this may be seen as an innovation, it actually is something that we humans appear to have wanted to do for a long time. This section looks at different ways that artists have attempted to show *narrative*, from murals and frescoes to Hogarth's "moral storyboards," and explores the techniques artists have used to visually drive the narrative.

"THE ART OF STORYTELLING IS AT OUR CORE. IT'S THE LIFEBLOOD OF HOW WE COMMUNICATE AND HOW WE DECIDE WHAT DESERVES OUR ATTENTION."
—Robert Redford, actor and founder of the Sundance Institute ("Storytelling to Save the Planet," *Huffington Post*, May 7, 2014)

"On stone, on wood, on canvas, on film, electronically . . . the idea is what never changes."
—Vittorio Storaro, cinematographer

Philosopher and theorist Roland Barthes said that the world's stories are innumerable, and that "the story exists at all times, in all places, in all societies. Storytelling starts with human history itself."[1] Barthes concluded that storytelling is "just there." It is a part of life. Different types of research, such as anthropological research by Claude Levi-Strauss and psychological research by Carl Jung, showed that there are not only many different stories, but within those stories there are patterns or structures that recur beyond the individual control of the storyteller.

More recently, the art historian Ernst Gombrich proposed that one of the things that has made Greek art so enduring and successful is the way it is rooted in Greek storytelling. It is true that the popularity of stories such as the *Iliad* and the *Odyssey* had a profound impact on the development of the visual arts. Greeks put stories on their household objects, such as vases and dishes. Greek theater boasted elaborate masks and painted scenic design. But we can go back even earlier: if we look at the Egyptian pottery used by ordinary households, far away from the official art of the Pharaohs, we can see that painted images from myths and proverbs were part of everyday life. If stories have been with us since our earliest times, as Barthes claims, then so has visual art; and more often than not, they have gone together.

Storytelling is so pervasive that it appears to be hardwired into our whole way of understanding ourselves and one another. For millennia, important cultural stories were kept in the heads of storytellers, as knowledge was passed down from generation to generation. We call this *oral culture*. However, we can see that before written language, early human societies developed the means of visual storytelling. Whether it is the remarkable cave paintings in Lascaux or the petroglyphs in southern Egypt, we see images painted on walls or carved into rocks, and these images are organized in such a way that they tell stories.

The first formally constructed narratives that we can read, because they relate to or accompany a written text, come from Mesopotamia and Egypt. *The Book of the Dead* explains what the belief systems were for the ancient Egyptians, and many other texts provide further examples of Egyptian mythology. But it's when we actually look at the papyrus drawings, the temple friezes, and the tomb murals of ancient Egypt that these stories of death and rebirth really come to life. In Mesopotamia, one of the first great examples of visual storytelling is the relief drawings commissioned by King Ashurbanipal of Assyria (668–627 BC). Wanting to commemorate his own military victories, he had his artists combine a relatively straightforward (though probably embellished) account of his kingly exploits with the long-established great epic story of Gilgamesh, creating a massive relief mural that covered the four huge walls of his reception chamber.

Storytelling on the Wall

The idea of the wall painting or mural as a storytelling device moved across the Mediterranean, and by about 500 BC was used by the Greeks. Few Greek murals survive, but they show clearly enough that painterly techniques such as perspective, tone, and shading were understood. Similarly, the white buildings and statues that we associate with classical Greece were not white at all: they were painted all over in vivid colors (archaeologists have found flakes and remnants of bright pigment on the ruins). Ancient Greek authors considered these paintings on the walls of public buildings to be significant and magnificent.

In Italy, the Romans and Etruscans followed the Greek lead in developing wall painting to a high level. The ancient city of Pompeii, near modern Naples, Italy, provides us with a good idea of the paintings encountered in daily life. In the Villa of the Mysteries, one of the largest rooms in the preserved house has been given over to a mural that depicts the rites of Dionysus. These rites were an important part of Greco-Roman religious practice. The four walls tell the story of a young woman making her first acts of worship and going through the process of acceptance into the cult. Although, by modern standards, the mural requires some knowledge of ancient religion to properly interpret it, the painting is highly realistic and the principal characters of the gods and goddesses are relatively easy to identify.

In Federico Fellini's film *Roma* (1972), a group of workers discovers a secret underground chamber decorated with beautiful ancient Roman murals. The men are astonished, but to their shock, the air of the modern city almost immediately begins to dissolve the paintings and they disappear forever.

Fellini was well aware of what he was doing with this scene, because he understood the importance of the art of ancient Rome and the enormous legacy it has left to the modern world. Interestingly, a similar scene is played out in the 1971 Egyptian film *Chitchat on the Nile* (dir. Hussein Kamal), where a group of corrupt socialites cavort on a huge Pharaonic statue, despoiling it; they then go on to accidentally kill a peasant woman. In both films, the encounter with the art of the past forms a crux in the story. The ancient art represents values that no longer exist, or are at risk, as a result of the decadence and degeneracy of modern life.

1.1
***Roma*, 1972**
Dir. Federico Fellini (1920–1993)
In Fellini's critical homage to his home city, the splendor of Rome's ancient history is suddenly revealed as subway workers discover these ancient murals underground, only to see them melt away upon contact with the air.

1.1

NARRATIVE AND STORYTELLING IN ART

COLOR AND NARRATIVE

KANDINSKY'S COLOR THEORY IN PAINTING AND IN CINEMA

PERSPECTIVE AND COMPOSITION

LIGHT

CASE STUDY: PETER GREENAWAY AND DUTCH PAINTING

EXERCISES, DISCUSSION QUESTIONS, FURTHER VIEWING, AND FURTHER READING

Sequential Narrative Images

There are number of different examples of visual narratives in art, aside from murals and frescoes. Paintings were also done on wooden panels. *Panel paintings* could be painted in groups and organized in a series.

Jacopo Pontormo and Francesco Bacchiacca's *Life of Joseph* (1515-18) is a series of six paintings depicting the well-known Old Testament story. The painters always identify the hero Joseph by his lilac-colored cape and wearing or carrying a red hat. In one of the largest in the set, *Joseph with Jacob in Egypt*, there are no fewer than four separate episodes from the story condensed into one painting. The Romans did the same thing in some of their murals—for example, showing different episodes from the *Aeneid* or the *Odyssey* on one wall. Pontormo and Bacchiacca combine both multi-episode paintings and single-episode paintings on panels, so they can be displayed according to taste. From our modern perspective, the series almost resembles a storyboard for a film.

Another approach to visual storytelling is the Japanese hand scroll, known as *emaki*. The viewer scrolls through the narrative from right to left, rolling out one segment with the left hand while rerolling the right-hand portion. The hand scroll provides scene-by-scene detail.

One of the most interesting examples of the Japanese hand scroll is *The Eyewitness Account of Commodore Perry's Expedition to Japan in 1854*, created by several Japanese artists working together, which is now in the British Museum. The Commodore Perry story itself was made into a film, *The Bushido Blade* (1981). The hand scroll dates back almost two thousand years before this, not only in Japan but in China and Korea, mostly depicting well-known myths and legends. The Japanese scrolls of the Edo period (between 1603 and 1868) are particularly dramatic and exquisite.

FRESCO

The mural painting technique used in ancient times was called fresco, or "fresh": color was applied to wet plaster, bonding it to the surface. This is a firm and long-lasting technique so long as the building remains intact and is not exposed to too much sun and weather. Some Etruscan underground tomb paintings have been discovered, and the interior murals in Pompeii survive because for most of the last two thousand years they were sealed in volcanic ash.

FURTHER VIEWING

Sandro Botticelli's *Three Miracles of Saint Zenobius* (1500), The National Gallery, London

In one long painting, Botticelli shows us three key episodes in the saint's life, all in a single street setting, a real and recognizable Florence street. Zenobius is identified in each section by his red cloak and bishop's hat.

A century before the Commodore Perry hand scroll was created, the eighteenth-century English artist William Hogarth created yet another kind of painting series, an original "filmic" narrative. Hogarth practiced the well-established trick of delivering an upright moral message by depicting lurid and salacious visual evidence of lust, greed, and degradation. In a series of six paintings, which Hogarth engraved and sold as prints (at a lower cost and in large quantities), the viewer is allowed to peek into the private, depraved life of Tom and witness the goings-on in the tavern, the gambling house, and finally the madhouse. Narrative painting is here used to deliver a vicarious experience to the viewer. One can easily compare *A Rake's Progress* to films about a character's personal downfall through poor life choices, such as *Requiem for a Dream* (2000, dir. Darren Aronofsky). Hogarth made another narrative series, *Marriage à la Mode*—a domestic drama depicting a marriage gone spectacularly wrong—and single-image narratives such as *Gin Lane*, a brilliant depiction of what happens when a community lavishly overindulges in gin. Incredibly, *Gin Lane* was based on real-life events and was used as part of a general crackdown on unlicensed distilling in London in the 1750s. With such characterful, exciting, and titillating stories to show us, it's not difficult to imagine that, were he alive today, William Hogarth might be a filmmaker, rather than a painter.

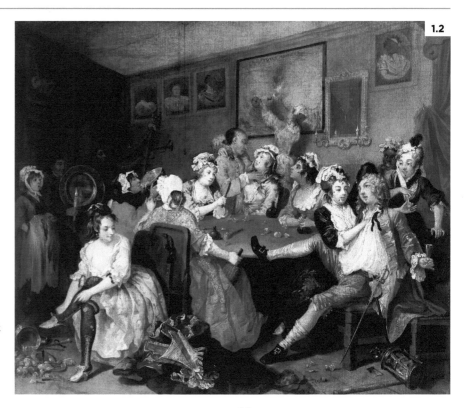

1.2

1.2
***The Rake's Progress,* "The Tavern Scene," 1733**
Artist: William Hogarth (1697–1764)
The Rake's Progress is a moral story of human weakness: young Tom inherits money, squanders it in dissolute living, tries to get his fortune back by marrying an ugly rich old woman, spends her money, falls victim to syphilis, and eventually dies, raving in a madhouse.

NARRATIVE AND STORYTELLING IN ART

COLOR AND NARRATIVE

KANDINSKY'S COLOR THEORY IN PAINTING AND IN CINEMA

PERSPECTIVE AND COMPOSITION

LIGHT

CASE STUDY: PETER GREENAWAY AND DUTCH PAINTING

EXERCISES, DISCUSSION QUESTIONS, FURTHER VIEWING, AND FURTHER READING

The Single-Image Narrative

Not all paintings are narrative, but until the twentieth century most had some narrative element—depicting a character in a setting, or referring to a known story. However, although storytelling has long been an important element in the construction and appreciation of painting, it is important to remember that coming up with a brand-new story has traditionally not been important in art. What has been important and valued is coming up with a fresh approach to a well-known story. So if the story is already known, why make a painting of it? Because encountering a story from a visual is an immediate emotional and sensual experience. The sensual engagement of the eye is an important factor in engaging the viewer's intellectual understanding of the story.

In a film, unlike a painting, the frame composition is not a self-sufficient statement. Film is time-based art, and so the visual material is constantly in flux. A film is a series of compositions that are continually broken down and reassembled. Nevertheless, painting established our fundamental ideas about narrative composition, which are at the core of both painting and film's *mise en scène*. Over centuries, painters worked out the most communicative hierarchies of objects, placement, use of color, light, and shade, and the ways that the artist can manipulate the viewer. Filmmakers have adopted and adapted these ideas to the moving image.

Despite centuries of frescoes and murals, illustrated books and painting series, eventually most painting became the single-image picture and most of Western art history consists of these. In these pictures, all kinds of subjects are presented within one frame, from large-scale history paintings depicting past events to portraits of important or self-important personages to landscapes and, finally, scenes from daily life. Despite the obvious problem of trying to cram often complex stories into a single static frame with only one subject, what is remarkable about the great paintings of art history is how narrative and exciting so many of them actually are. Sometimes pictures overtly depict stories, and sometimes we decipher and "read" the story through decoding the different elements within them.

But the history of art is not simply the history of different kinds of paintings or the lives of painters; it is also about developments in technology, knowledge, and technique.

PANEL PAINTING

Painting on wooden panels was much more convenient than painting directly onto the wall, because the panels could be moved around and grouped together as necessary. Byzantine icons were painted on wooden panels, as were the religious paintings for church interiors. In the sixteenth century, textile such as linen became popular, making paintings lighter and therefore even more mobile.

COLOR AND NARRATIVE

Color theory and color psychology are important aspects of fine art knowledge that have passed into the tool kit of the filmmaker. The history of color in painting and cinema is the history of a difficult quest to reproduce in art the colors seen with the human eye in the natural world. Yet in both cases, it is science that makes it possible.

A Brief History of Color

Colors used in painting started as natural pigments. Our most ancient ancestors discovered the power of colored pigments and used them in a variety of ways to draw colored pictures on the walls of caves. The first pigments were colored clays, vegetable dyes, and finely ground colored stones. The kind of human ingenuity involved in working out ways to turn these into art materials testifies to the importance and centrality of painting from earliest human history. Natural pigments include ochers and hematite, which are iron oxides and appear as a type of clay. In prehistoric times these pigments were used for everything from cave and rock art paintings to pottery to human tattoos. The most precious of the ground stones was lapis lazuli, a brilliant blue stone mined in Afghanistan to create ultramarine. Another natural source of blue was the indigo plant.

Red came from vermilion, or cinnabar (mercury sulfide), a toxic natural mineral found in igneous deposits. Yellow came from saffron, but also from derivations of urine or onion skins. Black was made from burning wood or bones, and white from ground bones or from lead. These natural substances had to be mixed with a "medium" such as egg yolk, oil, or animal glue made from boiling skins and bones. These made the color applicable to surfaces, and also made it stable so that it would be sturdy and long-lasting.

Synthetic pigments can be made from natural pigments that are refined, or can be artificially created. The Egyptians worked out a system whereby they could apply natural pigments to a metallic salt (a "mordant") and heat it, forming a stable "lake" pigment. Subsequent generations of artists and chemists worked on expanding this knowledge. Industrialism proved important in the history of color, as premixed oil paint in a tube became available in 1841. Before this, artists had to prepare their own paints, manually mixing pigments with a binding medium. In 1856, aniline dyes were discovered as a by-product of industrial processes. These cover a wide color spectrum and have the advantage of being much more stable and consistent than natural pigments. Soon it was possible to produce them inexpensively in large quantities. The ready availability of these pigments offered new opportunities to painters, and we see the stupendous results in the paintings from the last third of the nineteenth century onward. Vincent van Gogh, for example, was able to paint brilliant yellow and purple fields around Arles, France, because tube paint had recently become available and so had purple paint. The color purple had always been horribly unstable, which is why it is rarely seen in paintings, but even the new paints that Van Gogh used have faded, leaving the images now more blue than purple.

"COLOR IS ONLY AN INSTRUMENT"
Mark Rothko, American artist
(1903-1970)
(*Writings on Art*, 2006)

NARRATIVE AND
STORYTELLING
IN ART

COLOR AND
NARRATIVE

KANDINSKY'S
COLOR THEORY
IN PAINTING AND
IN CINEMA

PERSPECTIVE
AND
COMPOSITION

LIGHT

CASE STUDY:
PETER
GREENAWAY
AND DUTCH
PAINTING

EXERCISES,
DISCUSSION
QUESTIONS,
FURTHER VIEWING,
AND FURTHER
READING

In the twentieth century, industrial developments led to the invention of enamel paint, called Ripolin, which gives an ultra-hard glossy surface; latex or acrylic paint, which is derived from petroleum, became available in the 1950s. American painter Jackson Pollock used enamel in his famous drip paintings, while his fellow Abstract Expressionist Robert Motherwell preferred to use acrylic house paint. Briton David Hockney created innovative acrylic paintings in the 1960s.

Technical developments and the availability of certain pigments or types of paint (and their cost) affected how artists painted. New developments in painting materials and colors led to innovations and new approaches to painting. This is also true for surfaces. After millennia of painting on wooden panels, in sixteenth-century Italy, linen canvases were used, made from the sails of Venetian ships. Cotton canvas only came into use in the twentieth century; it was much cheaper than linen, enabling artists to create large canvas paintings at a reasonable cost. The combination of cheap cotton canvases and cheap synthetic colors made it possible to do large paintings without being commissioned by a church or government. Artists could create these large paintings and then sell them to private collectors. This economy of scale had a profound effect on the type of paintings that were produced in the first half of the twentieth century.

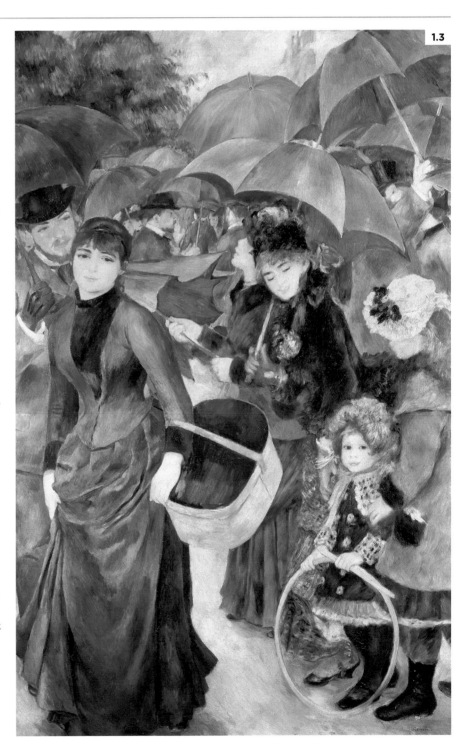

1.3

1.3
The Umbrellas, **1885**
Artist: Pierre-Auguste Renoir (1841–1919)
When Renoir painted *The Umbrellas* during a four-year period (1881–85), he used at least two completely different types of blue. Sixteen years later, Picasso's famous "blue period" (1901–1904) took advantage of a huge new range of blues.

We can see a similar trajectory in the history of cinema technology, as monochrome gave way to color, and color to Technicolor. The availability of film stocks and film speeds, and later the emergence of digital technologies, determined the choices available to the filmmaker, which in turn affected the aesthetic outcome of the work itself, with each period creating new forms of expression.

Italian cinematographer Vittorio Storaro has spent most of his professional life in extensive research into both the aesthetics and the technical aspects of color. His career is evenly divided between important European art films and television projects, and major Hollywood blockbuster films. To Storaro, the technical study of color must be applied to the emotional study of color. Storaro has observed that while the relationship between cinema and visual art had been there right from the very beginning, it was with the adoption of color film stock from 1929 onward that cinema was compelled to relate to painting, and so filmmakers turned to art history to review established color relationships in the construction of color cinema.

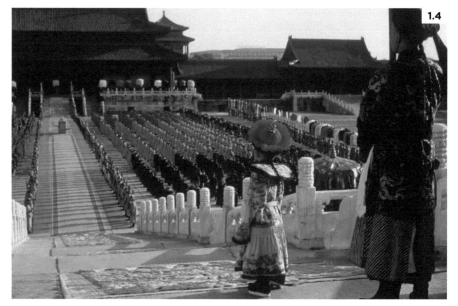

1.4

Throughout his career, Storaro has demonstrated an excellent knowledge and understanding of painting and art history, along with his technical knowledge and understanding of the camera. Storaro has worked out his own system of color symbolism and correspondences (see p. 25), and he describes every film he's done as "a journey into the colour spectrum."[2] For example, interviewed for the documentary *Visions of Light* (dir. Arnold Glassman, 1992), describing his work on *The Last Emperor*, he talks about his use of orange in the scenes with family, yellow to signify the coming into consciousness of the hero Pu Yi, and green when the young emperor begins his formal education. Green, Storaro says, is the color of knowledge.

1.4
The Last Emperor, **1987**
Dir. Bernardo Bertolucci, DP Vittorio Storaro
Storaro uses yellow as the dominant color when the child Pu Yi becomes emperor. Here he becomes aware of his status for the first time, under a giant yellow silk canopy in the Forbidden City. Storaro associates yellow with intuition and awareness; as the color of light, it symbolizes the sun. It is also the imperial color in China and represents the imperial status of the young emperor.

"WE USE COLOURS TO ARTICULATE DIFFERENT FEELINGS AND MOODS. . . . I BELIEVE THE MEANINGS OF DIFFERENT COLOURS ARE UNIVERSAL, BUT PEOPLE IN DIFFERENT CULTURES CAN INTERPRET THEM IN DIFFERENT WAYS."
—Vittorio Storaro, cinematographer (*ASC Magazine*, June 1998)

NARRATIVE AND
STORYTELLING
IN ART

COLOR AND
NARRATIVE

KANDINSKY'S
COLOR THEORY
IN PAINTING AND
IN CINEMA

PERSPECTIVE
AND
COMPOSITION

LIGHT

CASE STUDY:
PETER
GREENAWAY
AND DUTCH
PAINTING

EXERCISES,
DISCUSSION
QUESTIONS,
FURTHER VIEWING,
AND FURTHER
READING

Color: Symbolism and Psychology

Color symbolism is culturally determined and changes according to era and culture. Art allows some symbols to endure long after the original association has disappeared. Color symbolism sometimes reflects its origins. For example, purple is associated with royalty and luxury. The Romans had an expensive rare purple dye, which was restricted to the upper class. Red is often associated with blood, with earthy qualities such as passion, and with danger. Obviously, the sight of blood calls our attention to a dangerous situation, and vermilion red was a highly toxic substance. Black is often associated with death, and burned substances turn black; however, in some cultures, white is the color symbolic of death, not black.

In the Western artistic tradition, blue is always associated with Heaven, with the Christian holy family, in particular the Virgin Mary, and often appears as a color of awareness or enlightenment. But it can also suggest conservatism. In Eastern Mediterranean culture, blue wards off the evil eye, but in English "to feel blue" means to be a bit down (hence "the blues"). In Korea dark blue is the color of mourning, and the Hindu god Krishna is portrayed with light blue skin.

Color psychology comes after the expansion of our understanding of psychology from Sigmund Freud and his followers. There are different views about what colors connote psychologically. Perhaps we understand color more as metaphor. For example, the painter and art theorist Wassily Kandinsky said that color "exerts a spiritual effect, which touches the soul itself."[3]

As we have seen, the material development of color technology happened over a long period of time and involved science, trade, and experimentation. As new colors were discovered, many painters rushed to try them, only to find that they were unstable and soon resulted in disaster. Other colors remained stable during the painter's lifetime, but today we may find them strangely changed with time, as a result of oxidation, pollution, and sooty deposits from candlelight.

VITTORIO STORARO'S COLOR SYMBOLISM

Vittorio Storaro has developed his own color symbolism, derived from his research and experience. Interviewed in *Writing with Light*, Storaro expresses his symbolic system of color correspondences as follows:

Black—unconsciousness
Red—blood
Orange—family
Yellow—consciousness
Green—knowledge
Blue—intelligence
Indigo—the primeval state
Violet—the last stages of life
White—balance

Visit the website of Vittorio Storaro at www.storarovittorio.com, and you will soon see many paintings that the great DP has chosen to be associated with. There is also a short essay on the Italian painter Caravaggio.

1.5

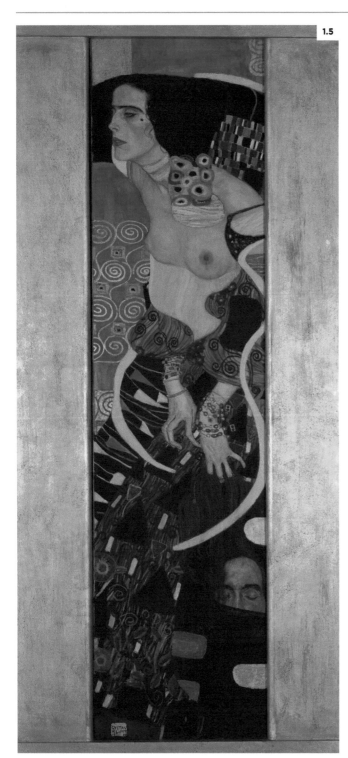

1.5

FURTHER VIEWING

It is possible to identify a number of painters worth looking at specifically for their innovative use of color. Many of them are discussed further in this book, but you can also look them up yourself.

Jan Vermeer (1632–1675). Notice Vermeer's use of rare and expensive lapis lazuli blue, particularly in the clothing of his subjects, such as the headscarf of the subject in *Girl with a Pearl Earring* (1665).

Henri Matisse (1869–1954). Matisse was fond of warm colors, particularly reds, and used them in unusual ways. Matisse was less concerned with natural rendering of colors and more with their dramatic, emotional, and psychological effects. See *Music* later in this chapter (p. 33).

John Singer Sargent (1856–1925). Best known as a portraitist, Sargent is one of painting's greatest colorists. See *A Dinner Table at Night* (1884).

Jan van Eyck (1390–1441). One of the earliest pioneers of oil paint. See the richly colored *Arnolfini Wedding* (1434).

Titian (c. 1477–1576). See Titian's *Flaying of Marsyas* in Chapter 5 (p. 147).

1.5
Judith II, 1909
Artist: Gustav Klimt (1862–1918)
Austrian painter Gustav Klimt incorporated gold leaf amid the strong colors of his heady, decorative, and lavish paintings and murals.

NARRATIVE AND
STORYTELLING
IN ART

COLOR AND
NARRATIVE

KANDINSKY'S
COLOR THEORY
IN PAINTING AND
IN CINEMA

PERSPECTIVE
AND
COMPOSITION

LIGHT

CASE STUDY:
PETER
GREENAWAY
AND DUTCH
PAINTING

EXERCISES,
DISCUSSION
QUESTIONS,
FURTHER VIEWING,
AND FURTHER
READING

Cinema and Color

Innovative color in cinema is normally a team effort between the production designer, who is head of the art department, and the DP.[4] Although color has long been central to the experience and technology of cinema, the aesthetic aspects of color in film have been studied far less than color in visual art.[5]

It took time for stable color film stock to be developed and adopted, but from the earliest experiments in cinema, attempts were made to bring color to the screen. For example, Georges Méliès hand-painted the frames of his fantasy films; D. W. Griffith used stenciling (known as PathéColor) in *The Birth of a Nation* (1915) and *Intolerance* (1916). This involved etching on glass plates, using these plates as master stencils to cover portions of the film, then applying colored dye to the appropriate parts of each frame. Color tinting was also practiced.

Along with the films of Vittorio Storaro, discussed in this chapter, and The Archers films, discussed in Chapter 3, you might like to think about the use of color in these films:

Amelie (2001): Jean-Pierre Jeunet, Bruno Delbonnel (DP), Aline Bonetto (art director)

Moulin Rouge (2001): Baz Luhrmann, Donald M. McAlpine (DP), Catherine Martin (production and costume designer), Ann Marie Beauchamp (art director)

Traffic (2000): Steven Soderbergh (director and DP), Philip Messina (production designer)

Don't Look Now (1973): Nicolas Roeg, Anthony Richmond (DP), Giovanni Soccol (art director)

The Colour of Pomegranates (1969): Sergei Parajanov (director and art director), Suren Shakhbazyan (DP), Stepan Andranikyan (production designer)

Red Desert (1964): Michelangelo Antonioni, Carlo Di Palma (DP), Piero Poletto (Art Director)

Gone with the Wind (1939): Victor Fleming, Ernest Haller (DP), William Cameron Menzies (production designer)

The Wizard of Oz (1939): Victor Fleming, Harold Rosson (DP), Cedric Gibbons (credited art director; there were many designers involved, not all credited)

THE ART OF PRODUCTION DESIGN

The production designer plays a key creative role in the filmmaking process, responsible for designing the overall look of a film. Working directly with the producer and director, the PD makes decisions about how to visually tell the story. The title "production designer" was first given to William Cameron Menzies for his work on *Gone with the Wind* as a way of recognizing his overarching contribution to the film. The term "art director" is also sometimes used; there is no hard rule about how the design roles are exercised in a film. Although it is tempting to contrast the production team of a film with the idea of the single individual "master" painter, remember that until the twentieth century most painters (and some even today) employed assistants—sometimes whole teams of assistants—to help execute large-scale works.

KANDINSKY'S COLOR THEORY IN PAINTING AND IN CINEMA

Yellow

Wassily Kandinsky (1866–1944) was hugely influential in developing an abstract art that invoked color as a major component. Having extensively studied the history of color theory (by writers ranging from scientist Sir Isaac Newton to the poet Goethe), Kandinsky tried to explain how we experience color. Kandinsky was writing in 1910, when cinema was beginning and there was no color film. However, Kandinsky's ideas about color had a broad impact that came to include all art forms, as well as interior design and even advertising.

Yellow, according to Kandinsky, assails every obstacle blindly, and bursts forth aimlessly in every direction. Yellow, if steadily gazed at in any geometrical form, has a disturbing influence, and reveals in the colour an insistent, aggressive character. The intensification of the yellow increases the painful shrillness of its note. Yellow is the typically earthly colour. It can never have profound meaning. An inter-mixture of blue makes it a sickly colour. It may be paralleled in human nature, with madness, not with melancholy or hypochondriacal mania, but rather with violent raving lunacy.[6]

Certainly, yellow is associated with the sun and summer, but in Western culture it is also the color of cowardice and greed. Yet in Imperial China, the royal family were regarded as direct descendants of the Sun, which was sacred, so they had the exclusive right to wear yellow.

Made during Sargent's stint as a war artist in July 1918, *Gassed* shows a field of soldiers who have experienced the blinding effects of mustard gas. Mustard gas, a yellow brown sulfur gas that destroys the skin and lungs, was a chemical weapon. The painting does two things: it represents a real thing that happened on the battlefield, and it illustrates a biblical legend of "the blind leading the blind." It also echoes the painting by the Flemish artist Pieter Bruegel the Elder of "the blind leading the blind," in which a group of blind men follow one another into a hole.

Sargent is both referring to the biblical story and the Bruegel painting and making a point about the war. But it's not simply a painting of the blind leading the blind. It is a painting of mustard gas. Here mustard (yellow) is both literal and symbolic. The yellow paint that Sargent uses throughout the picture recalls mustard yellow. It is sickening and sickly looking. This is

1.6
Gassed, 1919
Artist: John Singer Sargent (1856–1925)
One of the greatest paintings of World War 1, Gassed references Bruegel's *The Blind Leading the Blind* (1568) to depict a column of injured, poisoned soldiers.

1.6

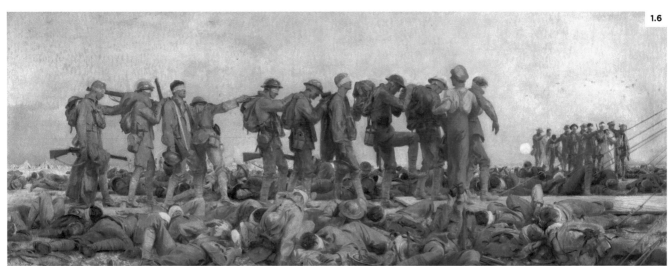

not bright, cheerful sunshine yellow; it is illness yellow. John Singer Sargent was a great colorist, known for his fine, delicately tinted portraits. Long after the use of mustard gas was banned, Singer Sargent's use of the sickly yellow color makes today's viewer feel squeamish and uncomfortable.

In *Jacob's Ladder*, the palette is dominated by sickly yellows, washed-out greens, and dull blues. The film is about a Vietnam veteran's mysterious and often horrific hallucinations, and his quest to find out what causes them. Director Lyne and DP Kimball use many different tones of yellow throughout the film. The yellow dust swirled up by helicopters, the strong yellow of the tropical sunrise, and the yellow tonality employed throughout the Vietnam sequences allude to the distorted wrongness of the situation. Even back home, Jacob finds that yellows dominate, veering from the yellow-green of a murky, deserted underground station to the warm and comforting golden yellows in his house. Yellow can be threatening and disturbing, or reassuring. Sickening yellow dominates the hospital, populated by horrific, grotesque characters, and echoes Kandinsky's relation of the color to lunacy. What is going on? Is Jacob in fact insane?

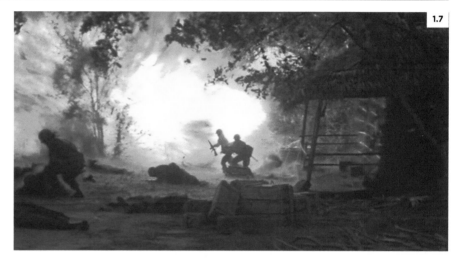

1.7

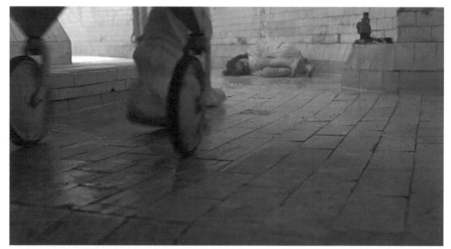

1.7
Jacob's Ladder, 1990
Dir. Adrian Lyne, DP Jeffrey L. Kimball
This psychological horror film draws on a broad palette of yellow tones.

Red and Blue

Kandinsky believed that red is a dynamic color: it "rings inwardly with a determined and powerful intensity. It glows in itself, maturely, and does not distribute its vigour aimlessly."[7] We pay attention when we see red. He notes that red can be used to connote very different things: "The varied powers of red are very striking. By a skillful use of it in its different shades, its fundamental tone may be made warm or cold."[8] Martin Scorsese uses red light in the restaurant scene in *Goodfellas* when Harry greets his fellow wiseguys; red indicates the warmth of their relationship, but also the danger.

Eugene Delacroix, in *Liberty Leading the People* (see Chapter 7), makes the red in the Tricolore flag at the top of the picture dominant over the white and blue. The Tricolore symbolizes the ideals of the French revolution: liberty, equality, and fraternity. Here red is the most active color, as Liberty and her motley collaboration of peasants, workers, bourgeois, and artists stride forward and make revolutionary history. Krzysztof Kieślowski (1941–1996) picks up on this in his *Three Colours* trilogy. *Red* (1994) is about fraternity, about people who have little in common gradually becoming closer and aware of their shared humanity.

Vittorio Storaro, strongly influenced by Kandinsky, sees red and blue at opposite points on the color wheel. For him, red is the color of consciousness, and blue the unconscious. David Lynch plays with the continual contrast of red and blue throughout the film *Blue Velvet* (1986). Dorothy's robe is blue velvet, but her heavily lipsticked mouth is bloody, meaty red. Lynch uses a mix of red and blue light in the nightclub scenes; and in the shots of the "perfect American small town," Lumberton, where the hero Jeffrey lives, we see red roses against a brilliant blue sky.

To Kandinsky, "the power of profound meaning is found in blue, and first in its physical movements (1) of retreat from the spectator, (2) of turning in upon its own centre."[9] A blue cast can often be useful in creating a sense of distance between subject and viewer, which is why blue casts are often used in science fiction films.

Kandinsky also notes the power of deep blues. "The inclination of blue to depth is so strong that its inner appeal is stronger when its shade is deeper."[10] A good example would be Vincent van Gogh's nocturnal pictures, such as *Starry Night*.

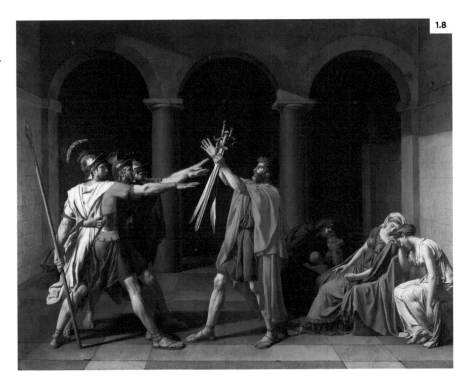

1.8

NARRATIVE AND
STORYTELLING
IN ART

COLOR AND
NARRATIVE

**KANDINSKY'S
COLOR THEORY
IN PAINTING AND
IN CINEMA**

PERSPECTIVE
AND
COMPOSITION

LIGHT

CASE STUDY:
PETER
GREENAWAY
AND DUTCH
PAINTING

EXERCISES,
DISCUSSION
QUESTIONS,
FURTHER VIEWING,
AND FURTHER
READING

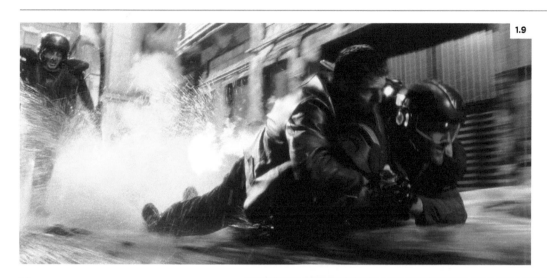

1.9

1.9
***Minority Report*, 2002**
Dir. Steven Spielberg, DP Janusz Kaminski
Minority Report is dominated by blue colors, in
both the interior and exterior scenes. Spielberg
also uses cool muted reds to complement
the blues. The overall effect is distancing and
menacing; like most sci-fi films, *Minority Report*
uses images of an imagined future to warn us in
the present.

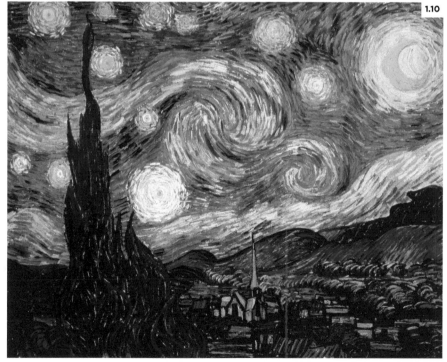

1.10

1.8
***Oath of the Horatii*, 1785**
Artist: Jacques-Louis David (1748–1825)
David puts a dramatic red cape on Napoleon
(1801, see Chapter 7), but long before that he
had used the red cape in the *Oath of the Horatii*,
showing the oath taken by three heroic brothers
willing to sacrifice their lives for Rome. Most of the
painting is in muted colors, but the red garments
of the brothers stand out, perhaps foreshadowing
the bloodshed to come.

1.10
***Starry Night*, 1889**
Artist: Vincent van Gogh (1853–1890)
Van Gogh used many different blue shades in his
paintings of the night sky. The deep blues offset
the stars and the yellow moon, which seem to
whirl and spin in this picture. In *Starry Night Over
the Rhone* (1888), he uses deeper blues and fewer
stars, and the effect is more contemplative.

Black

In Western culture, Kandinsky's evaluation of black is generally accepted: "Black is something burnt out, like the ashes of a funeral pyre, something motionless like a corpse. The silence of black is the silence of death."[11]

Spaniard Pablo Picasso and American Robert Motherwell chose black as the dominant color in their paintings of Spanish political events: Picasso's *Guernica* (1937) is a black-and-white depiction of the bombing of a Basque town. Motherwell's *Elegy to the Spanish Republic* paintings lament the country taken over by fascism.

In cinema, by the 1960s, color film stock became dominant and black-and-white relatively little used. However, some filmmakers continue to choose monochrome for certain dramas. Some examples of the use of black to signify death include Gillo Pontecorvo's choice of the black-and-white newsreel style for *The Battle of Algiers* (1966), Steven Spielberg's monochrome *Schindler's List* (1993), and Mathieu Kassovitz's black-and-white *La Haine* (1995).

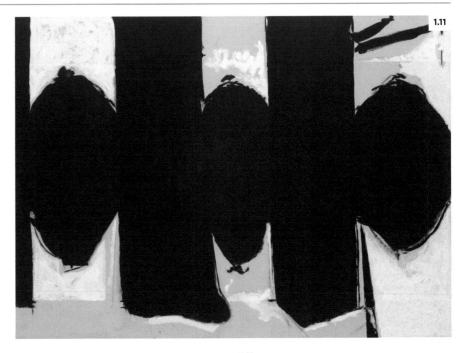

1.11

1.11
***Elegy to the Spanish Republic No. 110, Easter Day*, 1971**
Artist: Robert Motherwell (1915–1991)
Motherwell painted more than 100 pictures in this series, all with the recurring image of the large black oval, which references the ritual display of the dead bull's testicles at the finish of the bullfight. The pictures, he said, "are also general metaphors of the contrast between life and death, and their interrelation."[12]

Color can be part of storytelling. Artists and filmmakers are influenced by existing ideas about color that are culturally accepted, but they also sometimes modify these to create their own, personal color systems.

As well as science, culture and economy are as much a part of art's development as technology. Exploration and trade brought colors from different parts of the world. Industrialization brought synthetic colors and later brought enamels and acrylics. In motion pictures, digital technology now allows inexpensive endless transformation of color through grading as well as special visual effects.

NARRATIVE AND
STORYTELLING
IN ART

COLOR AND
NARRATIVE

KANDINSKY'S
COLOR THEORY
IN PAINTING AND
IN CINEMA

PERSPECTIVE
AND
COMPOSITION

LIGHT

CASE STUDY:
PETER
GREENAWAY
AND DUTCH
PAINTING

EXERCISES,
DISCUSSION
QUESTIONS,
FURTHER VIEWING,
AND FURTHER
READING

PERSPECTIVE AND COMPOSITION

Artists began the process of understanding the visual and how to construct it many centuries ago, building up bodies of knowledge and developing techniques, and then later in the nineteenth and twentieth centuries began questioning, subverting, and refuting them.

This is certainly true of the development of perspective in Western art. Broadly speaking, perspective of a kind was known in the ancient world, but was abandoned during the period we call the Middle Ages. In the Renaissance, largely thanks to the development of glass lenses and a greater understanding of the science of vision, perspective, initially used in engineering, was brought into art. This is one of the principal reasons why Renaissance art looks so different from medieval art, even if the religious subject matter is the same. Yet after five centuries of perspective drawing and painting, by the late nineteenth century, many artists began to move away from trying to achieve realistic perspective, opting instead for a flatter image, fusing the figurative with the abstract.

"YOU HAVE TO DECIDE WHETHER YOU WANT THE AUDIENCE TO SEE EVERYTHING CLEARLY. OR IF YOU WANT TO HOLD BACK A BIT."
—Remi Adefarasin, cinematographer
(_Elizabeth: The Golden Age_)[13]

Perspective

"Perspective" is the illusion made on a flat surface (such as wood, canvas, or paper) of a scene or object as it would be seen by the eye; that is, it gives the impression of a three-dimensional image and creates the impression of space and depth (and often of movement). One characteristic principle of perspective is that objects appear smaller as their distance from the viewer increases. In Matisse's _Music_ (1910), this is clearly not the case. Matisse was trained as a conventional academic painter but was not satisfied with the traditional approach. His interest in travel, color theory, and experimentation led him in a completely different direction. _Music_ removes all perspective, together with any kind of setting or cultural specificity, from the picture; the figures are flat and barely differentiated. Yet the strong contrast between the cool blues and greens and the fiery red of the figures gives the painting energy.

Look at _Scotland Forever_, in the Introduction. Are the horses the same size? Not at all; there is a tremendous sense of the regiment being large, its mass of soldiers trailing off into the distance, and this is shown by their being painted smaller. As well, Butler gives the impression of movement: we "feel" the horse in the foreground surging forward. This is perspective.

A Brief History of Perspective

In the past, it was often claimed that perspective was unknown before the Renaissance, and that Italian painters actually discovered perspective in painting. However, more recent discoveries from the ancient world demonstrate that Roman painters understood perspective, and with what we know about classical geometry and mathematics, we can accept that Greek painters probably did also. Furthermore, the flattened perspective that we see in ancient Egyptian and much later Japanese visual art does not necessarily indicate a lack of knowledge of perspective, but rather a stylistic decision.

However, we do know that in the late Roman Empire and Byzantium, and in the so-called Middle Ages (roughly 300–1200 AD), perspective painting is not in evidence. There is also little secular painting of any kind. In fact, what is interesting is how strange and different the painting of this period is from any other time in European art. While the Roman frescoes don't look odd to us at all, Byzantine icons and frescoes appear impossibly stylized and remote. Yet the art of this time was splendid and beautiful; take, for example, the marvelous Basilica of San Vitale at Ravenna, Italy. It can only be described as a tour de force in ecclesiastical interior decoration, every inch of its walls and ceiling covered in marvelous technically complex and sophisticated painting and gilding. But the style is noticeably flattened, distinctly different from the more realistic wall painting we see in Pompeii.

Art Meets Science: The First Camera and the Science of Composition

Historians, like the rest of us, love to give all-encompassing labels to things. The term *Renaissance* is a good example, long used to describe great social, political, philosophical, and importantly, artistic shifts in culture and knowledge that took place over a long period of time, roughly 400 years. For many complex reasons, certain Greek and Roman classical texts fell out of use, and in some cases even disappeared. But not for long, because many of these texts, particularly those involving mathematics, were widely used by scholars in the regions that had embraced Islam in the seventh century: Mesopotamia, Syria, Arabia, and most prominently, Egypt. And the scholars weren't simply using the texts, they were building on them, developing and extending knowledge, and eventually that knowledge found its way back to Europe.

For our purposes, one of the most important results of this "rediscovered" knowledge is the science of optics, developed by Ibn al-Haytham (also known as Alhazen), whose *Book of Optics* (1040 AD) asserted (correctly) that vision takes place when light enters the eye. He developed ideas about light, color, and vision and about visual perception that are still in use today, and made possible the further development of lenses. Alhazen combined this knowledge with the existing knowledge of lenses to create the first fully functioning camera, the camera obscura, which allowed a more accurate rendering of perspective. The camera obscura and its use by painters is discussed in detail in Chapter 2.

The development of optics was a by-product of the European glass industry. Known since Roman times, glass technology got finer and finer during the Renaissance. Alhazen had discussed the use of a convex lens to enlarge or magnify an image or object in his *Book of Optics*, and this knowledge was applied: Eyeglasses were invented in Italy in the thirteenth century, and different kinds of lenses were manufactured. Mirrors, originally made of polished metal or stone, were now reinvented as coated glass. None of these developments was aimed at helping or developing painting, but artists soon realized that optics offered new possibilities.

Due to the camera obscura and various other methods, such as using a grid or "drawing machine,"[14] perspective painting became the norm, and the quest for more accurate and realistic pictures began. Yet by the end of the nineteenth century, artists began to reject perspective painting. The influence of non-Western art, the rise of photography, and changing social relationships born of the Industrial Revolution created a desire to do something completely new, and many artists started to seek completely different approaches to perspective.

THE FIRST SCIENTIST: ALHAZEN

Alhazen, or Ibn al-Haytham, is credited as the first ever scientist. Born c. 965 in Basra, Iraq, he spent his life in research and scholarship, publishing many books, the most influential being the enormous *Book of Optics*, which was translated into Latin for European readers a century later. He died c. 1040 in Cairo. His discoveries about how the eye works led to everything from the camera to eyeglasses.

NARRATIVE AND
STORYTELLING
IN ART

COLOR AND
NARRATIVE

KANDINSKY'S
COLOR THEORY
IN PAINTING AND
IN CINEMA

PERSPECTIVE
AND
COMPOSITION

LIGHT

CASE STUDY:
PETER
GREENAWAY
AND DUTCH
PAINTING

EXERCISES,
DISCUSSION
QUESTIONS,
FURTHER VIEWING,
AND FURTHER
READING

Perspective and Film

Perspective in film is normally an issue of cinematography. Cinematography involves the camera and a huge range of decisions that are made about how to use it. This includes the type of lens, focal length, focus, and shot size. All of these influence the composition of the resulting cinematic picture. The image helps create an interpretation of the dramatic events through which the spectator may engage with the narrative unfolding of the story.

For example, the type of shots chosen can influence the way the viewer interprets what's going on. Shot size depends on the focal length of the camera's lens and how far the camera is placed from the subject. The most common shot sizes are the close-up, the medium shot, and the long shot. The close-up can offer us intimacy, but can also create tension. The medium shot is the most common, but it often serves to bridge between close-ups, when the most important things are said, and long shots, when we create an establishing view of events or allow the landscape to emerge as a protagonist in the story.

Painters have similar techniques: we can easily make a correspondence between the cinematic image and the painted image in terms of composition. What tends to work well in a painting also works well in a film. So a painting of a queen seated on a throne in ceremonial robes is going to look majestic and powerful; the same shot set up for cinema will also have the same connotations. However, in film, if we want the viewer to then become more intimately acquainted with that queen, and to learn more about her feelings or motivations, we are going to move to a close-up on the face, and perhaps even a cutaway close-up on the hands clutching the scepter.

Cinematographers have many other potential shots at hand, some of them relatively recent, such as the aerial shot, which gives an aerial perspective. This was understandably not something that could easily be imagined before the availability of flight.

One interesting perspective is the *point of view shot*, also known as the subjective camera. This is when the camera takes the perspective of a character, and the audience sees the scene as if through the character's eyes. Occasionally, films are made to be seen largely, or even entirely, through the perspective of the principal character. In *Russian Ark* (2002), by Russian director Alexander Sokurov (DP Tilman Büttner), the unseen narrator is played by the camera, using the first digital hard drive Steadicam system. Filmed entirely in the Winter Palace of the Russian State Hermitage Museum, it was shot in real time. Watching the film, one cannot help noticing that the Hermitage Museum, which is filled with art from every period of human history, acts as point and counterpoint to the action on the screen. The paintings and sculptures of the museum are as much a part of the cast as are the (more than 2,000) actors.

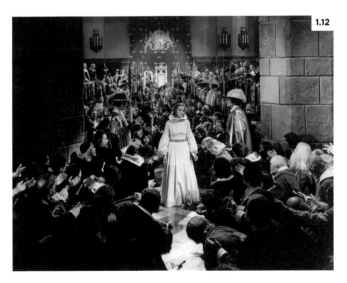

1.12

1.12
***Queen Christina*, 1933**
Dir. Rouben Mamoulian
A romantic drama with a historical setting, based on the life of seventeenth-century Queen Christina of Sweden, the composition of this scene still is strongly reminiscent of traditional court painting, like *The Persian Embassy to Louis XIV* (1715) by Nicolas de Largillière (1656–1746). But the viewer has little intimacy with Christina; we see her here in her official role. The contrast between shots like this and shots of Christina's passion and torment, told through close-ups, is what makes Mamoulian's film so powerful.

LIGHT

Most importantly, painters have helped filmmakers to understand how to use light. Filmmakers, and particularly cinematographers, often go to painting to learn about lighting. There are certain painters who are so crucial to light that we could even call them the first cinematographers. These are Caravaggio, Rembrandt, and Vermeer.

What can lighting do for painting? Lighting tells us where to look, it tells us what's important; it models faces and figures and reveals character. Lighting offers the illusion of three dimensionality, as well as mystery and drama. The "language" of lighting in film derives from lighting in painting, developed over hundreds of years since the Renaissance. It was oil paint, with its malleability and slow drying time, that allowed painters to build up layers of paint and create dramatic lighting effects. Painters construct narrative by lighting the elements they want to draw attention to and throwing other elements into shadow. Lighting creates visual interest, highlighting those that face the light and veiling those that turn away in shadow, simultaneously hiding and revealing. The viewer then "reads" the painting and works out why some things are made clear and some are obscured, and in this way begins the process of exploring the picture's narrative intent.

Rembrandt and Caravaggio use light/dark contrast (*chiaroscuro*) for psychological purposes. Light/dark symbolism appears often in religious texts. In general, darkness suggests mystery and the unknown. Light usually suggests security, virtue, truth.

Because these are such conventional symbolic associations, some artists and filmmakers deliberately reverse light/dark expectations. For example, *Realist* painters try to mimic natural light, sometimes by showing the light source. We see this in the Dutch interior paintings by Vermeer, De Hooch, and others, where the window is seen to be the principal light source. Some realist filmmakers try to approximate natural lighting through the use of available light, in combination with lights and reflectors either to augment the natural light or to soften the harsh contrast produced by sunlight.

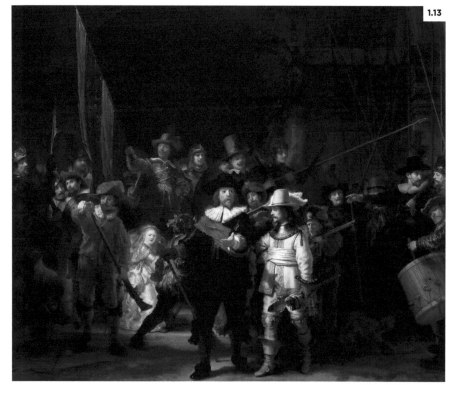

1.13

1.13
The Night Watch, 1642
Artist: Rembrandt Van Rijn (1606–1669)
Rembrandt's *Night Watch*, one of the most famous paintings in the world, is prized for its depiction of lighting, composition, and coloring. Jean-Luc Godard's film *Passion* (1982) reenacts *The Night Watch* with live actors.

NARRATIVE AND
STORYTELLING
IN ART

COLOR AND
NARRATIVE

KANDINSKY'S
COLOR THEORY
IN PAINTING AND
IN CINEMA

PERSPECTIVE
AND
COMPOSITION

LIGHT

CASE STUDY:
PETER
GREENAWAY
AND DUTCH
PAINTING

EXERCISES,
DISCUSSION
QUESTIONS,
FURTHER VIEWING,
AND FURTHER
READING

Chiaroscuro

Chiaroscuro is the use of bold and strong contrast between light and dark, affecting a whole composition. Rembrandt and Caravaggio are the most outstanding masters of chiaroscuro, using it to remarkable psychological effect in their paintings. This is important because psychologists have discovered that, shown a line drawing, most people actively attempt to interpret its meaning. Shown a color painting, they tend to react to it emotionally rather than intellectually. This is why chiaroscuro works so perfectly; it allows you to have your cake and eat it. The viewer interprets the meaning through the lines created by the juxtaposition of dark and light, and the presence of color, however limited, effects an emotional reaction.

High key lighting creates a bright, even picture that brings out color and creates an overall natural, yet "larger than life" emphasis. Bronzino's *Allegory of Venus and Cupid* shows this to good effect. High key lighting produces a flattering, natural effect that also matches the general mood of a romantic comedy, as in the film *When Harry Met Sally*, or *Knocked Up*.

Lighting from above tends to create a halo effect suggestive of spirituality. See Raphael's *The Crowning of the Virgin* (1502) or Murillo's *The Two Trinities* (1675). Indian film-maker Satiyajit Ray's *Pather Panchali* (1955) has many such shots.

A face that is shown in darkness or semi-darkness can symbolize self-division and ambivalence, as in Rembrandt's *Portrait of his Son Titus* and his many self-portraits. It is a favorite lighting method in film noir: see *The Killers* (Robert Siodmak, 1946) or *Drive* (Nicolas Winding Refn, 2011).

Lighting from below often makes the subject's face appear sinister or eerie, or otherwise disturbing, and is sometimes seen in horror or suspense films (*The Blair Witch Project*, dir. Eduardo Sánchez and Daniel Myrick, 1999; *Frankenstein*, dir. James Whale, 1931). Caravaggio does the same in *David with the Head of Goliath*. Yet see how it creates mystery and excitement in Joseph Wright of Derby's *An Experiment with a Bird in an Air Pump* (1768).

When the subject blocks out the source of light it creates a **silhouette**. See the painting *Wanderer above the Sea of Fog* (Caspar David Friedrich, 1818) in Chapter 6, p. 162. Silhouette is used to powerful effect in *Gone with the Wind* (1939) at key moments in the storytelling. Viewers can be made to feel threatened by bottom lighting, or silhouettes, for we tend to associate light with safety.

The Theater of Light

Both Caravaggio and Rembrandt could be considered theatrical painters. Both use chiaroscuro in an expressive, theatrical sense. Both rarely reveal the light source. Caravaggio's paintings combine detailed realism with highly dramatic use of light and shade. Caravaggio presents religious stories as earthly events happening to real people in the present, using lighting to express their intensity.

Seventeenth-century Dutch artists were acutely aware of the possibilities of light and shade. Painter Samuel van Hoogstraten wrote an influential manual for painters (*Introduction to the Academy of Painting*, or *The Visible World*, 1678), giving a whole chapter over to the study of shadows.

There is no visible light source in *The Anatomy Lesson*, which is usual in Rembrandt's paintings. However, Rembrandt lights the cadaver on the table, around which the medical students and their teacher, who are the subjects of this commissioned painting, are gathered. The artist even hints that the light is emanating from the corpse, because the subjects are lit by reflected light from the symbolic object. Why would Rembrandt do this? Dr. Nicholas Tulp was a renowned medical professor and it was only recently that it had been possible to use real cadavers in anatomy lessons. Tulp was allowed to do one dissection a year, on the body of a condemned criminal. Previously, religious custom forbade it. The anatomy lesson represents the bringing of knowledge—enlightenment—through science. Rembrandt uses lighting to portray this process of enlightenment, which would have been pleasing to the Guild of Surgeons who commissioned it, and the doctors who paid to be included in the painting.

Rembrandt is a painter not afraid to build an image with many dominant and different tones of black. Light and dark are powerful tools for the image maker. Gordon Willis, the DP of *The Godfather*, was known for daring to underexpose and create areas of real black, earning him the sobriquet "Prince of Darkness" from Conrad Hall. "I may have gone too far a couple of times," he said. "But I think Rembrandt went too far a couple of times."

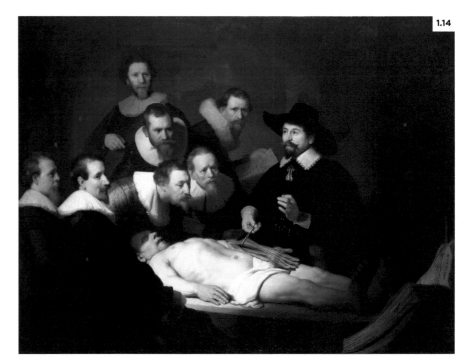

1.14

1.14
***The Anatomy Lesson of Dr. Nicolaes Tulp**, 1632*
Artist: Rembrandt Van Rijn (1606–1669)
Rembrandt painted *The Anatomy Lesson of Dr. Nicolaes Tulp* when he was just twenty-six. The painting was a commission for the board room of the Amsterdam Guild of Surgeons. Today it is in the Mauritshuis, at The Hague.

NARRATIVE AND
STORYTELLING
IN ART

COLOR AND
NARRATIVE

KANDINSKY'S
COLOR THEORY
IN PAINTING AND
IN CINEMA

PERSPECTIVE
AND
COMPOSITION

LIGHT

CASE STUDY:
PETER
GREENAWAY
AND DUTCH
PAINTING

EXERCISES,
DISCUSSION
QUESTIONS,
FURTHER VIEWING,
AND FURTHER
READING

1.15
The Godfather, 1972
**Dir. Francis Ford Coppola,
DP Gordon Willis**
Willis's lighting in this scene demonstrates his understanding of the effect wrought by Rembrandt's rich amber tones, range of blacks, and white highlights. Willis has described cinematography as "painting pictures in the dark."

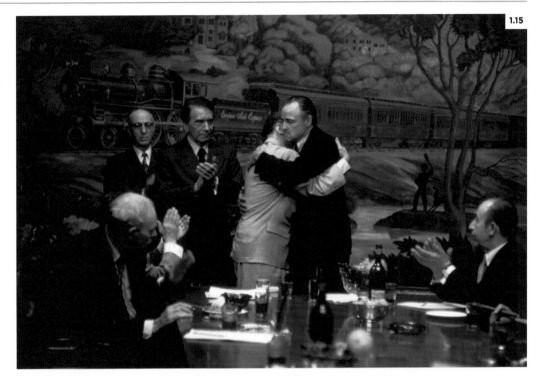

1.15

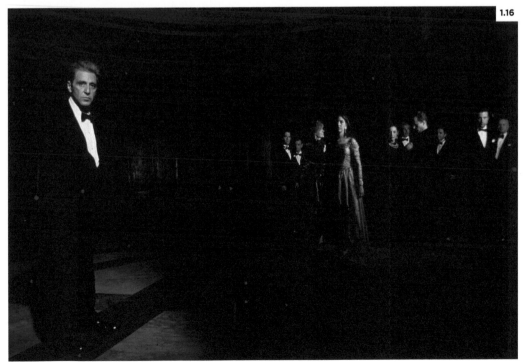

1.16

1.16
Godfather III, 1990
**Dir. Francis Ford Coppola,
DP Gordon Willis**
In *Godfather III*, Willis goes even further, with this chiaroscuro shot conveying Michael Corleone's sense of isolation and guilt, as well as his strength and power.

Vermeer uses chiaroscuro as part of the illusion of natural light to tell the story. In *Woman Holding a Balance* (1662), he uses cast shadows to more dramatic effect than in most of his paintings. The room is mostly dark, with a thin shaft of light coming in from a curtained window on the far left of the picture. We see a woman dressed in a fur-lined robe, holding jeweler's scales while standing at a table covered in jewelry. Behind is a large painting of the Day of Judgment, when the souls of the dead are to be weighed. Jewelry, and particularly pearls, although popular, were seen as symbols of vanity.

We may interpret the woman's weighing jewels in the darkened room as a furtive, secretive act. On the other hand, we could instead note that the white light sliding in through the chink in the curtain is falling on the jewels and also illuminating the whiteness of the woman's robe headdress and face. White, being frequently associated with innocence and purity, could be an indicator of the tension between the material and the spiritual. The golden white light bathes the woman like baptism. Although she is holding the balance, she's not actually weighing anything; it is empty.

Perhaps, through the judicious representation of light, Vermeer wants to say that although jewels are objects associated with vanity, if one is able to exert prudent judgment, and weigh things accordingly, having jewels doesn't make you a bad person.[15] The painting contains complex layers of visual symbolism.[16] We may read the painting as indicative of the value of temperance and balanced judgment. However, art historians do not agree on the meaning, and so

it is left to the viewer's imagination. Unlike Rembrandt's *Anatomy Lesson*, *Woman Holding a Balance* is not a commissioned portrait, so the artist is not flattering a subject.

Sometimes revealing the light source has its own dramatic value: in Hendrick ter Brugghen's *The Concert* (1626), musicians play by candlelight, which creates soft chiaroscuro without blacks, melded together by warm golden light.

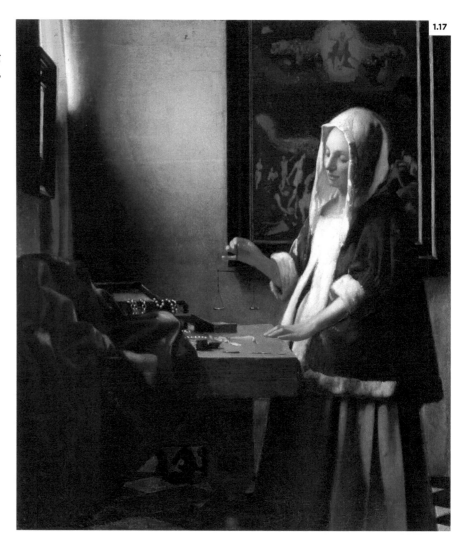

1.17

1.17
Woman Holding a Balance, 1662–1664
Artist: Jan Vermeer (1632–1675)
Lighting is one of the principal tools Vermeer is using here. Art historians have long argued over the precise "meaning" of this painting.

NARRATIVE AND
STORYTELLING
IN ART

COLOR AND
NARRATIVE

KANDINSKY'S
COLOR THEORY
IN PAINTING AND
IN CINEMA

PERSPECTIVE
AND
COMPOSITION

LIGHT

CASE STUDY:
PETER
GREENAWAY
AND DUTCH
PAINTING

EXERCISES,
DISCUSSION
QUESTIONS,
FURTHER VIEWING,
AND FURTHER
READING

Tenebrism

Stanley Kubrick (1928–1999) preferred to use natural light, and used the camera to compensate for problems caused by natural light's unreliability. When he wanted to film *Barry Lyndon* (1975), set in eighteenth-century England, he started with art: he "accumulated a very large picture file of drawings and paintings taken from art books. These pictures served as the reference for everything we needed to make—clothes, furniture, hand props, architecture, vehicles, etc."[17] However, he encountered a problem when he wanted to recreate a naturalistic, candlelit interior. Filming in candlelight had never been done successfully before. Kubrick and DP John Alcott used a rare Zeiss lens manufactured for NASA satellite photography. It had a speed of f0.7, 100 percent faster than the fastest available movie lens. Kubrick was able to shoot the scene by candlelight and make the best use of the soft, warm chiaroscuro that was the magical result.

It is possible to go further than chiaroscuro; *tenebrism* is the "spotlight" effect, the extreme tonal shading of dark and light, that we see in the work of Caravaggio and also the Spanish painter Zurbarán (1598–1664), particularly in his series of remarkable paintings of St. Francis, which are so high contrast they are nearly monochrome. Rembrandt's chiaroscuro depths are not made by the application of pure black: he built his darks up through layers of dark earth pigments. Tenebrism and chiaroscuro were highly prized by filmmakers in the period of monochrome, before the widespread use of color. We see it particularly in gangster pictures and *film noir*: the murky "gray" morality of the protagonists is depicted through high-contrast black and white.

One of the most masterful uses of tenebrism in cinema is in *Citizen Kane* (1941), directed by Orson Welles and photographed by Gregg Toland. Another is the suspenseful, expressionistic *Night of the Hunter* (1955) by Charles Laughton, DP Stanley Cortez.

Andrej Wadja's black-and-white *Ashes and Diamonds* (1958) has a magnificent finale when the wounded Resistance hero turned assassin gets tangled up in a courtyard full of washing lines of laundry, bleeding darkly over brilliant white sheets. And the *Godfather* trilogy (1972–1990, directed by Francis Ford Coppola, DP Gordon Willis) borrows openly from Rembrandt and Caravaggio in color, lighting, and composition. Willis's deep blacks in *The Godfather* were made by underexposing the film, which has caused problems in transferring the film to DVD because digital media do not handle underexposure well. Michael Mann's *Collateral* (2004), one of the first digitally shot features, is partly shot at night and has very soft chiaroscuro made up of gradations of darks—typical of the low-light capability of digital. Filmmakers are well aware of the dramatic power that chiaroscuro and the more extreme tenebrism offer, but the lesson was taught by painters.

FURTHER VIEWING

Examples of *tenebrism*

Francisco Ribalta, *Christ Embracing St. Bernard Clairvaux*, 1626

José de Ribera, *The Martyrdom of Saint Philip*, 1639

Georges de La Tour, *The Magdalen with the Smoking Flame*, 1640

Francisco Zurbaran, *Saint Francis in Meditation*, 1635–1639

CASE STUDY:
PETER GREENAWAY AND DUTCH PAINTING

"MOST PEOPLE ARE VISUALLY ILLITERATE. WHY SHOULD IT BE OTHERWISE? WE HAVE A TEXT-BASED CULTURE. OUR EDUCATIONAL SYSTEMS TEACH US TO VALUE TEXT OVER IMAGE, WHICH IS ONE OF THE REASONS WE HAVE SUCH AN IMPOVERISHED CINEMA."
—Peter Greenaway, director
(*Rembrandt's J'Accuse*, 2008)

Welsh-born Greenaway studied painting in London and soon after decided to become a filmmaker, producing in 1982 his first critically acclaimed film, *The Draughtsman's Contract*, a murder mystery set on a seventeenth-century English grand estate. In this film, Greenaway's fascination with painting and love of puzzles was established, motifs that recur in all of his works. Greenaway's films are quite particular in that they combine a stunning use of the visual with a strong connection to history (not least history of art) and contemporary sociopolitical critique. Greenaway's films often show us how the very greed that propels the powerful to the top eventually betrays them.

Frans Hals and the "Schuttersstuk"

"Schuttersstuk," militia paintings of *Schutterij*—voluntary city guard or citizen militia—were fashionable in the Netherlands in the early seventeenth century, a period known as the Dutch Golden Age. Civic guards had played a large role in the emancipation of cities and towns from feudal rule during the region's earlier struggle for independence, and were celebrated—and celebrated themselves. *Schutterij* were supposed to protect the town or city from attack and act in case of revolt or fire. It became a tradition to have a regular group portrait painted—a clue as to the role that art played in bourgeois life in the era, as well as to the prosperity they enjoyed. There are many Schuttersstuk militia paintings, including those by Cornelis van Haarlem, but Hals's are probably the most expressive.

What are they for, these expansive depictions of well-fed, jocund men? Paul Knevel muses that "it . . . does not seem far-fetched to regard the paintings of militia banquets as symbolic images of friendship and unity, all the more so because friendship and unity were key words in urban self-representation."[18]

NARRATIVE AND
STORYTELLING
IN ART

COLOR AND
NARRATIVE

KANDINSKY'S
COLOR THEORY
IN PAINTING AND
IN CINEMA

PERSPECTIVE
AND
COMPOSITION

LIGHT

**CASE STUDY:
PETER
GREENAWAY
AND DUTCH
PAINTING**

EXERCISES,
DISCUSSION
QUESTIONS,
FURTHER VIEWING,
AND FURTHER
READING

1.18

1.18
***The Banquet of the Officers of the St. George
Militia Company in 1616***
Artist: Frans Hals (1582–1666)
This is one of the greatest examples of Dutch
Militia paintings. Hals himself had served in
the same militia and knew the group well.
The people in the picture are depicted as real
individuals, not types or symbols. The original
is 1.75 × 3.24 meters. Today you can see it in the
Frans Hals Museum, Haarlem.

The Cook, the Thief, His Wife, and Her Lover (1989)

Greenaway's film is set in a lavish and smart restaurant, Le Hollandais ("The Dutch"), run by a French chef and patronized by the local mafioso Albert Spica (Michael Gambon) and his unlovely crew. Spica has just taken control of the restaurant and dines here nightly with his gang of thugs and his much-abused wife, Georgina (Helen Mirren). Spica also does not hesitate to use the backyard of the restaurant to enact monstrous revenge on those who cross him. All of the restaurant's workers are terrorized by him, though the Cook (Richard Bohringer) manages to keep his sang-froid.

Greenaway shoots most of the film in a large warehouse, transforming it into a huge restaurant with a cavernous kitchen. But this is unlike any real restaurant. The interiors of both kitchen and dining room are dramatic and sensual, richly textured and strongly colored, contrasting with the pristine whiteness of the bathroom (the unlikely setting for the Wife's passionate affair with the Lover). While the kitchen is a baroque vision of Hell, all steam and smoke and toiling minions, the dining room is dominated by one massive reproduction of Frans Hals's *The*

Banquet of the Officers of the St. George Militia Company in 1616. Why does Greenaway use this painting? What is the connection between Hals's painting and this film? We notice right away that Spica and his gang are dressed in a peculiar way: they wear the same sashes and hats as the militiamen in the painting—though the film is clearly set in late 1980s London.

The Dutch militiamen were civilians, burghers, respectable middle-class men, not professional soldiers. So why would Greenaway dress Spica and his villains in this way? First, the film has a distinct critique of consumerism and, implicitly, of capitalism—symbolized and illustrated by Spica's uncouth greed. The gang dress alike in this seventeenth-century fashion that sets them apart from the rest of the patrons. If, as we've seen, the paintings of militia banquets are symbolic images of friendship and unity, the film's story systematically portrays the course of betrayal of friendship and unity by all of the main characters, as the Wife betrays the Thief with the Lover, the Cook betrays his patron, the Thief, by allying with the Wife, and of course, the Thief in his greed and brutality betrays

everyone. He betrays all kinds of friendship and unity, even that of his own gang. At the same time, we can understand that Greenaway distrusts the *Schuttersstuk* painting of the pink-cheeked well-fed burgher army, these self-satisfied capitalists parading their wealth, fancy food, and splendid costumes.

What is the effect of this conceit on the story? As we have just seen, it serves to drive the plot, echoing the power relations explored in the film. It also adds visual interest. Greenaway's film is highly stylized, creating strong images. The ironic thing is that the Dutch paintings of the Golden Age are considered to be eminently realistic, yet by incorporating them into the contemporary drama Greenaway lifts his characters *out* of realism. But, as we will see, realism in film goes beyond the visual. What *is* real in the film are the human emotions and human psychology. Through the use of the painting, Greenaway links the greed, carnality, and venality of the past, in his reading of the complacent self-satisfaction of the Dutch Golden Age burghers, to the greed, carnality, and venality of the present—Thatcher's England in the late 1980s.

NARRATIVE AND
STORYTELLING
IN ART

COLOR AND
NARRATIVE

KANDINSKY'S
COLOR THEORY
IN PAINTING AND
IN CINEMA

PERSPECTIVE
AND
COMPOSITION

LIGHT

CASE STUDY:
PETER
GREENAWAY
AND DUTCH
PAINTING

EXERCISES,
DISCUSSION
QUESTIONS,
FURTHER VIEWING,
AND FURTHER
READING

1.19

1.19
The Cook, the Thief, His Wife, and Her Lover,
1989
Dir. Peter Greenaway
Greenaway's British gangster drama references
Dutch painting in a variety of ways.

FURTHER VIEWING

See also these examples of Rembrandt's chiaroscuro:

Self-Portrait with Velvet Beret and Furred Mantel, 1634

The Philosopher in Meditation, 1632

The Blinding of Samson, 1636

Rembrandt's Night Watch (1642) and Greenaway's *Nightwatching* (2007)

The *Night Watch* is quite different from the rest of the Schuttersstuk militia paintings. It is not just a group of men around a banquet table; it is far more theatrical, dramatic, posed. Compare its composition to Hals's painting. Instead of just lining the militiamen up on a horizontal plane, Rembrandt's composition creates the illusion of depth: he places the people in perspective, led from the front, capturing the moment of action. Historian Simon Schama points out that Rembrandt was well aware that these burgher militiamen were "pretend" soldiers; the real fighting was done far away by professionals.[19] But he gave them their moment of heroic action on canvas. Visually, too, Rembrandt makes powerful use of chiaroscuro, the use of bold and strong contrast between light and dark. Rembrandt is the most outstanding master of chiaroscuro in North European art; he used it to remarkable psychological effect in his paintings.

The image on page 36 is by Rembrandt: *The Night Watch*, or *The Company of Captain Frans Banning Cocq and Lieutenant Willem van Ruytenburch Preparing to March Out* (1642). The painting measures 3.63 × 4.37 meters. Banning Cocq (left) and van Ruytenburch (right) are in the foreground, surrounded by the rest of the militia in the Amsterdam street. The painting is lively, active; one can almost hear the street noise and bustle, almost smell the gunpowder and the nearby canal.

The painting of the *Night Watch* itself contains the puzzle and is the

subject of Greenaway's 2007 film. It focuses on the relationships between Rembrandt, who has transcended his humble origins and become a fashionable society painter, and the bourgeois civilian militiamen who want to be celebrated in their traditional Schuttersstuk group portrait. *Nightwatching* posits a conspiracy to murder the original captain of the musketeer regiment and replace him with the depicted Frans Banning Cocq and his deputy, Willem van Ruytenburch. Greenaway suggests that Rembrandt used the painting to expose and immortalize a conspiracy, using subtle allegory in his group portrait, subverting the highly prestigious commission into a tainted document that brought about Rembrandt's fall from grace into obscurity and penury. Through the story, Greenaway lays bare the hierarchy, corruption, and venality at the heart of ostensibly democratic and "free" Amsterdam of the Golden Age.

In *Nightwatching*, Greenaway, working with Reiner van Brummelen (his DP since 1999) and production designer Maarten Piersma, makes the whole film look like a Rembrandt painting. Most of the film is shot indoors, like *The Cook, the Thief, His Wife, and Her Lover*, in a huge warehouse studio fitted out to become various places in seventeenth-century Amsterdam. Greenaway and van Brummelen designed the lighting in strong, warm chiaroscuro. Striking visual effects are created simply by lighting, costume, and textiles, augmented

with period props. The way that each of the characters is lit echoes the techniques used in Rembrandt's portraits and compositions.

Many years after the *Night Watch*, Rembrandt made the portrait of his son, *Titus in the Red Hat*, set in a dramatic night landscape. This dynamic style of low-key lighting was distinctive in Rembrandt's portraiture, bringing dramatic flair to the image. Titus looks dashing, and wears a blood-red hat and a heavy neck chain that glints and adds a gold light to the picture. The effect is strongly theatrical, and by the shadowing on his face, Titus appears mysterious. The critic Andrew Graham Dixon points out that this was painted shortly after Rembrandt was made bankrupt. Was it a gesture of defiance, to paint his son as a nobleman wearing a probably fictional gold chain?

The high drama and sense of mystery that this kind of portrait lighting achieves is used throughout *Nightwatching*.

NARRATIVE AND
STORYTELLING
IN ART

COLOR AND
NARRATIVE

KANDINSKY'S
COLOR THEORY
IN PAINTING AND
IN CINEMA

PERSPECTIVE
AND
COMPOSITION

LIGHT

**CASE STUDY:
PETER
GREENAWAY
AND DUTCH
PAINTING**

EXERCISES,
DISCUSSION
QUESTIONS,
FURTHER VIEWING,
AND FURTHER
READING

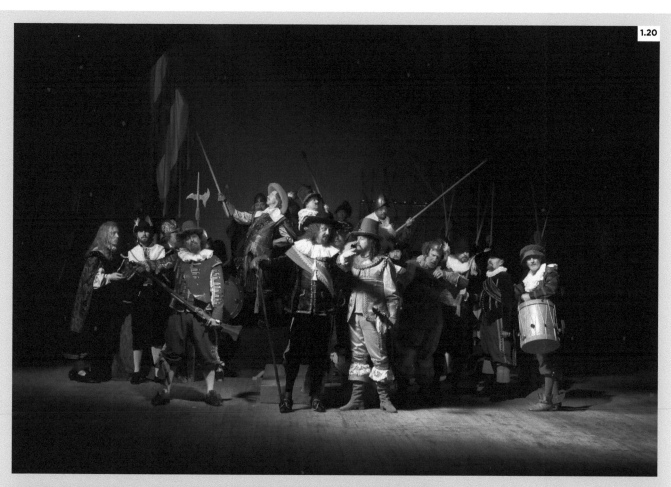

1.20

1.20
Nightwatching, 2007
Dir. Peter Greenaway
The lighting and composition of Greenaway's
biopic of Rembrandt are based on Rembrandt's
paintings.

FURTHER VIEWING

Prospero's Books (1991), in which Peter Greenaway's
interpretation of Shakespeare references Mannerist painters
such as Bronzino and Parmigianino

The Draughtsman's Contract (1982), which Greenaway has
said refers to Caravaggio and other Baroque artists

Goltzius and the Pelican Company (2012), Greenaway's
biopic of Hendrik Goltzius, sixteenth-century Dutch painter
and maker of erotic prints

EXERCISES AND DISCUSSION QUESTIONS

Composition, perspective, color, tonality, and lighting are common to both painting and cinema. Through studying paintings, filmmakers and particularly cinematographers can gain new insights not only into how to achieve a particular "look," but also into understanding how our visual culture has adopted particular ways of seeing the world through paintings. These techniques are used in traditional paintings, and in all films, to construct the visual driving the narrative, building context and subtext, and heightening emotional engagement with the work.

Exercise 1
Watch *Blue Velvet*, and note how many times the red-blue contrast appears in the film. What other colors are ascribed symbolic significance in the film?

Exercise 2
Refer to Vittorio Storaro's symbolic system of color correspondences on page 25. Watch any of the films on which Storaro was the DP, such as *The Sheltering Sky* (1990), *The Conformist* (1970), *Apocalypse Now* (1979), or *Bulworth* (1998). Do you see this system operating? How does he accomplish it? Is it useful to you as a viewer to know this?

Color symbolism is important for Storaro, but not everyone shares his view. How important is color symbolism to you as a filmmaker?

Exercise 3
Choose any of the paintings shown in this chapter, or elsewhere in this book. Locate your chosen painting online and have a good look at it, zooming in and scrolling around. What are the painting's "cinematic" qualities? As we have seen, the word *cinematic* has no precise meaning, but it is frequently used to mean that a picture has certain qualities that are shared with cinema: a dramatic moment or a striking composition. How is this achieved in your chosen picture? What else in the picture may be "cinematic"?

Exercise 4
Choose a static subject and location in natural light (a tree or part of a building, for example). Now, over the course of one clear day, record the changes in the light and how this affects the image you can make. Take a photograph just before sunrise, at sunrise, then again at noon, midafternoon, at sunset, and at twilight. Arrange the pictures so you can see them all at the same time. Notice how the change in the color temperature gives the same subject quite a different look. What kind of mood does each time of day suggest?

NARRATIVE AND
STORYTELLING
IN ART

COLOR AND
NARRATIVE

KANDINSKY'S
COLOR THEORY
IN PAINTING AND
IN CINEMA

PERSPECTIVE
AND
COMPOSITION

LIGHT

CASE STUDY:
PETER
GREENAWAY
AND DUTCH
PAINTING

**EXERCISES,
DISCUSSION
QUESTIONS,
FURTHER VIEWING,
AND FURTHER
READING**

Exercise 5

Many people believe that Vermeer also used optics, in the form of a camera obscura, which is discussed in detail in the next chapter. If this is true, then perhaps we could say that Vermeer, like a cinematographer, used a lens through which to see his composition.

Look at Vermeer's *The Music Lesson* and reinterpret this picture as an exercise in natural lighting for a film. You will need a window that admits a significant amount of natural light and actors to play the subjects. Using Vermeer as a guide, position your subject in front of the window. Using your camera, experiment with different focal lengths and different camera positions until you can create a shot that best resembles what Vermeer achieved.

Make sure you notice the light temperature. Morning light will be different from afternoon light and evening light. Light changes temperature at different times of the day, which means it has a slightly different color and very different intensity, all of which will affect your composition. What time of day do you think that Vermeer used?

Now experiment with your camera. Have your characters move into the shot. Try a tracking shot to follow your characters toward the window. How can you bring variation into the composition without going too far away from what Vermeer did?

DISCUSSION QUESTIONS

1. What is "Rembrandt lighting"? Why is it used in cinema? Aside from Gordon Willis, can you find any other DPs or directors who seem to be strongly influenced by Rembrandt?

2. We have seen Peter Greenaway's fascination with Rembrandt. Watch either *The Cook, the Thief, His Wife, and Her Lover* or *Nightwatching* or his early film *The Draughtsman's Contract*. How would you describe the overall visual style of any of these films?

3. We have seen in this chapter how significant cinematography is in cinema, yet many journalistic articles about movies just talk about actors and directors. Why do you think the actual craft of moviemaking is often ignored?

FURTHER VIEWING

FILM AND PERSPECTIVE

The Passion of Joan of Arc (1928, dir. Carl Theodore Dreyer, 1889–1968) is a film largely shot in close-up and extreme close-up.

The whole of *Man with a Movie Camera* (1929) by Dziga Vertov (1896–1954) is about a camera's experiments with perspective.

Jim Jarmusch's *Stranger Than Paradise* (1984) is made up of mostly static shots; he shot the movie without dollies or track. In *Night on Earth* (1991) he shot the whole film inside a taxi cab. Abbas Kiarostami's *Ten* (2002) is also filmed almost entirely inside a car. Conversely, David Lean's *Lawrence of Arabia* (1962) offers long and wide shots that show the huge expanse of the Arabian desert, a perspective that demonstrates how minuscule is human activity.

FILM AND LIGHTING

All films involve lighting to a great extent. The whole noir genre made a virtue of low budget and few resources, using chiaroscuro to powerful effect. *The Killers* (1946, directed by Robert Siodmak), *Build My Gallows High* (1947, directed by Jacques Tourneur), and *The Big Combo* (1955, directed by Joseph H. Lewis with DP John Alton) are some of the most distinctive. Carol Reed's *The Third Man* (1949, DP Robert Krasker) combines unusual camera angles and strong chiaroscuro and was largely shot on location in Vienna.

PAINTING

It is worth looking at all of Rembrandt's body of work, but look also at the pictures of Pieter de Hooch, to see how he rendered depth of field. DP Jack Cardiff credited de Hooch with teaching him a lot about shooting interiors and street scenes.

NARRATIVE AND
STORYTELLING
IN ART

COLOR AND
NARRATIVE

KANDINSKY'S
COLOR THEORY
IN PAINTING AND
IN CINEMA

PERSPECTIVE
AND
COMPOSITION

LIGHT

CASE STUDY:
PETER
GREENAWAY
AND DUTCH
PAINTING

**EXERCISES,
DISCUSSION
QUESTIONS,
FURTHER VIEWING,
AND FURTHER
READING**

FURTHER READING

Wassily Kandinsky, *Concerning the Spiritual in Art* (1914), Project Gutenberg, available free at http://www.gutenberg.org.

Philip Ball, *Bright Earth: Art and the Invention of Color* (University of Chicago Press, 2003).

John Gage, *Colour in Art* (Thames and Hudson, 2006).

John Gage, *Colour and Meaning: Arts, Science and Symbolism* (University of California Press, 1999).

Michel Pastoureau, *Blue: The History of a Color* (Princeton University Press, 2001); Pastoreau also wrote books about *Black* and *Green*.

Michael C. Riedlinge, "Orson Welles—Painter," *Senses of Cinema*, Dec. 2009, available at http://sensesofcinema.com/2009/feature-articles/orson-welles-painter.

Jack Cardiff, *Magic Hour: A Life in Movies* (Faber, 1997).

Jonathan Crary, *Techniques of the Observer: On Vision and Modernity in the 19th Century* (MIT Press, 1992).

Douglas Keesey, *The Films of Peter Greenaway: Sex, Death and Provocation* (McFarland, 2006).

Paula Willoquet-Maricondi and Mary Alemany-Galway, *Peter Greenaway's Postmodern/Poststructuralist Cinema* (Scarecrow Press, 2008).

Simon Schama, *The Embarrassment of Riches* (Harper Perennial, 2004).

Anne Hollander, *Moving Pictures* (Alfred A. Knopf, 1986).

Linda Murray, *The High Renaissance and Mannerism: Italy, the North and Spain 1500–1600* (Thames and Hudson, 1978).

Michael Bockemühl, *Rembrandt* (Taschen, 1991).

M. J. Kemp, *The Science of Art: Optical Themes in Western Art from Brunelleschi to Seurat* (Yale University Press, 1990).

NOTES

1 Roland Barthes, *Music, Image, Text*, trans. Stephen Heath (Fontana Press, 1977), p. 79.
2 Vittorio Storaro interviewed in *Writing with Light: Vittorio Storaro* (dir. David Thompson, 1992).
3 Wassily Kandinsky, introduction to *On the Spiritual in Art*, ed. and trans. Hilla Rebay (Solomon R. Guggenheim Foundation, 1912).
4 Wendy Everett, ed., *Questions of Colour in Cinema: From Paintbrush to Pixel* (Peter Lang, 2007).
5 Angela Dalle Vacche and Brian Price, eds., *Color: The Film Reader* (Routledge, 2006).
6 Kandinsky, op. cit., p. 63.
7 "Section VI. The Language of Form and Colour," in Wassily Kandinsky, *Concerning the Spiritual in Art*, trans. Michael T. H. Sadler, available at http://www.gutenberg.org/cache/epub/5321/pg5321.html.
8 *Ibid.*
9 Kandinsky, *On the Spiritual in Art*, ed. and trans. Hilla Rebay, p. 63.
10 "Section VI. The Language of Form and Colour."

11 Kandinsky, *On the Spiritual in Art*, ed. and trans. Hilla Rebay, p. 68.
12 Robert Motherwell quoted in *MoMA Highlights* (The Museum of Modern Art, 1999, 2004), p. 244.
13 Quoted in *Cinematographer Style*, dir. Jon Fauer (Docurama Films, 2006).
14 "Alberti's Frame was the name of the most successful of the drawing devices invented. This drawing machine is made up of a square wooden frame, across which horizontal and vertical threads are stretched at regular intervals to form a grid. A foot or so in front of this gridded frame is a rod, the same height as the distance from the bottom of the frame to the middle of the grid. This rod is important because, by lining up the eye with the rod and the centre of the grid, the eye is always fixed in the same position when looking at things" (*The Drawing Machine*, National Portrait Gallery, London). Grids continue to be used: many camera viewfinders have a grid option.

15 As discussed by Ivan Gaskell in "Vermeer, Judgment and Truth," *The Burlington Magazine*, Vol. 126, No. 978 (Sep. 1984): 557–561.
16 There is an excellent exercise available on the National Gallery of Art, Washington, DC, website, http://www.nga.gov/feature/vermeer.
17 Kubrick on Barry Lyndon, an interview with Michel Ciment in Michel Ciment, *Kubrick: The Definitive Edition* (Faber, 2003).
18 Paul Knevel, "Armed Citizens: The Representation of the Civic Militias in the 17th Century," in *The Public and Private in Dutch Culture of the Golden Age*, ed. Arthur K. Wheelock and Adele F. Seeff (University of Delaware Press, 2000).
19 "Rembrandt," *Simon Schama's The Power of Art* (BBC, November 3, 2008).

CHAPTER TWO
REALISM

We normally expect films to be realistic—that is, to present to us characters and events that we feel to be credible. Quite often, we want films to represent the world as it really is, or as close to it as a film can construct. This quest for "the real" is something that goes back to the ancient Greeks. This chapter looks at how the idea of "realism" developed out of Greek art and how it has manifested at different times throughout Western art. Yet "real" elements appear even in depictions that are clearly mythic or highly stylized.

In a sense, "the real" or "realism" is present in almost every kind and genre of painting. This chapter will explore realism as a quest to portray "the world as it appears to us." But it is important to remember that symbolism and metaphor also operate within realism.

Following many centuries of the imagined "real," by the nineteenth century the astonishing development of the photograph challenged, affected, and influenced the notion of "the real" in visual art.

**"OUR JOB ISN'T TO RECREATE REALITY, OUR JOB IS TO REPRESENT REALITY."
—Gordon Willis, cinematographer**

WHAT IS
REALISM?

WHAT IS
REPRESENTATION?

ART AFTER
PHOTOGRAPHY:
MODERN
CONCEPTIONS OF
REALISM IN ART

CASE STUDY:
REALISM AND THE
CAMERA OBSCURA

EXERCISES,
DISCUSSION
QUESTIONS, AND
FURTHER READING

WHAT IS REALISM?

Artists have not always been interested in depicting the world as it visually is. The very earliest art created by a civilization—that of ancient Egypt—presented a highly stylized visual representation of a society. Fast-forward several millennia, and we notice when we look at the contemporary art around us that a significant number of today's artists are equally unconcerned about attempting to present a realistic representation of the world as it is.

We can often find out a lot by looking at some of these ancient artworks. Of course, the objects and animals in the artworks are often included because of their symbolic importance. Yet one of the useful aspects of art history for the filmmaker is to see what past worlds actually looked like, though filtered through the artistic imagination. What did people wear? What was present in their everyday habitat? In the Egyptian paintings, we can see papyrus and lotus plants, the Nile, and an abundance of bird life. These really existed and largely still exist. In the pictures, stylized human forms wear specific costumes, jewelry, and hairstyles. It is not really surprising that in the films made depicting ancient Egyptian society, whether Egyptian-made films or the "sword and sandal dramas" produced in the 1950s (*Land of the Pharaohs*, *The Egyptian*, *The Ten Commandments*), attention was paid to include all these things in the *mise en scène*.

Our Western understanding of realism comes from the Greeks. In the earliest period of Greek art, known as the archaic period, Greek art was much like the Egyptian. It was about ideals such as beauty, virtue, heroism, athleticism, and so on, represented by stylized human forms aiming at perfection.

However, from the Athenian period onward (roughly 500 BC), there gradually arose an interest in depicting things as they actually existed within Greek society, not just presenting ideally perfect figures. Influenced by the great Greek philosopher Aristotle, Greeks became increasingly interested in realism, and this continued through the Roman era. Initially, this took the form of depicting comic characters that appeared in the Greek theater. Later, however, Greek artists became interested in representing actual people as they might have lived—for example, the famous sculpture of the philosopher Diogenes, with his begging bowl and his dog, in the Villa Albani, Rome. The old man has a sagging body, an unkempt beard, very far from the heroic beauty or magnificence we normally associate with Greek sculpture. Diogenes, an ascetic, is represented as a broken-down old man, skinny and hunched. Diogenes was a much respected philosopher. But instead of idealizing him, a man noted for his personal virtue as well as his intellect, the sculptor wanted the audience to understand the human aspect of Diogenes. This is an important development because, with this act, the sculptor is telling us that even frail and vulnerable human beings are capable of great and powerful acts—in this case, thinking philosophy. This is a far cry from idealization. It brings everything down to the human level.

2.1

2.1
Nebamun Hunting in the Marshes
Egyptian tomb painting, British Museum, around 1350 BC
This fragment from a tomb painting depicts a real person, Nebamun, a court official who lived almost 3,500 years ago. Here he is with his wife and daughter on board a skiff during a hunting trip on the Nile.

Mimesis

Aristotle is the key here. Aristotle wrote about almost everything imaginable: science, mathematics, theater, politics, geometry, and more. Although Aristotle's *Poetics* is an analysis of drama (and required reading for filmmakers), it also gives us some very interesting insights into realism throughout the arts. Aristotle talks about "mimesis," which is the term he uses to describe the representation or, more correctly, the imitation of life.

The word *mimesis* carries within it the word "mimic" and the word "imitation." Mimesis essentially means a representation imitating life. This imitation needs to be psychologically correct—having appropriate and immediately recognizable human qualities, qualities that we may understand as being psychological. Even if the subjects are gods and goddesses, within the artwork they need to express themselves in ways to which a human "real world" audience can relate. It is this process of relating to the characters in the artwork that allows us to enjoy the experience. We can feel sympathy, horror, disgust, attraction, repulsion, and sorrow—the whole gamut of human emotional reaction.

Aristotle points out that mimesis only really works if there is some distance between the representation and the reality. An artwork is not simply documentation. More recent research by Cambridge classicist Nigel Spivey has investigated this idea by looking at recent work by neuroscientists. When he asked why artistic images (for example, heroic bodies) are so often exaggerated, the new research led him to conclude that we humans don't really like absolute reality—we prefer things exaggerated. This is a shared biological instinct that appears to link us inexorably with our ancient ancestors.[1] Pure realism in art, as Aristotle had already pointed out in drama, is boring, in the same way that CCTV footage is boring compared to a drama or a documentary film. Add in a little exaggeration—but not too much—and things become interesting and worth looking at. We can achieve this exaggeration through composition, lighting, and color.

Greek and Roman art was never realistic in the way we understand realism today. There was never any real attempt to portray everyday life. When actual people were portrayed, these were mainly official portraits of the elite intended to make them seem particularly powerful, heroic, and important. However, we do see a strong interest in physical anatomy as well as facial expression and gesture. We can also get a reasonably useful indication of things such as costume and hairstyle.

Ritual and Spirit

After the Greek or Roman era, any interest in realism in Western art seems to completely disappear. The greater part of the art from 500 to 1400 AD is religious art, made for churches and religious foundations.

Professional art historians who study medieval paintings and icons can find all sorts of information by reading the complex visual codes or analyzing the materials used in the creation of the artwork. However, for everybody else, medieval artworks tend to have many shared characteristics that make a great deal of it undifferentiated. Certain tendencies in medieval art continued to be practiced for nearly a thousand years. The first of these is obviously the subject matter, frequently reproducing the Madonna and Child, the baptism of Jesus, the crucifixion, the Annunciation or the Nativity. When we look at paintings of the period up to about 1300, we notice right away that these artists are not interested in realism at all. Although perspective drawing was known to the ancient world, it was not used in the medieval period. Everything seems to exist on the same flat plane. The characters are undifferentiated, with the same facial expressions. Likewise, the gestures of the figures are stylized and repeated. The important aspects are the ritual gestures portrayed and the splendor of the gold leaf and rich colors.

Toward Realism

By the early sixteenth century, painting had largely left the exclusive preserve of the church, and painters were free, theoretically at least, to paint whatever they wanted for whoever was willing to buy the painting. But what is interesting is that the subject matter is still ostensibly religious in character. Take, for example, Pieter Bruegel the Elder's painting *The Massacre of the Innocents* (1565).

We see a scene snapped straight from sixteenth-century Flemish life. In fact, that's exactly what it depicts: an army invading a sixteenth-century Flemish town and terrorizing the inhabitants. There is snow on the ground; the trees are bare. In the foreground, a woodpile set for chopping has been abandoned. The townsfolk are cowering in terror and pleading with their oppressors; the soldiers are kicking in doors. We can think of Bruegel here as a cinematographer: he has deliberately chosen his artistic position—a hill overlooking the scene. The "camera" has a wide-angle view, taking in the entire scene as far back as the rump of the invading force. Everything is in deep focus, and all aspects of the image appear crisp and clear.

2.2

Bruegel here is saying to us, "This is what an invading force looks like; this is what invaders do." It is only the title, *The Massacre of the Innocents*, that links what we see in this picture to the biblical story in the New Testament. Everything else about it looks completely authentic, even realistic, and chimes with what we know (from historical sources) did actually happen with depressing frequency during that period of unrest and religious wars. Here we see realism together with metaphor. The artist is likening the scene to a story from the Bible. The injustice of the "massacre of the innocents" was an important Christian teaching, and here Bruegel is comparing the behavior of the military in his day to that of "Bad King Herod" in the biblical story.

2.2
The Massacre of the Innocents, 1565
Artist: Pieter Bruegel the Elder (c. 1525–1569)
Bruegel's painting is realistic in terms of what it reveals about the time and place when the painting was made. If one wanted to make a film set in sixteenth-century Flanders, Bruegel's *Massacre of the Innocents* would probably be a good starting point.

Filmmakers have to try to find ways to depict "the real," and the starting point is not any different from that of the painter: the imagination. Continuing with the theme of conflict we met in Bruegel, look at Victor Fleming's *Gone with the Wind* (1939). Fleming, his DP Ernest Haller, and production designer William Cameron Menzies had to find a way to depict the dreadful Battle of Atlanta in the American Civil War. There were a number of paintings made of the battle, and unlike earlier wars, there were also photographs. But Fleming's film does not copy them; his film has no battle scenes. Instead he shows us only the horrific aftermath, the casualties of war, in dramatic Technicolor. Watch the film and note the scene; notice Fleming's use of perspective, where he places the camera to create the desired effect. Bruegel also uses a "camera eye" to achieve mimesis—long before the camera.

Using a Steadycam, Uli Edel's *The Baader-Meinhof Complex* brings us into the battle, terrifyingly, from inside the conflict. We are in the battle, participating in it. This is another kind of realism—making viewers feel they are actually there, in physical proximity to the action, about to be assaulted. There is no distance between subject, viewer, and action. As we will see in the chapter on history and heroism, this kind of realism took on the challenge of directly confronting the viewer with the realities of conflict in the art and films of the twentieth century.

2.3

Cinema needs to be realistic in the mimetic sense: we need to have a kind of relatable psychological realism in order to identify with characters and get involved in the story. Traditionally painting is not much different: painters have sought to make us feel something—awe, admiration, desire, fear, piety—through the presentation of staged figurative images.

2.3
Gone With the Wind, 1939
Dir. Victor Fleming, DP Ernest Haller, production designer William Cameron Menzies
In this scene, the dead and wounded Confederate soldiers lie in the hot sun in an Atlanta square as the heroine Scarlett O'Hara searches in despair. But in this shot Scarlett is not important; Fleming wants us to feel the real horror of the war. It's not just about one woman; we are all here, scanning this deadly ground. And Fleming's dramatic crane shot makes no bones about what is responsible for the carnage: the Confederacy and its flag.

WHAT IS
REPRESENTATION?

ART AFTER
PHOTOGRAPHY:
MODERN
CONCEPTIONS OF
REALISM IN ART

CASE STUDY:
REALISM AND THE
CAMERA OBSCURA

EXERCISES,
DISCUSSION
QUESTIONS, AND
FURTHER READING

WHAT IS
REALISM?

Realism into Naturalism

When we say that something is "realistic," we generally mean that it looks like the world that we personally recognize, or that we are quite sure really existed. Therefore, we might say that Rembrandt's *Night Watch* (shown on p. 36) is realistic, because it shows people looking quite normal and behaving naturally, if a bit theatrically, but Bronzino's *Allegory of Venus and Cupid* is not realistic, because people do not have wings or reptilian tails. Even if we are not religious, we would probably call Caravaggio's *The Incredulity of St. Thomas* realistic. Another word for this kind of realism is *naturalism*, using paint to replicate nature in an observational and detailed way. "Naturalism" implies accuracy—so a leaf will be painted to exactly resemble a leaf. Caravaggio's *Basket of Fruit* (1599) is a good example of naturalism. The fruit in the basket looks real, even to the point of some of it being in a decaying state. There is a wormhole in the apple, and some of the leaves are curling and going brown. Caravaggio has even created a slight *trompe l'oeil* effect: the basket, which is shown sitting on a shelf, appears to be overhanging the edge, giving the whole thing a three-dimensional feel (the same fruit basket overhanging the edge of a table appears in his later *Supper at Emmaus*, 1601). This is painting come to life.

Of course, it is never completely possible to represent "the real" in any kind of art, even photography, because subjectivity is always present in the decision-making process of what to depict and how to do it.

We need to be aware that the term "realism" does not appear in art discourse until the nineteenth century, and even then it was not used approvingly. For the nineteenth century, "realism" meant painting the here and now, the modern world and its inhabitants. For most of art history, painting displays a kind of tension between painting things so that they *look* realistic, while at the same time expressing a bigger and more profound idea. We have already seen this in Bruegel's *Massacre of the Innocents*, where he connects the raid on a Flemish town to the biblical story of Herod's attempt kill the infant Christ, and in the discussion (Chapter 1) of Vermeer's *Woman Holding a Balance*, in which the woman at a table of jewelry is also a debate about virtue and vice. For the most part, both painting and cinema have been content with a realism that means constructing a lifelike image tempered by idealization.

But realism also has the ability to invoke the importance of things that are not in the realm of idealization. Realism can be the visual route to understanding both idealized worldviews and impoverished worldviews. Simply put, realism encompasses both Hollywood's glamorized realism and "gritty" social realism, which often has a political aspect. Both work in the dominant visual communication system of perspective realism.

"Mirror of Nature"

For most of history, art has been considered a "mirror of nature." Like a mirror, what you see is not "real," but it is an accurate representation. The artistry is in where you put the mirror. It is easy to see why more than a few artists had fun putting mirrors into their paintings—as in Vermeer's *Music Lesson*, Velázquez's *Las Meninas* and *The Rokeby Venus*, and Manet's *A Bar at the Folies-Bergères*. These artists use the mirror to intensify the illusion of reality, while at the same time exposing the illusion by making the act of viewing self-conscious.[2]

Filmmakers learned this lesson well. A number of films feature mirrors in crucial scenes: Orson Welles used fairground mirrors to powerful effect in *The Lady from Shanghai* and used multiple reflection in *Citizen Kane*; Scorsese's protagonists in *Taxi Driver* and *Raging Bull* talk to themselves in the mirror; Rainer Fassbinder's *Effi Briest* uses a number of evocative mirror shots; and the mirror motif is recurrent in many of Ingmar Bergman's films. Mirrors appear in the avant-garde also—notably in experimental filmmaker Maya Deren's haunting mirror-faced character in *Meshes of the Afternoon* (1943). Mirror scenes allow reality to be distorted or shown differently; they reveal what is hidden. After using a mirror to great effect in the self-trepanning scene in *Pi* (1998), Darren Aronofsky in *Black Swan* (2010) uses mirrors in a variety of ways, to indicate the fracturing personality of the heroine. Less dramatically, it is not uncommon to have a "self-realization" moment when a character looks at him- or herself in a mirror. Even a subtle shot of a face seen in a rearview mirror can add visual interest and drama to a scene.

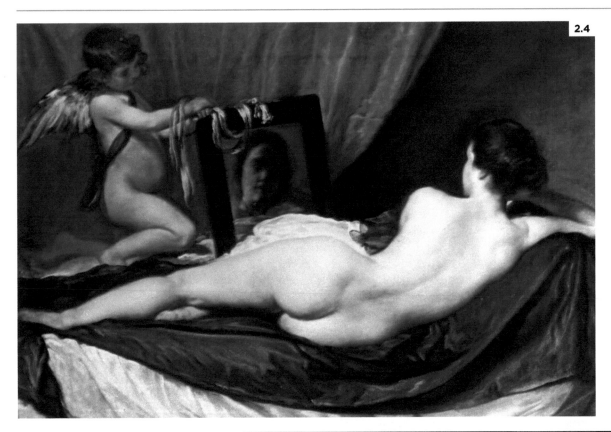

2.4

2.4
***The Rokeby Venus*, 1647–1651**
Artist: Diego Velázquez (1599–1660)
Venus is a popular subject in painting, and
Velázquez's rendering of the goddess admiring
herself in the mirror is one of the very best
versions. It is the mirror that adds interest: we are
intrigued by the fact that we see her face only in
reflection, while the image is dominated by the
curved line of her magnificent back and posterior.

2.5

2.5
***The Lady from Shanghai*, 1948**
Dir. Orson Welles (1915–1985)
Rita Hayworth's femme fatale Elsa confronts
her fate in the Hall of Mirrors of an abandoned
fairground, a stylish and strange climax in this
dramatic film noir love quadrangle. The multiple
images of Elsa here reveal the many "faces" of
her duplicity.

WHAT IS
REALISM?

WHAT IS
REPRESENTATION?

ART AFTER
PHOTOGRAPHY:
MODERN
CONCEPTIONS OF
REALISM IN ART

CASE STUDY:
REALISM AND THE
CAMERA OBSCURA

EXERCISES,
DISCUSSION
QUESTIONS, AND
FURTHER READING

Egyptian Realism:
The Fayum Portraits

Depicting real people looking as they do in real life was developed to an almost perfect state by the Egyptians during the Roman period (30 BC–5th century AD). This may come as a surprise, since we have already seen that the ancient Egyptians were not interested in realism; and indeed they weren't, in their public art. But a large number of portraits have been discovered in the necropolis (burial grounds at Fayum, an oasis region on the west bank of the Nile just south of what is now Cairo). They were "mummy portraits" painted during the subject's lifetime and then attached to the mummy after death and buried with the body. This means they were not painted as "art," unlike the Pompeii frescoes, but instead served a ritual function. Nevertheless, they are among the most realistic paintings ever produced, in any era. Because of the way they were buried in sarcophagi, underground, in the hot dry Egyptian climate, the Fayum portraits remained intact and now represent the largest surviving collection of ancient world panel paintings. Dating from c. 30 BC to the third century, they are remarkably well preserved, often retaining their brilliant colors, uncannily unfaded by time.

2.6

2.6
Portrait found at Fayum
This portrait was painted during the subject's lifetime and buried with the body after death.

Each painting is very naturalistic, revealing the minutiae of the subject's face and expression. They share ethnic similarity in the features, especially the large dark eyes; dental morphology studies of the mummies show they are indeed ethnic Egyptians, which may explain this. Do they look like exactly their subjects, in a photographic sense? We cannot know.

What the Fayum portraits prove is that painters have long known how to paint realistic and naturalistic images. This leads us to assume that when artists do not do this, there is a reason. We have already seen how the early Church rejected realism and perspective. In the twentieth century, artists like Picasso also turned away from naturalism, though he could paint it very well.

Next time you watch a film or television drama, notice if there are mirrors or glass windows used to dramatic effect. How is the mirror used to reflect images, and what are they trying to tell us? What are the different ways mirrors and glass are used in film shots?

Realism and Virtuosity: Caravaggio and Velázquez

Painting the real world in all its detail is not something that was much called for in the great commissioned portraits of monarchs or religious paintings for the Church. But painters often did it anyway, to show what they were capable of. Spaniard Diego Velázquez is the quintessential painter who could portray life in all its variety, as well as enchant us with visual trickery. His paintings of common life are as rich as Vermeer's, yet he spent most of his career as court painter to the king of Spain, with a number of Church commissions along the way.

One of Velásquez's most interesting early works is *An Old Woman Cooking Eggs* (1618), which shows an elderly woman sitting cooking eggs on a small stove. She is dressed simply and looks worn but serene. Both she and the boy with the melon under his arm look serious, but not sad. Velázquez contrasts youth and age, conveying the transience of life. The eggs, a commonly eaten food, also symbolize the cycle of life and death and, in particular, the idea of afterlife. In his paintings of everyday life, Velázquez depicted the frugal diet of common people: garlic, fish, eggs, sausages, cheeses, jugs of wine, and fruit. The scene conveys a down-to-earth philosophy.

Caravaggio had pioneered this approach; he was totally opposed to the idealistic atmospheres and artificial beauty of the Italian Renaissance. His paintings are populated by the lower classes, with their stained coarse clothing, bare dusty feet, faces and bodies with lines and wrinkles, old age and suffering. In *The Doubting of Thomas / The Incredulity of St. Thomas* (1602–1603), Thomas's jacket is torn and his hair is thinning; he is a worn-out working man. The other men in the picture are similarly middle-aged to elderly and tired. The receding hairline of the man in the rear reflects the light like an egg, unglamorous. These fellows don't look saintly or serene. Christ himself looks drawn. And he is serious: he physically pulls Thomas's hand toward him into the gaping wound, holding it with the meaty grip of a working man. Caravaggio depicts the story of Christ and St. Thomas as a meeting of real men, ordinary men who almost accidentally have become part of something great. Caravaggio does not hide that the process of Salvation is a struggle, and makes it clear that earthly life is hard. The men's poses are human and natural, and the lighting is strong and theatrical, with a dark background and strong foreground color.

Caravaggio's achievement cannot be overstated. Even after his popularity waned, his influence carried on. As critic Robert Hughes points out, "Caravaggio was one of the hinges of art history: there was art before him and art after him, and they were not the same."[3]

Realism as Drama

In Velásquez's *Old Woman Cooking Eggs*, the lighting is also dramatic: the subjects and their props are picked out with bright key lighting rendering them absolutely clear, while the background is dark and indistinct. This is quite different from the domestic scenes of Dutch painters such as de Hooch, Vermeer, or Teniers, where details of the room are visible. Despite the lighting, in general Velásquez's paintings are less theatrical than Caravaggio's. Dramatically, Velázquez is on the side of Vermeer rather than Rembrandt, with quieter and more contemplative paintings.

Although most portraits were made for wealthy people or aristocrats, some artists painted ordinary people to show their artistic dexterity as well as sometimes to make a point. Giovanni Moroni's *Portrait of a Man (The Tailor)* (1565–1570), in the National Gallery, is a realistic portrait, interesting because of the use of "eye contact." The subject is looking directly at Moroni's "camera" as if being interrupted at his work. Moroni asserts the humanity and dignity of the working man in this picture. It has been suggested that Moroni traded the picture for a nice suit of clothes, but we do not know.[4]

Old Woman Cooking Eggs brought Diego Velázquez much attention, and he was appointed court painter, where he executed *Las Meninas*, one of the most famous paintings in history. There are many different ways of looking at *Las Meninas*. On the one hand, it is a portrait of the young princess and her ladies in waiting at the Spanish court. On the other hand, it is painting of a man doing a painting. It is a commissioned court painting for the king of Spain. It

WHAT IS
REPRESENTATION?

ART AFTER
PHOTOGRAPHY:
MODERN
CONCEPTIONS OF
REALISM IN ART

CASE STUDY:
REALISM AND THE
CAMERA OBSCURA

EXERCISES,
DISCUSSION
QUESTIONS, AND
FURTHER READING

**WHAT IS
REALISM?**

is a modern representation of the art of illusion. It depicts realistically the life of the Spanish court. It is a self-reflexive meditation on the position of the artist in society.

Las Meninas is a group portrait, ostensibly centered on the Spanish princess, but Velázquez has actually portrayed himself in the act of painting the king and queen while the little princess and her retinue look on. The king and queen being painted stand in the viewer's position, as spectators looking on, outside the picture's space. If we look carefully, we can see them reflected in a small mirror on the rear wall of the room. Here Velázquez presents "the real" as being dependent on one's perspective: who sees what? Velázquez has not only painted a picture of the royal court, he has painted a portrait about the painting of a portrait—a picture about the making of pictures, the construction of illusions. The artist is in a prominent position, looking directly out of the frame and at the viewer. The critic Andrew Graham Dixon calls *Las Meninas* "a behind-the-scenes picture of a king having his state portrait painted, creaking props and all."[5] Dixon points out that as a painter, Velázquez "was far more than the mirror of nature. There is in Velázquez the subtlest of plays between illusion and artifice, between the painter's ability to fool the eye and his willingness to disclose his own trickery."[6]

2.7

2.7
***Las Meninas*, 1656**
Artist: Diego Velázquez (1599–1660)
Las Meninas (or, in English, *The Maids of Honor*) is considered to be his masterpiece. It shows the young princess and her courtiers attending a painting session, as Velázquez does a portrait of her parents.

"Social" Realism

Velázquez is a self-reflexive artist: he depicts the act of representation itself, and many of his paintings are pictures within pictures. Pablo Picasso is said to have called Velázquez "the true painter of reality."[7] Velásquez's consciousness of the viewer's perspective and his acknowledgment of the fact that any portrait is a construct by an artist, effortlessly demonstrated in *Las Meninas*, surely must make us agree with Picasso.

Caravaggio teaches us that you can portray the humdrum detail of daily life within a grand and highly dramatic story. There is no need to glamorize or idealize in order to tell a profound story. Velásquez shows us that you can use realism to play myriad visual tricks within a *mise en scène*, giving your viewers different points to look at and shifting their attention as to who or what is the "subject."

What Velázquez and Caravaggio have in common is that they worked at a time when art was one of the tools wielded by politics for the hearts and minds of the populace. In 1517 the Protestant Reformation split European society into Catholic and Protestant, which had widespread effects on all aspects of life and led to military conflict. The Catholic Church realized that military might alone would not shore up their position, so they addressed the issue with a series of measures known as the Counter-

Reformation, begun in 1545. This is important because, while Protestantism had an iconoclastic tendency that led to the removal of religious images in some churches (and a cessation in the commissioning of religious art), the Catholic Church increased its patronage of art. At the same time, in both Catholic and Protestant regions, secular art became more common and more desired by wealthy patrons.

As the major source of artistic commissions, the Catholic Church could decree the spiritual subjects and styles available to the painter. As part of its Counter-Reformation stance, the church also came to demand a more straightforward, dramatically realistic art. Moving away from the complicated symbolism of the Italian Renaissance with its complex allegorical statements, Counter-Reformation art was easier to understand and to identify with emotionally. Religious stories designed for baroque churches were to be dramatic and comprehensible, exciting and thought-provoking, and accompanied by stirring music. The combination of high drama and realism caught on, not only with Catholic artists but also with Protestants such as Rembrandt.

"Ugliness can have a certain beauty as well."
—Roger Deakins, BSC, ASC, cinematographer

Velázquez painted the illusionistic nature of painting, but other artists treated realism another way, painting accurately things that nobody actually wanted to see. This kind of realism, sometimes called "social realism," emphasizes uncomfortable and unappealing aspects of real life: class, poverty, crime, degradation and abjection, dirt, depravity, and so on. We usually associate this kind of realism with nineteenth-century art and literature, because this period was the first to actually use the term "realism" to describe the novels of Charles Dickens and the paintings of Gustav Courbet, for example. But we can turn back again to Pieter Bruegel the Elder and his 1568 painting *The Beggars* to see social realism.

In the late sixteenth century, physical disability was a common sight in towns and villages. Lack of good medical care, frequent military conflicts leading to injury, and total lack of any health and safety regulations meant that deformity and disability, whether by accident or congenital, was ever present and visible. Painters normally didn't paint these things, but from time to time artists felt compelled to represent all the aspects of the world around them. We can see in this impulse a kind of compassion, and perhaps even a drive to lay bare the cruelties of life and the injustices that created them. Bruegel's painting of *The Blind Leading the Blind*, discussed in Chapter 1, is the same kind of depiction: medical scientists have affirmed that the artist's representation of

WHAT IS
REALISM?

WHAT IS
REPRESENTATION?

ART AFTER
PHOTOGRAPHY:
MODERN
CONCEPTIONS OF
REALISM IN ART

CASE STUDY:
REALISM AND THE
CAMERA OBSCURA

EXERCISES,
DISCUSSION
QUESTIONS, AND
FURTHER READING

blindness in the painting is startlingly accurate. Each figure has a different eye condition: experts have identified corneal leukemia, black cataracts, atrophy, and gouged-out eyes. The true horror of blindness is rendered viscerally here.[8]

Velásquez's contemporary, Murillo, painted the street children of Seville, begging and huddling together for protection and companionship. Both Bruegel and Murillo bore witness to war, famine, and plague, and their paintings called attention to these real-world evils.

Murillo sympathized with the poor and the homeless, particularly the children, and wanted to call wider attention to social problems. But he didn't want his audience to turn away from his pictures in horror and disgust, so he presented a contrast between the beautiful, almost idealized faces of his urchins and their haggard expressions and torn, stained clothing. By combining beauty and ugliness, Murillo created paintings that are dramatic, approachable, and aesthetically pleasing. We can see this same impulse at work in films like the musical *Oliver!* (Carol Reed, 1968), which adapts Dickens's story of the tribulations of an adorable orphan boy who falls in with a den of photogenic child thieves. Danny Boyle's *Slumdog Millionaire* (2008) treads similar ground. Today it is sometimes dismissed as "Hollywood" poverty, but Murillo shows us how effective it can be, by making the unwatchable accessible.

2.8

2.8
The Beggars, **1568**
Artist: Pieter Bruegel the Elder (c. 1525–1569)
In this visual representation of a biblical parable, Bruegel accurately portrays blindness as well as folly.

This was not a popular approach in seventeenth-century painting, which tended to show evil in terms of religious belief or symbolism and rarely depicted social problems. However, in the nineteenth century this changed, and "social" realism enjoyed unprecedented popularity, matched only by the popularity of literary realism in the novels of Dickens and Dostoevsky and, later, the theater of Ibsen and Chekhov.

FURTHER VIEWING

Bartolomé Esteban Murillo,
*Beggar Boys Eating Grapes
and Melon* (1645)

In tandem with these writers, from the late eighteenth century onward, Russian art almost burst upon the world from a culture devoted to icon painting whose style had barely changed over centuries. In the nineteenth century, Russian realism accommodated the serene riverscapes of Izak Levitan and portraits by Vladimir Serov, but perhaps the most important was Ilya Repin. Though he made many portraits and historical pictures, Repin is best known for his unsentimental paintings of rough peasant life, corvée (forced) labor, and poverty set against the unparalleled Russian landscape. *Barge Haulers on the Volga* (1873), depicting a group of barge haulers, or *burlaki*—men who manually hauled the barges along the river—was praised by Dostoevsky as an unsentimental, realistic picture. Repin dispassionately depicts the men's backbreaking struggle, but he tells us what he thinks, pointedly including a small steam-powered boat in the background as a hint that modernization should sweep away this kind of brutal work. Another little detail he includes, as a subtle social comment, is the upside-down Russian flag flying from the main mast of the barge.

We can see how British director Ken Loach's work can be related to Repin's. Both painter and filmmaker are primarily interested in people and their stories, set against the forces that dominate their lives. In *Kes* (1969), the

2.9

brutality of life in a Yorkshire mining town and the way that the values and the lifestyle of working-class poverty conspire to crush the spirit of a young boy are set against pastoral green hills. Yet in both Repin's paintings and Loach's film, nature is inert; it does not nurture or provide sustenance of a physical or spiritual kind. Even the kestrel, the boy's pet and a symbol of nature and freedom, is vulnerable to the social forces that destroy it. Loach does not even give us the promise of the steamboat: there is little suggestion that any change in the way of life of the community is imminent, however we may wish it.

2.9
Kes, 1969
Dir. Ken Loach
Poverty, abuse, and deprivation blight the life of Billy Casper. Even the beauty of the natural landscape cannot offer any sustenance or hope: filmmaker Loach seeks political solutions, not romantic ones.

WHAT IS
REALISM?

WHAT IS
REPRESENTATION?

ART AFTER
PHOTOGRAPHY:
MODERN
CONCEPTIONS OF
REALISM IN ART

CASE STUDY:
REALISM AND THE
CAMERA OBSCURA

EXERCISES,
DISCUSSION
QUESTIONS, AND
FURTHER READING

JOHN BERGER AND THE POLITICS OF REALISM

In 1973 British writer John Berger made a groundbreaking four-part television program and accompanying book called *Ways of Seeing*. In it, he criticized traditional Western cultural aesthetics by asking questions about the ideological positions hidden in visual images. *Ways of Seeing*'s core argument is to persuade us to look take a more politicized, socioeconomically informed perspective when looking at or studying art. Berger's main premise is that the way we see things is affected by our knowledge and beliefs, and this is as true of the painters and audiences of the past as it is of us today.

Berger also points out that we see images very differently today than we did in the past: through technology we have almost limitless access to them, and images are everywhere. Following on from ideas articulated by Walther Benjamin ("The Work of Art in the Age of Mechanical Reproduction," 1936), Berger points out that we no longer have the "unique" experience of a painting when we experience it in reproduction, as you are experiencing it here in this book. This demystifies the artwork and leaves it more open to a politically charged critique.

The series and book are still widely used today as core texts in visual culture. You may have already encountered them. Berger's chapter on the Nude should be read in conjunction with Chapter 4 of this book.

2.10

2.10
Ivan's Childhood, 1962
**Dir. Andrei Tarkovsky
(1932–1986)**
Instead of making a film about heroes and glory, Tarkovsky and DP Vadim Yusov portrayed the harrowing conditions of war in the Russian winter.

"Socialist Realism"

In Russia after the 1917 revolution, social realism gave way to "socialist realism," which used a naturalistic style to depict idealized visions of leaders Stalin and Lenin, as well as the lives of revolutionary peasants and workers. Artists were approved and employed by the state, which ensured a very high level of technical skill, but the subject matter always had to be approved by the state, which limited the artists' scope for personal expression. Unsurprisingly, the same restrictions applied to Soviet cinema, though in both painting and film, excellent art could sometimes be produced even under these conditions. Soviet painters such as Kuzma Petrov-Vodkin and filmmakers like Vsevolod Pudovkin made significant achievements. In *Storm over Asia* (1928, DP Anatoli Golovnya), Pudovkin shows a young Mongolian peasant becoming an anti-imperialist revolutionary, a film that satisfied and entertained Soviet and Western audiences alike, despite the propagandist messages that prevail rather obviously throughout the film.

Later, the brilliance of Andrei Tarkovsky broke through Soviet paradigms to create unique, imaginative films rooted in realism. In *Ivan's Childhood* (1962), the ennui as well as the horrors of war are shown in the story of a boy soldier determined to avenge the murder of his family. Tarkovsky also includes flashback and dream sequences in his otherwise "realistic" presentation.

How realistic was it? About as realistic in its own way as Hollywood was. It was the flip side of Hollywood glamor. Russian artists had to toe the party line, while Western artists toed the bottom line.

Contemporary Social Realism

Though socialist realism is long gone, social realism endures, and we see it in the cinema of the Italian neo-realists as well as in British cinema. These filmmakers wanted to make films about real life and particularly social conditions. Starting with documentaries, Czech-born British filmmaker Karel Reisz moved into fiction films like 1960's *Saturday Night and Sunday Morning*, which shows the life of a young factory worker. These films avoid extreme images or exciting melodrama and try to focus on the nuances of everyday life.

The lack of embellishment or glamorization is a hallmark of social realism, and dark subject matter often predominates. Italian film director Pier Paolo Pasolini's grim first film, *Accatone* (1961), explores the life of an unemployed and unemployable pimp. Although this and other social realist films are not documentaries, they often have a documentary ethos—filming in natural light and authentic locations, and using at least some nonprofessional actors. Today filmmakers no longer only depict traditional social problems such as poverty, exploitation, and deprivation. Katherine Bigelow's war film *The Hurt Locker* (2008), a gritty portrayal of an Iraq War bomb disposal squad, is a good example of a modern social realistic film. Bigelow never overemphasizes the action or creates artificially heightened excitement, and gives a credible sense of the quotidian tension the team experiences. Courtney Hunt's powerful 2008 drama *Frozen River* portrays working-class life on the edge, as two women work as smugglers to survive.

But there are no contemporary painterly equivalents to Pasolini's or Bigelow's films. By the mid-twentieth century, painters had largely abandoned social realism to the filmmakers. American painter Leon Golub's 1980s paintings of torture, interrogation, and oppression have realist elements, but lean more toward expressionism as a visual form. Artists and painters are still concerned with social issues, but the form of visual representation has shifted away from photo-realism.

2.11

2.11
Frozen River, **2008**
Dir. Courtney Hunt, DP Reed Dawson Morano
Two impoverished working-class women, one white and one aboriginal, struggle to make ends meet by smuggling goods and people across the US–Canada border via a treacherous frozen river.

WHAT IS
REPRESENTATION?

ART AFTER
PHOTOGRAPHY:
MODERN
CONCEPTIONS OF
REALISM IN ART

CASE STUDY:
REALISM AND THE
CAMERA OBSCURA

EXERCISES,
DISCUSSION
QUESTIONS, AND
FURTHER READING

**WHAT IS
REALISM?**

Expressionism (see Glossary) is an approach in which the artist seeks to depict not "objective" reality but rather the subjective emotions and responses that objects and/or events arouse. It is concerned with expressing emotional and psychological states. Expressionism, an art movement that encompassed both visual art and cinema, will be discussed in Chapter 8.

The height of popularity for social realism in painting was the nineteenth century. Although painting of ordinary people and ordinary life existed before, as we've seen with Velázquez, Murillo, and others, it was the nineteenth century that brought a much bigger demand for this kind of art. The rapid pace of the Industrial Revolution made more people than ever aware of the social conditions around them. This was matched by a heightened awareness of social injustice, and an unprecedented collective movement to try to put things right. Abolition of slavery, improvement of social conditions, alleviation of poverty, and elimination of slum building were all causes enthusiastically taken up by the bourgeoisie. People were willing to buy paintings that depicted these things.

This brings us to an interesting question. Did artists want to use art to say something about the status quo? Or did artists paint pictures of social realities in order to provide their audiences with a cathartic vicarious experience? In this interpretation, looking at a picture of the downtrodden and acknowledging what is in the picture substitutes for having to look at the downtrodden themselves. Reading a Dickens novel about child exploitation and abuse is a substitute for actually witnessing child exploitation and abuse. In both cases, the audience may be motivated to take action, but because they are not directly confronted with the problem, they are not forced to do so. Some nineteenth-century critics rejected the idea that art should be instrumentalized in this way: the

Victorian poet and critic Algernon Swinburne thundered that "art should never be the handmaid of religion, exponent of duty, servant of fact, pioneer of morality,"[9] but many in the audience disagreed. Still, there remains the whiff of accusation that both Victorian narrative painting and Hollywood drama sentimentalize social problems as a substitute for taking action.

FURTHER VIEWING

Watch some of the social realist films mentioned above, or try these:

Los Olvidados, 1950 (dir. Luis Buñuel)

Bicycle Thieves, 1948 (dir. Vittorio de Sica)

A Taste of Honey, 1961 (dir. Tony Richardson)

Vagabonde, 1985 (dir. Agnes Varda)

Red Road, 2006 (dir. Andrea Arnold)

Biutiful, 2010 (dir. Alejandro González Iñárritu)

Winter's Bone, 2010 (dir. Debra Granik)

Make a list of others you find. Compare them. How are they similar? How are they different? How is "the real" represented?

WHAT IS REPRESENTATION?

Discussions of realism naturally bring us to issues of representation—how subjects are presented and what that presentation says about social attitudes at the time of the painting and today. Representation of race and ethnicity in Western art has been problematic, and continues to be so. Until the nineteenth century, all of the significant Western artists were ethnically European. Moreover, the representations of non-Western subjects were few, and when present, frequently problematic.

For example, people of African descent are presented in Western art largely as servants or in subordinate positions—portraits of specific persons (such as the Russian poet Pushkin) excepted. This was often for aesthetic reasons, with the darker skin serving as a foil to emphasize the luminous whiteness of the main subject. We can see this clearly in Manet's painting *Olympia*. The servant's darkness is offset by her creamy white dress, a tone similar to that of Olympia's flesh. The contrast of dark with shades of white is an important aspect of the picture. However, we must be aware that no artist makes decisions based purely on visual compositional requirements; in the case of representation, the wider contexts of race and/or social class are always present. Painting cannot be completely disconnected from the situation at the time the image was produced.

Unlike many previous painters of similar scenes, Manet doesn't really depict the servant in a servile way. She is bringing flowers and looking at Olympia, but is not physically attending her. Earlier paintings of similar subjects often showed the black servant combing the mistress's hair or in a clearly subordinate physical relationship, and significantly lower down in the frame (as in Théodore Chassériau's *Le Harem*, 1852). Here Manet has put the servant above Olympia; she is clearly not meant to be a receding, insignificant person. In fact, if it were not for our presumptions about the racial mistress–servant relationship, it might even be possible to view it as a painting of two women friends. The fact that we do not view it that way is because of our cultural assumptions. We assume the woman on the right is a servant because we are used to representations of black women as slaves or servants.

It is important to recognize that Manet's *Olympia* was a hugely controversial painting at the time of its first exhibition, and Manet intended it that way. There was a long history of nudes displaying themselves, as discussed in Chapter 4, but Manet included a number of details that indicated to his audiences that Olympia was in fact a prostitute—principally the orchid in her hair and the black ribbon tied around her neck. Likewise, since the eighteenth century it had become fashionable to paint the white subject with black servants;[10] by the 1840s the white nude with her black servant was a popular subject. But Manet made it much more stark. The white woman, far from being some kind of "European ideal," is presented here as a whore. Feminist writer Germaine Greer suggests that Manet here reveals the commercial reality of the client-prostitute relationship: the whore has no interest in or desire for her client.[11] However we read the painting, we can see that Manet wanted to challenge his audience, to invite them to see the world differently, perhaps more critically.

2.12

2.12
Olympia, 1863
Artist: Edouard Manet (1832–1883)
Olympia, a courtesan, reclines as her black maid brings flowers sent by an admirer. This kind of composition appears in the work of many painters.

WHAT IS
REALISM?

**WHAT IS
REPRESENTATION?**

ART AFTER
PHOTOGRAPHY:
MODERN
CONCEPTIONS OF
REALISM IN ART

CASE STUDY:
REALISM AND THE
CAMERA OBSCURA

EXERCISES,
DISCUSSION
QUESTIONS, AND
FURTHER READING

Orientalism and the "Exotic"

Manet's painting is referencing, and perhaps mocking, the "Odalisque" genre, a branch of Orientalist painting that purported to show "real life" in the harems of the Middle East. This kind of prurient art came about when artists and writers began to travel in large numbers to Turkey, Syria, and Egypt, beginning in the late eighteenth century. Fascinated by the cultural difference, which they barely understood, artists sought to represent this world, but their impressions are principally exotic and theatrical. Painters such as Jean-Léon Gérôme or Théodore Chassériau used a highly naturalistic style to depict eroticized scenes, such as superbly beautiful naked slave girls being sold at market or cavorting homoerotically in Turkish baths.

The images created by Orientalist artists were accepted as being accurate portrayals of distant lands, and have become culturally embedded and replicated in cinema since the earliest films. Silent film actresses like Theda Bara and Pola Negri frequently portrayed exotic Eastern *femmes fatales*. The documentary *Reel Bad Arabs* (directed by Sut Jhally, 2006) explains the process of transferring this exotic and often lascivious "Oriental" image from painting to screen right up to the present day, and calls attention to the role of art in creating enduring cultural assumptions and stereotypes.

Representation of people closer to home was even more fraught. Racial attitudes meant that there were very few representations of African American life. One of the most significant is *The Banjo Lesson* by Henry Ossawa Tanner (1859–1937). Like Ilya Repin, Tanner wanted to portray unsentimentally the realities of life. African American Tanner, born to a church minister and a former slave, is acknowledged as the first major painter of African descent in Western art. Educated in the United States, Tanner moved to Paris and spent the majority of his professional life there. However, his most famous painting, *The Banjo Lesson*, was painted following visits to the United States, where he sought to represent the reality of African American life. African Americans were usually seen as entertainers, and *The Banjo Lesson* is interesting because of the way Tanner presents this idea completely differently. The elderly man teaches the young boy to play the banjo: this is shown as a real moment of human interaction. Tanner reveals the struggle and trust that the lesson involves. Most of Tanner's paintings were commissions of religious and historical subjects, or portraits; the same was true for Repin. However, it is interesting to see that the works that both artists are best known for are *The Banjo Lesson* and *Barge Haulers on the Volga*.

Issues of representation—whether of gender, race, class, or sexuality— are important in the study of both art history and cinema, and have been taken very seriously by artists and filmmakers. We can see how painters like Manet, and perhaps John Singleton Copley in the eighteenth century (discussed in Chapter 4) and Karl Bodmer in the nineteenth century (discussed in Chapter 6), made paintings that challenged prevailing ideas or social assumptions. However, the critical debate around representation principally begins in the late twentieth century, with the advent of more political readings of art and film.[12] We might ask, what is the relationship between realism and representation? Critic bell hooks has said that "giving audiences what is real is precisely what movies do not do. They give the reimagined, reinvented version of the real. It may look like something familiar, but in actuality it is a different universe from the world of the real. That's what makes movies so compelling."[13] However, hooks goes on to say that, nevertheless, "movies not only provide a narrative for specific discourse of race, sex and class, they provide a shared experience, a common starting point from which diverse audiences can dialogue about these charged issues."[14] The same can be said of visual art, particularly the representational painting that has dominated much of art history.

Today the link between race and the exotic is less manifested in art, but even in the twenty-first century, representations of black people in Western art are relatively few, usually by artists of African descent; noteworthy examples include Barkley L. Hendricks in the United States and Lynette Yiadom Boakye in Britain. Equally, despite the increasing visibility and success of African American actors in the cinema, there have been relatively few African American directors and producers. One of the most prominent is Spike Lee, whose 1989 film *Do the Right Thing*, an intelligent and provocative depiction of racial tension in a Brooklyn neighborhood, was critically praised for being realistic, but also made number 22 on *Entertainment Weekly*'s list of The 25 Most Controversial Movies Ever (2008).

More recently, British directors Steve McQueen (*Twelve Years a Slave*, 2013) and Amma Asante (*Belle*, 2014) have found notable critical and popular success. *Belle* was inspired by a painting of the real-life eighteenth-century mixed-race heiress Dido Elizabeth Belle, and the theme of paintings as carriers of heritage and identity is explored throughout the film.

We can see that realistic representation of the world around us, in all its variety and diversity, is more difficult than we might imagine; it is still as selective and subjective as ever.

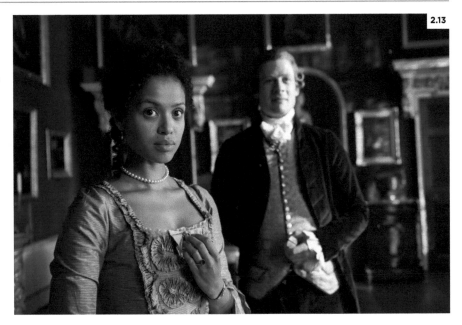

2.13

2.13
***Belle*, 2013**
Dir. Amma Asante
Belle grows up in a house full of paintings of her white ancestors.

FURTHER VIEWING

See also the work of African American producer-director Lee Daniels. He created the 2015 Fox TV series *Empire*, directed *Precious* (2009), and produced *Monster's Ball* (2001, directed by Marc Forster).

WHAT IS
REALISM?

WHAT IS
REPRESENTATION?

ART AFTER
PHOTOGRAPHY:
MODERN
CONCEPTIONS OF
REALISM IN ART

CASE STUDY:
REALISM AND THE
CAMERA OBSCURA

EXERCISES,
DISCUSSION
QUESTIONS, AND
FURTHER READING

ART AFTER PHOTOGRAPHY: MODERN CONCEPTIONS OF REALISM IN ART

The invention of the camera relieved artists of the responsibility of depicting the world. By the time the camera was invented, replicating the world around us no longer had to be done by hand. For example, in 1789 when Napoleon sent a large number of artists to Egypt to document all of the antiquities (*Description de l'Égypte*, published 1829), they had to do it with drawing. This kind of documentation was later replaced by photography. It is important to understand that these drawings were never meant to be art.

Yet photography was unable to replace drawing or painting as an art form. Some things cannot be photographed unless artificially created in detail, such as past events or purely imaginary things such as centaurs and dragons. When photography appeared, the first impulse of photographers was to photograph themselves and other people; photography came to substitute, to some extent, for portrait painting. Yet the inability to manipulate the photograph with the same flexibility and dexterity that the painter could manipulate paint, achieving a unique and often flattering result, meant that among the elite, the painted portrait remained supreme. This tendency remains true up to the present—which is not to say that painters were unaware of the possibilities offered by photography: taking photographs of models could save time in the studio, and save on modeling fees.[15]

Impressionism as "Realism"

Nevertheless, the existence of photography offered a challenge to painters and an opportunity to do things differently. Impressionist painters wanted to represent the real world in a visually different way. Edouard Manet, for example, did not believe that he needed to try to replicate in paint everything he saw before him, nor try to capture the fine details. Naturalism seemed pointless to him. He simplified the details, and avoided transitional tones and shading.

Impressionism is not about capturing what is "there" but is about what the eye *sees*. It is a completely retinal experience. Impressionist paintings are aware that the eye is an organic, moving entity, receiving and processing light, shadow, shape, and color. The eye operates not on an objective scale, but on a perceptual one. The eye is less concerned with something "being" blue than with it "looking" blue. The mutability of light and its effect on color, shape, and depth is at the core of every Impressionist painting.

2.14

Impression, Sunrise, 1872
Artist: Claude Monet (1840–1926)
The port at Le Havre is captured by Claude Monet at sunrise, showing the pinkish-red of the eastern sun and the morning haze. Monet shows us light and atmosphere, but hints at the structures of the port's industry. This emphasis on the appearance of shifting light on surfaces and the representation of changing atmospheric conditions is the essence of "impressionism." Former president of the American Society of Cinematographers Woody Omens has said that "When I think of painters that I'd like to make honorary members of the ASC, I would in a second nominate Monet, who taught me about color latitude and atmosphere."[16]

One of the keys to Impressionism is that many painters did not always work in the studio. With the availability of mass-produced tube paints and portable easels, it became easier to go outside and paint *en plein air* ("in the open air"). Although this had sometimes been done before, the Impressionists argued that this was a new kind of painting, capturing a way of seeing. It was about painting immediacy and movement, particularly the play of light as it shifts and changes the appearance of colors. Georges Seurat did this with *pointillism*: applying small, distinct dots of pure color in patterns to form an image. This technique had been used before in sections of paintings, but Seurat made whole compositions this way. In his large, cinematic painting *A Sunday on La Grande Jatte* (1886), this technique can be seen very clearly. Seurat even went back and worked on some of his earlier paintings to add pointillist elements to bring out the impression of diffused and

changing light. Seurat's images have strong realist elements in his depiction of the industrial landscape and scenes of everyday life, but through his work we can begin to see other ways that images might be considered cinematic.

Impressionism, then, *is* about the real, and about representing the real, but understanding that "the real" is also a matter of perception.

In *A Bar at the Folies-Bergère*, which was Manet's last painting, the subject is a real person who worked as a barmaid, and there are many accurate details of the place. But the real achievement in this painting is the painted mirror, which provides the backdrop of the entire painting. We can see the very bottom of the mirror's frame, just above the woman's hand; leaving us to understand that all the rest of the background of the painting is a mirror reflection. This immediately invites the viewer into the

position of the man seen reflected on the far right talking to the barmaid.

A Bar at the Folies-Bergère seems to be teeming with life, but it is actually showing a lone woman in an attitude of waiting. It is a strange picture, a picture of calm in the middle of a hectic setting. Manet explores the reflective qualities of mass-produced drink bottles, and their variety of colors, shapes, sizes, and labels. He enjoys the way they are bunched together, the rosé next to the beer next to the champagne. Manet did do plein-air painting, but this picture was not painted *in situ*: Manet sketched out the scene during visits to the *Folies* but painted it in the studio, setting up the bar and mirror and using the real barmaid as a model. Perhaps that's what gives the painting its feeling of isolation amidst bustle. Perhaps it reflects how Manet himself felt.

2.15

2.15
***A Bar at the Folies-Bergère*, 1882**
Artist: Edouard Manet (1832–1883)
Manet here is deliberately evoking the mirror trick in Velásquez's *Las Meninas.* Glass and myriad shiny surfaces are present in the painting, and the reflected crowd stretches far into the background. We can easily imagine the clatter and clink of glass, the chatter, and the music of the bar.

WHAT IS
REALISM?

WHAT IS
REPRESENTATION?

**ART AFTER
PHOTOGRAPHY:
MODERN
CONCEPTIONS OF
REALISM IN ART**

CASE STUDY:
REALISM AND THE
CAMERA OBSCURA

EXERCISES,
DISCUSSION
QUESTIONS, AND
FURTHER READING

Realism and Perception

Another approach to expressing the real as a series of impressions can be seen in the work of J. M. Whistler. *Nocturne: Blue and Gold—Old Battersea Bridge* (1872) almost denies us a vision of the bridge, swathed as it is in the evening mists from the river, illuminated faintly by the tiny points of light that emerge from the murk. If we compare it to a picture of *Old Battersea Bridge* in daylight by Walter Greaves (1874, also in the Tate Gallery), we immediately see the difference between Greaves's highly naturalistic, detailed rendering and Whistler's. Greaves tells us what the bridge looks like; Whistler intimates how the bridge appears in the evening.

Whistler's title is significant, because with it he transposes the condition of music or sound into the condition of painting or vision. A nocturne is a musical composition that is inspired by, or evocative of, the night. Whistler may be referring obliquely to an idea that comes out of German philosophy, *Gesamtkunstwerk* (or "total work of art"), which is an ideal, synthetic, all-embracing artwork that uses all or many art forms, or at least strives to do so. Whistler's "nocturne" is definitely a painting, but by virtue of its title the artist has connected it to music. This makes it clear that he emphatically does not want us to expect a literal, detailed rendering that gives us information about what Battersea Bridge looks like. Whistler is not interested in the factual reality of Battersea Bridge; his Battersea Bridge is metaphysical. Music is not literal and cannot be read that way; it cannot be directly descriptive or representative of something. Whistler wants us to perceive the painting in the tonal way, not as a clear representation; it becomes an expressive function of narrative. Yet at the same time, on a misty evening, when the streetlights come up and the city becomes shrouded in shifting, crepuscular light, the Thames and its bridges can look very much like Whistler's painting. So in some sense it is a realistic painting, and a very cinematic one.

2.16

2.16
Nocturne: Blue and Gold—Old Battersea Bridge,
1872
Artist: James McNeil Whistler (1834–1903)
Whistler's painting takes reality and transforms it, turning iron, water, light, and smog into a vision of beauty.

FURTHER VIEWING

Look at the following Impressionist paintings:

Claude Monet, *Impression, Sunrise*, 1872 (Marmottan Monet Museum) and *The Beach at Trouville*, 1870 (National Gallery London)

J. M. W. Turner, *Rain, Steam, and Speed—The Great Western Railway*, 1844 (National Gallery, London)

Georges Seurat, *Bathers at Asnières*, 1884 (National Gallery, London)

Berthe Morisot, *The Dining Room*, c. 1875 (National Gallery of Art, Washington, DC)

Compare this domestic interior by Morisot with one by Vermeer or Pieter de Hooch.

Realism and Moral Education

Cinema is all about light, because it is the act of light entering the camera that creates the image. It is not surprising that filmmakers have always looked to painters to inspire them toward ways to manipulate this light. Color cinematography pioneer Jack Cardiff always credited the Impressionists with teaching him about light and color. Cardiff was fascinated by the chromatic theories that had come out of Impressionism and sought to explore them in film.[18]

Impressionist influence can be seen in contemporary cinema—for example, in Joanna Hogg's film *Exhibition* (2013). The film is a realist dissection of a relationship between an artist couple as they grapple with a plan to sell their house. The house is both cocoon and prison, a home and a trap. Hogg's film is strongly visual and uses many Impressionist techniques, using light naturally filtered through blinds and leaves, emphasizing the changing patterns and colors wrought by time of day and shifting perspective. The same shot can be threatening or heavenly depending on the light. Hogg also uses glass and reflections to keep us aware of our shifting sympathies and perspectives as the story unfolds.

Another approach entirely was to use realist painting and its narrative potential as a means of direct social and moral education. While this tendency had already been present in Dutch genre painting, and Bruegel and Murillo had used painting to make oblique comments on the status quo, the Victorians took it to a literal level. In nineteenth-century British and American art, realism developed certain tendencies of *didacticism*. Painters created dramatic, highly explicit narratives, usually with matching literal titles, that leave the viewers in no uncertainty as to what they are encouraged to think and learn from looking at the painting. These paintings are often cinematic in a melodramatic way. A good example is *Past and Present No. 1* (1851) by Augustus Egg, which is in the Tate Gallery. This is a typical example of the much-reproduced and highly popular genre of didactic art. Egg paints the interior of a middle-class Victorian home: a stern husband is seated at the table admonishing his prostrate wife, who lies outstretched, hands clenched, face down on the carpet, while on the other side of the room,

SFUMATO

Whistler's *Nocturne: Blue and Gold* uses an old painting technique called *sfumato*.[17] Sfumato (deriving from the Latin for "to smoke") is fine shading that produces soft, imperceptible transitions between colors and tones. This means that there are no distinct outlines: areas blend into one another through miniscule brushstrokes, which makes for a subtle rendering of light and color. Leonardo da Vinci developed and perfected sfumato; see his *Mona Lisa*. The opposite of sfumato is chiaroscuro.

WHAT IS
REALISM?

WHAT IS
REPRESENTATION?

**ART AFTER
PHOTOGRAPHY:
MODERN
CONCEPTIONS OF
REALISM IN ART**

CASE STUDY:
REALISM AND THE
CAMERA OBSCURA

EXERCISES,
DISCUSSION
QUESTIONS, AND
FURTHER READING

Documentary Realism: Styles, Stylization, and Conventions of "the Real"

two little girls are making a house of cards. The construction of the painting, which features a great deal of heavy-handed symbolism, means that it is very obviously about a man discovering his wife's infidelity, and the destructive result it has on the family. While one of the girls ignores the situation and continues to play, the other is looking on at her mother's disgrace. Egg wants to tell us, in no uncertain terms and with no subtlety whatsoever, that the price of infidelity is total destruction of family life. Egg painted two other pictures in the *Past and Present* series, depicting in no uncertain terms the fate of the unhappy family.

This kind of moralist painting owes a huge debt to the work of William Hogarth, but the Victorian moralist painters lack Hogarth's scurrilous wit, sardonic humor, and obvious prurient interest in the vices that he's depicting. The Victorian paintings coldly reject all vice, and deny the viewer any vicarious pleasure in looking at it. It is precisely this type of didactic painting that the artists at the very end of the nineteenth

century, together with their spokesman, the writer and critic Oscar Wilde, particularly rejected. Rejection of this moralizing, didactic art is one of the cornerstones of modernism. And this is where we can see how the modernist impulse of painting diverges profoundly from the populist impulse of cinema. The moralizing melodrama expressed in Egg's three *Past and Present* pictures is the same kind of moral melodrama we see in the movies, right up to 1987's *Fatal Attraction* (dir. Adrian Lyne). Egg's series could be a film storyboard. The moralistic didacticism would have appealed to *Hayes production code*–dominated Hollywood (roughly 1930–1968), whereas Hogarth's more licentious images would not have passed the censor. Egg's paintings, like Hogarth's, were much reproduced, and influenced the visual culture regardless of the changing tastes in art appreciation. Melodramatic films about adultery or other vices (of which there are many) are usually seen as deriving from literature, but should also be seen as deriving from paintings like *Past and Present*.

After the development of the camera, documentary and documentation took on a significant role within visual culture. But just like any other artwork, the documentary is a construction, with its own library of styles and conventions that are used, celebrated, rejected, and abandoned as trends and fashions come and go. From the very earliest known documentary, Robert Flaherty's *Nanook of the North* (1922), through the newsreel footage of the 1930s, '40s, and '50s, to the highly artistic documentaries of Jennifer Baichel, Guy Maddin, or Sophie Fiennes today, when we talk about "documentary realism," there is no single approach.

Since the first uses of photography were in creating what we might call documentary images, as opposed to fine art images, black and white was quickly seen as being more "real" than color. Sophisticated film color was developed in the 1930s, but for many years the problem was that it tended to make everything "pretty." Color suited musicals or historical dramas, but its effects were considered inappropriate for realistic dramas.

FURTHER VIEWING

The Outcast by Richard Redgrave, RA, 1851
(Royal Academy of the Arts, London)

Edward Hopper and the Cinematic Quality of Light

"Realism suffers in the color medium." *Citizen Kane* DP Gregg Toland on color:

"Paradoxically enough, realism suffers in the color medium. . . . In the black and white picture, color is automatically supplied by the imagination of the spectator and the imagination is infallible, always supplying exactly the right shade. That is something physical science will continue to find tough competition."[19]

When working out how to shoot the Jake LaMotta biographical drama *Raging Bull* (1980), Martin Scorsese and DP Michael Chapman wanted to represent the 1940s as realistically as possible. Scorsese and Chapman went to Weegee's photos of 1940s New York. Arthur Fellig, aka "Weegee," was a press photographer who developed into being a documenter of gritty urban New York, but his work was also exhibited at the Museum of Modern Art. His published books of photography were so influential that he can be considered to be an artist of his era. Weegee's extremely high-contrast, dramatic photographs of real-life events on the streets of New York infuse the real with a clear sense of his personal style, and stylization created by the use of the flashbulb into a particular convention of "the real"; this convention informs the photography of *Raging Bull*.

The great painter of light in twentieth-century art is the American realist Edward Hopper. Hopper (1882–1967) came of age in the early days of the cinema and had a passion for the movies all his life. It would be fair to say that film was at least a subconscious influence on the painter as much as his paintings have, in turn, been influential to filmmakers.

Hopper painted contemporary America, its landscape, architecture, its street life and public spaces. Again, Hopper's realism is about selecting and refining the real world, making a series of choices in what to represent and how to represent it, yet at the same time we get a sense of its accuracy. Depicting things as mundane as gas stations, diners, and movie houses, Hopper portrays a world that is recognizable as authentic. But his cities are almost empty: they have a wondrous stillness and silence, yet there is unseen bustle and unheard racket in them. Hopper invites us to occupy a momentarily tranquil space in the middle of what we know is a crowded, noisy, and tumultuous city.

2.17

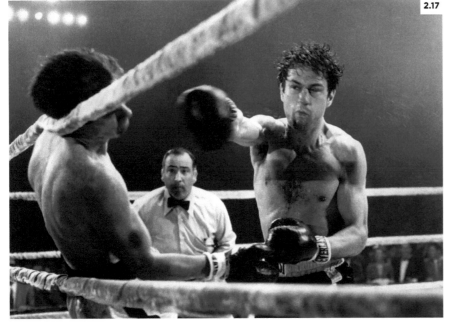

2.17
Raging Bull, 1980
Dir. Martin Scorsese, DP Michael Chapman
Black-and-white police photography, boxing photography, and above all the street photography of Weegee were the visual sources for *Raging Bull*.

WHAT IS
REALISM?

WHAT IS
REPRESENTATION?

ART AFTER
PHOTOGRAPHY:
MODERN
CONCEPTIONS OF
REALISM IN ART

CASE STUDY:
REALISM AND THE
CAMERA OBSCURA

EXERCISES,
DISCUSSION
QUESTIONS, AND
FURTHER READING

"Photo" Realism

Documentary realism coming from the camera also inspired painters, bolstered by the appreciation of painters such as Vermeer and Peter de Hooch who managed to achieve images with an almost photographic quality. Painters took up the challenge of making pictures that resembled photographs, looked as though they could be photographs, but had a whole host of subtle elements that meant they could not possibly be photographs. This tendency is called *photo-realism*, or photo painting. It is sometimes also called hyperrealism or super realism (though the definitions are not absolute, and great differences exist between different painters and their techniques).

But despite the modernity of photo-realism, older impulses are still at play. Eric Fischl's 1982 painting *The Old Man's Boat and the Old Man's Dog* (which you can see on his website, www.ericfischl.com) looks at first glance like a photograph of a group of people and a Dalmatian dog relaxing naked or semi-naked on a yacht while a big storm brews just ahead of them. We can immediately make connections with William Etty's 1832 painting *Youth at the Prow and Pleasure at the Helm* (Tate Gallery), which also depicts a group of young people enjoying themselves naked on a boat, with a violent storm imminent. They are doomed by their irresponsible folly and ignorant of their fate. Rejecting realism, Etty opts for a quasi-mythological vision of beauty, whereas Fischl's realism seems photographic, stark, and direct. We can imagine that Fischl's Old Man is a wealthy, decadent benefactor (perhaps an art collector?), who enjoys the cavorting of the naked youth on his boat, and the composition places the viewer among the party. Robert Hughes

has written of Fischl's "desire to turn the viewer into a voyeur, a reluctant and embarrassed witness."[20]

Both paintings want to communicate something about the moral breakdown of society. Fischl's photographic approach, composed like a snapshot, places the viewer on the boat, forced into the position of being one of the doomed party, as opposed to Etty's omniscient perspective. Despite the texture of the paint and the deliberate roughness of the brushwork, the painting could almost be a photo or a film frame, in a way that Etty's picture could never be. Although there are different concerns happening in each painting, and even though we should not overemphasize their visual similarity, it is apparent that, despite the 150 years between them and the changing artistic tastes, we can compare the late-twentieth-century photo-realist painter with the Victorian. And, in a more subtle way— note the oblique title—Fischl's painting is also a morality tale.

Alex Colville's work is realist and cinematic in a different way. Strongly influenced by Edward Hopper, the Canadian painter's work makes it clear that realism of content is not

necessarily just naturalism. Colville often depicted people in rural or domestic settings, and there is always the cinematic moment of suspense. In *Refrigerator* (1977), a naked couple seeks a snack. In *Pacific* (1967), a man looks out across water while a pistol rests on a table in the foreground (this image was copied in the film *Heat* by Michael Mann, 1995); twenty years later Colville continued the story with *Woman with Revolver* (1987). It is tempting to bring many of Colville's paintings together to form an imaginary storyboard for an exciting yet laconic feature. Colville's paintings are not exactly photo-realistic: they approach a technical perfection that nevertheless leaves room for the viewer's imagination.

Painters such as Chuck Close and Lucien Freud (1922–2011) continue the realist tradition in portraiture, and Gerhard Richter moves between photo-realism based on photographs and abstract.

Artists such as Gregory Crewdson and Jeff Wall use photography and digital technologies to create realistic, cinematic tableaux still images that owe as much or more to painting than to photography.

FURTHER VIEWING

Alex Colville, *Horse and Train* (1954); Colville's works can all be seen at http://www.alexcolville.ca

Richard Estes, *Supreme Hardware Store* (1973)

CASE STUDY:
REALISM AND THE CAMERA OBSCURA

How a Camera Obscura Works

Brendan Prendeville claims that "the very invention of photography could be partly thought of as an outcome or a by-product of realist painting tradition."[21]

As we saw in Chapter 1, in 1040 AD, Alhazen (Ibn al-Haytham) created the first fully functioning camera, the camera obscura, which allowed a more accurate rendering of perspective. However, it remained a curiosity of science (or "natural magic") until the early sixteenth century, when the Italians perfected a working camera obscura with a convex lens. Soon it was an accepted tool for artists and architects.

Of course, the core principle of the camera obscura is exactly the same as the photography camera and the later movie camera: light passes through a lens and records an image inside the chamber or "camera" (Latin for chamber or room).

The camera obscura was usually a closed room, a tent, or a cubicle; later a self-contained portable wooden box was developed, and in the eighteenth century these were widely manufactured. Many painters used the camera obscura, and other optical devices were developed using lenses and mirrors. It was all part of a widespread interest in accurate perspective. Artists wanted to depict the world in the same proportions, and according to the same principles, as the human eye sees the world. Following the same principle of tracing a project image, twentieth-century artists also employed overhead projectors and, later, digital projectors.

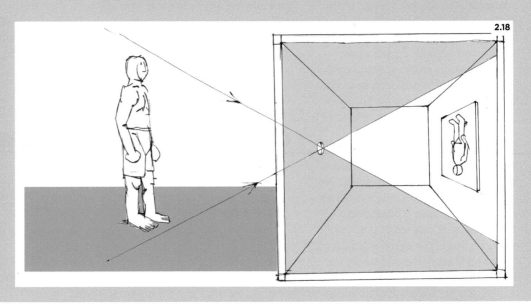

2.18

2.18
Diagram of the Camera Obscura
The image is projected through the lens onto a translucent screen. The artist is on the far side of the screen, tracing the image on the screen to create a sketch, which can then (using a wide variety of methods) be turned into a painting.

WHAT IS
REALISM?

WHAT IS
REPRESENTATION?

ART AFTER
PHOTOGRAPHY:
MODERN
CONCEPTIONS OF
REALISM IN ART

CASE STUDY:
REALISM AND THE
CAMERA OBSCURA

EXERCISES,
DISCUSSION
QUESTIONS, AND
FURTHER READING

"Houding"

The splendid and imaginative realism of Johannes Vermeer has led to much speculation and controversy about whether he used the camera obscura or other optical devices.[22]

To the seventeenth-century Dutch, the finest quality sought in painting was what they called "houding": the achievement of a harmonious realistic illusion. Mimesis, but harmonious mimesis. Realism, but balanced and proportionate realism. What they wanted was what the eye could see, the real world, but they wanted it to be arranged pleasingly.

Vermeer appears to have achieved this by employing quite precise geometrical measures. One of the reasons it has been long speculated that he used a camera obscura, despite the absence of any real evidence, is that his pictures show, to a greater to lesser degree, the depth of field illusion you get with a lens but do not see with the naked eye. Architect and Vermeer researcher Philip Steadman[23] believes that Vermeer is more likely to have used the *chambre d'obscura* than a box camera obscura, and he also posits that Vermeer used only one or two rooms as studios, setting them up slightly differently for each painting. Steadman demonstrates in his book *Vermeer's Camera* (2001) that the painter made pictures of only a few rooms, with the elements altered; for example, the lids on the virginals have different paintings on them but the musical instrument is the same. Likewise, there is differentiation of the tile patterns on the floor, but the proportion of the tiles is the same.

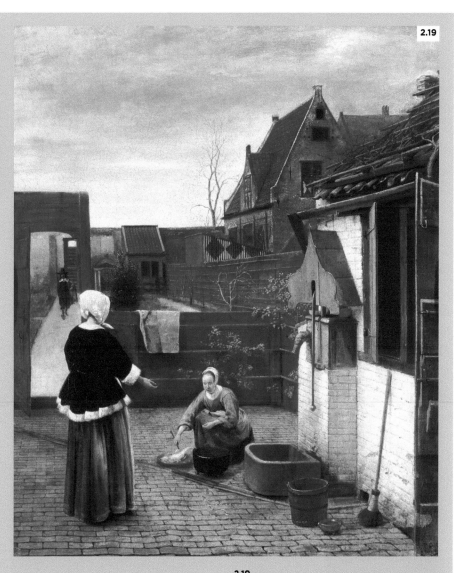

2.19

2.19
***A Woman and Her Maid in a Courtyard*, c. 1660**
Artist: Pieter de Hooch (1629–1684)
Apart from the detailed realism of the picture, notice how De Hooch places his characters in different positions in the composition. Notice his use of the arch and how, by turning the characters away from the viewer, he manages to create a sense both of voyeurism and of movement.

"Optics Don't Make Marks"

Pieter de Hooch's oeuvre has similar kinds of repetitive compositions, and Steadman notes there is some evidence that he felt commercial pressure to create variations on similar compositions.

Vermeer probably used an adjustable lens that you could turn and pull, similar to the lens of a slide projector. This would give him different focal points and allow him to pull things in and out of focus. We do not know if Pieter de Hooch used a camera obscura or not, but his pictures show the same perfect geometrical detail. De Hooch's paintings are interesting and notable for the way in which he depicts social relations, particularly comings and goings and interactions. De Hooch sees social relations as spatial relations. His pictures have many different perspectives; we look through doorways, windows, arches. It's very important to him how the human subjects in his paintings occupy space.

All of Vermeer's paintings show great awareness of lights and darks, and a good understanding of how to maximize this. Vermeer clearly was a great observer of life. Instead of drawing lines, he identified and marked out the dark points of the scene. Whether or not he did look though a camera obscura, by mapping out his paintings as darks and lights, we can see why he has been called a "painter of light."

The British painter David Hockney[24] spearheaded the contemporary investigation into how painters of the past used optical tools to assist them in getting composition, proportion, and perspective right. Hockney is a painter who moves easily between painting and photography and is comfortable using optical tools, or dispensing with them completely, according to his aims and intentions. Gathering together different practitioners, including scientists, architects, and historians, Hockney advanced the thesis that many artists in the Renaissance used optical aids. This is detailed in Hockney's book *The Secret Knowledge* (2006)[25] and in a 2003 BBC television film with the same title.[26] For some artists we have direct evidence that they used optical aids: eighteenth-century portrait painter Joshua Reynolds had a camera obscura that folded down to look exactly like a book; it is in the Science Museum in London. But for most artists, we don't have this kind of direct evidence, and the paintings alone offer up clues.[27]

But Hockney makes the key point that "optics don't make marks"; artists do. What he means is that looking through a camera obscura, or using a convex mirror to reflect an image onto a surface, does not actually create the painting; the ability to trace an image is not equivalent to the ability to paint and draw. This is shown quite cleverly in the film *Tim's Vermeer*, in which inventor Tim Jenison's effort to duplicate the painting techniques of Vermeer tests the theory that Vermeer painted using optical devices. The film shows Jenison painting with an optical aid, but the result is simply a pedestrian reproduction of a Vermeer. Nobody would believe that Jenison is a painter himself, or that he could rival Vermeer or any other painter, simply because he knows how to use an optical tool.

WHAT IS
REALISM?

WHAT IS
REPRESENTATION?

ART AFTER
PHOTOGRAPHY:
MODERN
CONCEPTIONS OF
REALISM IN ART

CASE STUDY:
REALISM AND THE
CAMERA OBSCURA

EXERCISES,
DISCUSSION
QUESTIONS, AND
FURTHER READING

The Camera Obscura and Cinema

When Alhazen looked through his homemade camera obscura, he saw the first ever moving image projection. With the application of the lens, the images could be manipulated and focused. The idea of moving images continued to intrigue, yet was so elusive it deserved its label "natural magic."

For centuries the camera obscura remained a fascinating toy, a popular fairground attraction, and many aristocratic houses had them as novelties. They were not just tools for painters and architects; they were also popular entertainments. It is interesting to think that people enjoyed looking at the camera obscura projecting an image of the street outside, when they could just look out the window and see that same street. But there is something entrancing and magical about the projected image. Jonathan Crary notes that many who offered their impressions of the *camera obscura* "single out as its most impressive feature its representation of movement" and were astonished by the flickering projected images "of pedestrians in motion or branches moving in the wind, as being more lifelike than the original objects."[28] And therein, most probably, lies the clue as to why we continue to enjoy cinema.

It is not surprising that as soon as still photography was invented, enthusiasts immediately tried to move further and fix the moving image. Fox Talbot, Niépce, and Daguerre modified commercially produced camera obscuras to create the first photographic cameras. What they achieved was to find a way to fix the single image; later, the inventors of ciné film found a way to fix multiple images.

Perhaps the real story of cinema, then, starts in the eleventh century, with Alhazen. There's no question that his work whetted human curiosity and a desire for moving images that was not satisfied until a millennium later. It is perhaps telling that appreciation of Vermeer's work was greatly revived in the middle of the nineteenth century; with the invention of the photographic camera, Vermeer's particular approach to realism could be appreciated in a completely different way. Similarly, it is interesting that Caravaggio was "rediscovered" in the twentieth century, when his "cinematic" qualities could be appreciated.

The Excitement and Suspense of Perspective

It is very tempting to see Vermeer's *The Music Lesson* as a composition suggested by the framing of a camera (or camera obscura). We see the subjects from the back. The woman appears to be focusing on playing her musical instrument, while the man, seen in profile, has abandoned his instrument on the floor and stands gazing at her. However, above her head in the mirror we see her face, and it seems that she's looking sideways at him. It is said that Vermeer would have had to manipulate the mirror to an unnatural position in order to get this accurate reflection. The floor is important: notice how the black-and-white tiling decisively leads the perspective, making us feel the distance between the musicians and the viewer. We immediately experience frustration: we are standing in the doorway peeking at them, too far away to hear what they're saying to each other.

Vermeer's use of the partial view is one of the most interesting aspects of the picture: the frame is cut off, effectively slicing the table and the painting on the wall in two, so we can't see what else or who else may be in the room. The naked eye would never see the room that way. Are we witnessing some kind of intimate tête-à-tête? Is it innocent, or not? Immediately we're caught up in the story; we want to know what's going on. The painting has triggered our interest.

Roman Polanski uses this partial view to good effect in a scene in *Rosemary's Baby* (1968). Neighbor Minnie (Ruth Gordon) tells Rosemary she will telephone her doctor and make an appointment for Rosemary, who readily agrees. We then see Minnie going into the bedroom and making a phone call. But Polanski never shows us Minnie's face: he shows us the side view of Minnie's back as she sits on the bed, hunched over, talking on the phone. Director of photography William A. Fraker originally set up the shot to show Minnie talking on the phone, but Polanski insisted on shifting the camera. Fraker admitted later that he thought Polanski was crazy, but went along with it. Then, he says, watching the final film in the cinema, he saw how the whole cinema audience inadvertently craned their necks, trying to see the rest of Minnie behind the doorway. "That's Polanski," Fraker concludes.[29] Later we find out some terrifying truths about Minnie, and the obscure secrecy of the phone conversation becomes clear.

In both the painting and the film, perspective and composition are used to dramatic effect. The camera offers us a framed, delimited image. It restricts what we can see. Whether it is Vermeer's camera obscura or Polanski and Fraker's movie camera, the partial view creates curiosity and drama.

WHAT IS
REALISM?

WHAT IS
REPRESENTATION?

ART AFTER
PHOTOGRAPHY:
MODERN
CONCEPTIONS OF
REALISM IN ART

CASE STUDY:
REALISM AND THE
CAMERA OBSCURA

EXERCISES,
DISCUSSION
QUESTIONS, AND
FURTHER READING

2.20
The Music Lesson, c. 1662
**Artist: Johannes Vermeer
(1632–1675)**
The Music Lesson is one of the
Dutch painter's finest works.
It invites us to consider how
the artist handles perspective,
and how this in turn drives the
painting's narrative power.

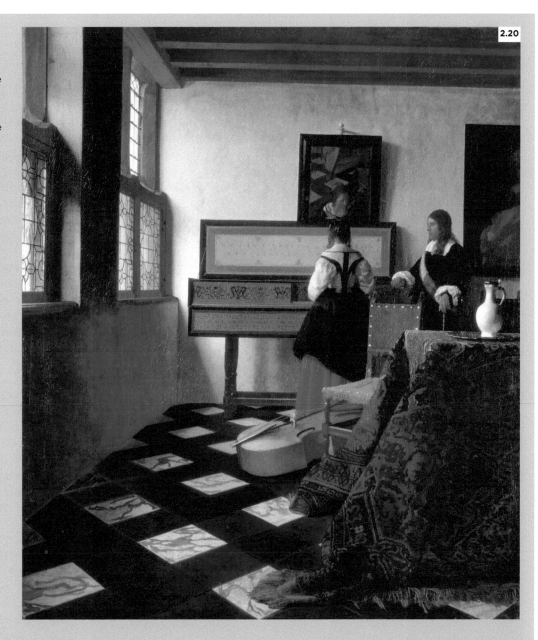

2.20

EXERCISES AND DISCUSSION QUESTIONS

In art and cinema, "realism" is about selecting and refining the world. It is reality at a remove. It is reality slightly exaggerated, through dramatic lighting, gesture, and composition. It can emphasize or even exaggerate the lushness of nature or the grimness of the human condition.

Artists and filmmakers select materials from the chaotic welter of reality, and in the process necessarily eliminate some details while emphasizing others. The resulting structure is not reality, but is a subjective, constructed representation of it.

Exercise 1
Study Manet's *A Bar at the Folies-Bergère* (*Le Bar aux Folies-Bergère*). There is a good-quality version online at the Courtauld Gallery website. Now, try to reinterpret it as a moving image scene. Start by planning it out in detail first, as Manet would have done. What props do you need? Design your set on paper.

Where will you place the characters? How will you light it? Where will your light source come from? How will you avoid flare in the glass? What is the best way to maximize the reflective qualities of the glass bottles? What sounds might be appropriate? Once you know all of this, try shooting the scene. What happens when the characters move?

Exercise 2
There are many biographical dramatized films about painters, and it is interesting to examine how cinema portrays painting. Find a film that portrays a painter of any period, or watch one of the following:

Pollock, 2000 (dir. Ed Harris)

Artemisia, 1997 (dir. Agnès Merlet)

Strokes of Fire (sometimes called *Painted Fire*), 2002 (dir. Kwon-taek Im)

Utamaro and His Five Women, 1946 (dir. Kenji Mizoguchi)

Mr. Turner, 2014 (dir. Mike Leigh)

Caravaggio, 1986 (dir. Derek Jarman)

Notice what techniques the painters in these films use. Do you learn much about their art from these biopics? Which of the films do you think best portrays the methods and experience of painting? Is it important? In what other ways do the films portray the "painterly life"?

DISCUSSION QUESTIONS

1. What are the visual differences of the realism expressed by a painter like Velásquez and the kind of realism we associate with contemporary cinema, such as in the film *Children of Men* by Alfonso Cuaron (DP Emmanuel Lubezki)?

2. Watch Peter Webber's film about Vermeer, *The Girl with the Pearl Earring*. It is a fiction film based on extensive research and speculation. What techniques does Webber's Vermeer (Colin Firth) use?

3. Compare Caravaggio's paintings *Supper at Emmaus* (there are two versions, one at the National Gallery and one in Milan's Pinacoteca di Brera) with Veronese's version of *Supper at Emmaus* in the Louvre. Both paintings can be seen online.

"Supper at Emmaus" was a popular subject: in the New Testament story, two of Jesus's disciples invite a stranger to supper, but at the table realize that he is in fact the resurrected Christ. What makes the paintings so different? What are the elements of "realism" in each?

WHAT IS
REALISM?

WHAT IS
REPRESENTATION?

ART AFTER
PHOTOGRAPHY:
MODERN
CONCEPTIONS OF
REALISM IN ART

CASE STUDY:
REALISM AND THE
CAMERA OBSCURA

**EXERCISES,
DISCUSSION
QUESTIONS, AND
FURTHER READING**

FURTHER READING

Charles A. Riley, *Color Codes: Modern Theories of Color in Philosophy, Painting and Architecture, Literature, Music, and Psychology* (UPNE, 1995)

Gregg Toland, "The Motion Picture Cameraman," *Theatre Arts*, September 1941, available at http://www.wellesnet.com

Brendan Prendeville, *Realism in 20th Century Painting* (Thames and Hudson, 2000)

Philip Steadman, *Vermeer's Camera: Uncovering the Truth Behind the Masterpieces* (Oxford University Press, 2002)

Roberta LaPucci, "Caravaggio and the Alchemy of Painting," *Painted Optics Symposium: Re-examining the Hockney-Falco Thesis Seven Years On*, Florence, September 7 and 9, 2008, available at http://robertalapucci.com/pdf/2009b.pdf

Jonathan Crary, *Techniques of the Observer* (MIT Press, 1992)

David Hockney, *Secret Knowledge: Rediscovering the Lost Techniques of the Old Masters* (Thames and Hudson, 2006)

Arnold Glassman, Todd McCarthy, and Stuart Samuels, *Visions of Light: The Art of Cinematography* (1992), 92 min.

J. H. Hammond, *The Camera Obscura: A Chronicle* (Adam Hilger, 1981)

L. Gowing, *Vermeer* (Faber, 1952)

NOTES

1 Nigel Spivey, *How Art Made the World* (BBC Books [UK], 2005; Basic Books [US], 2006). A five-part documentary broadcast by BBC/PBS is available on DVD.
2 Mirrors in art are discussed in depth in Gregory Galligan, "The Self Pictured: Manet, the Mirror, and the Occupation of Realist Painting," *The Art Bulletin*, Vol. 80, No. 1 (Mar. 1998), pp. 138–171.
3 Robert Hughes, "Caravaggio," in *Nothing If Not Critical* (Penguin, 1990), p. 17.
4 *National Gallery Companion Guide*, p. 141.
5 Andrew Graham Dixon, "The Prado Extension; Velázquez," *The Daily Telegraph*, January 6, 2008.
6 Andrew Graham Dixon, "Painter of Painters," *The Independent*, October 7, 1989.
7 Norbert Wolf, *Velázquez: The Face of Spain* (Taschen, 2011).
8 Rose-Marie Hagen and Rainer Hagen, *What Great Paintings Say* (Taschen, 2003).
9 Sally Mitchell, *Victorian Britain* (Routledge, 2011), p. 46.
10 See John Singleton Copley's subversion of this: *The Death of Major Peirson, 6 January 1781* (1783), has the black servant taking a gun and killing the sniper that killed his master. This is discussed further in Chapter 4.
11 Feminist writer Germaine Greer's take on Manet's *Olympia*: "Artists have always glamorised prostitution. Manet savaged all their delusions." *The Observer*, Sunday, February 6, 2011.
12 Seminal texts you should read (or may have already encountered) include Edward Said's *Orientalism* (Penguin revised edition, 2003), which addresses representation of race and ethnicity in literature and art; Laura Mulvey's "Visual Pleasure and Narrative Cinema" (Screen, 1975, and widely available online), which addresses gender representation and how we "look" at it in cinema; and John Berger's *Ways of Seeing* (Penguin, 2008) which addresses race, sex, and class across many forms of visual culture.
13 Bell hooks in the introduction to *Reel to Real: Race Class and Sex at the Movies* (Routledge, 1996, 2009), p.1.
14 *Ibid.*, p. 3.
15 Dominique de Font-Réaulx, *Painting and Photography: 1839–1914* (Flammarion, 2012).
16 Quoted in *Cinematographer Style* (2006). Directed and produced by Jon Fauer. DVD, color, 86 mins. In English. Distributed by Docurama Films.

17 Charles A. Riley, *Color Codes: Modern Theories of Color in Philosophy, Painting and Architecture, Literature, Music, and Psychology* (UPNE, 1995).
18 Cinematographer John Bailey, quoted in Steve Chagollan, "Jack Cardiff: Painter's Eye View," *Variety*, February 10, 2011.
19 Gregg Toland, "The Motion Picture Cameraman," *Theatre Arts*, September 1941, available at http://www.wellesnet.com.
20 Robert Hughes, "Eric Fischl," in *Nothing If Not Critical* (Penguin, 1990), p. 347.
21 Brendan Prendeville, *Realism in 20th Century Painting* (Thames and Hudson, 2000).
22 David Hockney, *Secret Knowledge: Rediscovering the Lost Techniques of the Old Masters* (Studio, 2006).
23 Philip Steadman, *Vermeer's Camera: Uncovering the Truth Behind the Masterpieces* (Oxford University Press, 2002).
24 David Hockney, *Secret Knowledge: Rediscovering the Lost Techniques of the Old Masters* (Thames and Hudson, 2006).
25 David Hockney, *Secret Knowledge: Rediscovering the Lost Techniques of the Old Masters* (Studio, 2006). See also the earlier *The Science of Art: Optical Themes in Western Art from Brunelleschi to Seurat* (Yale University Press, 1992), which covers some similar ground but gives a very good account of Brunelleschi's rediscovery of linear perspective and how this came to be used by artists. There is a good video demonstrating Brunelleschi's experiments at *Linear Perspective: Brunelleschi's Experiment*, https://youtu.be/bkNMM8uiMww.
26 *David Hockney: Secret Knowledge* (dir. Randall Knight, BBC, 2003).
27 For Caravaggio, John Varriano's *Caravaggio: The Art of Realism* (Penn State Press, 2010) offers up recent research on Caravaggio's possible use of mirrors. Caravaggio scholar Roberta LaPucci has an online lecture on the subject at https://youtu.be/YjXYfpnp_IA.
28 Jonathan Crary, *Techniques of the Observer* (MIT Press, 1992), p. 34. See particularly Chapter 2, "The Camera Obscura and Its Subject." Crary cautions us against accepting a technological determinist point of view of some kind of linear progression leading inevitably to cinema. Hopefully this book will also help you understand that art and cinema are in relation; one does not "lead to" the other.
29 William Fraker, interviewed in *Visons of Light* (1992).

CHAPTER THREE
BEYOND REALISM

The dream sequence and the fantasy sequence, well known to even the earliest filmmakers, often echo and borrow from paintings that represent mythical worlds, fascinating symbols, and dream states. From the beginning, artists sought to create images of fantasy worlds and fantastical characters.

In the last chapter we looked at how artists struggle to portray the "real" world, as it appears to us. Through complex combinations of subject matter, composition, lighting, and tone, the real manifested through the ages from the Greek sculpture of Diogenes to Edward Hopper's Chop Suey restaurant. We also saw that our definition of the real has more to do with subject matter than technique. Seurat's pointillism, Manet's broad strokes of paint, and Whistler's misty gray sfumato all tried to show something the painter saw, and that we could also see. Different techniques used by artists served the quest to portray the real.

However, looking over the history of art, it soon becomes clear that artists have just as often *not* sought to portray real things, though they might attempt painting techniques that render unreal things naturalistic, as if they were credible and visible. This is art of the imagination, and going beyond the real includes many different kinds of painting. Filmmakers have deliberately looked to Surrealism for ideas, inspiration, methodologies, and imagery. Others have sought to go beyond realism to create hyperreal or quirky environments. There is sometimes a tendency to believe that photography and—later—film belong to a linear progressive history, dominated by a search to achieve realism. But it is much more complex and rich than that. Going "beyond the real" has been as much a part of the artistic journey as achieving the real.

This chapter looks first at fantasy and symbolism before Surrealism and then at how Surrealism harnessed new ideas about psychology deriving from Freud.

**"UNLESS WE AGAIN BEGIN TO TELL FAIRY STORIES AND GHOST STORIES AT NIGHT BEFORE GOING TO SLEEP AND RECOUNTING OUR DREAMS UPON WAKING, NOTHING MORE IS TO BE EXPECTED OF OUR WESTERN CIVILISATION."
—Jan Svankmajer, 1987
(quoted in *Electric Sheep*, June 14, 2011)**

FANTASY
WORLDS IN
CINEMA AND
ART

ONEIRIC: THE
WORLD OF
DREAMS

SURREALISM

GOING BEYOND
THE REAL

CASE STUDY:
THE ARCHERS

EXERCISES,
DISCUSSION
QUESTIONS,
AND FURTHER
READING

FANTASY WORLDS
IN CINEMA AND ART

Mythology

Fantasy films such as superhero movies (*Thor*, 2011), fairy tales (*Maleficent*, 2014), and imagined worlds (*The Imaginarium of Doctor Parnassus*, 2009) all have their antecedents in painting. From very earliest times, painters sought to escape everyday life and create imaginary scenes, often based on mythological tales that went far beyond the official written versions that existed in books. Likewise, the prevalence of religion and religious stories also inspired people to think about what the afterlife might look like, and artists became interested in finding ways to depict Heaven.

The enthusiasm for artworks of pure imagination was part of cinema right from the beginning, with the fantastical films of cinema pioneer Georges Méliès. Méliès (1861–1938), who started out as a stage illusionist, was one of the early adopters of film technology. With *Voyage to the Moon* (1902) and *The Kingdom of the Fairies* (1903), Méliès founded not only two genres, fantasy and science fiction, but also invented visual special effects. Even today, his extravagant films are hugely entertaining and continue to fascinate by their sheer artistry. Méliès was himself the subject of the 2011 Martin Scorsese film *Hugo*.

Mythology provides our earliest starting point. We are all familiar with the human–animal hybrids of the Egyptian pantheon. Only certain animals figure in the religious system, so you get Horus the eagle-headed man, Bast the cat-headed woman, and so on. The Egyptians did not make up unreal animals; they combined real beasts with the human form, creating powerful figures in their sculptures and paintings. Usually they created a human body with an animal head, but sometimes, as in the case of the Sphinx, it is the other way around. It is a realistic pantheon, because both the human forms and the animal heads existed in the Egyptian landscape, and the animals were ones that were both common and important to the society. So the jackal-headed god Anubis was associated with the dead and was a guardian of the afterlife. This is pragmatic, because the jackal was a scavenger animal, known to hang around cemeteries and live on carrion.

The Greek pantheon of gods and heroes was human in appearance, but their mythological world was populated by a huge array of monsters, from the snake-haired Gorgon to the one-eyed Cyclops, not to mention fauns and satyrs, nymphs and flying horses. Greek myths may be full of monsters, but their world is full of very human jealousies, intrigues, and betrayals, as well as dramatic battles and encounters. It is not surprising that Greek and Roman myth has provided the biggest and most enduring source of subject matter for artists. As late as 1933, Pablo Picasso produced one of his most celebrated works, the etching series *Minotauromachy*. In the 1970s, Franco-Serbian painter Ljubomir Popvic found fame with representations of Venus, while in New York, Roy Lichtenstein made a comic strip Temple of Apollo in 1975. In 1981, Russian artists Komar and Melamed made the large neoclassical painting *Stalin and the Muses*. The list goes on up to the present.

So right from the beginning, there was a desire to portray fantasy and alternative worlds populated by mythical characters and creatures. The quest for a naturalistic style of painting was not limited to realistic subjects, but applied equally to subjects well beyond the scope of the actually observable. This is why, in a painting like Bronzino's *Allegory of Venus and Cupid, Venus* looks like a real, fleshy woman and the other characters, although clearly not realistic, look at least credible.

Myth and Drama in Painting and Film

It was important for many painters to make mythical compositions look credible. But some achieved it better than others. In *Perseus and Andromeda*, Titian has painted a dark and dangerous moment. His Perseus is diving headfirst into the unknown. The monster's gaping mouth is truly horrible. Even though we know the story, we can't help but be afraid for Perseus and the heavily chained Andromeda. This is painting as drama. We are quite ready to believe in this incredible, mythic, unbelievable world because of the way Titian presents it.

The visual depiction of suspense is what all action movies rely upon, from classical epics such as *Clash of the Titans* to *The Matrix*—the moment the hero's life is held in the balance, and in a moment all could be lost. Titian shows us how composition persuades us; he makes us believe that we are there.

Cinema has tried with varying results to depict Greek myths, most notably in the pre-CGI era by animator Ray Harryhausen, who used stop frame models. But computer-generated imaging (CGI) has allowed filmmakers to go much further in creating completely unreal worlds. C. S. Lewis's *Narnia Chronicles* feature characters from Greek myths, such as Tumnus the faun (plus various different made-up ones, including the talking lion Aslan), in a Christian storyline. Adapting these books would be very difficult without CGI, because the characters in the world they depict could easily be made risible. The same problems were faced by those who wanted to adapt J. R. R. Tolkien's *Lord of the Rings*, but computer-generated imaging allowed the creation of centaurs, orcs, and various other complex characters.

A film like Victor Fleming's *Wizard of Oz* (1939) gets around the problem of the trio of Scarecrow, Tin Man, and Lion not looking credible, first, by presenting the whole story as a dreamscape, experienced by the injured, unconscious Dorothy. Fleming shot Oz in Technicolor, whereas the "real" world of Kansas was shot in black and white. Second, Fleming makes a clear visual link between the odd trio and the three farmhands. This adds an extra layer of subtlety and meaning to the film, as the viewers are asked to identify and to actively make the connection between real and unreal, fantasy creature and real person. *The Lion, the Witch and the Wardrobe*, in contrast, presents the fantasy world as naturalistically as Titian's mythic world of Perseus and Andromeda.

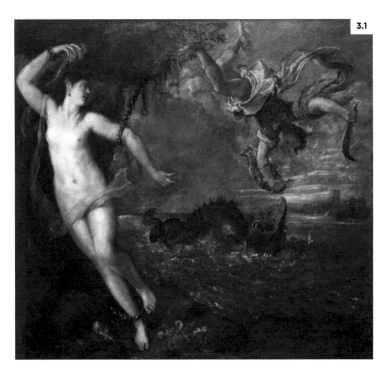

3.1

3.1
***Perseus and Andromeda*, c. 1554**
Artist: Titian (Tiziano Vecelli)
(c. 1488/1490–1576)
This version of the well-known myth of *Perseus and Andromeda* is a good example of just why Titian is considered a master painter. Here he captures the suspenseful moment when Perseus leaps into the sea to behead the beast, diving headfirst into the unknown. Titian knows that we all know the story, that Perseus does kill the beast and rescues Andromeda, and eventually they will live happily ever after. But, crucially, he does not paint that certainty. We cannot be sure that this hero will make it.

FANTASY
WORLDS IN
CINEMA AND
ART

ONEIRIC: THE
WORLD OF
DREAMS

SURREALISM

GOING BEYOND
THE REAL

CASE STUDY:
THE ARCHERS

EXERCISES,
DISCUSSION
QUESTIONS,
AND FURTHER
READING

Medievalism

It was not only the classical world that inspired artists. In the nineteenth century, the Middle Ages were a popular subject for visual arts. Particularly in Britain, medievalism dominated. The famous Houses of Parliament with Big Ben look like medieval buildings, but are not. They were built in the mid-nineteenth century as "Gothic Revival" architecture. The medieval held sway in painting too. One of the most interesting is John Everett Millais's painting of *Ophelia* (1852), showing the drowned Shakespearean tragic heroine, which nearly killed his model (she got hypothermia from being submerged in water). John Waterhouse's *Lady of Shallot* (1888) and the Pre-Raphaelite fantasies of Dante Gabriel Rossetti, Edward Burne-Jones, and William Morris are exemplars of this trend. The popularity of these paintings continues up to the present, despite varying critical response from the arts establishment and intelligentsia. What is interesting about the Pre-Raphaelites and the other medievalists is that they considered themselves realists. They understood they weren't painting the world as it is, but they took great pride in painting the medieval world as if it were real: they painted every flower, splash of water, and blade of grass as naturalistically as possible, taking advantage of new colors and new paint formulations. But they were idealists. They rejected the industrial modern world in favor of a romantic "golden age." Medievalism's popularity long ago passed into motion pictures, from *Robin Hood* to the medievalist *Game of Thrones*, a direct heritor of the Pre-Raphaelite impulse.

Symbolism

In France, maverick painter Gustave Moreau (1826–1898) embraced both classical myth and medievalism, creating large, exquisitely detailed scenes rendered in highly saturated color. The resulting effect is almost as if his canvases were covered in jewels. Moreau belonged to a loose movement known as Symbolism, which had adherents throughout Europe. Symbolism could incorporate all kinds of images and painting styles, from Henri Matisse's elemental *The Dance* (1910) to George Frederick Watts's melancholic *Minotaur* (1885) to Odilon Redon's *Cyclops* (1898). What symbolist paintings have in common is little other than strangeness. But they're all clearly removed from the real world of industrial, mechanized, and increasingly democratic Europe.

Of course, paintings have always contained symbols. One of the difficulties with appreciating medieval and Renaissance paintings is that only specialists tend to know and understand the complex symbolic codes presented in the paintings, which communicate complicated and often profound ideas. Even realist paintings contain motifs and symbols that communicate much more than simply representing their real-life counterparts. We have seen this already in looking at the use of glass and mirrors by Velásquez and Manet, or the scales by Vermeer.

3.2
The Isle of the Dead, 1880
Artist: Arnold Böcklin (1827–1901)
Arnold Böcklin's 1880 painting *The Isle of the Dead*, as well as being highly popular in its time and much reproduced, is a cinematic rendering of the symbolist picture par excellence.

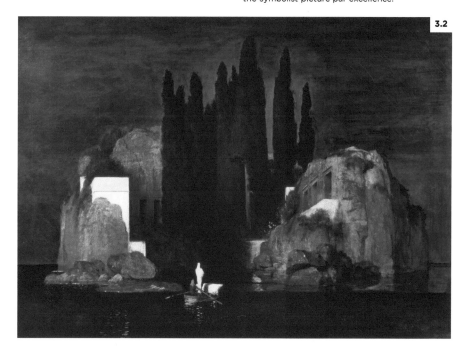

3.2

Seeing Heaven

Arnold Böcklin specialized in powerfully atmospheric scenes. His *Centaur at the Blacksmith's Forge* (1888) is a naturalistic interpretation of a mythic subject (he made many dramatic paintings depicting centaurs, fauns, and nymphs), but in *Isle of the Dead* he creates something altogether more original and fascinating. *Isle* is a cinematic dream of death, mysterious yet strangely calm, almost comforting. Böcklin offers us mystery but not terror, suspense but ambivalence. The shrouded figure is indistinct, yet sharply lit; the sunset floods the forbidding island with golden, almost heavenly radiance. It is a painting of high sensation, yet it evokes contradictory sensations. The painting was immediately successful, and Böcklin made five different versions of it. In an era when cholera epidemics were rife (Böcklin himself experienced these twice) and other diseases common, death was everywhere and unavoidable. Böcklin's painting neither hides the dread of death nor offers up a specific promise of Heaven, yet his strange and complex vision is neither negative nor nihilistic.

Böcklin does not offer a vision of Heaven or Hell; his *Isle of the Dead* may not be real, but it is not unearthly. The problem of depicting Heaven and Hell was one that many painters faced, given that Bible stories made up so many commissions in the Renaissance and Baroque period. We will discuss visions of Hell in a later chapter ("Horror"), but how did artists depict Heaven?

The Renaissance painters wanted to find ways to depict Heaven and Earth in relation, and so they often created vertical paintings with Heaven at the top, in the sky, and Earth in the bottom half. In *The Creation and Fall of Man* (1513) by Mariotto Albertinelli, we see angels standing in the sky, and Earth is an idealized version of the Arno Valley, near Florence. But the clouds look too much like pillows, and the angels stand stiffly upon them.

Venetian Paolo Veronese managed to largely solve the problem of depicting something that has never been seen and can barely be imagined in his great altarpiece in Verona, *The Martyrdom of St. George*, 1565. This is the best example of Heaven above in the clouds and Earth below. It has pure clarity of image and storytelling, and makes use of the "split screen" (in this case, a vertical "split screen" effect). Why does it work? Heaven is clearly delineated: its characters are active, have conversations; there are different things going on up there. Earth below is equally full of action, as the soldiers physically struggle to execute the robust, athletic saint. On Earth people are all colors, but in Heaven they are all pale, luminous white; Earth thus reflects realism and Heaven idealism. (This is not necessarily reflective of race attitudes—more likely, symbolism and convention.) We see the heavenly characters debating what to do, as a chubby angel reaches down, about to anoint the saint in his last breath. It is powerfully narrative.

FANTASY
WORLDS IN
CINEMA AND
ART

ONEIRIC: THE
WORLD OF
DREAMS

SURREALISM

GOING BEYOND
THE REAL

CASE STUDY:
THE ARCHERS

EXERCISES,
DISCUSSION
QUESTIONS,
AND FURTHER
READING

St. George illustrates one of the conundrums of the Christian painter: Heaven here is occupied by saints and the virtues; we don't see "God," only the Virgin and Child. It looks suspiciously like a pagan, classical pantheon. In other paintings of Heaven and Earth, Veronese uses a strong beam of light coming down from the sky as a visual link between Heaven and Earth.

Depicting Heaven in cinema has been even more difficult. The Veronese option of setting Heaven in the clouds is used to good effect in comedy, but this doesn't work well in drama. In the great Powell and Pressburger film *A Matter of Life and Death* (1946), discussed in the case study later in this chapter, Powell decided to film the real world in color and Heaven in black and white, making an immediate visual separation between the two realms. *What Dreams May Come* (Vincent Ward, 1998) is a clever reworking of the Orpheus myth. In it, Heaven's appearance can be controlled by the imagination of the subject. Ward has protagonist Chris (Robin Williams) initially construct his Heaven as a painting, made from real paint. Chris flounders around in an Impressionist landscape, getting covered in pigment, as he adjusts himself to the afterlife. Painting is a motif that runs throughout the film, and even if the film's drama has serious limitations, the production design in *What Dreams May Come* is some of the most imaginative in late-twentieth-century cinema. It is interesting to note that the film was shot on super-high-saturation Fuji Velvia film stock; the still version of this stock is used in fine art photography. Director Vincent Ward is a successful visual artist and painter as well as a filmmaker.

We have already looked at color in Adrian Lyne's *Jacob's Ladder*, but the film has many visual art references and inspirations, including H. R. Giger, Francis Bacon, and Joel-Peter Witkin. In Judaic and early Christian texts, "Jacob's ladder" is a ladder or staircase to Heaven, a meeting point between Heaven and Earth. For centuries it has been depicted in painting—for example, by Salomon DeBray, Jacques Stella, William Blake, and Marc Chagall—as well as featuring in folk art. Powell and Pressburger used it in the 1946 film *A Matter of Life and Death*, which shares some thematic similarities with Lyne's film. Alternatively, in *Enter the Void* (2010), Gaspar Noe suggests the afterlife is a kind of swirling, abstract, melting, colorful void that eludes any classification as "Heaven." In this film, Noe references the *The Tibetan Book of the Dead*, a Buddhist text about the afterlife, eschewing traditional Christian ideas.

Fantasy worlds remained popular subjects in art well into the twentieth century. Cinema inherited this taste, as can be seen in the early films of Georges Méliès, through Fritz Lang's *Metropolis*, to the blockbuster adaptations of *Beowulf*, *Narnia*, and *The Lord of the Rings*.

ONEIRIC: THE WORLD OF DREAMS

The dream sequence is a familiar feature of cinema, appearing in films of many different genres. We've already looked at *Jacob's Ladder,* about the horrific dreams of a returning Vietnam veteran. Other films that have important dream sequences include Ingmar Bergman's meditative Swedish film *Wild Strawberries* (1957), Alfred Hitchcock's psychological thriller *Spellbound* (1945), Sam Mendes's exploration of a suburban husband experiencing midlife crisis in *American Beauty* (1999), David Lynch's thriller *Lost Highway* (1997), and Ridley Scott's dystopian *Blade Runner* (1982). But even social realist dramas can have dream sequences: Pasolini's *Accatone* (1961), Luis Buñuel's brutal Mexican social drama *Los Olvidados* (1950), and Peter Mullan's *NEDS* (2010) set in 1970s Glasgow all have protagonists who experience revealing dream sequences. These are a few examples from a potentially long list, but it shows how completely different types of films can all have significant diversions in which we see into the dreams of the protagonist.

Unsurprisingly, painters had explored the dream long before cinema, but it was not until the late nineteenth century, at the same time that the infant discipline of psychology was emerging, that art's struggle to manifest the world of the dream in visual form became an obsession.

There are many examples of paintings that show the dreamer and the dream. In *The Nightmare*, a ghostly horse glares out of the picture, while next to it a swooning or perhaps dead woman lies with the demon squatting over her. Is the vision a dream, or is the woman the dreamer? Füssli allows us to imagine. We see the dreamer and the dream in one image. Similarly, in Goya's *The Sleep of*

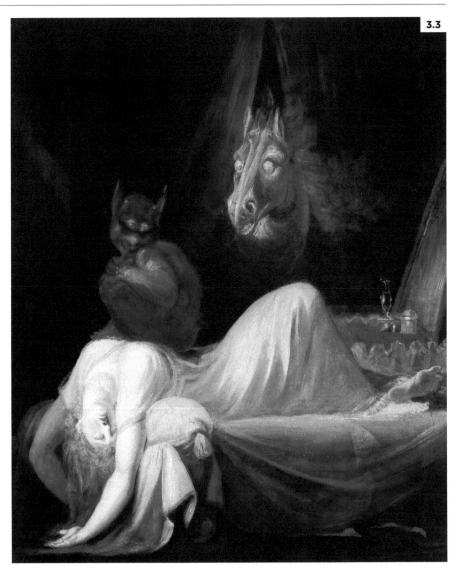

3.3

Reason Produces Monsters (*Los Caprichos*, 1797–1799), we see a man sleeping, and as he dreams black bats of irrationality circle his head. As irrationality is represented by black bats, clearly Goya wants to tell us that irrationality is not a good thing, but perhaps it is as inevitable as sleep. Freud would have grasped that straightaway. He saw the dream as a keyhole through which we can see our unconscious mind at work, with all the irrationalities that we try to repress in

3.3
***The Nightmare*, 1781**
Artist: Henri Füssli (1741–1825)
Henri Füssli's *The Nightmare* is one of the most famous and cinematic dream paintings.

FANTASY
WORLDS IN
CINEMA AND
ART

ONEIRIC: THE
WORLD OF
DREAMS

SURREALISM

GOING BEYOND
THE REAL

CASE STUDY:
THE ARCHERS

EXERCISES,
DISCUSSION
QUESTIONS,
AND FURTHER
READING

The Dreamscape

waking life. Goya offers a picture *of* a man dreaming and we see elements of the dream *in* the picture. Pictures like this resemble the paintings of Heaven by Veronese: there we see Heaven and Earth simultaneously; here we see the dreamer and the dream together in the picture.

From the turn of the twentieth century, artists began to paint pictures that sought to actually replicate dreams, rather than painting a picture of somebody sleeping and having a dream. They were inspired by a general cultural interest in dreams, fueled by cultural and scientific discourse that led to the emergence of psychology. This was the time when Sigmund Freud began to formulate his psychoanalytic theory, and painters moved from contriving imaginary worlds to putting on canvases images derived from, or suggested by, the dream state.

The Nightmare and *The Sleep of Reason* are strange and unsettling images, but they are not dreamscapes. Paul Nash's *Landscape from a Dream* (1936) is an exemplar of dreamscape painting. Nash tried to replicate the dream landscape, the place *we see ourselves in* when dreams happen. The dreamer is not in the picture. The juxtaposition of objects in the landscape, the picture-within-a-picture, and the symbolism of the hawk all suggest the dreamworld of the unconscious mind. Nash was not a Surrealist but was aware of Surrealism, and he explored its ideas in *Landscape from a Dream*. According to Nash, the hawk belongs to the material world while the spheres refer to the soul.

Another example is Henri Rousseau's *The Dream* (1910). The painting shows a tropical jungle scene, with lions and lavish vegetation, and in the middle of it all a nude woman lies on a red velvet sofa. It is a hypnotic and exuberant vision of desire.

In cinema,[1] filmmakers can choose between having the protagonist seen in the dream, or not. What is the dream principally meant to convey—a moment of awakening for the protagonist (*Wild Strawberries*) or insight into hidden desires or motivations (*Blade Runner*, *American Beauty*)?

Although the two films are dissimilar, both *Wild Strawberries* (1957, Ingmar Bergman) and *Papillon* (1973, Franklin J. Schaffner) feature protagonists having complex dream sequences that illustrate the realization that they have wasted and abused their lives. In both cases, the protagonists are in dire situations. The Swedish doctor is at the end of his life, facing his own mortality; the French thief understands that in the South American prison where he is rotting away, even if he remains alive his quality of life is a kind of death. The dream sequence in both cases is a necessary cognitive process for reawakening the protagonists to what is important about life and a determination to strive to make something of value out of the little time they have left. The dream sequences in both films show the characters themselves as actors in the dream. But not all dream sequences feature the character. In an admittedly short dream sequence, *Blade Runner* protagonist Deckard, falling asleep at the piano, has a dreamy vision of a unicorn rushing forward, but Deckard is not in the dream and does not interact with the unicorn. It exists as a symbolic image, perhaps representing his lover Rachael, who, as a replicant, is to a real woman as the unicorn is to a real horse.

FURTHER VIEWING

See other paintings of the dreamer and the dream:

Odilon Redon, *Cyclops* (1914)

Kuzma Petrov-Vodkin, *Sleep* (1911)

Ferdinand Hodler, *Night* (1889)

Giorgio De Chirico's
Dream Cityscapes

Paul Nash primarily painted tangible landscapes, so when he made *Landscape from a Dream* he tells us bluntly that it is a dreamscape. Italian painter Giorgio de Chirico painted real landscapes and cityscapes merging into dreamscapes. De Chirico was strongly influenced by Böcklin's later work such as *Isle of the Dead*, creating strange, oneiric cityscapes that are drawn from real places in which de Chirico lived.[2] The critic Robert Hughes notes that the town where de Chirico grew up was bisected by a railway, and the strange appearance of a train among the houses may have been a fact of his childhood memory.[3] His cityscapes feature the same elements in different combinations: the arcade, the tower, the piazza, the shadow, the statue, the train, the mannequin, and sometimes an incongruous artichoke or bunch of bananas.

De Chirico was highly aware of the resonant and mystical qualities of places. He explained that when he visited Versailles, "Everything gazed at me with mysterious, questioning eyes. And then I realised that every corner of the palace, every column, every window possessed a spirit, an impenetrable soul."[4]

Mystery and Melancholy of a Street (1914) is one of de Chirico's most intriguing, unsettling, and cinematic pictures. It is based on a real place in Turin, Piazza Vittorio Veneto, which is surrounded by stark, deep-shadowed arcades forming arches of darkness; these are a recurrent motif in de Chirico's cityscapes. Hughes says that "no painter ever made an architectural feature more his own."[5] But it is not Turin, it is a fantasy town, a state of mind, a haunted place we might encounter in a dream. It is a picture of emptiness: the empty arcades, the empty wheeled wagon, gaping threads as if ready to devour the small figure of the girl playing with a hoop who enters the frame from the left. In the distance, the shadow of a large statue looms. The only glimpse we have of anything like life is the sliver of green hills in the far distance, indistinct and perhaps a mirage. There is an eerie mood and a strange artificiality; it is a dream signifying alienation and loss, offering a memory of the past and disquiet at the present. Some critics have seen a stylistic link between de Chirico's paintings of disquieting, empty modern life amid the ruins of the past and the style of some of the =wall paintings found at Pompeii.[6] De Chirico's work has been described as "metaphysical painting"—in Italian, "Pittura Metafisica."

De Chirico, who was also a poet and essayist, was inspired by philosopher Friedrich Nietzsche's descriptions of the old arcaded buildings surrounding quiet piazzas in Turin. Painting in a realist style, de Chirico depicted the piazzas as unnaturally empty but for objects and statues that appear together in strange juxtapositions. The compositions are modeled on illusionistic one-point perspective, deliberately subverted. He used unnaturally sharp contrasts of light and shade, rendering the scene vaguely threatening yet, in a dreamlike way, strangely melancholic and poignant. To de Chirico, the only thing that is "real" is the past, but it remains hidden behind the apparent reality of appearances.

De Chirico's "metaphysical painting" is cinematic because it is full of suspense, offering us an emptiness that is charged and profound. We can see de Chirico's influence on filmmakers as diverse as Fritz Lang, Alfred Hitchcock, and Federico Fellini. The deserted cityscapes of Michelangelo Antonioni's films from the 1960s are pure de Chirico. But unsettling deserted cityscapes are reinterpreted as a feature across genres, including science fiction and video games. It was de Chirico who first demonstrated the power and tension that lie in an empty street.

FANTASY
WORLDS IN
CINEMA AND
ART

ONEIRIC: THE
WORLD OF
DREAMS

SURREALISM

GOING BEYOND
THE REAL

CASE STUDY:
THE ARCHERS

EXERCISES,
DISCUSSION
QUESTIONS,
AND FURTHER
READING

In the eighteenth century, a growing interest in the difference between the rational mind and the irrational mind started to influence artists. One aspect of Romanticism was to believe that the irrational mind (which in the past had been the preserve of the Devil) could perhaps contain dark, but nonetheless accurate, truths. The irrationality of dreams began to attract artists and writers, helped no doubt by the increasing availability of opium, thanks to international colonial trade. By the late nineteenth and early twentieth centuries, the desire to represent the dream took on a kind of urgency among painters. Initially, paintings tended toward representing the dreamer having the dream. Then, and more interestingly, painters started to want to present the dream without the dreamer, the dream landscape. Giorgio de Chirico's singular works had a major influence on the Surrealists, and on Italian and world cinema up to the present day.

FURTHER VIEWING

Giorgio de Chirico, *The Enigma of the Hour* (1911) and *Piazza d'Italia* (1913).

Gare Montparnasse, aka *The Melancholy of Departure* (1914), is a strange rendering of the normally frenzied and bustling Paris train station at 1:25 in the afternoon. A large bunch of green bananas lies in the foreground of the completely deserted station, while in the far distance a steam train passes by.

Paul Nash, *We Are Making a New World* (1918) and *Battle of Britain* (1941). The war-torn landscapes are dreamlike yet horribly real.

SURREALISM

In terms of cinematic dream images, French painter Yves Tanguy's whole body of work could be considered as variations on a dream landscape: huge empty planes with indistinct structures or formations that, as soon as you start to make sense out of them, slip away. Salvador Dali's paintings are much more representative and precise, even though what they represent is strange. Dali's works often have dreamlike qualities, though he embeds complex symbolism in his pictures. Dali uses a naturalistic style adopted from Renaissance painting and includes everyday objects in unusual juxtapositions, offering us familiarity amid strangeness, just as the dream often combines the familiar with the unknown. What Tanguy, Dali, and Ernst had in common was membership of an artist group called the Surrealists.

What Is Surrealism?

We are used to the term "surreal" being used to describe anything that looks odd or combines disparate elements in an unusual way. But Surrealism was a specific movement, founded in Paris in the early 1920s.[7] It is important to realize that Surrealism had a program and a contentious membership that is still argued over. It had, and still has, strict though apparently changeable rules about what does or does not constitute Surrealism.

Its founder and leader, André Breton, had been a medical student studying neurology when he was called up for service in World War I. After four grueling years as a medic, he abandoned his studies to become a poet. Moving to Paris, he gathered around him other young like-minded poets and painters and formed the Surrealist Group. Breton and his friends did not want to continue the cultural forms of poetry and art that had prevailed before the war. They saw the war as a result of a demented society that must not be allowed to reassert itself. To that end, they felt that artists must follow Freud's lead in paying active attention to the unconscious mind, seeking to liberate the human mind. If the mind could be set free, they believed, society would follow. The Surrealists believed that the dream was a revolutionary force. Artists and poets tried to access their unconscious minds with various exercises that included inducing trances in themselves or each other. We must remember that these were all young people seeking to make their mark on the world; their understanding of Freud was slight, yet there was a broad interest in the unconscious mind that was half scientific and half speculative, and the Surrealist Group plugged into that with gusto.

As a medical student, André Breton had been interested in neurology and the pioneering work of Pierre Janet; he had heard of Freud's ideas, although they were not yet translated into French and were not widely known.[8] As well as communicating the exciting new ideas to his friends, Breton published a whole novel of trance-state "automatic" writing called *The Magnetic Fields*, and he and his poet friends experimented with writing under trance or hypnosis. But for surrealist painters, automatic painting was not possible; they were still driven to consciously create "pictures." Dali had a personal process of developing ideas he called "the paranoiac critical method," but the pictures themselves are highly and consciously crafted. The Surrealists themselves debated whether conscious art forms such as painting or cinema could ever be "surreal."

FURTHER VIEWING

Yves Tanguy, *Azure Day* (1937)

Salvador Dali, *Dream Caused by the Flight of a Bee around a Pomegranate a Second Before Awakening* (1944), *The Persistence of Memory* (1931), and *Sleep* (1937) all show "the dreamer and the dream."

Max Ernst's 1939 painting *The Entire City* shows a huge crumbling city, a massive and densely packed structure, brooding under a strange ring-shaped moon; this is an image that has fed intravenously into the whole sci-fi genre.

FANTASY
WORLDS IN
CINEMA AND
ART

ONEIRIC: THE
WORLD OF
DREAMS

SURREALISM

GOING BEYOND
THE REAL

CASE STUDY:
THE ARCHERS

EXERCISES,
DISCUSSION
QUESTIONS,
AND FURTHER
READING

The Surrealists were fascinated by cinema, and even if the group's members and associates made relatively few films, they were active filmgoers and critics. They often celebrated the populist aspects of cinema, even its vigorous vulgarity, almost universally championing Charlie Chaplin, while at the same time cautioning the viewer to "open our eyes in front of the screen . . . analyse the feeling that transports us, reason it out to discover the cause of that sublimation of ourselves" (surrealist poet Louis Aragon).[9] Following critic Jean Goudel, they believed that cinema should be bolder and go further in its potential to explore dream states and the unconscious, exhorting filmmakers to fully open up their art "to the unexplored regions of the dream."

Like de Chirico's metaphysical paintings, the dreamlike pictures of the Surrealists are often empty or sparsely populated, containing strange juxtapositions. The Surrealists shared with de Chirico a desire to create paintings that explore the visionary world of the mind, beyond physical reality yet revealing the disquieting nature of the everyday.

In Dali's *Mountain Lake* (1938), a large telephone receiver appears in the landscape, hanging on a crutch. Dali was a prolific artist: his body of work ranged from fashion to filmmaking. He collaborated with his fellow Spaniard filmmaker Luis Buñuel to make *Un Chien Andalou* (1929) and *L'Age d'Or* (1930), but the painter and filmmaker fell out after the latter film and never spoke again, though both lived long lives.

Buñuel went on to a career as an independent, iconoclastic filmmaker in France and Mexico and never totally left Surrealism behind, despite working in documentary (*Las Hurdes*, 1933), social realism (*Los Olvidados*, 1950), and musical (*Gran Casino*, 1947); his greatest films have strong Surreal elements, as in *The Discreet Charm of the Bourgeoisie* (1972).

In Hollywood, Dali made the scenography for Alfred Hitchcock's *Spellbound* and even collaborated with Walt Disney, though that film (*Destino*) was not released until 2003. But Salvador Dali's paintings are often too packed with detail to be truly cinematic: they don't really contain characters or a sense of a moment in time. Dali's influence does appear in cinema: Terry Gilliam described his film *The Imaginarium of Doctor Parnassus* (2009) as "a Salvador Dali painting come to life." But when compared to Dali, Gilliam admitted, "Dali's a conman, I'm convinced"[10] and "I'd rather be compared to Magritte."[11]

Magritte: The Subversion of the Real

There was a realist strand within Surrealism that feeds more directly into cinema; the most prominent of those painters is the Belgian René Magritte. Magritte had some association with the surrealist group but never conformed to its boundaries; yet, if anything, his work illustrates the idea of "beyond the real" more than any other Surrealist. Magritte's pictures are firmly located within the real world, but through the use of juxtaposition, inversion, replacement, and other techniques, he subverts the real world completely and in doing so invites us to see it differently and to question it.

What Magritte and Dali have in common other than precise naturalistic painting styles is that they continually paint their obsessions. This was a relatively new tendency in painting, not really seen before the end of the nineteenth century. In the twentieth century, artists claimed more freedom in subject matter and painted obsessions and fantasies in ways that would have been unthinkable before. It only remained whether or not their obsessions were accessible enough that they would find clients to purchase the paintings.

Dali was obsessed with the landscape around Cadaques, where he grew up and lived in later life. He also had his own private symbology, which reoccurs throughout many paintings—for example, the crutch, which he claimed to be simultaneously a symbol of death and symbol of resurrection, and the soft clocks symbolizing the fluidity and relativity of time (*The Persistence of Memory*, 1931).

Magritte is obsessed with a number of symbols that recur over and over again: the suited and bowler-hatted man, the green apple, the seagull, and the train. These symbols were created by the artist. Freud believed that there are symbols particular to the individual and the personal unconscious, and other symbols that are more widely shared. Exploring this idea further, his disciple Carl Jung posited that most of our unconscious language of symbols is universal, which he called a collective unconscious. We also have our own personal symbology, peculiar to each individual. What Dali and Magritte are saying in their paintings is that their own personal symbolism could be accessible to everybody. It's a confident idea, yet the sheer success and popularity of their works indicate that they were not wrong.

In *Time Transfixed* (1938), René Magritte shows us a small but perfectly functioning steam train emerging from a fireplace. Magritte's images are categorized by their deliberately bourgeois aspect: the room where this is happening is a well-appointed bourgeois room, with a fine marble fireplace, wooden paneling, and a big mirror—a fine family home. Out of all of this appropriate comfort, a small steam train comes flying, pumping white steam at full speed. So we have the phallic symbol of the train rushing out of the yonic fireplace—all of it happening in the discreet environment of the middle-class living room.

Magritte said, "I decided to paint the image of a locomotive. . . . In order for its mystery to be evoked, another immediately familiar image without mystery—the image of a dining room fireplace—was joined."[12] The painting

therefore combines juxtaposition of unrelated elements with altered scale, creating an absurdity that manages to be humorous, alluring, perplexing, and slightly saucy at the same time. Terry Gilliam says that he finds Magritte's pictures funny, "but the stuff sticks with you because it's in some ways profound."[13]

Magritte was not so Freudian as to be satisfied with simply creating Freudian sexual symbols in his paintings. His paintings are much more about altering the real world. Magritte's technique is not simply to create and then repeat symbols derived from ordinary objects, although this is great part of what he does. Most of his paintings explore altering the familiar through juxtaposition of objects, like the cloth hindering the lovers' kiss. He also often works by altering perspective: in *The Listening Room* (1952), Magritte puts a green apple on the floor of a room, but the apple is so big it fills the entire room. Or is it the room that is so small that the apple can barely fit into it?

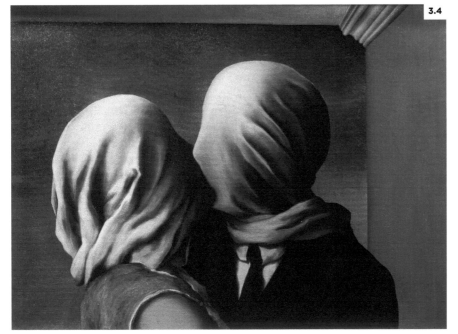

3.4

3.4
***The Lovers* (1928)**
Artist: René Magritte (1898–1967)
In *The Lovers* (1928), a couple are kissing, but their heads are covered by a barrier of white fabric, transforming the passionate kiss into a gesture of isolation and frustration. The fabric is soft muslin, like a winding-sheet used to wrap the dead. But the couple are alive, and they persist in the kiss despite their shrouds. "There is no more chilling icon of the frustration of sexual communication," said Robert Hughes.[14]

FANTASY
WORLDS IN
CINEMA AND
ART

ONEIRIC: THE
WORLD OF
DREAMS

GOING BEYOND
THE REAL

CASE STUDY:
THE ARCHERS

EXERCISES,
DISCUSSION
QUESTIONS,
AND FURTHER
READING

SURREALISM

Surreal People

Magritte's technique is called *depaysement*, meaning the transfer of an object from its normal environment or context to a completely different one. The effect is always strange and unsettling.

Depaysement is powerful in films: Spike Jonze's *Being John Malkovich* (1999) has the Magritte-like "Floor 7½"—a perfectly normal office floor that is nevertheless half the height of a normal office: the employees have to bend and hunch in order to do their work. And, according to actor Ellen Burstyn, the creepy poster shot for the film *The Exorcist* (1973) was inspired by Magritte's *The Empire of Light* (1953), a streetscape in which daytime and night are inexplicably merged.

When asked what his pictures "mean," Magritte replied, "It does not mean anything, because mystery means nothing either, it is unknowable." This cryptic approach to painting allows one's imagination to interpret the meaning.

Magritte was influenced by de Chirico. Both share a fascination for creating mysterious and enigmatic images through incongruous juxtapositions of familiar objects, though Magritte's spaces are full of dry wit while de Chirico's are melancholic.

Although Magritte's and Dali's paintings have figures in them, they are not characters in any real sense. Most of the Surrealists were not concerned with things like narrative and character.

Although one might be forgiven for thinking that all of the Surrealists were male, this is not the case: two of the most significant surrealist artworks were made by women. Meret Oppenheim's *Object (Le Déjeuner en fourrure)* (1936), with teacup, saucer, and spoon all covered in fur, is duly famous and remains unsettling and disturbing right up to the present.

Dorothea Tanning (1910–2012) an American painter who lived in France, was a member of the Surrealist Group, and later married Max Ernst. Her painting *Eine Kleine Nachtmusik* (1943) is very much about the figures in the picture and their experiences. It depicts two girls, both disheveled; one appears to be sleeping propped against the doorway, bright blond hair tumbling down her back, but her dress is open, exposing her naked torso. The other girl has her side and back turned toward us, so we don't see her face, but her long black hair is inexplicably standing straight up. The scene takes place in a corridor, an in-between space, in a hotel or some kind of institution with most of the doors firmly closed, apart from one at the far right, which is open a crack, through which we can see a bright yellow-orange light, perhaps fire. The whole scene is lit with a low key light, which gives emphasis to the green, red, and wood-brown of the décor.

This is dreaming par excellence. Eroticism is hinted at, in the semi-nudity of the blonde girl. But is she a girl, or a doll? What is happening? In the center of the picture, a monstrous sunflower, together with its bent stalk, sits at the top of the staircase. The flower is sentient: we have a sense that it has made its way up the stairs, because we can see a couple of petals on the staircase. The blonde girl clutches one of the petals in her hand, while the dark-haired girl appears to be decisively confronting the flower. Tanning has remarked, "It's about confrontation."

Is it a dream, or a memory, or something more? Surrealism saw the dream as a revolutionary force that was engaged in attempting to reconcile the liberation of desire with political liberation.

The Surrealists were fascinated by cinema.[15] Although films featuring surrealist incidents, or short surreal films (see *The Man Without a Head*, dir. Juan Solanas, 2003), are not uncommon, there are relatively few purely surrealist films in which the whole world of the film could be said to be surreal. More commonly, Surrealism temporarily erupts into a film, in the form of a dream sequence or a fantasy sequence. But a few contemporary feature filmmakers manage to create and sustain a completely surrealistic approach, creating a filmic world that remains firmly within Surrealism, not moving between the "surreal" and the "real." Terry Gilliam's *Brazil* (1985) and many of his subsequent films, including *The Imaginarium of Dr. Parnassus*

The Surreal World: Jan Švankmajer

(2009), are clearly influenced by surrealist painting and film, and explore surrealist ideas. David Lynch's work shows strong surrealist influences, principally in his use of bizarre juxtapositions and details. The ending of *Blue Velvet* (1986) implies that the restoration of "reality" is in fact nothing of the kind. Twenty years later, the surreal world of *Inland Empire* (2006) melts together modern Los Angeles, a nameless place in Eastern Europe, and a film set. Michael Richardson sees early Tim Burton as one of the few Hollywood directors with a surrealist perspective, "especially in his love for popular culture in its subversive aspects, his exploration of otherness and sympathy for outsiders and his sometimes acerbic commentary on American values."[16] Jim Jarmusch is another filmmaker with a surrealist sensibility, though with a distinctly low-fidelity approach compared to Gilliam and Burton. Cult Chilean director Alejandro Jodorowsky's 2013 film *The Dance of Reality* is a surreal autobiography, combining the 84-year-old director's personal history with poetry, metaphor, and mythology, expressing his view that there is no objective reality, but rather a "dance" of the imagination.

Jan Švankmajer grew up in communist Czechoslovakia and was strongly influenced by Czech Surrealism, which existed separately from, but parallel to, the more dominant French Surrealism. Švankmajer worked extensively in the theater, particularly the experimental theater of the magic lantern and puppetry, and started making films in 1968. His closest collaborator was his wife, Eva Švankmajerova, an accomplished and well-known surrealist painter and sculptor. Švankmajer made his mark in the West with short animated films, but his greatest accomplishments are his completely surreal feature films, which combine live action with stop-motion animation, starting with *Alice* in 1988, which combines Czech folktales with Lewis Carroll's novel. After the end of communism, he had more opportunities to make feature films; in 1994 he produced *Faust*, which combines different versions of the Faust legend with Czech puppetry. Returning to Czech folklore, in 2000 he produced *Little Otik*, a disturbing tale about a middle-class childless couple who "adopt" a piece of wood and raise it as a baby. But "Otik" comes to life and has an insatiable appetite.

There is strong sense of the grotesque about Švankmajer's films. This is due to the specific nature of Czech Surrealism, which is rooted in both Czech art and a strong, critical relationship with realism.[17] Psychology and the unconscious mind are only one strand. One of the Czech Surrealists, Vratislav Effenberger, said that "imagination does not mean turning away from reality but its antithesis: reaching through to the dynamic core of reality."[18] The work of surrealist painters like Jindřich Štyrský (*The Bathe*,1934) are about rearranging the real in highly critical ways. Švankmajer's *Surviving Life* takes clear aim at psychoanalytic theories, by having Freud and Jung as minor characters in the comic but ultimately poignant story of a married man who lives a double life in his dreams, where he falls in love with another woman. Švankmajer has observed, "This civilization is based on rationality, totalitarianism that is, and anything that is outside of this particular point or reference of reality, is difficult to comprehend and is therefore pushed away."[19] He points out that "it is dream and reality that *together* create a human life."[20]

FURTHER VIEWING

Dorothea Tanning, *Birthday* (1942)

FANTASY
WORLDS IN
CINEMA AND
ART

ONEIRIC: THE
WORLD OF
DREAMS

SURREALISM

GOING BEYOND
THE REAL

CASE STUDY:
THE ARCHERS

EXERCISES,
DISCUSSION
QUESTIONS,
AND FURTHER
READING

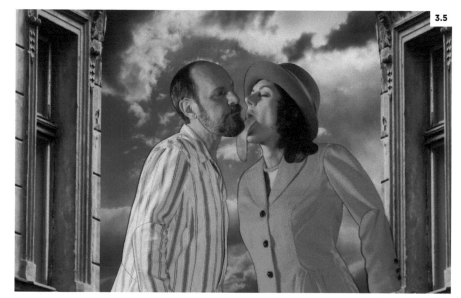

3.5

3.5
Surviving Life, 2010
Dir. Jan Švankmajer
Middle-aged Eugene keeps dreaming about a
gorgeous young woman. He can't wait to get to
sleep, which arouses the suspicions of his wife.

Czech Surrealism makes an
appearance in one of the most famous
and influential of all American avant-
garde films, *Meshes of the Afternoon*
(1944), by Maya Deren. Filmmaker
Alexander Hamid was actually
responsible for the camera work in
that film, and he was a member of the
Czech surrealist group.

FURTHER VIEWING

The Surrealist Group members and their associates did not
make many films, but the few they made have been highly
influential for later generations of filmmakers and artists.
Here are a few that are available on DVD or online:

Un Chien Andalou (Bunuel and Dali, 1929)

L'Age d'Or (Bunuel and Dali, 1930)

The Seashell and the Clergyman (Germaine Dulac and Antonin
Artaud, 1927)

The Blood of a Poet (Jean Cocteau, 1930). Cocteau denied
being a Surrealist, and the group rejected him anyway, but the
fact remains that *The Blood of a Poet* has a strong surrealist
sensibility and should be looked at as a companion work.

Rose Hobart (Joseph Cornell, 1936). Cornell was the only
significant American Surrealist to make films.

GOING BEYOND THE REAL

Sometimes artists feel they have to completely distort reality, while keeping all of its qualities, in order to make a point.

George Grosz's painting *The Suicide* was made in 1916, during the First World War. Gross was a soldier in the trenches and experienced its horrors firsthand. He was wounded and returned angry and frustrated to Berlin, where he painted this savage picture. It is a pitiless image: one man hanging from a lamppost, another lying dead in the street, which is patrolled by feral dogs. A man rushes by, with his head down, ignoring everything around him. The naked prostitute and her geriatric client stand at the window surveying everything, looking satisfied and unconcerned. It is a brutal picture of decadence, pitilessness, and human brutality. But is it real, or is it fantasy? It is neither. What Grosz has done is paint how he feels about Berlin in 1916. This is one of the key techniques of the Expressionists. The picture contains both reality and fantasy.

In his autobiography, Grosz said of that time, "My drawings expressed my despair, hate and disillusionment. I had utter contempt for mankind in general."[21] But this is only one reading of the painting. In an essay, novelist Mario Vargas Llosa notes that Grosz had a romantic fascination for underground characters, criminals, gangsters, suicides, whores. All these characters have escaped the conformist respectable life. Vargas Llosa thinks that Grossz's outsider characters are social fighters in a sense, because the real corruption is not coming from them.[22] Art historian Ursula Zeller says that "by giving his art a strong moral purpose, he intended to become the German Hogarth."[23] Both Hogarth and Grosz were aware of the power of the grotesque to impart strong impressions.

In 1751 Venetian painter Pietro Longhi made *Exhibition of the Rhinoceros at Venice*. This is a simple realistic painting of an actual event, when a rhinoceros was brought to Europe and toured around on public display. Such animals had rarely been seen in Europe, and it was shown in Venice during the Venice Carnival.

What makes Longhi's picture, now in London's National Gallery, particularly interesting from our perspective today is that the strangeness in the picture is completely different from what it would have been in Longhi's day. The Venetians of 1751 would have been absolutely astounded and amazed by the appearance of the rhinoceros. With its huge bulk, leathery skin, and tiny eyes, it would have looked like nothing ever seen before. Longhi paints all the detail, even the droppings of the rhinoceros (who was called Clara). But today we don't find the rhinoceros particularly strange, or even interesting. We're used to wildlife photography, and many of us have seen rhinoceros up close in zoos. Today what we find strange and interesting and unsettling is the appearance of the Venetian spectators. They are dressed in the traditional Carnival costume of the eighteenth century: tricorn hats, black veils, and masks.

It seems obvious that Stanley Kubrick used Pietro Longhi's paintings in his preparations for *Eyes Wide Shut*, which features a mysterious and dangerous masque event. So the filmmaker is able to use the realist work of the Venetian painter, who was painting the frivolity, entertainment, and diversions of his society, as a blueprint for designing a strange, even diabolical, ritual event.

FURTHER VIEWING

See *Barfly* (1987, dir. Barbet Schroeder), a biopic of writer Charles Bukowski, which also explores Vargas Llosa's idea of marginalized, damaged characters representing the true struggle against the "establishment." Can you think of other films that explore this theme?

See also: *Il Ridotto* (Pietro Longhi, 1740).

FANTASY
WORLDS IN
CINEMA AND
ART

ONEIRIC: THE
WORLD OF
DREAMS

SURREALISM

GOING BEYOND
THE REAL

CASE STUDY:
THE ARCHERS

EXERCISES,
DISCUSSION
QUESTIONS,
AND FURTHER
READING

The Eruption of the Strange

In the midst of realism, the unreal can suddenly appear. In Longhi's case, the real rhinoceros is unreal, simply because it is so unusual that it is almost incredible. It's not unreal in the same way as, for example, Böcklin's *Centaur* is unreal, but to Longhi's audience, the rhinoceros was not much less odd than a centaur. The eruption of the strange, the moment that pushes beyond realism, occurs in both painting and cinema. Because it is time-based, cinema can explore these erupting moments more comprehensively than can painting.

We have already discussed the dream sequence, which is the standard way that the not-real bursts into the real, offering an alternative perspective. Michel Gondry's 2004 film *Eternal Sunshine of the Spotless Mind* explores memory, depicting the distorted memories that his characters agonize over as they attempt to improve their lives by deleting their past from their minds. In *The Science of Sleep* (2006), Gondry's protagonist fails to distinguish between his real world and his dreamworld; the viewer can distinguish them because Gondry constitutes the dreamworld out of crude handmade objects that simulate their real-life counterparts.

But some painters manage to elide the real and the not-real in clever ways, as we have seen in the work of Dorothea Tanning. Sidney Nolan's painting *Inland Australia* (1950) is a post-photography painted landscape that represents the interior of his native country, both as a real place and as a nightmare space of emptiness and mystery. Dora Carrington does something similar in *Spanish Landscape with Mountains* (1924). She's painted a realistic landscape, but rearranged it so that on second look, it seems not quite real. Georgia O'Keefe does similar things in her landscapes and still lifes. In some cases, the pictures are not that strange at first sight, but upon contemplation their oddness and beyond-real qualities are revealed. Or the opposite is true: the picture looks unreal, then gradually as you look at it, the delineation of the real becomes manifest, as in O'Keefe's *Jack in the Pulpit* (1930).

The Eruption of the Real

Pietro Longhi's painting depicts an "eruption" of the strange into the realm of the real. Yet, as we've seen, what is real and what is strange can depend on the viewer. Georgian painter and filmmaker Sergei Parajanov's 1984 film *The Legend of the Suram Fortress* is a dreamlike interpretation of a well-known Georgian folktale. Parajanov made the film after long and bitter years of struggle against the Soviet authorities, during which he was imprisoned and forbidden to make films. *Legend of the Suram Fortress* is an intensely visual, highly stylized, and theatrical film that, more than anything else, resembles a moving Symbolist painting.

In the middle of a seductive and complex blend of folktale, visual symbolism, and theatrical drama, Parajanov makes the real erupt briefly into the mythic world of the film. As characters perform a compelling ritualistic dance, with the Black Sea in the background, the viewer can see Soviet ships lying at anchor. The incongruity of the gray ships, which come as lightning bolts of modernity, industrialism, and above all totalitarian military power, invades and disrupts the viewer's experience. Yet they do not disturb the world of the film, which carries on, the characters oblivious to the threatening world in the background.

FURTHER VIEWING

The Colour of Pomegranates (1968) confirmed Parajanov's distinctive artistic style.

Parajanov's paintings can be seen at http://www.parajanov.com.

"It is a rich world, alive and serviceable." — Michelangelo Antonioni and Giorgio Morandi

The film centers around a monarch's failed attempts to rebuild the crumbling Suram fortress and protect his threatened empire. In 1984, it might have been read as a metaphor for the Georgian people under the Soviet yoke (perhaps represented by the ships, to remind everyone just what was out there). In hindsight, we might reread it as a prescient legend of an empire that could not be held together without the brutality of human sacrifice. *The Legend of the Suram Fortress* is elliptical and strange, beautiful and profound.

Giorgio Morandi might at first glance appear to be a painter with nothing to say to filmmakers. He spent most of his career painting still lifes, plus the occasional landscape. The bulk of Morandi's work has the same subject: the ordinary bottles, boxes, jars, jugs, and crockery that could be found in any domestic environment. He used a limited color palette, principally different tones of gray and gray-blue, washed-out yellows and ochers, with the occasional injection of a brighter red or blue.

A photograph taken inside Morandi's studio reveals that the vessels he painted were themselves all matte: either porcelain, terra-cotta, or stoneware. He would then "depersonalize" these objects by removing any labels; he sometimes applied matte paint to glass bottles and jars, or filled them with paint, to remove shine and reflections. This resulted in a completely different effect from, for example, *The Bar at the Folies-Bergère*.

Manet made oil paint represent glass. His bottles and glasses are shiny and scintillating; the labels are carelessly yet proudly displayed. Morandi strictly denies this; he completely controls the light in his pictures. Morandi doesn't allow the bottles themselves to reflect the light; they are simply bland, ready-made forms that he could arrange and rearrange to explore their abstract qualities and relationships.

There's nothing narrative, cinematic, or dramatic in Morandi's paintings, which are arrangements of pure form. But perhaps surprisingly, Morandi has been inspirational to important, influential Italian filmmakers. Like de Chirico, Morandi is interested in space and arrangements of things in space. De Chirico was interested in the townscape and the arrangement of forms within the physical environment, space to move around in and where things potentially could happen. Morandi's work has little of the tension of de Chirico's townscapes, and his objects, unlike de Chirico's juxtapositions, are recognizable and ordinary. Morandi's work is tranquil, but that doesn't mean it is easy or uninteresting. Look again at the arrangement: the more we look at it, the more we are able to see its metaphoric power. It is not a difficult stretch to imagine this arrangement of different-sized and different-shaped bottles to be an arrangement of different-sized and different-shaped bodies standing in proximity to each other. Or perhaps we could look at it architecturally, as arrangements of different-sized and different-shaped buildings in the cityscape. Part of the key to understanding this may be in considering Morandi's method. Using the same objects over and over and

3.6
Still Life, 1952
Artist: Giorgio Morandi (1890–1964)
Morandi's work is about composition and arrangement.

3.6

FANTASY
WORLDS IN
CINEMA AND
ART

ONEIRIC: THE
WORLD OF
DREAMS

SURREALISM

GOING BEYOND
THE REAL

CASE STUDY:
THE ARCHERS

EXERCISES,
DISCUSSION
QUESTIONS,
AND FURTHER
READING

over again, he spent a great deal of time contemplating them before he actually picked up the brush and started painting; his work invites us to the same kind of contemplation.

In *La Dolce Vita*, his 1960 signature film about the decadence of contemporary Italian high society, Federico Fellini features Morandi's paintings as a counterpoint to the messy, chaotic, and often brutal attitudes and actions of his characters. Michelangelo Antonioni also features Morandi's paintings in *La Notte* (1961), which details the breakdown of a bourgeois marriage, as a couple fall undramatically, but no less inexorably, out of love. But Antonioni goes much further.

In *The Red Desert* (*Il Deserto Rosso*, 1964), following a suicide attempt, Giuliana (Monica Vitti), a young wife and mother, struggles to adjust to her life in an industrial northern Italian town. She feels permanently alienated from her environment, which is characterized by polluted landscapes tainted by industrialism, and huge factories. Even the old town where she lives is eerily quiet and lacking life. Photographed by Carlo DePalma, the "desert" in *The Red Desert* is a metaphor for the dry emotional life of the characters. The human figures in the film are often shown very small, dominated by the high radio towers and broad cooling towers on the landscape. Antonioni, a master of the long take, arranges the figures in the landscape in a way similar to Morandi's arrangements in his paintings. The whole film features striking organization of forms, and on one level, the characters are just forms as well. Arrangements are not simply by size, but also by color: the factories are

3.7

represented in various different tones of gray and yellowish ochers, whereas Giuliana and Corrado both have red hair, and for large parts of the film Giuliana wears a bright green coat. Color appears elsewhere: the radio tower is red, and a yellow flag on a ship seems to add a splash of color. But the flag is a signal that there's a contagious disease on board the ship; yellow is also the color of the poisonous smoke that emanates from the factories.

Antonioni echoed Morandi in another way: he actually painted the surfaces of some of his locations. He painted a row of trees white, so that they would show up on his color film as gray.

Antonioni did not use the industrial setting simply to condemn it, although he certainly had criticism. He believed that we need to find poetry and beauty in the world as it is. "My intention," he said, "was to translate the poetry of that world in which even factories can be beautiful. And curves of factories and the chimneys can be more beautiful than the outline of trees, which we are already too accustomed to seeing. It is a rich world, alive and serviceable." He goes on to say

3.7
***The Red Desert*, 1964**
Dir. Michelangelo Antonioni (1912–2007)
In one of the most haunting scenes of *The Red Desert*, Giuliana and Corrado walk down the street in the town and stop next to a market barrow. But all of the merchandise, the fruits and vegetables and other things, are painted matte gray. Antonioni has turned the market stall into a Morandi painting. It is a powerful moment when the unreal erupts into the real.

that the theme of *The Red Desert* is the theme of adjustment. The world will not stop for Giuliana; she must, like the rest of us, learn to adjust to it and to find the poetry and beauty within it.[24]

We can see how Morandi's arrangement of ordinary things could be inspirational to Antonioni. It is not the things that must change; it is us, if we are ever to have any kind of satisfying emotional life.

CASE STUDY: THE ARCHERS

In 1940s England, a remarkable production company, The Archers, was founded by Michael Powell and Emeric Pressburger. Both were experienced filmmakers, and they came together to create a shared vision of making highly original, imaginative, and technically excellent films. Pressburger and Powell shared the producer-director-writer credit and always attributed their achievement to their collaborative approach, not only together, but with those with whom they worked—notably, artists Alfred Junge and Hein Heckroth, cinematographer Jack Cardiff, dancers Robert Helpmann and Moira Shearer, and actors such as Deborah Kerr and Anton Walbrook. The Archers attracted and retained quality, working numerous times with the same talented people.

Fashions change, as we have seen. Rembrandt fell out of favor during his long life and died almost forgotten; Vermeer and Caravaggio remained out of view for centuries after their deaths, only to be rediscovered as the geniuses they truly were; and so fared Emeric Pressburger and Michael Powell and the Archers. By the late 1950s, audiences had moved on from their surrealistic, complex, fantastically extravagant films. Yet by the 1980s, The Archers' work was being reappraised, championed as seminal by such diverse directors

as Martin Scorsese, Francis Ford Coppola, Brian de Palma, and Steven Spielberg in the United States. In the UK, Ridley Scott and Sally Potter have claimed influence from Powell and Pressburger.

So what was The Archers' secret? Pressburger was the archetypal cultured European, a Hungarian-born classical musician and writer. After working in the German film industry, he moved to England in 1935 to get away from the Nazi regime. Powell was an ordinary middle-class boy from Kent, who surprised everyone by giving up his trainee position in a bank to become a runner in a film studio in the south of France. The partnership was concerned with developing unusual stories with innovative visual approaches. They were very sharp at spotting, attracting, and retaining the most artistically talented people available. They took risks that nobody else would take: hiring ballet dancer Moira Shearer to act the lead dramatic role in *The Red Shoes*. They gave the job of director of photography to young cameraman Jack Cardiff on the powerful, visually complex film *A Matter of Life and Death*. They hired fine artists like Junge and Heckroth and gave them full artistic freedom to design their films' visuals. This audacity frightened the industry in the end.

But who were these creators of the visual impact? This case study looks at cinematographer Jack Cardiff, who learned to be a cameraman from painting; painter Alfred Junge whose stage designs reinvigorated European opera and astonished British stage and screen; and Hein Heckroth, the surrealist painter who constantly moved between gallery and film set. We will look at three key films made between 1946 and 1948: *A Matter of Life and Death*, *Black Narcissus*, and *The Red Shoes*. All three were lensed by Jack Cardiff.

"ONE DAY GAZING AT A ROOM FULL OF PAINTINGS, I REALIZED SOMETHING STARKLY OBVIOUS THAT I'D NEVER NOTICED BEFORE: LIGHT, IT WAS LIGHT THAT WAS THE ALL PERVADING ELEMENT IN PAINTING. . . . IT WAS LIGHT THAT DOMINATED THE SUBJECT AND BROUGHT THE CANVAS TO LIFE."
—Jack Cardiff, *Magic Hour*

Jack Cardiff at the National Gallery

In his compelling autobiography *Magic Hour* (1997), Jack Cardiff described his lack of formal education, particularly in the mathematics and sciences deemed essential for a technician. Cardiff acknowledges that his film school was the library and the National Gallery in London, where he said "my heroes were painters." He describes his first exposure to painting: "We traipsed inside a gray provincial building and entered into what was for me a wondrous new world: painting rows and rows of brilliantly coloured dreams. The curtain had risen on a new source of enchantment and those resolved to see more paintings from then on."[25]

Cardiff's parents worked in the theater, and he was very used to stagecraft, but painting opened up new vistas. "In our showbiz travels, museums were rarely encountered, but when my parents were resting in London, I was able to visit the National Gallery or the Tate and on these occasions, I was in transports of delight."[26]

All his life, Cardiff painted, and he credited painting with teaching him about light, color, and composition. He would set himself the task of copying a painting—a Renoir, for example—in order to learn how to paint light. He was able to apply this knowledge to the camera, to be able to look at the frame and analyze how to light it, following the examples of painters.

The Impressionist painters taught Cardiff how color operates, how colors complement each other, and how to contrast colors to create dramatic effects. From painting he learned how light causes color to appear changed at different times of the day because of the light-temperature shifts. Paintings demonstrated what colors complemented each other, and which produced disturbing effects. This painterly training was particularly useful to Cardiff because at that time there was no digital technology, and many of the films that he worked on used in-camera matte processes. Powell and Pressburger's films in particular rely on matte painting on glass to create their stunning, often astonishing visual compositions.

3.8
A Matter of Life and Death, 1947
Dir. The Archers
Michael Powell's astonishing black-and-white stairway to Heaven.

Cardiff attributed his opportunity to become the first Technicolor camera operator in Britain to his knowledge of painting. In his autobiography, and in the biographical film made by Craig McCall, *Cameraman: The Life and Times of Jack Cardiff* (2010), he recounts how, when he attended an interview for the Technicolor job in 1937, he was forced to confess that he had almost no technical understanding of cinematography. After what he called a "shocked silence," he was asked what made him a good cameraman. Cardiff replied that he studied the many forms of light in the world around him, and he studied the lighting used by the Old Masters of painting. The following day, to Cardiff's shock and amazement, he was told that he had been chosen for the position. This eventually led him to earn an Academy Award, and multiple Academy nominations, as well as a host of other awards. Cardiff is considered the greatest cinematographer Britain has ever produced.

If one looks at the acquisition history of the paintings in London's National Gallery or Tate Britain, one can easily guess some of the paintings that inspired Cardiff in the films he shot for The Archers. The interiors of *Black Narcissus*—in particular the chapel scenes—surely owe something to the white-on-white tones and crystal-clear light of the architectural interior of Pieter Saenredam's *The Interior of the Grote Kerk at Haarlem* (1636). Pierre-Auguste Renoir's *At the Theatre (The First Visit)* (1876–1877) conveys the excitement of a theatrical performance, which is what the sumptuously colored *Red Shoes* is all about. Renoir's *The Umbrellas* must have taught Cardiff how many shades and tones of blue could be created within a picture.

A Matter of Life and Death was Cardiff's first film as director of photography for the Archers, and he was immediately confronted by Michael Powell's determination to push all previous boundaries. The film began as a wartime propaganda commission, yet The Archers created the antithesis of a war film. In the story, airman Peter Carter should have died when forced to jump from his burning plane without a parachute. However, the emissary of death fails to find him in the English fog and he survives, waking up on the beach. He goes on to fall in love with June, an American WAC controller. But Heaven will not let him go so quickly, and there ensues a trial in Heaven, where Carter and June have to prove the strength of their feelings and argue the case that Carter should live.

A Matter of Life and Death

The film is shot entirely in Technicolor, but it is not all color. Michael Powell wanted to reverse Victor Fleming's achievement in the *Wizard of Oz*, making the real world in glorious Technicolor and Heaven in black and white. Cardiff persuaded him not to use black-and-white film but to shoot using Technicolor film, but without processing the dyes, rendering it in a pearly monochrome. This was highly innovative, especially as it allowed the gradual fade between color and monochrome, creating stunning effects, and also allowed some of the Heaven sequences to render the stars in color (which was done in matte) while the principal action and characters remain in monochrome. The film is exceptionally powerful: it opens with a vision of Hell, trapped in a burning plane without a parachute. Carter then moves through territory highly reminiscent of Arnold Böcklin's classical landscapes, even taking direction from a young boy whose pose resembles one of Böcklin's fauns. The film contains numerous classical painting references, as well as new original motifs. The "Jacob's ladder" idea of a stairway between Heaven and Earth is used to powerful effect in the film.

FANTASY
WORLDS IN
CINEMA AND
ART

ONEIRIC: THE
WORLD OF
DREAMS

SURREALISM

GOING BEYOND
THE REAL

CASE STUDY:
THE ARCHERS

EXERCISES,
DISCUSSION
QUESTIONS,
AND FURTHER
READING

Alfred Junge: Painting Cinema:
Black Narcissus

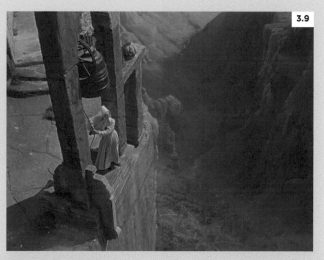

3.9

Unlike Cardiff, German-born Alfred Junge was formally trained in art and went on to work in theater, doing everything from acting to lighting. He started working with the Berlin State Opera and state theater, then moved over to UFA in Berlin and was very successful. Junge was part of a wave of ultra-talented artist designers entering the new media of cinema in Germany. He was invited to work in Britain in 1926 and again in 1932, when he decided it was probably a good idea to remain in the country and work for the Gaumont-British art department. When war broke out, he was initially interned as an enemy alien but was released to work with Michael Powell in the Archers film *The Life and Times of Colonel Blimp*, the first color film Powell shot and the first Technicolor film for Junge. Junge's abilities as an artist were immediately apparent, as can be seen in the lavishly painted watercolor sketches he created for the film.

Junge found working with Powell and Pressburger quite different from the more restricted art direction role on other films. He said "I was able to work as freely and imaginatively as ever, and to feel that I was helping to contribute actively to the artistic results achieved."[27]

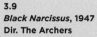

3.9
Black Narcissus, 1947
Dir. The Archers
Despite the dramatic Himalayan setting, almost every frame of this film was shot in the studio, or in a nearby park. Its dramatic visual splendor is a tribute to the art direction and cinematography of Junge and Cardiff.

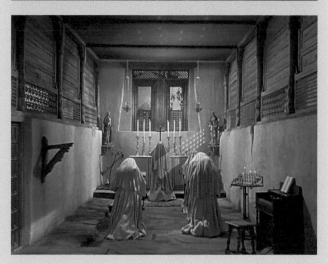

In his 1986 memoir, Michael Powell says that Junge was "probably the greatest art director that films have ever known."[28] Catherine Surowiec points out that, though often overlooked by the public when they discuss films, art directors "help to create the world of cinema magic, painting with images of light and shade." Often their sketches are works of art in themselves, and this was certainly true of Junge. Set designs indicate atmosphere, mood, lighting, perspective, pictorial composition, volume, and spatial relationships.

Black Narcissus was a challenging film. It is set in India, and tells the story of a group of nuns who are sent to a remote community in the Himalayan Mountains to establish a school and clinic for the local people. But soon the strange and unearthly mountain landscape, and the stress of isolation as they go about their business in a windy mountaintop crumbling palace, leads to sexual tension and the beginnings of psychological breakdown. Featuring powerful, compelling performances by the two female leads, Deborah Kerr and Kathleen Byron, *Black Narcissus* was unlike anything that a British production company had produced to date.

What's particularly interesting about the film is that not one frame of it was actually shot in India. Most of it was shot in the studio using a big plaster set made by Junge, which was the palace complex. The tropical vegetation was found in the gardens of a stately home on the outskirts of London. Everything else— the fantastic mountain landscape, the stunning sunrises and sunsets, and the terrifying cliff drop where the final murderous battle between Deborah Kerr's Sister Clodagh and Kathleen Byron's Sister Ruth takes place—was all hand painted. Alfred Junge presided over the creation of some of the biggest and most impressive canvas paintings ever painted in twentieth century Britain, as well as countless glass paintings. Walter Percy ("Pop") Day was the head of the painting unit. The quality of the painting can be appreciated by watching the film, because it becomes clear that although, on the one hand, everything appears realistic, on the other hand, it goes far beyond realism. Junge creates a kind of hyperrealism that is haunting, philosophical, and far more beautiful and terrifying than the real thing. The painted world of *Black Narcissus* surely has to stand as one of the greatest painting triumphs of twentieth-century art, not only

twentieth-century cinema. *Black Narcissus* won Academy Awards for both design and cinematography.

Michael Powell on *Black Narcissus*: "It is the most erotic film I have ever made. It is all done by suggestion, but eroticism is in every frame and image from the beginning to the end."[29]

"MY PASSIONATE STUDY OF PAINTERS AND LIGHT HELPED ME IMMEASURABLY AS A LIGHTING CAMERAMAN. REMBRANDT, VERMEER, PIETER DE HOOCH AND THE MIGHTY TURNER WERE MY IDOLS."
—Jack Cardiff, *Magic Hour*[30]

FANTASY
WORLDS IN
CINEMA AND
ART

ONEIRIC: THE
WORLD OF
DREAMS

SURREALISM

GOING BEYOND
THE REAL

CASE STUDY:
THE ARCHERS

EXERCISES,
DISCUSSION
QUESTIONS,
AND FURTHER
READING

Hein Heckroth: Surrealism, Ballet Macabre, and *The Red Shoes*

Powell and Pressburger's *The Red Shoes* proved to be a controversial film in the end. It was so audacious, so outlandish, so unprecedented that it terrified the Rank organization, which financed The Archers films. Yet it is one of the landmarks in filmmaking, and one of a very few great films about dance. The production design in this film was done by Hein Heckroth, a German surrealist painter with a background in designing ballet. Heckroth and his collaborator Ivor Beddoes created around 2,000 storyboard sketches, drawings, and paintings for *The Red Shoes*. Heckroth was already working for The Archers, as he had done the costumes for *Black Narcissus*. Powell was extremely impressed with Heckroth's distinctive costume design, and so was Cardiff, because the particular drapery of the nuns' robes, coupled with the off-white color, gave the film an almost sculptural feel—as if at times the nuns were statues come to life, particularly set against the lavish vegetation of the landscape. Powell had initially expected Junge to do the art direction of *The Red Shoes*, but they were unable to agree on a direction. Powell said later that he felt Junge was unwilling to go to the kind of dangerous extremes the film demanded.

The Red Shoes is loosely based on a Hans Christian Andersen story reinterpreted by Pressburger. It is a disturbing allegory of art, feeding off and ultimately destroying normal life. Ballerina Victoria achieves stardom as a protégé of the driven impresario Lermontov. But it is a Faustian pact, and she is forced to choose between her husband and a "normal" life or giving herself up completely to art. The ballet sequence embedded in the film illustrates the Andersen story: the Faustian pact between the young girl and the Shoemaker, who supplies the enchanted red shoes in which she dances to her death.

The Red Shoes is an extremely demanding film because, as well as being a powerful psychological and relationship drama, it also contains a 15-minute ballet sequence. The sequence is particularly important in the history of cinema, because it's not simply a rendering of the stage show. The camera becomes part of the ballet, following the dancers around, shooting from above, below, and in close-up. It was particularly difficult to do, and of course it had never been done before. Typically for The Archers, the dancing was of the highest order: the choreography of the ballet sequences was done by Robert Helpmann, an acclaimed dancer, and featured the legendary Ballets Russes soloist and choreographer Léonide Massine, in a self-created part as the Shoemaker. Balletophiles consider the *Red Shoes Ballet* the greatest dance sequence ever put on film. When Powell invited Cardiff to shoot "a film about ballet," the cameraman did not like the idea, but admitted that he soon became fascinated by the art form and determined to find the most innovative way possible to commit it to cinema.

The film presented a challenge to Heckroth, who was used to designing for stage ballets and had innovated back projection in theater design, which is how he got into cinema in the first place. But up until *The Red Shoes*, he had primarily acted as a costume designer in films. Heckroth wanted "a new type of film décor," one less heavy and restricted and free from the limitations of the stage. He said that "my biggest desire all of my life as an artist, was to get movement into my work."[31] This is one of the things that frustrated him in his parallel career as a painter of fine art, which he exhibited regularly in galleries. In Germany, Heckroth shared a gallery with Surrealist Max Ernst and Expressionist Otto Dix. Michael Powell believed that *The Red Shoes* was "the first time a painter had been given the chance to design a film . . . and it was a triumph."[32]

EXERCISES AND DISCUSSION QUESTIONS

The line separating the real and the unreal is always going to be blurred. This is as true in painting as it is in cinema. The human imagination is constantly seeking ways to explain the world as it is, but also the world as we think and feel that it is. In trying to harness the human imagination and allow it to enhance and illuminate reality, artists and filmmakers have turned to fantastic forms from mythology, exploration of the unconscious, and subversion of the ordinary objects of everyday life by giving them new qualities.

Exercise
Select a favorite painting that depicts a dream state or a surreal vision. Perhaps choose one that has been featured in this chapter, such as Arnold Böcklin or Giorgio de Chirico, or look up other pictures by the artists discussed here. Look up the works of Leonora Carrington, Henri Rousseau, and William Blake.

Imagine recreating the painting as a scene in your own movie. What kind of camera setups would you use? What kind of sound would you choose to accompany this scene?

DISCUSSION QUESTION

Cinematographer Jack Cardiff found that painting helped him to understand form and color, and it was one of the most significant tools in his development as a cinematographer. What other art forms might be valuable as part of the filmmaker's self-development?

FANTASY
WORLDS IN
CINEMA AND
ART

ONEIRIC: THE
WORLD OF
DREAMS

SURREALISM

GOING BEYOND
THE REAL

CASE STUDY:
THE ARCHERS

**EXERCISES,
DISCUSSION
QUESTIONS,
AND FURTHER
READING**

FURTHER READING

Leslie Halpern, *Dreams on Film: The Cinematic Struggle Between Art and Science* (McFarland, 2003). This is the standard text on the subject of dreams and cinema, based on both film and scientific research.

Michael Richardson, *Surrealism and Cinema* (Berg, 2006)

Paul Hammond, ed., *The Shadow and Its Shadows: Surrealist Writings on the Cinema* (City Lights, 2001). This collection of writings by the Surrealists themselves is fascinating; it contains a particularly insightful review of *King Kong* (1933) by the writer Jean Ferry.

Rene Passeron, *Surrealism* (Terrail, 2005)

Patrick Waldberg, *Surrealism* (Thames and Hudson, 1978)

P. Hames, ed., *The Cinema of Jan Švankmajer: Dark Alchemy*, 2nd ed. (Wallflower, 2008)

Wendy Jackson, "The Surrealist Conspirator: An Interview with Jan Svankmajer," *Animation World Magazine*, Issue 2.3 (June 1997)

Mario Vargas Llosa, "You Nourish Yourself with Everything You Hate," *Tate Etc.*, (Spring 2007)

Shulamith Behr, *Expressionism* (Tate, 1999)

Seymour Chatman and Paul Duncan, eds., *Michelangelo Antonioni: The Investigation* (Taschen, 2004)

Dan Fleming, *Making the Transformational Moment in Film* (Michael Wiese Productions, 2011)

NOTES

1 Leslie Halper, *Dreams on Film: The Cinematic Struggle Between Art and Science* (McFarland & Co., 2003); this is the standard text.
2 Ara H. Merjian, *Giorgio de Chirico and the Metaphysical City* (Yale University Press, 2014).
3 Robert Hughes, *Nothing If Not Critical: Selected Essays on Art and Artists* (Penguin, 1992).
4 Giorgio de Chirico, *The Memoirs of Giorgio de Chirico* (Perseus Books Group, 1994).
5 Hughes, *op. cit.*, p. 161.
6 "The Spirits Released: De Chirico and Metaphysical Perspective," in "Italian Art Now," *Art & Design* (Academy Editions, 1989), Vol. 5, No. 1/2, pp. 6–17.
7 René Passeron, *Surrealism* (Terrail, 2005).
8 Anna Balakian and Anna Elizabeth Balakian, *Surrealism: The Road to the Absolute* (University of Chicago Press, 1986).
9 See this and more writings on cinema by the Surrealists themselves in Paul Hammond, ed., *The Shadow and Its Shadows: Surrealist Writings on the Cinema* (City Lights, 2001).
10 Terry Gilliam, *Interviews*, ed. David Sterritt and Lucille Rhodes (University Press of Mississippi, 2004), p. 34.
11 *Ibid.*, p. 11.
12 Margherita Andreotti, *The Essential Guide* (The Art Institute of Chicago, 2013), p. 278.
13 Terry Gilliam, interviewed by Imogen Carter in "René Magritte: Enigmatic Master of the Impossible Dream," *The Observer*, Sunday, June 19, 2011.
14 Robert Hughes, "Magritte," in *Nothing If Not Critical* (Penguin, 1990), p. 157.
15 Paul Hammond, ed., *The Shadow and Its Shadows: Surrealist Writings on the Cinema* (City Lights, 2001).
16 Michael Richardson, *Surrealism and Cinema* (Berg, 2006).
17 See Jan Uhde, "Jan Svankmajer: Genius Loci as a Source of Surrealist Inspiration," in Graeme Harper and Rob Stone, *The Unsilvered Screen: Surrealism on Film* (Wallflower, 2007).
18 "The Film Experiment," in P. Hames, ed., *The Cinema of Jan Švankmajer: Dark Alchemy*, 2nd ed. (Wallflower, 2008), pp. 8–39.
19 Wendy Jackson, "The Surrealist Conspirator: An Interview with Jan Svankmajer," *Animation World Magazine*, Issue 2.3, June 1997.
20 Jan Švankmajer quoted in John-Paul Pryor, "Surviving Life, Conversations with Leading Cultural Figures," *AnOther Magazine*, November 30, 2011, available at http://www.anothermag.com/art-photography/1589/jan-svankmajer-on-surviving-life.
21 Simon Wilson, *Tate Gallery: An Illustrated Companion* (Tate Gallery, London, revised edition 1991), p. 124.
22 Mario Vargas Llosa, "You Nourish Yourself with Everything You Hate," *Tate Etc.*, Issue 9 (Spring 2007).
23 "George Grosz," *MOMA*, http://www.moma.org/collection/artist.php?artist_id=2374.
24 Seymour Chatman and Paul Duncan, eds., *Michelangelo Antonioni: The Investigation* (Taschen, 2004), pp. 91–95.
25 Jack Cardiff, *Magic Hour* (Faber & Faber Film, 1997), p. 42.
26 *Ibid.*
27 Quoted in Catherine A. Surowiec, *Accent on Design: Four European Art Directors* (British Film Institute, 1992).
28 Michael Powell, *A Life in Movies* (Faber & Faber, 2000), p. 628.
29 *Ibid.*, p. 584.
30 *Ibid.*, p. 44.
31 *Ibid.*, p. 653.
32 *Ibid.*, p. 630.

PART 2

CHAPTER FOUR
SEX AND VIOLENCE

Sex and violence are well represented in every major museum art collection, and sexuality and violence are well represented—and sensationalized—throughout the history of art. Some filmmakers have quite often simply borrowed sexual and violent imagery from existing paintings. Others unconsciously echo deeply ingrained representations of gender and sexuality long established by painting.

We might ask why we even wish to see sex and violence represented, in art or film? It is a good question, but we have to accept the fact that images of sex and violence go back to the very earliest human images. The Willendorf Venus, the oldest carved object yet discovered, is a sexually explicit female torso. The epic battles of King Ashurbanipal and Pharaoh Ramses II cover whole walls. Voyeurism, the practice of getting sexual gratification by looking at sexual objects, is practiced through art. Art allows us to explore the things that frighten and disturb us.

While present-day audiences reject the sexual attitudes behind many of the works of art history, we must be careful not to judge them too strictly by the moral standards of today. At the same time, we should not simply venerate them as objects of beauty without understanding the broader context in which they were made. The same negotiation takes place with regard to depictions of violence. Since drama is driven by conflict, violence will be present in drama, whether it is cinema or painting based on myths or history. The level of violence, how graphically it is portrayed, and what is considered socially acceptable are negotiated by each successive generation of artists and audience. Screenwriter Paul Schrader points out that when you censor violence in art because you think it's not good for society, you still have the violence in society, but you don't have the art that comments on the violence and helps us understand it.

This chapter will look at examples of the representation of sexuality and violence in art and cinema. Films examined here will be realist dramas (not genre pictures). The discussion is gendered toward female representation: although there is art that includes men and sex (the many renderings of Saint Sebastian, for example), females are overwhelmingly overrepresented. The chapter concludes with a case study of the relationship between filmmaker Martin Scorsese and painter Caravaggio.

SEX IN ART
AND CINEMA

VIOLENCE
IN ART AND
CINEMA

SEX AND
VIOLENCE

CASE STUDY:
MARTIN
SCORSESE AND
CARAVAGGIO

EXERCISES,
DISCUSSION
QUESTIONS,
AND FURTHER
READING

SEX IN ART AND CINEMA

Until the twentieth century, it's easy to divide the bulk of paintings of women into one of three categories: the Goddess symbolizes perfection and desire, but is unattainable; the Whore is the sexually available woman, who can fulfill desire, but only temporarily, for a fee; and the Mother is all of the "respectable" women—the Madonna, the saints, mothers, wives, and daughters. All have been painted in different styles and by different artists, but we can recognize these three directions repeated over and over throughout the pictures of women in Western art. This means that the same visual culture tendencies were taken up without question from the very early days of cinema. We have the nurturing mother; the desirable but dangerous *femme fatale*; and, most commonly in film plots, the beautiful goddess who has to be won by the hero.

Until the twentieth century, there were relatively few female painters, and of these only a handful ever practiced history painting, or anything other than portraiture. The majority of female painters were limited by convention to portraits and scenes of domestic life. Within these strictures, however, painters like Elizabeth Vigee-Lebrun,

Berthe Morisot, and others created images of domestic life and nurture, which made enormous contributions to the visual culture of the Mother image. However, it was out of the question that women should portray sexuality in any form, so painting mythological nudes was out of their remit. Likewise, women were unable to paint the *demi-monde* of brothels, taverns, and bars—the so-called "low life" pictures associated with seventeenth-century "genre" Dutch painters like Adriaen Brouwer (1605–1638) or nineteenth-century painters like Manet or Toulouse-Lautrec.

> One unusual version of the Mother image is *The Tempest* (c. 1508) by Italian painter Giorgione. A nude woman breastfeeds a baby while a soldier stands (guard?) nearby and overhead a huge storm explodes in to the sky. Is there a sexual element in the picture?

This section will focus on the principal representations of sexuality in art—mythological sex, biblical sex, and exotic sex—as well as alternative approaches to representing these sexual conventions.

Naked or Nude?

When surveying Western art since the Renaissance, one thing soon becomes clear: women are very often nude. Men might be nude, but women are nude much more often. In fact, there is a whole category called "the Nude" that depicts only females. We call a painting as "a nude" regardless its ostensible subject.

The art historian Kenneth Clark said that to be naked is simply to be without clothes, but "the nude" is different. Nakedness is just there; the nude is there specifically *to be looked at*. And, as the critic John Berger noted, the nude is a woman, and she is there to be looked at by the man.[1] In terms of the economy of art up to the twentieth century, financial power was in the hands of men, and the commissioners of paintings were largely, though not exclusively, men. This does not mean that women did not enjoy these paintings, perhaps even identify with them, but everybody tacitly agreed that the function of the nude body was to be looked at and desired. This is why many nude paintings were not intended for public view. Paintings like Rubens's *Angelica and the Hermit* or Velázquez's *Rokeby Venus* (1651) would have been kept behind a curtain. The owner would open the curtain to look at the painting, or show it to his friends, but it would not have been on public view the way that it is today in a museum. There was, however, a huge trade in prints of nudes: diarist Samuel Pepys owned a print of King Charles II's lover Nell Gwynn, topless.

Mythical Sex

See *Angelica and the Hermit* (1626) by Peter Paul Rubens (1577–1640). Angelica is a character in Ludovico Ariosto's narrative poem *Orlando Furioso* (canto 8). She seeks help from a hermit, who instead drugs her with a sleeping potion. Appealing to literature, the Bible, or classical mythology gave painters (and their clients) an excuse to show nudity and sexuality. Rubens offers a full frontal nude display of Angelica, overlooked by the leering, groping hermit. Luckily for Angelica, the hermit is too old and decrepit to achieve his aim.

This attitude began to change, and by the nineteenth century nudes regularly scandalized the annual Paris Salon— and attracted huge crowds. Not every country produced nudes: they were extremely rare in Spanish, British, and American painting. One of the few English painters to do so was William Etty. His mythological scenes featuring splendid nude figures were admired but disapproved of by moralistic English society. However, the fact that British artists' models did not pose nude meant that modeling was a respectable opportunity for good-looking working-class women, in much the same way as early Hollywood offered opportunities for attractive American girls.

The presence of the nude in art derives from the Renaissance revival of classical ideals based on the remains of Greco-Roman art. Nudity meant something completely different in the classical era, when artists portrayed their deities nude to amplify their ideal forms and exemplify beauty.

Real people (like Pericles, Caesar, or Alexander the Great) were not usually portrayed nude: they were more likely to be portrayed as a bust (head and shoulders only) or, if full length, clothed. But whereas the Greeks and the Romans took equal pleasure in the nude male and nude female, from the Renaissance onward, painting developed a particular tendency toward the female nude, with its soft and sinuous curves.

> Can we use Clarke's concept of "naked" and "nude" in cinema? When is a character "nude"? When is a character "naked"?

Until the nineteenth century, it was extremely rare to find nudes that represented contemporary life. Instead, nudity was more commonly used in representing mythical subject matter. Conveniently, Greek and Roman myths have so much sexual licentiousness that it's very easy to find stories and characters brimming with sexual activities. Venus, goddess of love, was a reliable source of nudes. One of the most notable is Botticelli's *Birth of Venus*, a nude borne on the waves by a seashell.

> Botticelli's Venus is recreated by director Terry Gilliam in *The Adventures of Baron Munchausen* (1988, DP Giuseppe Rotunno).

Although nudity and sensuality are most commonly associated with Renaissance Italian art, one of the most striking nudes of this period was by the sixteenth-century painter Lucas Cranach the Elder, one of the most important and influential German artists. Although he was a friend of Martin Luther (making the best-known portrait of the religious reformer), Cranach's pictures were bought by both Protestant and Catholic patrons and thus were widely disseminated. Because of his popularity, Cranach mass-produced many of his pictures, making copies of them for sale.

THE PERFECT CURVE

Painter William Hogarth, in his book *The Analysis of Beauty* (1753), developed the concept of the "line of beauty." He wrote that using an S-shaped (serpentine) curved line in a composition signifies life, liveliness, activity, and excitement, whereas straight lines convey stasis, even death.

SEX IN ART
AND CINEMA

VIOLENCE
IN ART AND
CINEMA

SEX AND
VIOLENCE

CASE STUDY:
MARTIN
SCORSESE AND
CARAVAGGIO

EXERCISES,
DISCUSSION
QUESTIONS,
AND FURTHER
READING

What makes Cranach's Venus so fascinating? Her gaze is not quite confrontational, more invitational, and very direct. She promises sexual availability, but at the same time, there's something about her half-closed eyes and little smile that makes us not entirely trust her. She does not look like a classical Greco-Roman nude. She is an individual, a character. Although he did not use an actual woman as a nude model, the two pictures of Venus that Cranach made (the other being Venus with Cupid) show the same woman's face and jewelry. She has pubic hair, which is extremely uncommon throughout the whole history of the nude. The way she holds the veil and her facial expression offer us an allusion to the biblical character of Salome, discussed below, who is normally represented in art as a dangerous *femme fatale*. In the composition, Venus is foregrounded as if on the stage: there is no background, and she is starkly lit as if by a key light. The effect is dramatic and stagy, yet also intimate and personal. This is a private picture, a "pinup."

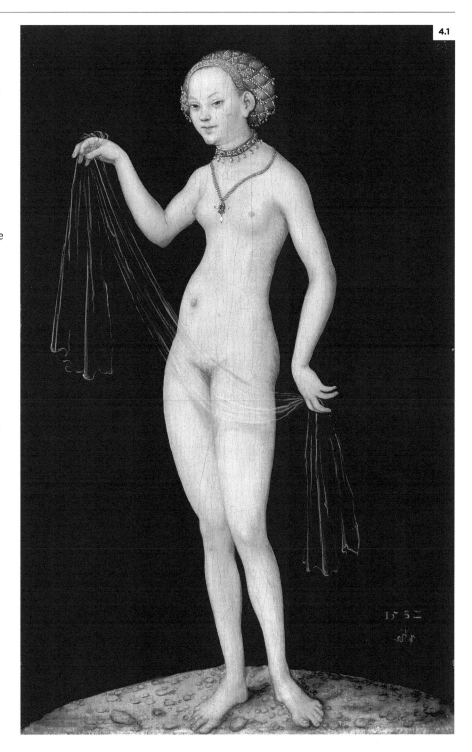

4.1

4.1
Venus, 1532
Artist: Lucas Cranach the Elder (1472–1553)
The sensuous female nude was a specialty of Cranach, despite his having no female models; he painted instead from imagination and general observation.

Biblical Sex

The earthy yet unattainable goddess-like image of sexual allure was one of the first things that cinema wanted to explore. In both classical and postclassical art, Venus is nearly always shown nude. However, because of the USA's 1930 Hays Code, nudity could not be shown in movies, so sexuality needed to be expressed through subtle innuendo. For example, in the cabaret scene of Charles Vidor's film noir *Gilda* (1946), Rita Hayworth does a superlatively erotic striptease taking off only a single glove. Yet the composition is very close to Cranach's: Gilda is no less a Venus, flourishing her assets and creating desire.

The sexually desirable but unobtainable woman—the imaginary goddess—continued to be explored in cinema, particularly in the 1950s: Marilyn Monroe's Venus-like screen persona can be seen in films such as *The Seven Year Itch* (Billy Wilder, 1955). In France, Roger Vadim's *And God Created Woman* (1956), with Brigitte Bardot, features a hypersexual Juliette who is psychologically unobtainable. Later, feminist film theory criticized such representation of women in films (and, by implication, in art). Yet the love goddess is a very powerful figure. She is ultimately elusive, and she has the power to manipulate, though not necessarily to control, that power.

Significant Venuses include Giorgione's *Sleeping Venus* (c. 1510) and Titian's *Venus of Urbino* (1538); both paintings show the goddess passive, inviting, and unapologetically erotic. We see Velázquez's *Rokeby Venus* (1647–1651) from behind, gazing at herself in a mirror; her face is obscured, bringing mystery to the erotic. Sometimes mythological pictures took eroticism quite far: Paolo Fiammingo's *Allegory of Love* (1585) is a frank depiction of intercourse. Many artists, of course, made private erotic drawings and prints.

Venus paintings can present her simply to be admired, as in the previous examples, or more actively, acting out a scene from mythology (for example, Nicolas Poussin's *Venus Presenting Arms to Aeneas*, 1639). In all cases, it is her physical beauty that is most emphasized.

The Le Nain Brothers' realist *Venus in Vulcan's Forge* (1641) shows a beautiful but modest Venus visiting her husband Vulcan at his forge. One of the workers is ogling her as she speaks to Vulcan. What the audience knows, however, is that Venus is cheating on Vulcan with Mars—the story that launched a thousand dramas, never mind soaps.

With the wealth of explicit sex-related stories in classical mythology (in Ovid's *Metamorphoses*, Apuleius's comic novel *The Golden Ass*, and more), it is not surprising that mythological subjects in painting feature nudity in abundance. What might be more surprising is how many painters used biblical stories as an excuse for nudity and sexual themes. Two of the most popular were "Susannah and the Elders" and "David and Bathsheba."

In the first story, Susanna is having a bath in her garden. Unbeknownst to her, two lecherous elders of the community are spying on her. In Tintoretto's version (1555), Susannah is bathing, happy and oblivious; to Guido Reni (1625), she seems mildly irritated; in Pieter Rubens (1607), she is abruptly startled. All three lavishly emphasize her nude body. *Susanna at her Bath* by Francesco Hayez (1850) offers us the opportunity to be the elders: it is a painting about voyeurism that enables us to be voyeurs, but in a safe, vicarious way. But not all depictions celebrate her nudity: in Anthony van Dyck's 1621 painting, Susannah hides her nakedness and looks truly horrified. In Artemisia Gentileschi's 1610 version, Susannah is not displayed erotically, and she shrinks in disgust from the pawing hands of the men.

SEX IN ART
AND CINEMA

VIOLENCE
IN ART AND
CINEMA

SEX AND
VIOLENCE

CASE STUDY:
MARTIN
SCORSESE AND
CARAVAGGIO

EXERCISES,
DISCUSSION
QUESTIONS,
AND FURTHER
READING

The story of David and Bathsheba again involves voyeurism, as King David watches Bathsheba having a bath and approaches her, despite the fact that her husband is one of his generals. He later engineers for the husband to be killed in battle and takes Bathsheba as his wife. This is a serious spiritual crime, and as such it could be used as a subject for monumental history painting, without fear of being frivolous or licentious. Although the subject has been painted by many artists over the years, the most renowned rendering of Bathsheba is by Rembrandt (in the Louvre). This is a life-size picture, with only Bathsheba in the frame, not David. It is considered a masterpiece of psychological painting because Rembrandt has shown us both Bathsheba's moral and spiritual dilemma at being the king's lover and her luscious beauty, which makes us absolutely empathize with David's position.

Another very popular subject for biblical history painting is the *femme fatale* story of Salome. The key theme is Salome's erotic "dance of the seven veils," through which she entices King Herod to cut off the head of St. John the Baptist. In painting, there are essentially two renderings of Salome: one showing her carrying the head of the Baptist, the other showing the dance of the seven veils. The dance only started to appear in pictures in the late nineteenth century; the most prominent are by French Symbolist Gustave Moreau (1874). Around this time the *femme fatale* emerged as a key Symbolist motif, and it remains popular.

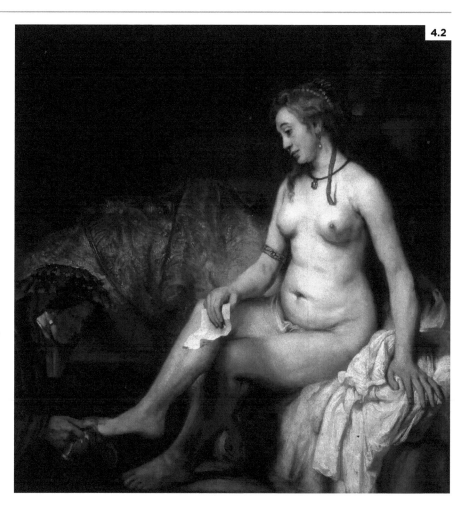

4.2

4.2
***Bathsheba Bathing*, 1654**
Artist: Rembrandt van Rijn (1606–1669)
While Bathsheba is bathing, she is spied upon by King David, who sends her a letter summoning her; this is the moment Rembrandt paints, and he captures Bathsheba's deep unease.

HOLLYWOOD AND BIBLICAL EPICS

From the late 1940s through the early 1960s, many Hollywood films based on Bible stories were produced. These were very freely adapted, often ahistorical, visually lavish extravaganzas. It is immediately obvious how keenly paintings were used in constructing the compositions, costumes, and sets for these films. The most desirable female stars of the day were cast. The films continued painting's tradition of ensuring that sex is at the forefront of the visual display, and the painted film posters reinforce that message. Some notably racy biblical epics include:

- *Salome* (William Dieterle, 1953); the poster features Rita Hayworth in a revealing belly-dancing costume.

- *Solomon and Sheba* (King Vidor, 1959); this time Gina Lollobrigida as Sheba wears the flimsy belly-dancing costume.

- *David and Bathsheba* (Henry King, 1951) has Susan Hayward as the adulterous Bathsheba.

- *The Ten Commandments* (1956) by the master of the epic, Cecil B. DeMille; overheated sexuality is provided by Anne Baxter as Egyptian princess Nefretiri.

- *Sodom and Gomorrah* (1962) is an atypical outing for noir director Robert Aldritch, with Pier Angeli as Lot's wife; this is quite tame compared to the Bible's version.

- *Esther and the King* (1960) by western director Raoul Walsh; the poster has Joan Collins prostrating herself in a revealing gown.

- *Sins of Jezebel* (1953) by Reginald Le Borg (better known as a horror director); the poster promises it will be "ravishing, seductive, shameless."

Exotic Sex

Sometimes a nude was just a nude, with no mythological or biblical rationale. The term "odalisque" was borrowed from the Ottomans to describe or define these nudes-for-nudes-sake. With little understanding of the complex Ottoman sexual social structure, Westerners understood the term *odalisque* to mean a harem concubine. Eastern culture and especially the idea of the harem fascinated Westerners; however, because of the very nature of the harem in the social structure, no Westerner was ever able to glimpse inside one. Hence, harem paintings were based on a combination of febrile imagination and visits to Middle Eastern brothels. By the eighteenth century, "odalisque" was used to refer to any eroticized portrait in which a nude woman reclines, displaying herself for the spectator.

French painter Francois Boucher was interested in painting beauty, particularly the human body in a variety of ways, always rendering it luscious and beautiful. Boucher was not an "Orientalist" painter; his painting *The Odalisque* (1749) is one of many nudes, including mythological scenes and portraits of court mistresses. His portrait of one of Louis XV's mistresses, Louise O'Murphy (c. 1752), is very similar to *The Odalisque* and is sometimes called *The Blonde Odalisque*. Boucher was a particular favorite of Louis XV's official chief mistress, the witty and intelligent Mme. de Pompadour, and often painted her portrait, as well as designing tapestries, theatrical scenery, and countless other things. Mme. de Pompadour was never painted nude, nor portrayed as anything except a well-dressed, respectable, confident woman, in contrast to the coquettish Odalisque.

SEX IN ART
AND CINEMA

VIOLENCE
IN ART AND
CINEMA

SEX AND
VIOLENCE

CASE STUDY:
MARTIN
SCORSESE AND
CARAVAGGIO

EXERCISES,
DISCUSSION
QUESTIONS,
AND FURTHER
READING

The complex sexual mores and arranged dynastic marriages of European culture meant that extramarital sex was available, but in specific hierarchies. At the top was the "official mistress," often a domestic and intellectual as well as sexual relationship; there are many portraits of these women, such as Mme. Pompadour. A courtesan could give her sexual favors to more than one man, and these relationships were often short-lived; Boucher's *Odalisque* is a typical representation. The whore was a more nakedly commercial relationship. Henri Toulouse-Lautrec's *Bed* (1898) is an unusually tender portrait of the prostitute as a vulnerable woman.

Boucher earned good money from wealthy collectors for the Odalisque paintings, though at the expense of earning disapproval. He spread himself quite thin as an artist and was sometimes castigated for stooping to easy eroticism instead of trying for something more profound. But Boucher's *Odalisque* offers us something quite interesting: an amiable sweet-faced female figure. She is not cold and remote, not a goddess; Boucher has painted her as a mortal woman. She lies in an overtly sexual pose, putting the viewer in the position of the lover only moments before the sexual act will take place. To accuse this painting, at least, of being easy eroticism would be absolutely incorrect. Look at the composition and the way in which Boucher uses the blue drapery. The bright, intense blue sets off the pink tones of the flesh and creates a magnificent contrast. Yet the blue is also calming and soothing, bringing a freshness to the painting.

It may be tempting to dismiss Boucher's work as decorative and frivolous, in the same way that the philosopher Diderot did. His subjects are not challenging: eroticized mythology (*Pan and Syrinx*, 1759), idealized pastoral scenes of beautifully dressed shepherds and shepherdesses (*The Interrupted Sleep*, 1750), and gentle landscapes (*Landscape with a Watermill*, 1755). Diderot felt that Boucher's vision was fundamentally dishonest and besides, "what can be in the imagination of a man who spends his life with prostitutes of the basest kind?"[2] Boucher did paint courtesans, but he was also the first painter to the king and director of the Royal Academy. He was not interested in realism, nor did his audience desire it.

Today it is more useful to look for Boucher's achievements in terms of his depiction of sex and sensuality. His attention to form, his rejection of drama in favor of playful, poetic mischievous and painterly scenes, and his high-toned palette of blues and pinks create a vision in which (in the words of one modern critic) "erotic mythological fantasies are floating concoctions of silk and skin, ethereal and flimsy and . . . hugely pleasurable."[3] Far from condemning

Boucher's highly sensuous Rococo frolics as decadent and immoral, Jonathan Jones sees him as "defiantly unserious and delightfully ambitious in the scale and proliferation of his visual frolics."[4]

François Boucher's *Odalisque* is only nominally eastern in subject matter. However, there were painters who were particularly attracted to "eastern exoticism"—the Orientalist school of painters. As mentioned in Chapter 2, when discussing representation, these painters created an enduring image of the East as a place of exotic sex, irrationality, and primitivism. One of the most significant of these was Théodore Chassériau. He was born in the Spanish Caribbean to a French father and a mixed-race mother. Moving to Paris and studying painting, he made traditional mythological and religious paintings, but became interested in North Africa and began to go regularly to Algeria. We should not see his pictures as being realistic; instead, they are imaginative collages of classical antiquity (seen on visits to Italy), mythological and history paintings, and observed reality.

FURTHER VIEWING

The Swing (1767) by Jean-Honoré Fragonard, one of Boucher's pupils, is one of the most popular and influential paintings of frivolity and flirtatiousness. See also the influential *La Grande Odalisque* (1814), painted by Jean Auguste Dominique Ingres. Notice how Ingres has distorted the line of the body to make it even more sinuous and sensual. Ingres painted a number of odalisques.

Napoleon Bonaparte's expedition to Egypt (1798–1801)[5] and the publication of the *Description de l'Égypte* created great interest in North African and Middle Eastern culture, and people started to go there as tourists, including painters and writers. Not all those who painted non-European cultures eroticized them, though many did. Because these women were nominally "foreign," they could be divorced from common reality. One of the most important painters of the "lascivious Orient" is Jean-Léon Gérôme. His superb academic technique, naturalistic style, and mastery of color make his views of Egypt and other Muslim societies seem realistic and observational. Some, such as his *Prayer in Cairo* (1865), depicting worshippers on a rooftop at prayer time, probably are. However, his visions of harems and slave markets are imaginative, deliberately eroticized views. Gérôme's success meant that many lesser painters followed in his wake, offering increasingly more erotic harem and bath scenes, with a particular interest in nude slave auctions, ultimately solidifying the popular image of "the East" as a place of sordid pornography and sexual vice.[6]

4.3

4.3
The White Slave, 1888
Artist: Jean-Jules-Antoine Lecomte du Nouy (1842–1923)
The White Slave is typical of the dubious "delicious scandal" that portraits of the East could command. "White slavery" was a sensational popular subject in early cinema and has long continued, even in musicals (*Thoroughly Modern Millie*, 1967, George Roy Hill) and art house films, like Bernardo Berlotucci's *The Sheltering Sky* (1990).

FURTHER VIEWING

Eugène Delacroix, *The Women of Algiers* (1834). It was difficult to sketch local women, but Delacroix managed to create this sensual but not sexual picture of Algerian female life.

Jean-Léon Gérôme, *The Grand Baths at Bursa* (1883)

Gérôme sketched the public baths in the Turkish city of Bursa on the days when the baths were reserved for men; back in Paris, he added in nude female models.

How far do Orientalist pictures and odalisques represent familiar images of woman still represented in cinema today?

SEX IN ART
AND CINEMA

VIOLENCE
IN ART AND
CINEMA

SEX AND
VIOLENCE

CASE STUDY:
MARTIN
SCORSESE AND
CARAVAGGIO

EXERCISES,
DISCUSSION
QUESTIONS,
AND FURTHER
READING

The Sex Comedy

Since ancient Greece, the sex comedy—comedy motivated by sexual situations and love affairs—has been one of the most popular and enduring subgenres in theater, and subsequently in cinema. Because so many paintings are based on myths and stories, paintings can also give visual representation to the sex comedy.

One of the most compelling is Bronzino's *An Allegory with Venus and Cupid* (c. 1545; also known as *The Allegory of Venus, Cupid, Folly and Time*). The painting contains a great deal of complex symbolism, but also contains all of the necessary ingredients for modern sex comedy. It was commissioned in Florence as a gift for French King Francis I. We can imagine the painting in the royal courts of Paris and Florence, which were famous for lavish display, wealth, and intrigue. Although art historians argue over its precise symbolic meanings, from the sexual comedy perspective it can be read quite clearly. The themes of the painting appear to be lust, deceit, and jealousy, but since the main subject is the goddess of love, love is at the heart story. So how can we read this painting as a visual explication of the sex comedy?

The principal character, front and center, is Venus, painted in the smooth pearly style characteristic of Bronzino. She is being embraced and her breast caressed by Cupid; they appear to be in the middle of a passionate kiss. On the right an *amore* is about to throw a cascade of rose petals on the lovers. But Cupid is actually Venus's son. He's much younger than she, and even in ancient Greece incest was a taboo. So, Venus and Cupid are making a display of lust, but it's not real. Behind them lurk a number of other characters. On

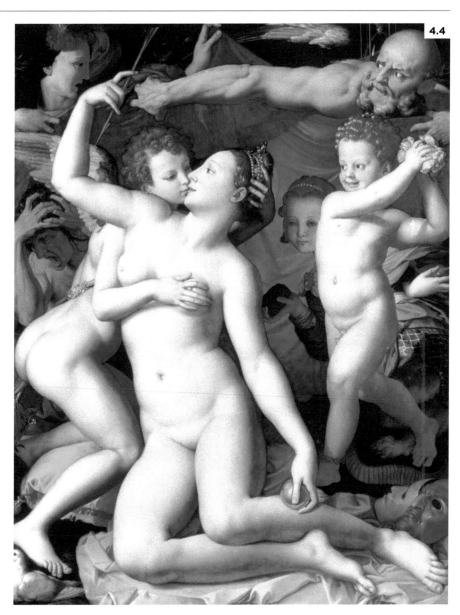

4.4

4.4
An Allegory with Venus and Cupid, c. 1545
Artist: Bronzino (1503–1572)
The painting contains a great deal of complex symbolism, but also contains all of the necessary ingredients for a modern sex comedy.

the left is an older character in some distress. Above is an old man, the common representation of Father Time. Behind the *amore* is a strange character. She has a pretty girl's face, but if you look at her bottom half, under her dress is a reptile body and a tail. She is holding out a tempting honeycomb.

Let us see these characters as participants in the typical sex comedy. The female lead, of course, is Venus, extremely beautiful, displaying herself very deliberately, and always key lit to her best advantage. Cupid is the pretend lover, the one that Venus uses to arouse jealousy in the male protagonist, the viewer. She makes a display of being passionate with Cupid, and he goes along with it, but she is not serious. The *amore* is the foolish friend, who cheers on Venus without thinking about the repercussions of her actions. The older character behind Cupid is perhaps an angry parent, or other disapproving establishment figure. Danger comes in the form of the pretty-faced, reptile-bodied honey bearer. She is the deceitful one who tries to upset the true romance of Venus and the protagonist.

Bronzino offers all the ingredients of the traditional sex comedy, which have remained virtually unchanged since the days of the Greek playwright Menander, right up to modern comedies such as *Knocked Up* (2007, dir. Judd Apatow) or *The Five-Year Engagement* (2010, dir. Nicholas Stoller). Bronzino underlines the theatrical nature of the composition by including Time holding the curtain for the duration of the performance; at Venus's feet we see two theatrical masks, making the point even clearer. Sex comedies often end with some kind of moral lesson learned, as true love is reestablished, but the moral package is never the point of a sex comedy, it is simply its justification. The same holds true for Bronzino's painting.

Confrontational Sex

By the twentieth century, more women were independent, and more became artists. This meant that women's representation of women, and of themselves, began to change. At the same time, men started to question the traditional representations of women in art. As noted earlier, the main pictures painted by women had been domestic subjects and portraits, including self-portraits. Natalya Goncharova was a Russian avant-garde artist and designer whose work included stage sets, costume design, and fashion design as well as paintings. A radical experimental painter, Goncharova chose to paint her self-portrait, *Woman with a Cigarette*, in a very confrontational way. Exposing her left breast, she bows slightly ironically to traditional composition. Yet she does not try to prettify herself, she's not afraid to look a little tired, and she shows herself smoking a cigarette, which symbolizes her liberation from conventional social mores. Even more, she looks as though she's actively participating in social and intellectual life, as she indeed was.

SEX IN ART
AND CINEMA

VIOLENCE
IN ART AND
CINEMA

SEX AND
VIOLENCE

CASE STUDY:
MARTIN
SCORSESE AND
CARAVAGGIO

EXERCISES,
DISCUSSION
QUESTIONS,
AND FURTHER
READING

Eduard Manet addressed the Odalisque genre with *Olympia*, seen in Chapter 2 (p. 68), representing the real world of the mid-nineteenth-century courtesan. The composition is almost the same as Titian's *Venus of Urbino*, but when the painting appeared in Paris in 1865, it caused a shock. It was received as an excessively realistic depiction of a prostitute, and her direct stare out at the viewer disconcerted the audience. The painting contains various symbols that would have been read at the time as clear indications of the nature of her profession. These include the black velvet ribbon around her neck, the earrings, and the orchid in her hair. The high key lighting is harsh and stark, giving an overall sense of flatness, eliminating shading and soft filters. The painting as a whole lacks sensuality. Manet has exposed the cold commerce at the heart of the "love industry."

Pablo Picasso's *Les Demoiselles d'Avignon* (1907) is set in a real Barcelona brothel. The conventions of the genre are all there—the nude women openly displaying themselves for the customer-spectator—and the composition is very like those of Chasseriau and Gérôme. But Picasso's rendering, stylistically anticipating his later Cubist period, completely disorients the genre. The women display themselves vulgarly, in contrast with the coquettish poses in conventional harem pictures, and are confrontational. Two of them wear masks, considered to be based on the African masks that Picasso saw in the museum and later collected. However, Picasso intended no African connotation. The effect is to render the women outwardly grotesque, while at the same time hiding their real faces. The composition of the central female figure is almost exactly like Chasseriau's 1852 *The Toilet in the Seraglio*. There's nothing sensual in this picture; it is all sharp angles, no "line of beauty" here. It is even harsher than Manet's *Olympia*. But Picasso was not interested in simply representing the women of the brothel. Picasso painted women throughout his life, but he never restricted himself to painting only their beauty. He painted his friends and lovers exactly the way he felt about them at the moment of painting, not in order to display them, but to explore his relationship with them.

In the period immediately following *Demoiselles*, Picasso and his friends founded Cubism (see Glossary), an avant-garde art movement that sought to do away with realistic representation and instead bring different views of a subject (usually objects or figures) together in the same picture. Many critics have cited the influence of early cinema on the development of Cubism; this is discussed further in Chapter 8.[7]

The confrontational frankness shown by modernist painters like Manet, Picasso, and Goncharova represents major changes in the way visual culture represented the female. Although mass culture, such as cinema and popular novels, continued to reach back to older, more docile traditional images of women as Goddess, Mother, or Whore, painters—male and female—in the twentieth century started to challenge exactly those representations. They have often done this provocatively and confrontationally, not only in painting but also in photography and performance art.[8]

VIOLENCE IN ART AND CINEMA

Unlike sex, violence has not been contentious in art; far from being controversial or questioned, the representation of violence has been elevated to the highest level in the hierarchy of painting. History paintings—in particular, paintings depicting war—make up the bulk of the genre.

In cinema, drama comes out of conflict, so it is no surprise that many films involve violence. Violence in films, as in paintings, has been far less censured than sexuality. Extremely violent torture porn films are briefly addressed in the chapter on horror, but the violence in most films is judged by whether or not it is gratuitous (that is, more than is necessary to convey the impact). But we can even question whether the violence in some paintings is gratuitous. This section will focus on war painting and the representation of sanctioned violence. The case study will look at the films of Martin Scorsese, most of which have violence at their core, and the paintings by his inspiration, Caravaggio.

Battle and Its Aftermath

Whether presenting mythological battles, legendary battles, or actual battles, history painting overflows with martial, military imagery. There are so many paintings of battles spread around the museums of the world that the subject of war painting and its impact on cinema could easily form several books on its own. Battle paintings have been extremely important in cinema, because they don't just document conflict, they dramatize it. This is an extremely important distinction. In cinema, pure realism would not make an effective battle scene. We need drama and excitement, and the audience needs to feel that they are involved. Many of the painters who painted battles were aware of this; we will take a closer look at several whose cinematic qualities continue to assist filmmakers in composing war scenes.

Elizabeth Southerden Thompson, Lady Butler (1846–1933) is one of the greatest British war painters. Her subjects range from the Napoleonic Wars right through to World War I. Having studied painting, Thompson saw the massive history canvases on display in Paris and decided that she too would like to paint military subjects. Her huge pictures were innovative because she depicted not only panoramic views of battles, but also the experience of the ordinary soldiers. She carefully researched her paintings, and often used as models soldiers wearing their uniforms and carrying the weapons they had used in battle. Thompson's paintings were extremely popular and are still very well known (frequently referred to or reproduced as book covers and in magazines), though she herself has been almost forgotten in the canon of art history. Her most popular and influential painting is probably

Scotland for Ever (1881), depicting the charge of the Scots Greys at the Battle of Waterloo (see p. 185). Her composition is dynamic: as a viewer you are placed in the position of the enemy lines, the horses thundering toward you. Thompson also painted defeat, which was understandably less popular, though arguably even more powerful. *Remnants of an Army* (1879) shows the only British survivor of the 1842 retreat from Kabul. In her 1922 autobiography she wrote, "I never painted for the glory of war, but to portray its pathos and heroism."[9]

Horace Vernet (1789–1863), born into a family of painters, has the distinction of actually being born in the Louvre, in the year of the French Revolution. He was drawn to military painting but rejected academic French styles, wanting to make military painting from a contemporary perspective. He depicted the street fighting in Paris during the 1848 revolution (*Street Fighting on Rue Soufflot, Paris, June 25, 1848*) as well as a number of other battles, including those of the Crimean War.

Vernet's pyramid composition in the Crimea War picture *The Taking of the Malakoff Redoubt* (1858) captures the moment when the defeated British officer has to salute the French flag, as they stand atop a hill seemingly constructed of dead French and British corpses. In this one painting, he shows the moment of victory for the French, humiliation for the British, and the utter wastage of human life, which takes up a full two-thirds of the painting. Like Elizabeth Butler, he chose a realistic style, without neglecting the need for monumental dramatic effect. Both found powerful drama in depicting pathos, as well as in depicting glory.

SEX IN ART
AND CINEMA

**VIOLENCE
IN ART AND
CINEMA**

SEX AND
VIOLENCE

CASE STUDY:
MARTIN
SCORSESE AND
CARAVAGGIO

EXERCISES,
DISCUSSION
QUESTIONS,
AND FURTHER
READING

John Singleton Copley (1738–1815) was an American painter, born in Boston, who later settled in London. *The Death of Major Peirson, 6 January 1781* (painted in 1783), shows the French attempt to seize the island of Jersey. In the battle, the young major was killed by a French sniper, and immediately Peirson's black manservant shot the sniper dead. Here Copley actually presents us with a black hero, one of the very few in Western painting. The dead major is in the center of the painting, as women and children flee in terror on the right. Pompey, the hero, stands out due to his black uniform and strong diagonal body position. He is shown in equality with the white soldiers, using his weapon proficiently and shooting down the enemy.

4.5

4.5
***The Battle of Somah*, 1836**
Artist: Horace Vernet (1789–1863)
Vernet made a number of paintings of the French conquest of Algeria, many commissioned by the king.[10] Vernet was praised for his realism, and for not over-glorifying the events depicted.

FURTHER VIEWING

Horace Vernet, *The Wounded Trumpeter*, 1819

Elizabeth Thompson Lady Butler, *The Retreat from Mons*, 1927

Brutal Violence

As the official painter to the royal court, Francisco Goya was used to painting the monarchy and the finery of the elite. But when war broke out, and things got progressively worse, he used his brush to record what was happening in his country. *The Third of May 1808*, one of the most influential images of warfare ever painted, depicts a nighttime military execution, lit only by a lamp, as a firing squad of rigidly identical, disciplined soldiers is about to kill a group of captives. But this is not an army that is being executed: Goya makes it very clear that the prisoners are ordinary Spaniards. The man about to be shot holds up his arms in alarm, in a crucifixion pose, while at his feet bodies of those already slain lie covered in blood. It is a dreadful, disturbing, and absolutely unheroic picture of war, a counterpoint to the whole *oeuvre* of history painting. Although *The Third of May* appears as vivid as if it were painted near the scene of action, it was made six years after the actual event. Robert Hughes says that "before Goya no artist had taken on such subject matter in such depth. Battles had been formal affairs with idealized heroes, hacking at one another but dying noble, and even graceful, deaths. Not the mindless and terrible slaughter that Goya wanted us all to know is the reality of war, ancient or modern."[11]

Goya followed this painting with an 82-part series of aquatint etchings, *The Disasters of War*, which reinforced his horror and disgust at the war and is an outstanding denunciation of violence. There are no heroes in this series, only perpetrators and victims, and by using black-and-white etching Goya could portray extreme gore and brutality in a way that no painting could. For example, in plate number 37, he shows how the mutilated torsos and body parts of victims were stuck on trees in the landscape. As the series goes on, it gets more and more fanciful, as he starts to build in elements of satire, absurdity, and grotesquerie. In plate 74, a wolf sits writing a message on a sheet of paper: "Misera humanidad. La culpa es tuya" (Miserable humanity. The blame is yours). Goya knew the series would appall people, and it was not published in his lifetime. In 1924, Word War I veteran and artist Otto Dix created his own version, based on his experiences in the trenches: *Der Kreig*, a 52-part testament to the horror of war. Dix shows violence, death, rape, and the rotting, decaying bodies.

War films have generally been less graphic, though in the harrowing *Come and See* (1985, dir. Elem Klimov), set in World War II, the child protagonist witnesses a pile of bodies being stacked behind a house, a barn full of people on fire, and a gang rape. *All Quiet on the Western Front* (Lewis Milestone, 1930), released as a silent and a sound film, may be the first true "war film" in its realistic depiction of an actual conflict. It did not hide the violence of war: in one memorable scene, during an attack, a soldier grabs onto barbed wire, but when a shell explodes, only his arms are left, hanging from the wire, a scene strongly reminiscent of Dix's *Der Kreig*.

4.6

4.6
The Third of May 1808, 1814
Artist: Francisco Goya (1746–1828)
One of a number of compositions that Goya created around the subject of the Peninsular War in Spain. Critic Robert Hughes says that here "Goya speaks for the victims: not only for those killed in French reprisals in Madrid, but for all the millions of victims destroyed, before and since, in the name of The People."[12]

SEX IN ART
AND CINEMA

**VIOLENCE
IN ART AND
CINEMA**

SEX AND
VIOLENCE

CASE STUDY:
MARTIN
SCORSESE AND
CARAVAGGIO

EXERCISES,
DISCUSSION
QUESTIONS,
AND FURTHER
READING

The introduction of the Hays Code in 1930 limited the possibilities for screen violence in war films; the emphasis was on bravery, self-sacrifice, and often romantic subplots. During World War II, films occasionally used strong violence to jolt the audience into heightened awareness of the war's dangers. *Bataan* (Tay Garnett, 1943) chronicles a horrific defeat of Americans in the Philippines; made just a year after the 1942 events, it depicts stoicism, bravery, and sacrifice but also reveals graphic violence. In the final scene, hero Dane (Robert Taylor) runs out of ammunition but continues firing, with the machine gun pointing at the audience. Interestingly the Battle of Bataan was the subject of two further films. *Cry "Havoc"* (Richard Thorpe, 1943), about the nurses at Bataan, shows less violence, but at the end has the women surrendering to Japanese forces, their terrible fate implied. *Back to Bataan*, made in 1945, directed by Edward Dmytryk and starring John Wayne, is highly fictionalized; here the tone is much more upbeat than in Garnett's film, and the combat less graphic.

The post-Vietnam era offered new departures in visual storytelling. *Casualties of War* (Brian De Palma, 1989), based on a true story, details the violent rape and murder of a Vietnamese girl by US troops. De Palma returns to the same theme in *Redacted* (2007), also depressingly based on a true story from the Iraq war, but in this later film he uses a different aesthetic, digital video—camcorder footage, YouTube-like video clips, documentary footage—all created by De Palma. The film is often referred to as a "docudrama," but it is entirely constructed.

FURTHER VIEWING

Watch these war films for their depiction of violence:

La Grande Illusion (Jean Renoir, 1937)

The Battle of Algiers (Gillo Pontecorvo, 1966)

Full Metal Jacket (Stanley Kubrick, 1987)

Interesting war films revisiting history:

Glory (Edward Zwick, 1989)—the US Civil War and the Battle of Fort Wagner

Days of Glory (Rachid Bouchareb, 2006)—French Algerian troops in World War II France

State-Sanctioned Violence

The Execution of Lady Jane Grey by French painter Paul Delaroche was exhibited in the Paris Salon in 1834. Several contemporary sources described the trial and execution of the young Queen of England, which Delaroche was able to use. He visited the Tower of London twice; his notes and sketches of the tower and its environs show how methodical he was. National Gallery curator Chris Riopelle says that Delaroche "wanted you to feel he was acting as a historian."[13] However, he also understood the necessity of creating the right dramatic moment. He played around with actual historical detail: for example, he set the execution in the Tower's interior, rather than outside on the green where it actually took place. This allowed him to concentrate the lighting and to compress the elements of the picture into a tight, claustrophobic arrangement, increasing the sense of dread. As well, he understood that to really convey the violence of the execution, it was better not to portray the actual moment of violent death, but to emphasize the innocent victim. Therefore, he presents Jane in a shining white silk dress and blindfold, being guided to the execution block on which she must lay her head. Her hands reach out, trying to feel her way. The viewer's impulse is to grab those hands and pull her out of the picture immediately. Beside her, the implacable executioner holds the huge axe. The composition is balanced on the left by the mourners in the background.

4.7
***The Execution of Lady Jane Grey*, 1833**
Artist: Paul Delaroche (1797–1856)
The real Jane Grey was only sixteen years old when she became the victim of a dynastic dispute in sixteenth-century England. Delaroche was fascinated by English history and researched it in depth.

SEX IN ART
AND CINEMA

**VIOLENCE
IN ART AND
CINEMA**

SEX AND
VIOLENCE

CASE STUDY:
MARTIN
SCORSESE AND
CARAVAGGIO

EXERCISES,
DISCUSSION
QUESTIONS,
AND FURTHER
READING

Extreme Violence

In Chapter 2 we looked at Pieter Bruegel the Elder's painting *The Massacre of the Innocents*. We saw how Bruegel had transferred the biblical story, in which King Herod commands his soldiers to kill the infant boys in Bethlehem, into the rendering of a contemporary Flemish town being raided by military force. Many painters have used this as their subject—some like Bruegel reinterpreting it in a contemporary context, others retaining the original biblical setting.

Cornelis van Haarlem reinterprets this biblical myth in two versions of the massacre, 1590 and 1591. Van Haarlem's massacre is not realistic: it is a nightmarish and grotesque subversion of classical ideals. This is very different from Goya, who based *The Third of May* on firsthand accounts of the depredations that were happening during the Peninsular War, or Otto Dix, who spent the First World War as a private soldier in the trenches. Rather, this is war of the imagination, where sheer brutality reigns. In the earlier, 1590 version, the images are even more horrible: piles of dead babies lie on the ground, and the most prominent image is of a huge man straddling a woman while he murders her baby. Further back on the left, a group of women have caught one soldier and are killing him; in the background people flee in terror, while another soldier beats a woman. The grotesquely muscular, gargantuan nude bodies of the soldiers flinging babies about and cutting their throats are graphic and repulsive. Van Haarlem takes the classical notion of perfection— muscular, beautiful bodies—and then subverts it by showing them doing acts of utter evil.[14] Van Haarlem's work belongs to a school of painting known as Dutch (or Northern) Mannerism (see Glossary), known for dramatic, highly stylized, and vividly colored compositions, often featuring twisted and complex poses, sometimes (as here) sheering off toward the grotesque.

The Moment of Violence

Like Otto Dix, C. R. W. Nevinson (1889–1946) served in the First World War, with the medical corps. He was of the generation of young painters who depicted their wartime experience. In *Paths of Glory* (1917), Nevinson shows us dead soldiers in a muddy landscape surrounded by barbed wire. It was painted during the war, not afterwards, and it caused controversy at the time (the painting was officially censored as hindering the war effort and Nevinson was publicly reprimanded). *Paths of Glory* is a reflective piece meant for musing upon and thinking about the devastation of war and waste of life. In his earlier picture *Bursting Shell* (1915), Nevinson does something completely different: instead of telling us what the war looked like, he conveys to us what the war felt like. The painting, which is in the Tate Britain, recreates the effect of an explosion: out of the brick-built environment a vortex of light appears, and everything is shattered by huge angular jagged shards of darkness that appear to rush into the painting from all sides. The effect is completely disorienting, dizzying, even frightening. However, it is exciting, a moment of violence to experience, not reflect upon. *Bursting Shell* can be related to avant-garde movements Vorticism and Futurism (see Glossary).

By 1917 it seems Nevinson's view on the war was clear. Both the painting and the 1957 Stanley Kubrick antiwar film *Paths of Glory* get their title from a line in a Thomas Gray poem: "The paths of glory lead but to the grave."

SEX AND VIOLENCE

Sex and violence together are often one of the most contentious problems in cinema, when violence becomes sexualized. There are different ways of portraying it, such as displacement, but quite often the relationship between sex and violence is the turning point of the plot: think of all those *femmes fatales* of the film noirs, or the neo-noirs like *Body Heat* (1981) or *Sin City* (2005).

Sex and violence is not a relationship made in cinema, but was already long established in painting. One popular subject of painters was "Judith Beheading Holofernes." Although the early versions were restrained, painters (or their clients) soon developed a prurient interest in combining the sex and the violence by emphasizing Judith's sexuality. There are three particularly important paintings that show the actual moment of killing: Caravaggio's *Judith Slaying Holofernes*

(1612), Artemisia Gentileschi's (c. 1620), and the 1622 one by Johann Liss shown here. All three are extremely violent, although the one by Liss is probably the goriest. Liss and Gentileschi show just how hard work it is to cut off the head of a grown man. Without being sexually provocative, they demonstrate the dangerous nexus of sex and violence. The subject remained popular: Goya completed a version in 1823, and the Austrian painter Gustav Klimt took time out from painting Viennese high society to make two versions of Judith carrying the head and exulting in it.

On the one hand, this is another example of a Bible story (albeit an apocryphal story) being used as another excuse for a sexualized visual narrative; on the other hand, it is interesting how the same story was continually revived, even leading to two Italian films (in 1929 and 1959). While there

are many pictures of victimized women in art, there are few examples of the actively violent female. Judith is the most frequently depicted. Judith is an interesting and conflicted subject: on the one hand, she really is the heroine, a woman saving her people from the general's depredations; on the other hand (and especially to the paintings' male audiences), she is a terrifying, avenging female, arousing disturbing sexual fantasies. None of the pictures of Judith by Caravaggio, Liss, or Gentileschi sexualizes her, but notice how Liss shows the blood ejaculating in a gory spray from the severed neck.

SEX IN ART
AND CINEMA

VIOLENCE
IN ART AND
CINEMA

**SEX AND
VIOLENCE**

CASE STUDY:
MARTIN
SCORSESE AND
CARAVAGGIO

EXERCISES,
DISCUSSION
QUESTIONS,
AND FURTHER
READING

4.8

4.8
Judith in the Tent of Holofernes,
1622
Artist: Johann Liss (1597–1631)
This painting is based on an
apocryphal Bible story: Judith was
a Hebrew woman who used her
feminine wiles to get into the tent
of the enemy Assyrian general
Holofernes and then cut off
his head.

CASE STUDY:
MARTIN SCORSESE AND CARAVAGGIO

The violence in Martin Scorsese's work has sometimes been called "baroque." The discussion here will focus on *Taxi Driver* and *Goodfellas*, along with two paintings by Caravaggio.

Peter Greenaway actively used Dutch painting as the basis for his subject matter and his *mise en scène*. Peter Webber based *The Girl with the Pearl Earring* on a number of Vermeer paintings. Michael Mann used a painting by Canadian artist Alex Colville to set up a shot in *Heat*. But these are relatively limited approaches to the way in which filmmakers use art history. Far more common is the way in which Martin Scorsese uses painting: as inspiration in staging narrative events and a tool in understanding how painting can energize and guide the process

of film composition. When British art historian Andrew Graham Dixon wrote a book about Caravaggio,[15] he went to Martin Scorsese and asked him why he felt Caravaggio was one of his chief inspirations.

Perhaps above all, Scorsese has been inspired by Caravaggio simply because he is one of the greatest painters of the "cinematic" moment: "You come upon the scene midway and you're immersed in it. It was different from the composition of the paintings that preceded it. It was like modern staging in film: it was so powerful and direct. He would have been a great filmmaker, there's no doubt about it."[16]

The 1970s New York of *Mean Streets* and *Taxi Driver* is a decaying city, edging toward bankruptcy, rife

with crime and decay. The neon lights give beauty to the night city, but the glowing shop fronts are porn theaters and bars. The desperation of ordinary people is conveyed in the street shots, and in the undercurrent of violence. In *Taxi Driver*, when the grocery is robbed, Travis shoots the robber, but the real violence happens afterwards when the frustrated and desperate shopkeeper beats the dying man with a crowbar in a paroxysm of anger. *Goodfellas* portrays the lives of New York gangsters, a favorite subject for Hollywood for decades; but Scorsese shows us that the mobsters and their molls are not glamorous, despite all the money that slides though their hands. The coarse women are utterly ordinary; the men are lumpen.

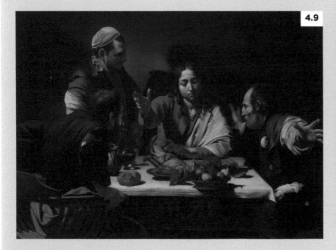

4.9

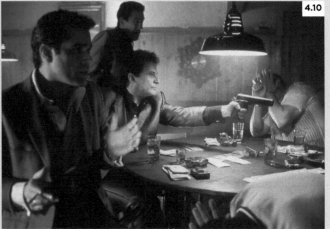

4.10

4.9
***The Supper at Emmaus*, 1601**
Artist: Caravaggio (1571–1610)
As well as the "dirty realism" of the painting, note the tensed position of the figure on the left, and the arm reaching out of the canvas on the right.

4.10
Goodfellas
Dir. Martin Scorsese, DP Michael Ballhaus
Notice how both Scorsese and Caravaggio organize groups of men—here, a group around a table.

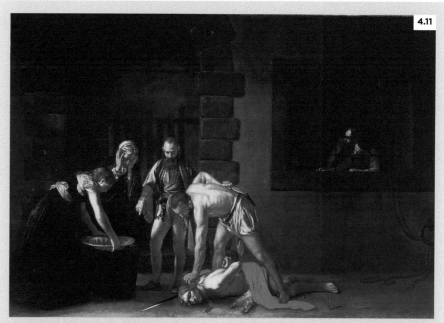

4.11

The bleak lives and desperation of ordinary people is what Scorsese was looking to portray in these films, and this is what he found in Caravaggio's great religious paintings. Before he decided to pursue filmmaking, Scorsese entertained the idea of becoming a priest, and certainly cultural Catholicism is a hallmark of all of his films.

What makes Caravaggio so important to Scorsese is realism, his insistence on setting all of the religious stories in the back streets of Rome and Naples. Take, for example, his rendering of *The Supper at Emmaus* (1601). This has been painted by many artists, but only Caravaggio's two versions make viewers feel that they are really sitting in a shabby inn, looking at a group of poor workers having a meal, and that one of them might actually be the Savior. Caravaggio offers up salvation within a dingy, dirty, completely ordinary place. It's as if he's saying, "If it can't happen here, it can't happen at all." Characters with lank, greasy hair, dirty nails, sweat-stained garments—this is sometimes referred to as "dirty realism." In film it's often called "gritty realism," but it means the same thing.

Scorsese says, "I felt an affinity with the work, because they didn't seem like the usual models from the Renaissance, these were people who were really living life. It was direct and powerful that way and it was startling." He notes, "There's something in Caravaggio that shows a real street knowledge of the sinner; his sacred paintings are profane."

Both the painter and the filmmaker show powerful yet highly controlled violence. In *Taxi Driver*'s climactic scene, a single light bulb barely illuminates the corridor; the violence erupts like a bomb in a space that is claustrophobic, horribly intimate. Scorsese concludes the scene by following the trail of gore back out into the world, where it all started. Scorsese takes a different approach in *Goodfellas*, which is not about violence per se, but about the workings of the criminal subculture. Here, only one character, Tommy, played by Joe Pesci, is consistently seen committing acts of violence. His outbursts of violence are sudden, very brief, and very deadly. While many acts of violence are referred to throughout the film, Scorsese limits and controls the amount of violence that we see in any one scene.

4.11
The Decapitation of St. John the Baptist, 1608
Artist: Caravaggio (1571–1610)
Caravaggio made several versions of the decapitated Baptist, but here he shows the awful moment of death. The scene plays out in a dim courtyard, illuminated by an unseen light source. John has already had his throat cut; dying, he is held down by his assailant, who is preparing to hack the head off. The woman on the left holds the silver dish that will be used to serve the head up to King Herod and Salome. The execution is business as usual, efficient, bleak, and stark. The older woman alone appears appalled, holding the sides of her head, but helplessly unable to intervene; she can only bear witness.

EXERCISES AND DISCUSSION QUESTIONS

The line separating the real and the unreal is always going to be blurred. This is as true in painting as it is in cinema. The human imagination is constantly seeking ways to explain the world as it is, but also the world as we think and feel that it is. In trying to harness the human imagination and allow it to enhance and illuminate reality, artists and filmmakers have turned to fantastic forms from mythology, exploration of the unconscious, and subversion of the ordinary objects of everyday life by giving them new qualities.

Exercise

Select a scene from *Taxi Driver* or *Goodfellas*. Watch it and freeze frame it at a scene of violence. What are the elements of this composition? How would it feel to you, if it was a painting instead of a freeze frame? What, to you, are the essential differences?

Try this exercise with other films.

DISCUSSION QUESTIONS

1. Although a number of paintings show black soldiers in active duty, only John Singleton Copley's makes one a hero. Similarly, cinema has only very lately begun to represent nonwhite soldiers as individual participants in conflict. Edward Zwick in *Glory* (1989) filmed the little-known true story of the African American 54th Massachusetts Volunteer Infantry during the American Civil War, in particular their part in the battle of Fort Wagner. In 2006 French director Rachid Bouchareb made *Days of Glory* (*Indigènes*), which depicted another true story, the experience of African soldiers serving in the Free French Forces during the Second World War.

 Think about point of view and image making in terms of history painting and historical stories in cinema. How does the representation of war, either in painting or cinema, affect the way we think about it?

2. As a child, van Haarlem experienced the Spanish army laying siege to his hometown of Haarlem, and it's possible that his nightmarish vision in *The Massacre of the Innocents* (1591) was aroused by childhood trauma. Are such paintings simply gratuitous violence, or do they express something necessary? Compare van Haarlem's interpretation of *The Massacre of the Innocents* with that of Bruegel from Chapter 2, and also Pieter Paul Rubens's renderings (1611 and 1636).

3. How do filmmakers visually convey the brutality and horror of war? Compare films made during and just after World War II with those made just after the Vietnam War.

4. Since the demise of the Hays Code in Hollywood, sex and violence have been increasingly accepted elements in films. Are there any examples you can find in art history that show sex or violence that would be unacceptable in mainstream cinema even today? Explore artists like Rubens, Otto Dix, Hermann Nitzsch, Gustave Courbet, and Ronald Ophuis.

FURTHER READING

John Berger, *Ways of Seeing* (Penguin Modern Classics, 2008)

John Berger, *About Looking* (Bloomsbury Publishing, 2009)

Flaminio Gualdoni, *The History of the Nude* (Skira, 2013)

Andrew Graham-Dixon, *Caravaggio: A Life Sacred and Profane* (Penguin, 2010)

Edward Said, *Orientalism* (Penguin, 1971)

Ian Christie, *Scorsese on Scorsese*, 3rd ed. (Faber & Faber, 2003)

Francisco Goya, *The Disasters of War* (Dover Books, 1968)

NOTES

1 See John Berger, *Ways of Seeing* (Penguin Classics, 2008).

2 Quoted in Karen Wilkin, "The Talk of the Salon," *The New Criterion*, Vol. 14 (Jan. 1996), p. 60.

3 Jonathan Jones, "For Critics, It's Better to Be Interesting than Right," *The Guardian*, January 28, 2011.

4 *Ibid.* Another modern critic, Waldemar Januszcak, notes, "Yes, he [Boucher] is a peddler of soft porn, but the exact course of his intentions remains fascinatingly unchartable." From "Boucher and Chardin at the Wallace Collection," June 22, 2008, http://www.waldemar.tv/2008/06/boucher-and-chardin-at-the-wallace-collection.

5 Egyptian filmmaker Yusuf Chahine made a film about this, *Adieu Bonaparte* (1985), with Patrice Chéreau as Napoléon Bonaparte.

6 For an extended discussion of Orientalism and the cinema, see *Reel Bad Arabs* (dir. Sut Jhally and Jack Shaheen, 2006); the book was published by Interlink in 2009. For a theoretical discussion of Orientalist art and colonialism, see Edward Said, *Orientalism* (Penguin, 1971).

7 Bernice B. Rose, *Picasso, Braque and Early Film in Cubism* (Pace Wildenstein, 2007); see also Gerald Noxon, "Cinema and Cubism" (1900–1915), *The Journal of the Society of Cinematologists*, Vol. 2 (1962), pp. 23–33.

8 A useful website is http://figurationfeminine.blogspot.co.uk (in French).

9 Elizabeth Butler, *An Autobiography* (Constable & Co., 1922), available at http://www.gutenberg.org.

10 "The scenes pit the well-organised French against the savage Arabs to sustain the illusion of a confrontation between civilisation and barbarism." Albert Boime, *Art in an Age of Counterrevolution, 1815–1848* (University of Chicago Press, 2004).

11 Robert Hughes, *Goya* (Vintage, 2004).

12 Robert Hughes, "Goya," in *Nothing If Not Critical: Selected Essays on Art and Artists* (Penguin, 1990).

13 Chris Riopelle in *The National Gallery Podcast: Episode Forty One*, March 2010, available at www.nationalgallery.org.uk.

14 Seymour Slive, *Dutch Painting 1600–1800* (Yale University Press, 1995).

15 Andrew Graham-Dixon, *Caravaggio: A Life Sacred and Profane* (Penguin, 2010).

16 BBC, *The Culture Show*.

CHAPTER FIVE
HORROR

"TERROR AND HORROR ARE SO FAR OPPOSITE, THAT THE FIRST EXPANDS THE SOUL, AND AWAKENS THE FACULTIES TO A HIGH DEGREE OF LIFE; THE OTHER CONTRACTS, FREEZES, AND NEARLY ANNIHILATES THEM."
—Ann Radcliffe (1764–1823), "On the Supernatural in Poetry"[1]

Horror is a genre in cinema, but it doesn't exist as a category or genre in art. Nevertheless, it is clear that horror movie imagery derives, in no small part, from a wealth of art historical images. The Greeks had a mythology full of horrendous monsters: the Hydra, the Gorgon, the Cyclops, and more. The medieval world believed in witches, and monsters such as the manticore. Religion gives us images of the Devil, and demons ready to drag the sinner into the pits of Hell. Remote parts of the world gave rise to stories about the Loch Ness monster lurking in the depths of a Scottish lake, the Yeti of the high Himalayas, and the Sasquatch in the Pacific coastal forests. We have had no lack of horrible stories to entertain ourselves. However, we are probably less familiar with the art history of horror. This chapter will look at four principal categories: religious horror, involving images of the Devil; supernatural horror, involving witchcraft, vampires, and the uncanny; body horror, where the body itself becomes a site of horror through torture or forced modification of the body; and finally, the ever popular monsters—dragons, giants, and aliens.

The chapter includes a case study looking at the wonderful world of Mexican director Guillermo del Toro and how the Spanish painter Francisco de Goya has been a long-standing influence on his work.

RELIGIOUS
HORROR

SUPERNATURAL
HORROR

BODY HORROR

MONSTERS

CASE STUDY:
GUILLERMO
DEL TORO AND
FRANCISCO
DE GOYA

EXERCISES,
DISCUSSION
QUESTIONS,
AND FURTHER
READING

RELIGIOUS HORROR

The theme of the temptation of St. Anthony of Egypt became very popular all over Europe during the sixteenth and seventeenth centuries. Anthony was the founder of monasticism, and the best-known story tells how he went into the desert to live as a hermit. The Devil arrived and tried to entice Anthony into the sins of gluttony and lust, to no avail. In art, the symbols for his temptation are pigs for gluttony and demoniacally beautiful women (*succubi*) for lust. Paintings of Anthony's temptations began appearing in Italy at the end of the fifteenth century and soon spread across Europe.

One of the best-known Temptations of St. Anthony is by Hieronymus Bosch, but it is only one of a number of major works in which the saint is mistreated by fabulously graphic demons of all kinds. Artists were free to display all kinds of strange zoomorphic and anthropomorphic devils, including the more salacious temptations of nudes and sexually vulgar demons. And these were popular. David Teniers the Younger (1610–1690) alone painted approximately 300–400 variations of the Temptations of Saint Anthony. As well as offering a cautionary tale, the demonic images are entertaining and stimulating in their own right.

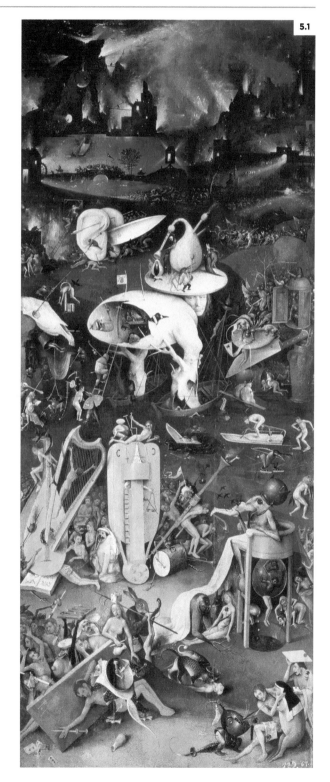

5.1

5.1
***Triptych of the Garden of Earthly Delights*, n.d.**
Hieronymus Bosch (1450–1516)
This is one panel of a triptych that depicts Paradise on the left panel, the "earthly delights" on the middle panel, and on the right panel, seen here, Hell and its bizarre punishments.

Despite the importance of the figure of the Devil in European Christian culture until the eighteenth century, and the enormous plethora of religion-inspired artistic subjects, actual depictions of the Devil in art are relatively rare. None appear in the canon of what is normally considered "great art." The few depictions that do exist normally appear in artworks designed specifically for churches, such as *The Devil Presenting St. Augustine with the Book of Vices*, oil on wood, by Michael Pacher (1479–1481), now in the Alte Pinakothek, Munich. The painting depicts the saint, clad in a bright red robe, facing down the Devil. Pacher depicts the Devil as reptilian, orange-horned and green-skinned, with batlike wings and two faces, one on its head and the other at its rectum. This depiction is not a self-standing artwork but forms part of a large church altarpiece.

Devils and demons appeared more frequently in prints and illustrations to books, such as the rather frightening Witch of Endor evoking the Prophet Samuel, by seventeenth-century engraver Johann Heinrich Schonfeld, or the many Devil pictures in the *Malleus Maleficarum* (1487), a German witch-hunting manual. Clearly, the Church was not keen on commissioning depictions of the Devil for public view, perhaps because the threat was more powerful when left to the imagination or, conversely, perhaps the Church felt that the image was too frightening. There was no "official" Church-sanctioned public image of the Devil, so evil was communicated more often by a range of symbols, some deriving from pre-Christian religions.[2]

Images of Hell do appear in art. For example, in *The Rich Man Being Led to Hell* (1647) by David Teniers the Younger, Hell is depicted as an unpleasant place, populated by demons and monsters, but no principal Devil is depicted. The artist is much more interested in illustrating the plight of the selfish rich man and the predicament he has found himself in. Likewise, Bosch's depiction of Hell in the *Garden of Earthly Delights* does not contain the Devil, though it contains all kinds of monstrous creatures. Yet however much they may have believed in Hell and the temptations of the Devil, when it came to painting, it was almost impossible to avoid a grotesquerie that entertains more than frightens.

RELIGIOUS
HORROR

SUPERNATURAL
HORROR BODY HORROR MONSTERS

CASE STUDY: EXERCISES,
GUILLERMO DISCUSSION
DEL TORO AND QUESTIONS,
FRANCISCO AND FURTHER
DE GOYA READING

This also presents a problem for filmmakers: how to present absolute evil? As Darren Oldridge points out, "representing the Devil in film presents similar problems to those encountered in other visual arts. As the personification of an abstract concept, it is difficult to translate Satan into a moving image."[3] The strange and creepy 1922 Danish silent *Häxan* (written and directed by Benjamin Christensen, who plays the horned Devil) is an early, and often compelling, example. The Devil in human form has been represented many times in film history, from Walter Huston's "Mr. Scratch" in William Dieterle's political fantasy *The Devil and Daniel Webster* (1941, DP Joseph H. August) to Robert de Niro's dapper "Louis Cyphre" in the voodoo-infused *Angel Heart* (1987, Alan Parker, DP Michael Seresin) and 2010's *Devil* (dir. John Erick Dowdle), which mostly takes place in a stuck elevator. However, these depictions, while effective in their respective stories, do not offer a special visual image.

With lavish reenactments and dramatizations, *Häxan: Witchcraft Through the Ages* (1922), directed by Benjamin Christensen, is one of the first films that can be considered a "docudrama." Based on the *Malleus Maleficarum*, a fifteenth-century text about witch hunting, it is also one of the few films to attempt to show the Devil in monstrous form.

The filmmaker who came closest to realizing a genuinely frightening depiction of the Devil was William Friedkin in *The Exorcist*. In this case, the Devil is manifested in the body of a young girl. The image still remains disturbing, as it plays on the fear of a person being completely transformed by a demonic possession. Echoing Pacher's depiction, her skin becomes greenish, her eyes bulge out and turn red, and she almost ceases to resemble a human being. The transformation from a young innocent girl into a portal for the Beast is the driving narrative of the story. This was achieved by the talented makeup and special effects artist Dick Smith, who pioneered techniques using foam latex, plastics, and innovative makeup tones. Smith was extremely influential, mentoring both J. J. Abrams and Guillermo del Toro, among others.

Poet and painter William Blake (1757–1827) completely rejected previous demonic imagery for his depiction of Satan. His devil in *Satan, Mortal Sin* (c. 1805) is no scaly, hideous monster, but instead a beautiful fallen angel, a sublime, heroic figure. Blake was not being original; there are numerous similar renderings of Satan in eighteenth-century English art. *Satan Summoning His Legions* was depicted by Royal Academicians John Cozens (1752–1797), Thomas Stothard (1755–1834), and Sir Thomas Lawrence (1769–1830). This representation was due in part to Enlightenment ideas and the influence of John Milton's epic poem *Paradise Lost* (1667), which inspired a romantic, even sympathetic depiction of the Devil as a Promethean figure.

See also the film *The Devil Rides Out* (1968). Peter Stanford, author of *The Devil: A Biography*, notes that director Terence Fisher "offers a devil figure bedecked with every Christian cliche from the past 2000 years. Blood sacrifices, nocturnal orgies and witchcraft combine to dress/camp up an otherwise routine thriller."[4]

SUPERNATURAL HORROR

Although unlike in northern Europe, witch hunting was not a cultural phenomenon in Italy, Italian artist Salvator Rosa was influenced by northern European prints in creating *Witches at Their Incantations* (c. 1646). It is a powerful chiaroscuro painting of horror, set in a nocturnal landscape. The witches cast hideous spells in the foreground, using body parts. An animated bird skeleton towers over them, and a man hangs from a withered tree. One witch has already conjured up a grotesque beast, while another feeds a baby into a monster's maw. The composition is voyeuristic, as if the viewer is spying on the witches. Voyeurism is a major trope in horror; it is the catalyst for the 1975 horror film *Race with the Devil* (dir. Jack Starrett), as Peter Fonda and Warren Oates spy on a Satanic rite, depicted very like Rosa's composition, and incur the cult's wrath.

The 1781 painting *The Nightmare* by Henry Füssli (sometimes spelled Fuesli), seen in Chapter 3, was one of the most popular and sensational pictures of its day. Since its first public exhibition at the Royal Academy, it has been an icon of horror.

As previously discussed, it is a dream picture, but what a dream! Here we see demons, ghosts, and death all together in one painting. The demon sits on the chest of the swooning woman, as the ghost horse peers through the blood-red curtain with terrifying blind white eyes, straight at the viewer. The depicted lighting also adds to the unsettling narrative, with the light brightest on the woman's face, arm, and chest, illuminating them yet at the same time illuminating the diabolical features of the demon and the mare.

The title is a play on words: "mare" is obviously the horse, but it also refers to *mara*, a Nordic mythical spirit sent to torment sleepers. The horse is probably based on the ghostly beast figures in Salvator Rosa's *Saul and the Witch of Endor* (1668). One critic wrote, "*The Night Mare* by Mr. Fussli, like all his productions, has strong marks of genius about it; but hag-riding is too unpleasant a thought to be agreeable to any one."[5] "Hag-riding" is the term used to describe the visions associated with sleep paralysis; it comes from the older idea that during sleep a hag or witch would torment the sleeper. Sometimes the tormentor is described as an *incubus*—a male demon that sexually assaults the female sleeper (the female-on-male equivalent is the *succubus*, depicted in art by Edvard Munch and Felicien Rops, among others). The sexualized version of the vampire myth, as portrayed in novels by John Polidori (*The Vampyr*, 1819) and Bram Stoker (*Dracula*, 1897), clearly derives from this notion, though the vampire displaces the sex act by blood sucking.[6]

See Edvard Munch's *The Vampyre*, 1893. Munch's title was not *Vampire* but *Love and Pain*, but audiences saw supernatural sadomasochism in it.

The sexualization of horror is part of "Gothic," a style in art and literature that emphasizes the macabre and the sensational. Contemporary critics were taken aback by the overt sexuality of Füssli's *The Nightmare*. Modern critics have speculated that the painting's intent is actually to show female orgasm. Some go so far as to accuse the painting of being a rape fantasy, even "spiced with a touch of necrophilia," and Füssli made many erotic private drawings. Visitors noted that Sigmund Freud had the print hanging in his office at Berggasse 16 in Vienna. Yet for all the sexuality in the picture, there is nothing overt or graphic, no nudity. It is all suggested by the position of the body.

This is the painting of imagination. In it can be seen the influences of classicism and also the grotesque, in the gargoyle-like demon. Füssli painted at least three other versions of the painting, and it was widely copied and reproduced. Even other artists made their own versions of the theme. It has inspired other artists and filmmakers, from F. W. Murnau in *Nosferatu* (1922) to Ken Russell, who restaged *The Nightmare* in his 1986 film *Gothic*. Supernatural eroticism continues to be an essential element of the horror genre to the present today.

RELIGIOUS
HORROR

SUPERNATURAL
HORROR

BODY HORROR

MONSTERS

CASE STUDY:
GUILLERMO
DEL TORO AND
FRANCISCO
DE GOYA

EXERCISES,
DISCUSSION
QUESTIONS,
AND FURTHER
READING

Though it is rare to see renderings of the supernatural in contemporary fine art, it continues to be popular in illustration, comic books, and graphic art worldwide. In cinema, the supernatural is a thriving subgenre of horror. Michael J. Bassett's 2009 horror film *Solomon Kane* (DP Dan Laustsen, production designer Ricky Eyres) combines moody, misty winter landscapes, strongly reminiscent of the paintings of Caspar David Friedrich and Arnold Böcklin, with mutant monsters and a demon to create an effective, atmospheric thriller.

Arnold Böcklin's *The Plague* (1898) shows a horrific supernatural figure representing the plague—a very real terror, since diseases like cholera were rife. See also how his moody *Ruins in a Moonlit Landscape* (1849) evokes the possibility of the supernatural.[7]

WHAT IS "GOTHIC"?

The term "Gothic" is so overused as to be almost meaningless. Gothic can refer to early East Germanic tribes, or their language. Alternatively, it is most used to describe a much later medieval art movement. We talk about Gothic architecture, but we can also fast-forward to the nineteenth century and talk about Gothic Revival architecture, or neo-Gothic. Complicating matters still further, Gothic is associated with Romanticism, particularly in art and fiction. This is where Füssli's work fits, alongside a whole host of others. From the late twentieth century, we can also talk about Gothic subculture in fashion and music, and that itself has been subdivided into a whole host of aspects. Gothic is also a font.

If the term is so overused, at what point is it useful to us? Principally, what we are talking about in this book is more properly called neo-Gothic. It is important to understand the literary precedents of Gothic art, which started in England in the 1760s and has continued gaining popularity up to the present day. Gothic novels inspired many paintings, with their scenes of mystery, horror, the supernatural, as well as psychological terror. Plots were meant to be dark, tempestuous, with madness and ghosts and base urges such as revenge or lust. Mary Shelley's *Frankenstein* (1818) and the stories of Edgar Allan Poe (1809–1849) exemplify Gothic literature. The popularity of such literature crossed over into art, and we see painters like Füssli plugging into the same dramatic, supernatural, emotional temper. However, unlike violence and horror dealt with in realism (such as Goya's *Disaster of War* or the opening sequence of Spielberg's *Saving Private Ryan*), the depictions of terror within Gothic are not meant as a cathartic experience, but are meant to be enjoyed as thrills for their own sake. We can see this strongly in *The Nightmare*: its chief and perhaps only purpose is to thrill.

BODY HORROR

Body horror is based on deep-seated fear of the disfigurement and despoliation of the living body, and of the decomposition of the dead body. It reminds us of our mortality, frailty, and vulnerability. Ancient cultures understood this fear very well; for example, in ancient Egypt it was believed that despoiling a body meant that the soul could not reach the afterlife. Likewise, to disfigure a statue was a grave insult to whomever it represented. Body horror in art and cinema is based on the visual representation of this violence toward the body; to varying degrees, the shock is in witnessing the desecration of the living or the dead.

One of the earliest horrific images in Western art is actually a crucifixion scene: Matthias Grünewald's crucifixion for the Isenheim altarpiece (1512–1516). It is a nighttime scene, with the crucified body in the front and center of the composition. Grünewald's Christ is a macabre figure, distorted in agony, his body already decaying as he slowly dies a monstrous, torturous death. This is a painting about the extremes of physical suffering, yet it was not painted to terrify its viewers. It was painted for a hospital, and it was meant to help people suffering from plague: by identifying their own suffering bodies with the suffering of the Savior, it was meant to bring hope, if not in this life then in the afterlife. Very few representations of the crucifixion since Grünewald's have been so graphic.

Martin Scorsese also emphasized the brutality of crucifixion in *The Last Temptation of Christ* (1988). Mel Gibson's 2004 film *The Passion of the Christ* was controversial because of the extreme violence of the crucifixion, and there were accusations that it turned the story into a kind of body horror. This raises the question: when does extreme violence turn into body horror? It is a matter of degree, but we can call it body horror when the principal emphasis of the picture or the film is on the torn and mutilated body.

This is certainly the case in Titian's *The Punishment of Marsyas* (c. 1570). According to the legend, Marsyas was a satyr (a half-human, half-animal creature) who challenged the god Apollo to a music contest and lost. The punishment, for his hubris in challenging a god, was to be flayed alive. Titian (1488–1576) paints the flaying as a kind of diabolical party. This is not the only painting of this horrible punishment; the subject was also addressed by José de Ribera (1637), also quite a disturbing image. In Ribera's picture, the animalistic aspects of the satyr are almost completely imperceptible. The horror lies in the visceral depiction of Marsyas screaming in agony as Apollo strips open his leg. Bartolomeo Manfred's *Apollo and Marsyas* (1616–1620) is tame by comparison. In Titian's version there's quite a crowd, playing music and seemingly enjoying themselves. Marsyas is upside down, like an animal at slaughter, but also maybe an alchemical reference to the symbol of the Hanged Man.[8] The mundane reality of the dog lapping up the spilt blood, while another character is collecting the blood in a bucket, like a butcher going to make blood pudding, renders the scene both prosaic and repulsive in the same moment. Yet perhaps this is another alchemical reference.

Why would artists want to paint something as horrifying as somebody being flayed alive? Titian and Ribera did not paint these pictures just for the gore. In classical times, Marsyas was always ambiguous. He was the mortal, subhuman creature who dared to challenge a god, thus upsetting the hierarchy and deserving of punishment. However, to the Romans, he was sometimes portrayed as a proponent of free speech and a symbol of liberty, and was associated with the common people. Sometimes he was even seen as a subversive symbol in opposition to the emperor. It is possible that in late Renaissance Italy, this Roman interpretation of the mythological character of Marsyas still had currency. Another possibility is that Titian was inspired by the recent terrible execution of the governor of Venetian Cyprus, Marcantonio Bragadin, captured by the Ottomans in 1571 and flayed alive.[9] Flaying was not common, but it was known to happen.

As discussed in the previous chapter, there are scenes of violence in paintings that would be considered too extreme for cinema audiences. However, in 2008, *Martyrs*, directed by Pascal Laugier, featured the protagonist Anna (Morjana Alaoui) being flayed alive in graphic detail. The film, part of the movement known as New French Extremity, continues to be controversial. However, so-called New French Extremity is only one direction in body horror cinema. Some filmmakers, such as Catherine Breillat, have been widely acclaimed for combining body horror with philosophical and intellectual questions. The same can be said, in a more populist way, about the work

RELIGIOUS HORROR SUPERNATURAL HORROR MONSTERS CASE STUDY: GUILLERMO DEL TORO AND FRANCISCO DE GOYA EXERCISES, DISCUSSION QUESTIONS, AND FURTHER READING

BODY HORROR

of David Cronenberg. Cronenberg's earliest films, including *The Brood* (1979), *Videodrome* (1983), and *The Fly* (1986), are all masterpieces of the body horror genre. In 2005, Eli Roth made the first *Hostel* film, which deeply divided critics, unsure if it was "just one damn blow-torching after another"[10] or "splatter with a conscience."[11] In 2010, *A Serbian Film* (Srđan Spasojević) was released, though almost immediately banned in many countries. The film follows a down-on-his-luck former porn actor who agrees to make one more movie, which turns out to be a snuff film; it features graphic depictions of necrophilia, rape, all kinds of torture, and child sexual abuse. Though it completely unimpressed critics, the film remains alongside *The Human Centipede*, *Cannibal Holocaust*, and others, as examples of how filmmakers push the limits of what is acceptable. *A Serbian Film* and *Cannibal Holocaust* are also, not coincidentally, films about filmmaking.

Because films are aimed at mass audiences, they incur censorship controversy in ways that paintings, which can easily be hidden away in private, can usually avoid.

Traces of body horror are evident in the bleeding dead game and slabs of meat of sixteenth- and seventeenth-century Flemish still life, and the highly symbolic skulls in *vanitas* paintings. In both cases, the pictures were meant to remind the viewer of their own mortality, and that all the things of the earthly world are ultimately in vain. Only God separates us from the butchered pheasant. In the same way, body horror films also remind us of our own mortality and the vulnerability of the flesh.

A modern perspective on body horror in art is offered by Francis Bacon in *Three Studies for a Crucifixion* (1962). This is Bacon's second attempt at a crucifixion scene; the first, painted in 1944, is in the Tate Britain. While the earlier painting shows three barely anthropomorphic monstrous creatures, the 1962 painting explicitly connects the human body to the slaughterhouse, to meat, to the inevitability of death. In fact, Francis Bacon's whole body of work could be considered an exercise in painting body horror. Critic Adrian Searle notes that "Bacon's art . . . contains an entire repertoire of bruises, wounds, amputations done up with soiled bandages."[12] Bacon here completely rejects the idea of composed spirituality in death; he also rejects the pretty, romanticized view of death seen in paintings such as the morbid but sentimental *Death of Chatterton* by Henry Wallis (1856), one of the most popular and widely reproduced of Victorian paintings.

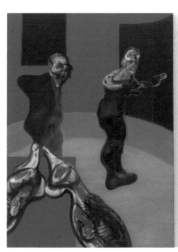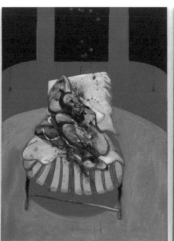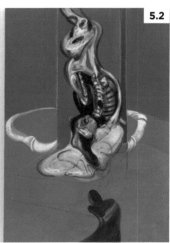

5.2
Three Studies for a Crucifixion, 1962
Artist: Francis Bacon (1909–1992)
Bacon made a number of "crucifixion" paintings, the last in 1988. This 1962 picture, which is at the Guggenheim in New York, emphasizes the visceral qualities of death, the body as dead meat, lumps of flesh.

5.2

MONSTERS

Lastly, a principal stock-in-trade of the horror genre is the monster. Monsters appear in the Old Testament, principally the creatures Leviathan and Behemoth (1 Enoch 60:7–8). Later Christian legend brings monsters into the stories of saints, such as St. George and the Dragon. The archetypal image of man killing monster, man versus beast, is one that resonates throughout art, and countless versions exist in Western painting. Dragons, or massive reptilian creatures, appear in both European and Asian legends and art.

In *Two Followers of Cadmus Devoured by a Dragon* by Cornelis van Haarlem, the emphasis is less on the dragon itself than on the violence of the dragon's attack on the men. The horror of the painting lies in the way the dragon is sinking its teeth into the face of one man and digging its claws into the other man's nude flesh. Even more repulsive is the severed head in the immediate foreground, with the windpipe and internal organs exposed in a grotesque manner. The agony of the body reminded van Haarlem's viewers of the threats, dangers, and sacrifice required to defend the faith. Modern audiences notice how helpless the huge, muscular bodies of the men are against the teeth and claws of the beast. The visual depiction produces a vicarious thrill, yet the narrative of pain is offset by the morality of the subject.

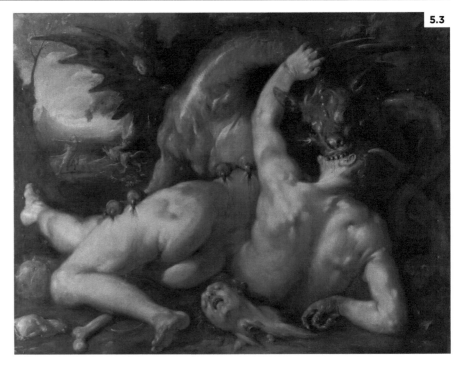

5.3

5.3
Two Followers of Cadmus Devoured by a Dragon, 1588
Artist: Cornelis van Haarlem (1562–1638)
Artfully combining monster horror with deliberate body horror, Van Haarlem offers a highly stylized picture, with grotesque, unnatural nudes in twisted poses, and a slavering monster.

RELIGIOUS
HORROR

SUPERNATURAL
HORROR

BODY HORROR

MONSTERS

CASE STUDY:
GUILLERMO
DEL TORO AND
FRANCISCO
DE GOYA

EXERCISES,
DISCUSSION
QUESTIONS,
AND FURTHER
READING

Monsters of all kinds appear in the work of Bosch, chiefly the terrifying hybrid monster that sticks together two or more disparate creatures, as seen in *The Garden of Earthly Delights*, the painting that begins this chapter. Even more horribly, some of the monsters are hybrids of living creature and object, such as the knife blade with ears and the Tree-Man. The knife with ears can be seen as a very early visualization of the cyborg—a being with both organic and biomechatronic parts. The right-hand panel of the triptych depicts Hell and the torments of damnation. It was not meant to be horror, but rather an allegory. In Flemish painting at this time, Hell often contained strange allegorical creatures that represented concepts and proverbs that formed conventions of morality at the time.

Hybrid monsters, or mutants, are a staple of the horror cinema, starting with James Whale's *Frankenstein* (1931) continuing up to *The Fly* (1958) and beyond. Aliens continue the monster tradition, in a huge variety of shapes and forms. Some of the most effective aliens include *The Quatermass Xperiment* (1955) and artist H. R. Giger's design for the *Alien* series.

What we can learn particularly from looking at art history is that monsters tend to take two principal forms: the human-plus-other hybrid or the reptilian (sometimes insectoid). These appear so frequently, even in the earliest art, that it is probable that these images plug into deep-seated primal fears.

In the late nineteenth century, interest in psychology developed into the representation of psychological states in art, beginning with the Symbolists and moving on to Expressionism, which is discussed in a later chapter. One of the best known is *The Scream* (1893) by Edvard Munch, a boldly colored howl of anguish; a lone figure stands on a bridge in a blood-red sunset, clutching its face and screaming into the void. Munch eschews realism in favor of raw expression. It is not a horror image exactly, but it conveys the psychology of horror. In the twentieth century, familiarity with psychology led to the development of psychological horror in cinema—for example, Fritz Lang's serial killer film *M* (1931) or Alfred Hitchcock's body of work, particularly *Psycho*. But this is manifested little in visual art. Artists turned to considering fears and anxieties in other ways, such as political representation, racial oppression, gender, and sexuality as aggressive political tools rather than representations of fears or moral servitude. It could be argued that in the twentieth century, with its two world wars, the image of horror had become all too real. With the evolution of cinema as a complex site of narrative, imagination, and illusion, cinema is perhaps better able to mirror the complex inner fears of the modern age.

In his ambivalent review of *The Exorcist*, critic Roger Ebert asks, "Are people so numb they need movies of this intensity in order to feel anything at all? It's hard to say."[13] It is true that until *The Exorcist*, few films had attempted such a stark evocation of evil. But as we look back to the history of art, we can see that tremendous horrors have been depicted in detail, covering every possible category of horror. Many of these are truly great works of art, such as Titian's *Flaying of Marsyas* or Goya's *Saturn Devouring His Children*; others are better considered as pieces from their time, such as Van Haarlem's *Followers of Cadmus*. Certainly, we have long desired to experience both terror and horror. So perhaps Ebert misjudged audiences: it is simply part of the human condition to desire vicarious, intense, horrific experience.

CASE STUDY: GUILLERMO DEL TORO AND FRANCISCO DE GOYA

Magic or Madness: Goya's Supernatural

Francisco de Goya (1746–1828) was a Spanish artist whose paintings, drawings, and engravings reflected contemporary historical upheavals and influenced important nineteenth- and twentieth-century painters. In 1775 he went to the Spanish court to paint preparatory paintings for the Royal Tapestry Factory, and eventually became court painter. But it is not Goya's court paintings, nor even his masterful renderings of the Spanish royal family and its aristocracy, that are his claim to fame and lasting influence. Rather, it his paintings of violence and horror that fired the imagination of the next generation of European artists, and continue to fascinate and inspire up to the present day.

Guillermo del Toro (b. 1964) is a Mexican-born writer-director known for highly original and visually striking films that loosely shelter under the "horror" label, ranging from dark fantasy to action movie. As well as writing and directing, del Toro is a makeup and special effects artist and remains highly involved with creating the makeup and special effects on every film he directs.

Del Toro has said many times over in interviews how he has been influenced by visual arts, in particular the paintings and drawings of Francisco de Goya. This case study will look at Goya's paintings and some of Del Toro's films in order to understand how the influence of visual culture can operate when addressing primal fears and terror.

Goya painted and drew both scenes of madness and scenes of the supernatural. They are different, but he was fascinated by both. He asserted that he didn't believe in the supernatural, but the traditions associated with folk belief were all around him, and he could "plug into" that visual culture for his images. Madness, he understood, was very real, and no less dreadful. As Robert Hughes has pointed out, Goya "shared the general interest in mental extremity that characterize Romanticism in European art. . . . Almost all the great artists of Goya's time from Fuseli to Byron were fascinated by madness, that porthole into unplumbed depths of character and motive."

Goya painted a picture of madmen tussling in the courtyard of the asylum (*Yard with Lunatics*, in Spanish: *Corral de locos* 1793-1794), their demented expressions as hopeless as the bleakness of their surroundings. But much more to the taste of his audience were his supernatural pictures. St. Francis Borgia at the *Deathbed of an Impenitent* (1788) is the first of Goya's paintings in which demons take a starring role. It shows a man lying in bed while the saint tries to save his soul, but the impenitent

"I'M NOT AFRAID OF WITCHES, HOBGOBLINS, APPARITIONS, BOASTFUL GIANTS, KNAVES, OR VARLETS ETC., NOR INDEED OF ANY KIND OF BEINGS EXCEPT HUMAN BEINGS."
—Francisco de Goya[14]

RELIGIOUS HORROR

SUPERNATURAL HORROR

BODY HORROR

MONSTERS

CASE STUDY: GUILLERMO DEL TORO AND FRANCISCO DE GOYA

EXERCISES, DISCUSSION QUESTIONS, AND FURTHER READING

rejects this as the devils crouch over him. Goya depicts them as hideous, malevolent beings straight out of Spanish folk art.

He was commissioned by his patron the Duchess of Osuna in 1798 to paint a series of small pictures of witches. Scenes of witchcraft (*brujería*) were popular in folk culture, and as with horror movies today, you don't actually have to believe in witches and devils to get a frisson of excitement when looking at them. Goya's paintings of witches are similar to Salvatore Rosa's *Witches at Their Incantations*, showing the witches casting spells and emphasizing the horrific nature of their props: dead babies, a goatlike Satan, and human sacrifice. In the following year he returned to the subject of witchcraft in parts of *Los Caprichos*, though here it is more satirical and a few of the images have a comic element. *Capricho No. 68: "Linda maestra"* (Pretty teacher) shows an ugly old witch teaching a young, pretty witch how to ride a broomstick. The broomstick of course doubles as a phallic symbol and the whole image has a satirical sexual aspect to it as well as horror. Witchcraft is the subject yet again among his last works, the Black Paintings, with *Witches' Sabbath* (1821–1823).

In the eighty prints of *Los Caprichos* (1799), Goya criticizes everything: politics, the Church, superstition, and human frailty. Though influenced by William Hogarth's prints of *Gin Lane* and *The Rake's Progress*, Goya's images lack the theatricality of Hogarth's: they are more immediate, more grotesque, more startling. The *Caprichos* didn't sell; republished again in the middle of the nineteenth century, they found a far more appreciative audience and went on to influence both Symbolist painting and German Expressionist art and cinema. Today they are considered among the finest examples of graphic art in art history and still manage to thoroughly astound and disturb. Goya continues to influence contemporary art: British artists Jake and Dinos Chapman have frequently referenced Goya in their works, though this has had mixed critical response.[15]

Witches' Sabbath has been construed by some critics as a thinly veiled reference to the deeply conservative restored Spanish monarchy and its revival of the Inquisition. Tellingly, Goya went into exile soon afterward, moving to Bordeaux at age seventy-eight. Despite years of working for the court, *Los Caprichos*, the *Disasters*, and the *Black Paintings* show us how Goya felt about the authority of the Church and the state, but also mob culture and human ignorance.

Del Toro says, "I hate structure. I'm completely anti-structural in terms of believing in institutions. I hate them. I hate any institutionalised social, religious, or economical thing."[16] Goya might have agreed with that. As in Goya's artworks, systems of thinking and the institutions that support them are criticized in Del Toro's three films about the supernatural. In *Cronos*, the greed and selfishness of the de la Guardia Corporation is a much more destructive force than the vampire. In *The Devil's Backbone*, the orphanage is in the charge of disturbed and psychopathic people; although the film turns on the apparition of a child's ghost, the real horror is not Santi but the very human evil of Jacinto, the adult charged with caring for the helpless children. In *Pan's Labyrinth*, Captain Vidal, the Falangist fanatic, embodies not only the dark, bloody forces of militarism, authoritarianism, and brutality, but even on the domestic level, he treats his young new wife as a possession, has contempt for his stepdaughter, and sees his baby son simply as a carrier of his name. Vidal's treatment of his political enemies is as close to Goya's *Disasters of War* as would be permitted in a mass entertainment film.

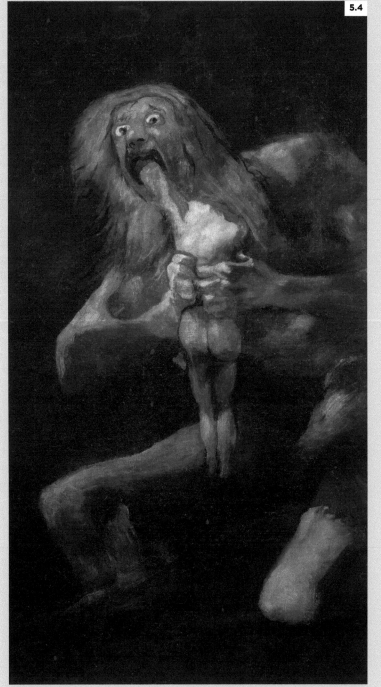

5.4

The Devourer

Del Toro first saw Goya's *Saturn Devouring His Children* on the cover of a book when he was a child. He recalls how shocked he was by the expression of madness, but also anguish, on the face of Saturn and says that it always struck him as being "one of the most brutal images I ever saw."[17] The filmmaker has acknowledged that the painting has stayed with him ever since, and it is clear that it influenced his creation of the Pale Man. Notice the color palette of the Pale Man and his room, the flesh tones and the shiny wet blood-reds. It is almost identical to the color palette in the painting and the blood seeping from the bleeding torso. Eyes are a powerful motif in both the film and the painting: the Pale Man has his eyes in his hands, embedded in stigmata in each palm. Saturn's eyes are the most prominent things in the painting—anguished, wide-open, terrorized black holes surrounded by bright white eyeballs. The key to understanding both the Pale Man and the Titan is that they are following their nature: they do what they do because that is what they are. Vidal, on the other hand, has free will; he makes a rational choice to do evil, and so he is worse.

5.4
***Saturn Devouring His Children*, 1819–1823**
Artist: Francisco de Goya (1746–1828)
Goya's version of the Greek myth of the Titan Cronos (or Saturn) who, fearing that his position would be overthrown by one of his children, ate each one as soon as it was born.

RELIGIOUS HORROR

SUPERNATURAL HORROR

BODY HORROR

MONSTERS

CASE STUDY: GUILLERMO DEL TORO AND FRANCISCO DE GOYA

EXERCISES, DISCUSSION QUESTIONS, AND FURTHER READING

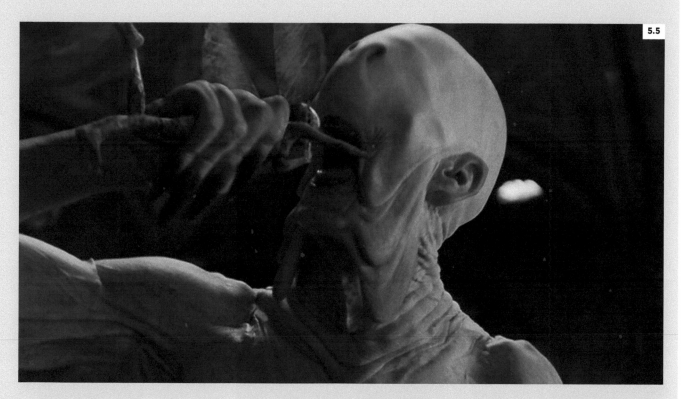

5.5

Cannibalism happens for several reasons. Aside from obvious cases such as shipwrecks, the eating of human flesh is usually ritualized, and involves a transfer of power. *Saturn* eats his children to keep his power; the frieze on the Pale Man's walls implies the same. Saturn was not Goya's first depiction of cannibalism. In *Cannibals Beholding Human Remains* (c. 1808), a group of naked cannibals pull apart a body and exultantly gnaw on its flesh. Hughes points out that "nobody had painted such scenes before with the same peculiarly secular feeling. The painting has no pertinence to religion or mythology."[18] It is art coming out of the dark part of the imagination, understanding both the horror and exhilaration of the feast.

5.5
***Pan's Labyrinth*, 2006: "The Pale Man"**
Dir. Guillermo del Toro, DP Guillermo Navarro
It is not just the pale man himself; it is his environment. He lives in a room decorated with a frieze of paintings that depict his brutalities, particularly the devouring of children. The fact that these are painted on the wall of his room indicates the institutional nature of his position, his authority. The frieze bears a strong resemblance to Goya's *Disasters of War* in the brutality of the images. "I wanted to represent political power within the creatures," del Toro says.[19]

War Horror

Often considered as an allegory of war, the Colossus is actually difficult to read. Is the *Colossus* causing the panic, or overseeing the panic? Possibly, he is completely unconnected to the events on Earth but simply obeys his own internal laws and, just by being, terrorizes them. The same enigma is at the core of *Pacific Rim*. We are plunged into the middle of war: all of Earth against the Kaiju, reptilian-insectoid monsters of unimaginable size. Despite the claim that ecological disaster has precipitated the situation, the humans never know exactly why the giants appeared. The only way to fight the monstrosity is with counter-monsters, the cyborg Jaeger.

Writer and critic Mark Kermode calls del Toro "the finest exponent of fabulist film,"[20] which reminds us that sometimes the best thing to do with the fantasy worlds of horror—in art or cinema—is simply to sit back and enjoy them for their ability to deliver "beautiful terror" to the safety of our armchairs.

However, Goya is likely not the only source of artistic inspiration in del Toro's work. The renowned Mexican muralist José Clemente Orozco 1883-1949 may be even more important. Some of Orozco's finest works are available to the public in the city of Guadalajara's Government Palace and the Cabañas Cultural Institute, painted between 1936 and 1939. Born and raised in Guadalajara, del Toro likely saw these huge, dramatic murals on many occasions. Orozco was highly political and critical, and his murals are cinematic and exciting, depicting the colonial history of Mexico as a tumult of blood, fire, and violence.

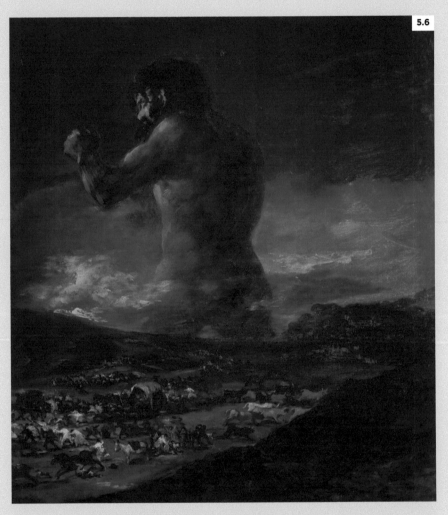

5.6

5.6
***The Colossus*, c. 1812**
Artist: Francisco de Goya (1746–1828)
The giant specter stalks the sky with an attitude of angry defiance, while below him people and animals flee in all directions in an hysterical state of panic.

RELIGIOUS
HORROR

SUPERNATURAL
HORROR

BODY HORROR

MONSTERS

**CASE STUDY:
GUILLERMO
DEL TORO AND
FRANCISCO
DE GOYA**

EXERCISES,
DISCUSSION
QUESTIONS,
AND FURTHER
READING

5.7

5.7
Pacific Rim, **2013**
Dir. Guillermo del Toro, DP Guillermo Navarro
Del Toro has said on a number of occasions that
he was influenced by Goya's *Colossus* in creating
scenes of the battles between the giants: the
reptilian Kaiju and the cyborg Jaeger.

EXERCISES AND DISCUSSION QUESTIONS

Exercise 1

Cinema, like art, has struggled to give form to abstract concepts like evil, or the philosophical questions around spirit and mortality. Watch any of the horror films mentioned in this chapter or any of those suggested below, and note when and how abstract concepts such as evil or the spirit world are portrayed by characters, symbols, or other visual manifestations.

Suggested horror films (you may have already seen these, but they are classics of the genre):

Carrie (Brian de Palma, 1976; remade 2013 by Kimberly Peirce)

Suspiria (Dario Argento, 1977)

Let the Right One In (Tomas Alfredson, 2008)

The Ring (Gore Verbinski, 2002; Japanese original *Ringu* directed by Hideo Nakata)

Exercise 2

William Blake made a series of paintings about the "red dragon," an avatar of the Devil in the Book of Revelation. *The Great Red Dragon and the Woman Clothed in Sun* was a key plot point in *Red Dragon* (2002) directed by Brett Ratner. Watch this film and notice the different ways that elements of the painting are integrated into the story.

Exercise 3

Select a favorite painting that depicts a horror vision. Either choose one that has been discussed in depth in this chapter, by Salvator Rosa, Francis Bacon, Titian, or Goya, or look up others such as William Blake, Hans Memmling, Théodore Géricault, Matthias Grunewald, or Alfred Kubin, or see Bacon's 1953 *Study after Velazquez's Portrait of Innocent X* (sometimes called *Screaming Pope*). Imagine recreating the painting as a scene in your own movie. What kind of camera setups would you use? Imagine it as an audiovisual experience. What kind of sound or music would you choose to accompany this scene?

DISCUSSION QUESTIONS

Both Peter Paul Rubens and Francisco de Goya painted disturbing versions of *Saturn Devouring His Son*, both in the Prado Museum. Which is more cinematic? What are the criteria you used to make that assessment? How would you storyboard such a scene?

FURTHER READING

Keith McDonald and Roger Clark, *Guillermo del Toro: Film as Alchemic Art* (Bloomsbury, 2014)

Francisco de Goya, *Los Caprichos* (Dover Publications, 1969)

Colin Odell and Michelle LeBlanc, *Horror Films* (Kamera Books, 2010)

Darren Oldridge, *The Devil: A Very Short Introduction* (Oxford University Press, 2012)

Carol J. Clover, *Men, Women, and Chain Saws: Gender in the Modern Horror Film*, rev. ed. (Princeton University Press, 2015)

Daniel Zalewski, "Show the Monster: Guillermo del Toro's quest to get amazing creatures onscreen." *The New Yorker*, February 7, 2011

David Craven, *Art and Revolution in Latin America, 1910-1990*, 2nd ed. (Yale University Press, 2002)

James Oles, *Diego Rivera, David Alfaro Siqueiros, José Clemente Orozco* (The Museum of Modern Art, 2011)

Desmond Rochfort, *Mexican Muralists: Orozco, Rivera* (Siqueiros Chronicle Books, 1998)

NOTES

1 Ann Radcliffe, "On the Supernatural in Poetry," *The New Monthly Magazine and Literary Journal*, Vol. 16, No. 1 (1826), pp. 145–152.

2 Darren Oldridge, *The Devil: A Very Short Introduction* (Oxford University Press, 2012). Jeffrey Burton Russell, *Lucifer: The Devil in the Middle Ages* (Cornell University Press, 1984) and *Satan: The Early Christian Tradition* (Cornell University Press, 1981) both discuss the evolution of the idea of the Devil, with some discussion of art. Dennis Wheatley, *The Devil and All His Works* (Hutchinson & Co., 1971), is a dated but entertaining and well-illustrated discussion of the subject.

3 Oldridge, *op. cit.*

4 "The 10 Best Devils," *The Guardian*, September 18, 2010.

5 *The Morning Chronicle, and London Advertiser*, No. 4048 (May 9, 1782).

6 Jane P. Davidson, *Early Modern Supernatural: The Dark Side of European Culture, 1400–1700* (ABC-CLIO, 2012).

7 Suzanne L. Marchand and David F. Lindenfeld, *Germany at the Fin de Siècle: Culture, Politics, and Ideas* (LSU Press, 2004).

8 Joseph L. Henderson and Dyane N. Sherwood, *Transformation of the Psyche: The Symbolic Alchemy of the Splendor Solis* (Routledge, 2004), discusses the practice of alchemy in Venice. Lawrence Principe, *The Secrets of Alchemy* (University of Chicago Press, 2012), explains the symbolism.

9 This claim is made by artist and curator Helen Lessore, *Partial Testament: Essays on Some Moderns in the Great Tradition* (Tate Publishing, 1986).

10 Nigel Floyd in *Time Out London*, March 20, 2006.

11 Simon Crook in *Empire*, no date, available at www.empireonline.com/reviews.

12 Adrian Searle, "Painted Screams", *The Guardian*, Tuesday 9th September 2008

13 Roger Ebert, The Exorcist, *Chicago Sun Times*, December 26th 1973. Ebert's review is archived on http://www.rogerebert.com/reviews/the-exorcist-1973

14 From a letter to Martin Zapater, quoted in Robert Hughes, *Goya* (Vintage, 2004), p. 151.

15 Adrian Hamilton, "The Shocking Truth: Why Jake and Dinos Chapman's Tactics Are Wearing Thin," *The Independent on Sunday*, December 1, 2013; Alan Riding "Goya Probably Would Not Be Amused," *The New York Times*, April 6, 2003.

16 Interview with Enrique Diaz, www.nuvein.org.

17 Guardian NFT Interview, Mark Kermode and Guillermo del Toro, 2006. *Pan's Labyrinth*, 2007, Optimum Releasing DVD Extras.

18 Robert Huges, *Goya* (Vintage, 2004), p. 233.

19 Quoted in Mark Kermode, "Pain Should Not Be Sought—but It Should Never Be Avoided," *The Observer*, November 5, 2006, and in Mark Kermode, "Girl Interrupted," *Sight & Sound*, December 2006.

20 Mark Kermode, *BBC Culture Show*, 2006. Archived on YouTube, https://youtu.be/iqdEKahV-gs.

CHAPTER SIX
LANDSCAPE

Paintings have created many different visual reference points which have been repurposed, both consciously and unconsciously by filmmakers. The previous chapters have looked at the representation of gender and of beauty, at violence, and also at the visual manifestations of our deepest fears. Landscape painting, as a way of seeing the natural world, developed over the course of the seventeenth century, and became extremely important in the English-speaking world. English artists took up landscape painting with enthusiasm, and this tendency was replicated in the new nation of the United States of America, as the painters of the American West created the first great movement in American art.

Landscapes helped people to see the world, and to reorder it. Landscape paintings allowed us to see the relation of ordinary man to his environment. They helped us to appreciate the natural beauty of the terrain, in all seasons, in daytime and moonlight.

WHY
LANDSCAPE?

BEAUTIFUL,
PICTURESQUE,
OR SUBLIME?

THE AMERICAN
LANDSCAPE AND
THE AMERICAN
WEST

CASE STUDY:
THE ROAD
MOVIE

EXERCISES,
DISCUSSION
QUESTIONS,
AND FURTHER
READING

WHY LANDSCAPE?

The ancient Greeks and Romans painted *trompe l'oeil* landscapes on their walls, to give the illusion of sitting in the open air or in a garden. In the late medieval period (1200–1400), we start to see landscapes in paintings. However, even though these landscapes are often reasonably accurate depictions of recognizable places, they served principally as backgrounds to the subject matter.

The idea that Art ennobles Nature is a classic Renaissance doctrine. Nature (or landscape) is not interesting or important in itself, but once represented through art it is transformed and repurposed in a variety of ways. However, during the eighteenth century, the so-called "cult of nature" held that it is in fact Nature that ennobles Man. Landscape painting embodies both notions.

Unlike historical or mythological subjects, landscape was not highly valued in painting. Painters who were interested in landscape usually pretended that they were actually painting something else. Nicholas Poussin (1594–1664) made mainly religious and allegorical works, but the landscape element is frequently dominant. Sometimes he simply painted landscapes with something dramatic happening, as in his *Landscape with a Man Killed by a Snake* (1648).

Poussin's friend and fellow Frenchman in Italy, Claude Lorrain, was even more compelled by landscape. Claude put the obligatory mythical figures in the composition, but it is said that he was so uninterested in painting figures that he used to hire other artists to do that while he painted the landscape. Claude was particularly interested in painting the sun as the preeminent dynamic light source.

However, neither Poussin nor Claude painted "real" landscapes; they painted imaginary landscapes, taking elements from real places, but based on the observation of nature, particularly light on different surfaces.

Rubens and Netherlandish Landscape

Flemish painter Pieter Paul Rubens (1577–1640) is one of the most important painters in the history of art, not only for his skill but because of his facility in every type of painting and genre, from history painting to mythology, from intense religious subjects to landscape. Following the influence of Pieter Bruegel, he painted rural landscapes with simple peasants and country life. Rubens was one of the first artists to really develop the details of the landscape. Late in life he devoted much of his time to painting his own country estate, Het Steen, a real place he knew well.

Throughout the seventeenth century, the Dutch and Flemish developed landscape painting to a high level, painting everything from simple peasant scenes to dramatic seascapes. Realism, not idealism, dominates. Jacob van Ruisdael (1628–1682) is considered the master of Dutch landscape, while Albert Cuyp (1620–1691) was highly versatile, creating both country scenes and marine paintings, or seascapes. Cuyp's *A River Scene with Distant Windmills* (1640–1642) is typical, a detailed picture of specific and identifiable Dutch terrain, in which the marshy land creates a flat environment, so the horizon lies low and the sky dominates the image.

Pictures of countryside with peasants, shepherds, and the like are known as "pastoral." Idealized images of rural life gained considerable popularity in the eighteenth century, and this popularity continued well into the twentieth.

FURTHER VIEWING

The splendid flare of the sunlight in Claude's *Seaport with the Embarkation of the Queen of Sheba* (1648) and his sun at dusk in *A Seaport* (1644).

Pieter Paul Rubens, *The Rainbow Landscape* (1636).

Watteau and the *Fête Galante*

Jean-Antoine Watteau was not exactly a landscape painter; he was a painter of social interaction. But his pictures are so infused with the energies of nature that he was highly influential to the subsequent development of landscape painting and composition of figures in the landscape. Watteau was not an aristocratic painter: his clients were bourgeois, and for them he invented a new type of painting, the *fête galante* ("courtship party")—small pictures exploring the psychology of love, as fashionably dressed, attractive couples pursue love, music, and conversation in an imaginary parklike landscape setting. His characters wander in sunlit glades, over a gentle terrain where there is abundant foliage for the lovers to slip away into, as the trees move in the soft wind. The effect is of a gentle eroticism of both nature and sentiment.

FURTHER VIEWING

Eric Rohmer's 2007 film *Les Amours d'Astrée et de Céladon* (*Romance of Astree and Celadon*) strongly references Watteau's *fête galante* compositions.

See also Watteau's *Les Champs-Elysées* (1717), one of his most beautiful pictures. If you visit Paris today, you can easily forget that "Champs-Elysées" means "Elysian Fields," but in the eighteenth century the Champs-Elysées really was countryside, a place of picnics and relaxation, as Watteau shows. However, critic Robert Hughes cautions us against looking for social realism in Watteau's pictures: "Outside of the gilt frames . . . France was continuously at war for most of Watteau's life. . . . Men need paradises, however fictive, in times of trouble."[1] Watteau communicates this through the structured theatricality of his characters, many of whom are drawn from the *commedia del arte* theater tradition.

WHY
LANDSCAPE?

BEAUTIFUL,
PICTURESQUE,
OR SUBLIME?

THE AMERICAN
LANDSCAPE AND
THE AMERICAN
WEST

CASE STUDY:
THE ROAD
MOVIE

EXERCISES,
DISCUSSION
QUESTIONS,
AND FURTHER
READING

6.1
***Meeting in the Open Air*, 1720**
Artist: Jean-Antoine Watteau (1684–1721)
French painter Watteau shows the pleasure and
enjoyment of love, expressed with freedom and
ease, yet there is often a sense of wistfulness,
almost melancholia.

BEAUTIFUL, PICTURESQUE, OR SUBLIME?

Salvator Rosa

The English writer Joseph Addison (1672–1719) described the sublime as something that "fills the mind with an agreeable kind of horror."[2] The word comes from the Latin, meaning "up to a limit." The word was used to describe the emotional state generated by evocations of extreme aspects of nature—storms, mountains, oceans, deserts—emotions that are thrilling in an irrational and excessive way, beyond the powers of reason, and uncontrollably wonderful.

Critics distinguished between the Beautiful, the Picturesque, and the Sublime. Beauty was to be found in classical notions of balance and harmony. But they also appreciated what a little bit of imbalance could bring. There was a taste for the unpredictable, the intricate, the complex, and the irregular. In landscape, philosopher Edmund Burke distinguished quite clearly between the beautiful and the sublime. The beautiful was associated with the pastoral, where people have developed and tamed the landscape. Beauty, Burke said, humanizes the landscape. But in the sublime, the wildness of Nature invokes its elemental power and gives pleasure. Painters like Salvator Rosa and Jacob van Ruisdael conveyed the delightful horror of wild scenery. Sitting somewhere between the beautiful and the sublime could be found the picturesque, which involved creating drama, but avoiding the extreme. Picturesque is about nature's dramatic irregularity, which can be seen in ruins overgrown by nature, dark clouds intensified by shafts of light, and so forth. The picturesque is expressed in the eighteenth-century style known as *rococo*, which turns away from classical ideals to appreciation of natural forms, particularly intricacy, asymmetry, and curves.

In the previous chapter, we looked at Salvator Rosa and his painting *Witches at Their Incantations*, but that was only one of many thrilling and deliberately sensational paintings that the Italian artist made. Salvator Rosa (1615–1673) specialized in edgy subject matter. He was born into a poor family of painters and builders in Naples, but his sheer brilliance as both painter and writer soon propelled him into the public eye. He was friends with the Rome-based French landscape painter Claude Lorrain (1600–1682), but their paintings could not be more different. Rosa's canvases feature "precipices, mountains, walls, torrents, rumblings," in the approving words of English Gothic novelist Horace Walpole.[3] Rosa's paintings of the Italian hinterland revel in giant rock formations, twisted trees, ruined buildings. His landscapes are wild, uncultivated, and barely inhabited. To the audience, Rosa's brigands were a thrilling alternative to rationality and stability, safely experienced in a frame and not in the street. In the eighteenth century, there grew up a popular myth that along with painting bandits, Salvator Rosa himself was part of a group of artist-outlaws involved in political unrest and perhaps other depredations. Rosa's handsome, piratical self-portraits no doubt added to the romantic fiction.

FURTHER VIEWING

Because so many of Rosa's paintings were bought by English people visiting Italy in the eighteenth century, one of the best places to see them online is BBC's Your Paintings site: http://www.bbc.co.uk/arts/yourpaintings/artists/salvator-rosa.

WHY
LANDSCAPE?

BEAUTIFUL,
PICTURESQUE,
OR SUBLIME?

THE AMERICAN
LANDSCAPE AND
THE AMERICAN
WEST

CASE STUDY:
THE ROAD
MOVIE

EXERCISES,
DISCUSSION
QUESTIONS,
AND FURTHER
READING

English Landscape

In the early eighteenth century, English intelligentsia noticed that, despite major accomplishments in literature, painting had so far eluded Anglo culture. Dutch painting was well established in England, because almost all of the painters active in England in the previous two centuries were Dutch.

Rubens and Watteau provided the two principal models for eighteenth-century English landscape painting. Both artists pay great attention to the movement of light in foliage, and the compositions are organized in such a way that there is as much interest in the landscape as there is in the figures. But these painters' gentle landscapes were not the only inspiration. Salvator Rosa's thrilling and titillating vistas were also extremely popular, and in the eighteenth century almost all of his paintings were bought and shipped to England.

In the eighteenth century, for the first time, many Englishmen, and some women, dared to become painters. Most were from modest backgrounds: Hogarth's father was a poor schoolteacher, George Romney's father was a cabinetmaker, Gainsborough's was a cloth dealer and then a postman, and Turner's was a barber. All of them needed to earn a living, and they were able to do so from painting the portraits and the landholdings of the bourgeoisie.

While portrait painting remained the bread and butter for English painters, landscape became increasingly popular. Thomas Gainsborough left behind many letters in which he complained to his friends about having to paint portraits when he would really rather be out in the countryside painting the landscape and its peasant folk. Gainsborough developed realistic landscape painting to the point that it was finally taken seriously. As tourism and traveling became more and more popular throughout the eighteenth century, people wanted souvenirs, not only of trips to Italy but of trips around the country as well, and gradually landscape painting became a viable genre for the working painter.

Caspar David Friedrich and "Romantic" Landscape

Friedrich was the foremost German romantic painter in an era when German Romanticism came to dominate all aspects of art, particularly music. Friedrich chose introspective and melancholy subjects. Unlike many other painters, he didn't bother going to Italy or more established "picturesque" places, but remained in northern Germany, where he painted unusual things such as cemeteries, fogbound vistas, ice, and lone figures in silhouette or at twilight. Friedrich's depiction of figures is particularly unusual: he often paints them facing away from the viewer, so we see only the back.

Friedrich's paintings were sensational at the time, seen as embodying the ultimate "Romantic" spirit, but were forgotten as fashions changed. Interest in him was revived in the late nineteenth century by symbolists like Böcklin, and later we can see traces in the war paintings of Paul Nash. Friedrich's renderings of light and the effects of natural phenomena such as fog and ice are exciting and cinematic. Moreover, he paints the "dramatic moment." It is easy to see why he was so inspirational in early German cinema (notably Murnau's *Nosferatu*[4]) and beyond, right up to the present, in a wide variety of extraordinarily diverse films. His influence can be seen in both Andrei Tarkovsky's and Alexander Sokurov's[5] films. Tim Burton[6] used Friedrich in the Gothic fantasy *Sleepy Hollow* (1999), and references appear in the disturbing psychosexual drama *The Piano Teacher* (2001) by Michael Haneke.[7]

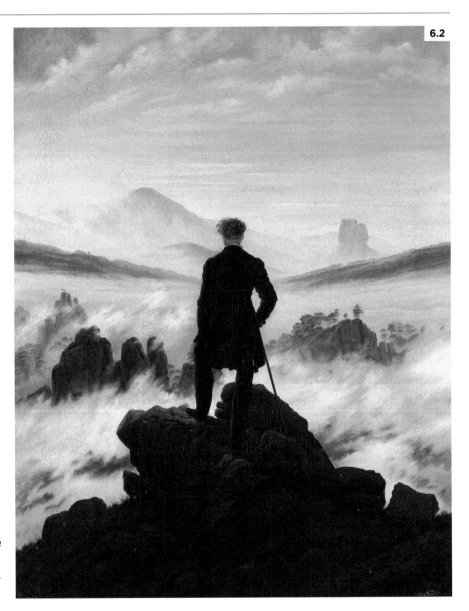

6.2

6.2
***The Wanderer above the Sea of Fog**, 1818*
Artist: Caspar David Friedrich (1774–1840)
Friedrich's painting illustrates the sublime, as Man contemplates the awesomeness and terror of pure Nature.

WHY
LANDSCAPE?

BEAUTIFUL,
PICTURESQUE,
OR SUBLIME?

THE AMERICAN
LANDSCAPE AND
THE AMERICAN
WEST

CASE STUDY:
THE ROAD
MOVIE

EXERCISES,
DISCUSSION
QUESTIONS,
AND FURTHER
READING

6.3

6.3
Frozen River, 2008
Dir. Courtney Hunt, DP Reed Dawson Morano
Although *Frozen River* is a social realist picture,
the thrill and tension when the protagonists drive
out onto the frozen river (filmed on location in
subfreezing temperatures in upstate New York)
owe much to painters of the sublime like Friedrich.
See also his *The Sea of Ice* (1824; also called
The Wreck of Hope, or *The Arctic Shipwreck*).
Friedrich did not visit the icebound shipwreck, but
he certainly had plenty of opportunity to see ice
on the northern Baltic coast in winter.

WHAT IS "ROMANTIC" IN ART?

One of the most prominent problematic terminologies is the
word "Romantic." In cinema, when we say a romantic film, we
mean one whose main plotline involves a personal relationship
that undergoes some type of stress. Needless to say, this
definition doesn't mean anything in art. Instead, we use the
words "romantic" and "Romanticism" to mean a particular
movement that starts at some undefinable point in the late
eighteenth century and goes on up to some undefinable
point in the nineteenth century. But this immediately creates
difficulties: Salvator Rosa lived long before the so-called
Romantic period, yet he is often described as a "pre-Romantic."

What are some of the key elements of Romanticism? They
include the idea that Nature is good, and that justice and
freedom are better than hierarchy. The romantic hero is often
a loner, a rebel. Overall, Romanticism involves a strong belief
in the primacy of the senses and emotions over the intellect.
Romantic art tends to suggest a shared yet personal emotional
response to the world.

J. M. W. Turner: Diffusion and Illusion

One theme that we can see clearly emerging is how landscape painting takes the fascination with light (which we saw in Vermeer, Caravaggio, and Rembrandt) and brings it outside. All of the landscape painters discussed here are united in their interest in light, and particularly light in nature.

English painter Joseph Mallord William Turner (1775–1851) started as a relatively classical painter, painting in Italy, but at some point in the middle of his career he moved from classical compositions to a kind of sublime rendering, established through his use of color. He moved toward an instinctive representation of light, extreme weather, haze, and the burn of hot afternoon sun on water; he began to blur and fragment the image, in imitation of how the eye reacts to light.

In *Rain, Steam and Speed* we see one of the first really significant representations of the Industrial Revolution in art. Turner creates an illusion of moving light, cloud, and steam dissolving together, capturing a cinematic moment. Modern industry is portrayed as elemental, alive. The image is so diffused it is almost not a landscape; Turner has also been claimed as the forerunner to abstract art. Yet it is impossible to miss the sensation that the train is real, hurtling toward you out of the steam and mist.

Actor Timothy Spall, who played Turner in Mike Leigh's film *Mr. Turner* (2014), says, "He was a painter of the sublime. That word has come to mean something rather different now, something you say after you've tasted something nice in a restaurant. But the sublime then was the power of nature, and man's irrelevance within it and the futility of attempting to conquer it. That's what Turner painted, that ferocious competition between beauty and horror."[8]

6.4

6.4
***Rain, Steam and Speed—The Great Western Railway*, 1844**
Joseph Mallord William Turner (1775–1851)
Turner depicts the rapid and tumultuous transformation of the landscape by the Industrial Revolution in a composition of strong diagonals and bold contrasts of light and dark, so diffused as to be almost abstract.

WHY
LANDSCAPE?

BEAUTIFUL,
PICTURESQUE,
OR SUBLIME?

THE AMERICAN
LANDSCAPE AND
THE AMERICAN
WEST

CASE STUDY:
THE ROAD
MOVIE

EXERCISES,
DISCUSSION
QUESTIONS,
AND FURTHER
READING

Landscape and Location

Location is a physical and mental landscape. In film, the artistic production of landscape can be achieved either through location filming or by construction of the landscape, as in *Black Narcissus*.

We have already looked at Michael Angelo Antonioni's film *Red Desert* and the north Italian industrial landscape. Clearly influenced by Antonioni, Bob Rafelson's 1970 film *Five Easy Pieces* uses the stark contrast of the California oilfields with the lush green landscape of the American Northwest as physical manifestation of the antihero Bobby Dupea's state of mind.

Film studios such as those built in Hollywood, London, Cinecitta in Rome, and Babelsberg in Berlin could meet almost all of the needs of the film shoot, but they could not always supply landscape. As we have seen, most of *Black Narcissus* was shot in the studio, but they did have to go to a garden location to shoot the foliage. Despite the brilliance of scene and matte painters, sometimes the film crew just has to go elsewhere.

FURTHER VIEWING

Landscape and location: some cinema milestones worth seeing. These films come from a range of film cultures and periods, with diverse approaches to landscape. Each film places landscape at the core of the story and demonstrates how the treatment of landscape contributes to the mood and visual style of the film.

Wales in California? *How Green Was My Valley* (1941, DP Arthur C. Miller), set in Wales, was originally intended to be shot in Technicolor on location, to make the most of the Welsh valley landscape. However, this was not possible because of the Second World War, so *Stagecoach* director John Ford was brought in to direct the film at a purpose-built location in an unspoiled wilderness region, now a state park. (Despite the title, it is in black and white.)

The haunting centerpiece of *Night of the Hunter* (1955, dir. Charles Laughton, DP Stanley Cortez) is a beautiful yet frightening moonlight journey down the Ohio River, as two children are pursued by an evil preacher. Most of the film, however, was shot on soundstages.

Egyptian film *The Mummy,* or *Night of Counting the Years* (1969, dir. Shadi Abdel Salam) was shot on location among the stunning ruined temples and vast underground chambers of ancient Egypt. The film is a masterpiece in creative location shooting by veteran Egyptian DP Abdel Aziz Fahmy.

In the Russian film *Stalker* (1979, dir. Andrei Tarkovsky, DP Alexander Knyazhinsky), a devastated postindustrial landscape, overgrown by nature and full of hidden dangers, provides the location for "the Zone," a mysterious region of invisible terrors where the normal laws of physics cannot be relied upon.

Daughter of Keltoum (2001, dir. Mehdi Charef, DP Alain Levent), set in Algeria, was shot on location in Tunisia and features a grueling overland journey made by a young Swiss woman visiting her birthplace for the first time to search for her birth mother. The difficult and bleak desert landscape visibly drains and disorients the protagonist. Alain Levent also shot the 1962 Nouvelle Vague real-time classic *Cléo from 5 to 7* (dir. Agnes Varda), which was made in the busy streets of Paris.

THE AMERICAN LANDSCAPE AND THE AMERICAN WEST

American landscape painting is an essential part of the development and articulation of the American dream. Americans often came to study or tour in Europe, and American-born Benjamin West was president of the Royal Academy. But Americans wanted to find their own artistic vision, and in the nineteenth century they found it in landscape.

Influenced by eighteenth-century European landscape, combining the realism of Thomas Gainsborough with the drama of Salvator Rosa, American painters combined literalism with lyricism, painting real places but with all the idealization of European art. It was an era of historical change in America, from being a wild natural landscape to a developed, populated one. The cultural elite was principally based in the American Northeast, with English, Dutch, and German background. They remained closely connected to, and interested in, European cultural developments, including landscape painting.

The Hudson River School

American art had lacked a specific cultural history: America had no ruins or castles. But what it did have was nature in abundance. Americans wanted to view the wilderness, and appreciated the opportunity to buy paintings of it. The Hudson River School explored the thrill of sublime scenery. This was new in America. Previously, wilderness was feared and loathed; in the nineteenth century this changed, and it became America's most distinctive feature—a symbol of the nation's potential.

New York City was the cultural center, and most painters were based there. In 1825 Thomas Cole (1801–1848) helped establish the National Academy of Design and brought artists together to paint the region around the Hudson River Valley in New York State. They painted romantic, sublime stormy skies and dramatic rock formations as well as gorgeous autumnal colors. Cole and the others celebrated the novelty of the American landscape in art, noting that, in contrast to views of Italy and Switzerland, it was not "hackneyed and worn by the daily pencils of hundreds."[9] They stressed their advantage, that in America the sublime wilderness was real and still relatively close by. But Cole was no exponent of the American Dream: he also used landscape art to warn of the dangers of material progress and expansionism. The reality was that the Hudson River Valley was no longer a pristine wilderness; it was a populated and touristed area, where the Native population had been driven out decades before.

Albert Bierstadt and the Myth of the West

The United States government sponsored scientific excursions out to the western prairies and beyond, to document the territory in drawing and painting (and later, photography). The image shown here of Albert Bierstadt's *View of Long's Peak from Estes Park (Indian Encampment)* depicts a night scene, with the clear sky bright and peppered with innumerable stars. The snow-covered peaks are sharply visible, reflecting moonlight and starlight. The rest of the image is softer and murkier, in contrast to the absolute clarity of the peaks. The light falls much more gently on the grassy valley, enveloping the Indian encampment in dusk. It is an interesting composition in two halves: the mountains and the brilliant dark-blue sky are invoked with line and deep-focus detail; they seem clearer and nearer than the foreground, expressed with sfumato strokes and soft coloration, a combination of gentle earth tones. The eternity of mountain and sky are clear, but human life is indistinct, almost dissolved into the earth.

Bierstadt studied painting in Germany, returning to the United States at age twenty-seven. He continued to be interested in landscape, and joined government survey excursions to Colorado and Wyoming. Highly successful, he understood the theatrical drama of scenery; his pictures are often enormous, carefully composed for theatrical and pictorial effect. He also experimented with daguerreotype photography and stereoscopy, producing in 1859 a collection of stereograms "Views in the West." He made his exhibitions into events, selling tickets and creating elaborate dioramas and theatrical displays of the work. Critic Malcolm Robinson calls him "a mythmaker of the first order."[10]

His depictions of the little-known American West appealed to the industrial upper middle class, who valued the great size of the canvases and their virtuoso workmanship, as well as the celebration of America's seemingly limitless natural resources. Bierstadt knew how to create a sensation, and his popularity was expanded by the printing firm Currier and Ives, who produced lithographed versions of his paintings for the masses. These popular prints did much to foster the American "Promised Land" myth and created a familiarity with the image of "the West." Later critics questioned Bierstadt glorifications of the landscape on this scale. Although impressive and beautiful, they hint nothing about the hardships of the real "wild" West.

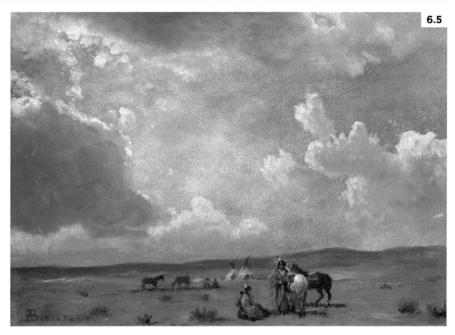

6.5

6.5
View of Long's Peak from Estes Park (Indian Encampment), 1876
Artist: Albert Bierstadt (1830–1902)
Bierstadt made a sketching trip to Estes Park, Colorado, in the dramatic Rocky Mountains, in late 1876. The park was already open for tourism by 1867, with the first hotels appearing around the time of Bierstadt's visit.

Painting Native American Life

Sometimes Native Americans are included in pictures as "pure witnesses" to the sublime wilderness, even though in many places they had already been driven out as white settlement and tourism were established. These paintings offered a romanticized view of Native life, which is paradoxical as this was the era of Indian[11] wars, whose explicit aim was to bring to an end the Native American way of life. Bierstadt's "Indian encampment" was at least part fantasy.

George Catlin (1796–1872) was the first great painter of Indian life; he aimed "to rescue from oblivion their primitive looks and customs."[12] He went out West when it was still dangerous, joining a diplomatic mission up the Mississippi River into Native American territory in 1830. Catlin made many portraits of Native people and described their way of life in his paintings.[13] He created a huge "Indian Gallery" of portraits that toured America and Europe for a decade. He painted important personages like Seminole Chief Osceola and Ha-Na-Tah-Muah, Wolf chief of the Mandan people. But he also painted Indian village life, buffalo hunting trips, and family scenes of mothers with children. Catlin's subjects trusted him, even allowing him to make portraits of the Blackfoot "medicine men" and

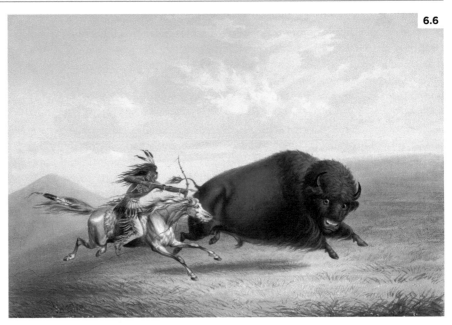

6.6

to depict the shamanic initiations of the Mandan people. Catlin was angry about the expropriation of the Indians and the corruption of their culture by white settlement.[14] Yet this noble aim to preserve Native culture came with its own challenge: making ends meet led him to questionable, compromising strategies. He lured audiences to his exhibitions by presenting Natives enacting war dances, almost a "Wild West Show" of sensationalism and exploitation.

6.6
Buffalo Chase, **1844**
Artist: George Catlin (1796–1872)
Catlin's mission was to record the vanishing Native American way of life.

WHY
LANDSCAPE?

BEAUTIFUL,
PICTURESQUE,
OR SUBLIME?

**THE AMERICAN
LANDSCAPE AND
THE AMERICAN
WEST**

CASE STUDY:
THE ROAD
MOVIE

EXERCISES,
DISCUSSION
QUESTIONS,
AND FURTHER
READING

One of the starkest paintings of Native life is by Swiss artist Karl Bodmer (1809–1893). In *"Mih-tutta-hang-kutch" Mandan Village* (1834), he portrays the dispossessed and displaced Natives in the bleak winter landscape. Like Catlin, Bodmer wanted to record the threatened Native American culture. Bodmer visited the Mandan people during an exceptionally severe winter when there was little food, and even his traveling companion contracted scurvy from the limited diet. The suffering people are foregrounded, and the snowy landscape stretches on forever, unrelieved by any attempt to glamorize or beautify it in any way. This is a picture as critical as a war photograph by Robert Capa. Bodmer was reluctant to share the prevailing American view of the Native; he questioned the belief in "progress" and returned to Europe.

Visual artists responded to the popular interest in stories of the Wild West and created iconic images for magazines that fed into movie imagery. Like Bodmer and Catlin, Frederic Remington (1861–1909) was interested in Native Americans, though his pictures largely championed the white cowboy's point of view. *A Dash for the Timber* (1889) depicts a team of cowboys at full heroic gallop in the middle of battle. Remington was a writer as well as an artist, and illustrated his own books. In his *The Old Stage-Coach of the Plains* (1901), the coach crests a hill under a night sky, a dramatic and cinematic narrative moment.

6.7

By the late nineteenth century, the reputation of these "western" painters declined in art appreciation circles, but the imagery was revived in the popular imagination by the creators of western stories and novels and began the twentieth-century fascination with the western in the movies.

6.7
Wyoming String Team c. 1880, **1966**
Artist: Nick Eggenhofer (1897–1985)
Young Nick Eggenhofer saw the 1898 silent movie *Buffalo Bill's Wild West*, shot by the Thomas Edison film company, and became fascinated by the legends of the Old West. He began working as an illustrator of western scenes for magazines and book covers. His work became some of the best-known images of the Old West and remained highly popular during the golden age of the western from the 1920s through to the late 1950s. In recent years he has been reclaimed as a fine artist, with exhibitions in museums, and his work is widely collected. *Wyoming String Team c. 1880* is a history painting, made almost a hundred years after the Old West had passed into legend.

FURTHER VIEWING

The best place to see art of the American West is the Joslyn Art Museum in Omaha, Nebraska, which has the most comprehensive collection by Carl Bodmer, as well as many paintings by Bierstadt, Catlin, and others. The Joslyn website (http://www.joslyn.org) provides an excellent virtual tour of the collection, with the opportunity to study the paintings in detail.

The Western

By the time the Thomas Edison company turned its cameras on Buffalo Bill, the imagery of the American West had been established for almost a century: a vast empty landscape, with stunning scenery, few people, and picturesque Native populations. Early western movies were able to use these paintings and illustrations to create exciting settings that were already familiar to audiences. Early American cinema audiences were almost entirely based in urban areas, particularly the immigrant-populated cities of the eastern seaboard, who only saw the West in the cinema and in art.

The western is the most landscape-centric film genre. Indeed, the landscape defines the western completely, as the stories are inextricably linked to their location. But the visual imagery of the western is drawn almost completely from painting: the sublime vision, dramatic sunsets, a sense of isolation, emphasis on topography such as mountains, rivers, and lakes. Figures are often depicted as almost miniscule.

But the paintings are themselves nostalgic, showing a vanishing way of life, hiding the reality of tourism and the squalor that existed in both Native encampments and settler villages. The popular media of the time did not elaborate on these things.

The western is a truly American genre, in painting and in cinema. The covered wagon trains, the cowboys, the Indian camps, and the monumental landscapes of Colorado, the Rocky Mountains, and the Great Plains belonged only to America. The appeal of the western was that it could be a shared cultural experience, bringing together immigrants from the four corners of the earth to participate in an "American" story. Exported, the western film made America a glamorous and exciting place.

The western film tries to have the best of both worlds: a stunning yet nostalgic landscape, almost completely unspoiled by humans, yet, paradoxically, the western is full of stories of human heroism, depredation, and betrayal. In the next chapter we will look at artistic depictions of heroism, and how they feed into cinema.

6.8

6.8
***Stagecoach*, 1939**
Dir. John Ford
By the late 1930s, location shooting made it possible to take the whole film on location to Monument Valley in Utah, where Ford shot almost all of his western films.

CASE STUDY:
THE ROAD MOVIE

Although the road movie may seem to be the quintessential American genre, its roots lie in Europe and in a literary tradition known as the picaresque,[15] in which the plot is structured as a journey.[16] In cinema, by the middle of the twentieth century, the western began to merge into the road movie. The two have much in common:[17] the movement of characters between civilization and wilderness, the contrast between civility and barbarism, and the wide open landscape. The road symbolizes and embodies America's historical frontier ethos, recurring as a persistent theme of American culture. The western had always offered a "particular conception of American national identity revolving around individualism and aggression." In the linear narrative structure of the road movie, these characteristics "become concentrated and codified."[18] The landscape of the road movie, as with the western, is the inexorable "third character" of the film—it both mirrors and influences the action and the mood.

6.9

6.9
Easy Rider, 1968
Dir. Dennis Hopper, DP Laszlo Kovacs
"It's about 2 guys riding across the west, John Ford's west, only they're going to go east."
(Peter Fonda)

WHY
LANDSCAPE?

BEAUTIFUL,
PICTURESQUE,
OR SUBLIME?

THE AMERICAN
LANDSCAPE AND
THE AMERICAN
WEST

CASE STUDY:
THE ROAD
MOVIE

EXERCISES,
DISCUSSION
QUESTIONS,
AND FURTHER
READING

Heading West

Two young men with motorcycles cut a lucrative drug deal and then ride across the USA to the New Orleans Mardi Gras. On their way they visit a hippie commune and a Mexican American farm, befriend a civil rights lawyer, and encounter intolerance and violence. Peter Fonda and Dennis Hopper wanted to make a movie that would take the pulse of the era, a time convulsed by the Vietnam War and the perceived "generation gap" between the conservative older generation and the youth.[19]

Easy Rider contrasts "America the beautiful" with an ugly America: the beauty of the landscape against the brutality of its inhabitants. But not all of the landscape: the film idealizes the Southwest, with its dramatic desert vistas, populated by hospitable, spiritual folk—Native Americans, Hispanics, hippies—and indicts the South. "In the Southwest the protagonists enjoy the freedom of the road, the hospitality of those they encounter in the beauty and mystery of the region's wilderness." Conversely, the South, despite occasional glimpses of verdant beauty and Old South plantation houses, reveals African American poverty and a despoiled industrial world of oil refineries, cheap cafes, and ignorant bigots.[20]

The movie was made on location, following much of the famed old Route 66 through California, Arizona, New Mexico, and Louisiana, and a great deal of it was shot on the open road by DP Laszlo Kovacs. Fonda and Hopper rode their motorcycles on the road, accompanied by the camera car, a 1968 Chevy convertible with the backseat taken out and a pinewood floor where the tripod was fixed. This allowed Kovacs to use a telephoto lens to offer many different points of view while aligning the movement of the bikes, capturing the landscape from the bikers' perspective. "Laszlo was able to give us a sense of freedom of being on the road, of being able to experience America for the first time . . . he was able to be that metaphor of freedom" (Cinematographer Ellen Kuras).[21]

Kovacs, a refugee from the 1956 Soviet invasion of Hungary, recalls first crossing America by bus, sitting in the front seat. His first impression of America was that it was a "devastatingly beautiful country . . . it left such an impression on me [. . .] that later on I was able to use it in my movies." The trip also "taught me one lesson that the environment the background is so important it has to be a third character because it tells so much about people who live in it."[22]

The landscape is indeed a character in *Easy Rider*. As Fonda points out, the film reverses the classic western route of east to west. The journey starts in hope, with stunning sequences in the Painted Desert and in Monument Valley (interestingly, the film crew left New Mexico and passed right through Texas; if they shot there, none of the footage is in the film) and ends on a nondescript roadside on the banks of the Atchafalaya River in upstate Louisiana. Kovacs invoked romanticism through the use of lens flare; previously considered a grave camera error, Conrad Hall had used it in 1967's *Cool Hand Luke*. Kovacs saw its aesthetic possibility to create what he called "rainbows" of light, romanticizing the landscape and offering a shimmer of hope that is belied by the film's story.[23]

Twentieth-Century Landscape Painting and the Madness of Civilization

Since the locus of the American art world was still New York, other parts of the country were relatively underrepresented until the 1960s. While the Southwest was painted, by Georgia O'Keefe among others, the Deep South less so.[24] O'Keefe, a New York artist, went to New Mexico in the 1930s and painted its desert landscapes, later making it her permanent base; the state later became one of the most significant artistic communities outside New York. Charles Sheeler (1883–1965) painted the industrial landscape (see *American Landscape*, 1930, a depiction of the Ford plant on the River Rouge near Detroit, Michigan, strangely devoid of people). Regional painters did have a local impact: the Bayou School painters settled in and around New Orleans and captured that area's particularity (see the works of William Henry Buck, 1840–1888, and others on the Historic New Orleans Collection website, http://www.hnoc.org). Others explored remote locations: Canadian painter Emily Carr (1871–1945) traveled alone by canoe around the Pacific Northwest.

While American painting in the mid-twentieth century was dominated by Abstract Expressionism, landscape painting did survive. However, it was Pop Art that addressed the modern American landscape from the 1960s, critiquing the romanticism of the road, the lure of the highway, and the vastness of the American terrain. While pop artists acknowledged the dominance of the road as an American motif, and mobility as a characteristic of American culture, they "questioned the road as a metaphor for freedom seeing it as quote little more than a conveyor belt that runs through a repetition repetitive vacuous monotonous environment."[25]

Andy Warhol borrowed newspaper clippings to create colored silk screens devoted to a series of car crashes, critiquing the media's concentration on highway disasters, deglamorizing the myth of the car crash as a romantic "blaze of glory" ending (see *Orange Car Crash Fourteen Times*, 1963). Allan D'Arcangelo (1930–1988; see *US Highway 1, Number 5*, 1963) reduced the road to a series of signs, a never ending blacktop of ennui where nothing happens. Even the desert is critiqued in Lyn Foulkes's paintings: in *Death Valley, USA* (1963), the landscape is unromanticized, undistinguished, inhospitable, and unpleasant. In the 1995 painting *The Western Viewpoint* (which can be seen on the website http://llynfoulkes.com), Foulkes paints the desert as a dried-out inhospitable environment, inhabited by a pastiche image of an "Indian" couple in traditional dress, echoing the art and film trope of the "spiritual Native" in the desert environment. They are overlooked by a Mickey Mouse sitting on a fence post surveying the scene, with the symbol of a question mark above his head. In the foreground is a fence bearing a sign "This fence is state property. Do not move without permit." A drooping American flag stands to the right. It is a highly critical perspective, an approach that has much in common with a film like *Natural Born Killers* by Oliver Stone, a road movie that criticizes every romanticized cliché of the road movie, and the media that glorify senseless violence.

WHY
LANDSCAPE?

BEAUTIFUL,
PICTURESQUE,
OR SUBLIME?

THE AMERICAN
LANDSCAPE AND
THE AMERICAN
WEST

CASE STUDY:
THE ROAD
MOVIE

EXERCISES,
DISCUSSION
QUESTIONS,
AND FURTHER
READING

Losing the Way: *Meek's Cutoff*

From her first feature, *River of Grass* (1994), American independent filmmaker Kelly Reichardt emerged with a fresh approach to the road movie, particularly as regards landscape. In *Old Joy*, old friends Kurt and Mark leave the city for a weekend in Oregon's Cascade Mountains, searching for a hot spring. Reichardt's style is low key and realistic, following the protagonists through the lush green landscape of the West Coast forest, reminiscent of some of Emily Carr's deep forest paintings such as *The Tree* (1931) or *Young Pines in Light* (1935).[26] But the men can no longer communicate the way they used to; life has changed them. Kurt has retained the freewheeling lifestyle of his youth, but it no longer satisfies him; Mark has opted for a settled, traditional, even complacent life, but fears he has missed out on something. The friendship is not riven, but it has changed; something has been lost. This is mirrored in the landscape: they camp out for the night in what we assume is a pristine wilderness, but in the morning light it is revealed as a dumping ground, bestrewn with rubbish.

"WE'RE NOT LOST. WE'RE JUST FINDING OUR WAY."
—Stephen Meek in *Meek's Cutoff*

6.10
***Old Joy*, 2006**
Dir. Kelly Reichardt, DP Peter Sillen
In *Old Joy*, the characters' attempt to restore a friendship through a journey into the remote landscape is sublime yet ambivalent.

6.11
***Meek's Cutoff*, 2010**
Dir. Kelly Reichardt, DP Christopher Blauvelt
Covered wagon trains are a staple of the western genre, and were much depicted by American artists, but Reichardt and Blauvelt have interpreted this scene in a painterly way strongly reminiscent of French realist Millet.

In *Meek's Cutoff*, Reichart's approach is even more painterly. The film combines the western and the road movie, based on a true story: on the Oregon Trail in 1845, frontier guide Stephen Meek led a wagon train through the Oregon desert but apparently got lost, leading the train into deep hardship. Reichardt depicts the period when the pioneers realize that the garrulous, self-mythologizing Meek has no idea where he is going, and worse, no clue where the next source of water lies. After leading them to a salt lake, Meek is distrusted by the group. The group encounter and capture a lone Native American man and have to decide whether to trust him to lead them to water.

Shot in the archaic 1.37:1 Academy aspect ratio, the film dwells on the figures in the huge, empty landscape. The film consists principally of the everyday realities of frontier life, told in still, long takes showing "Reichardt's lingering obsession with the wheel-mending, bread-kneading, water-rationing, hardscrabble materiality of pioneer life, a close-up view of the women's West."[27] The landscape drains them, overwhelms them, denying them water, denying them everything except inexorable sun and hard ground. Roger Ebert notes that the characters' "personalities seem to weaken in the force of the wilderness."[28]

6.12

Reichardt's depiction of the encounter between the white settlers and the Native (Rod Rondeaux as "The Cayuse") and their inability to communicate is both realistic and poignant. But Rondeaux's brave is not in control of his environment: he is as alone as the settlers—he may also be lost.

6.12
Meek's Cutoff, 2010
Dir. Kelly Reichardt
The figures are silhouetted or semi-silhouetted against the sky and dry, scrubby ground. The textiles on the line and the skirt of the dress are caught by the wind. While the foreground of the image is homely, the vast blank expanse beyond and the lone rider indicate a deep sense of isolation.

Jean Francois Millet, a nineteenth-century French realist, is known for his scenes of the French countryside and the way of life there. He and his friends left Paris for Barbizon, a village near Fontainebleau south of the capital. Inspired by English painters like John Constable, they wanted to paint nature, and especially landscapes. Millet wanted to produce landscapes with figures, but instead of idealized pretty shepherdesses and milkmaids, he portrayed real people, peasants working in the fields. Muted, glowing light created by cloud formations and weather, as well as the position of the sun or moon, infuse all of his works. Millet himself came from a farming family and knew the rhythms of peasant life at first hand. See also *The Gleaners* (1857).

Many of *Meek's Cutoff*'s compositions and lighting bear strong resemblance to Millet's works, including the night scenes (see *The Sheepfold, Moonlight*, 1856). At other times, such as the campfire scenes, we see Rembrandtian chiaroscuro. The powerful heat of high noon in the Oregon desert is conveyed in a stark, hard-edged look; the colors, usually so muted and softened, suddenly seem almost unbearable. Is *Meek's Cutoff* a western or a road movie? It is both. It critiques the whole body of "knowledge" about "the West" framed by cinema and by painters like Bierstadt, Remington, Eggenhofer, and others. The road is unknown, the destination seems unattainable (in real life the wagon train did make it, barely). The West is dramatic, beautiful, empty, mysterious, terrifying. The film is mainly about the people lost in it, wandering, thirsty, vulnerable, yet poignantly hopeful.

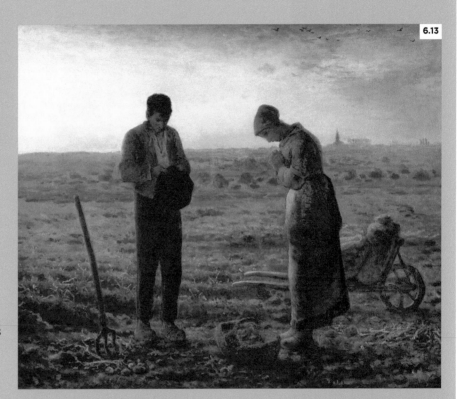

6.13

6.13
L'Angélus (The Angelus), 1857–1859
Artist: Jean Francois Millet (1814–1875)
In a potato field, a man and a woman are reciting the Angelus, a Catholic prayer traditionally recited at 6 p.m. Millet wanted to catch the rhythms of peasant life in a simple scene. The light is beginning to fade.

The End of Desire

The European road movie is influenced by the American road movie, but is very different. One of the earliest and most interesting is *The Wages of Fear* (1953), directed by Henri-Georges Clouzot, DP Armand Thirard, in which four European men are hired to drive two trucks loaded with nitroglycerin over precarious mountain dirt roads. Filmed on location in Mexico and set in an unspecified Latin American country, it is normally considered a thriller rather than a road movie, but almost all of the action (which occurs in the second half of the film), and all of the suspense and tension, takes place on the road. The Mexican landscape is dramatic, covered in rocks and cacti, and the road consists of dangerous hairpin turns and crumbling bridges, but it's very clear that in this film there is no romanticizing whatsoever of the West, or of the road.

6.14

6.14
Stalker, 1979
Dir. Andrei Tarkovsky
Tarkovsky creates a mysterious postapocalyptic landscape out of postindustrial ruins in Soviet Estonia, including a dilapidated shipyard, a decommissioned hydroelectric station, and an abandoned oil processing plant.

WHY
LANDSCAPE?

BEAUTIFUL,
PICTURESQUE,
OR SUBLIME?

THE AMERICAN
LANDSCAPE AND
THE AMERICAN
WEST

CASE STUDY:
THE ROAD
MOVIE

EXERCISES,
DISCUSSION
QUESTIONS,
AND FURTHER
READING

The French landscape in winter is the setting for Agnes Varda's 1985 film *Vagabond*, a road movie about a young female drifter. Again, there is a refusal to romanticize, prettify, or even find any beauty in the out-of-season Languedoc landscape. Director Varda has said of the film that she wanted to explore what freedom meant—but not only freedom, also the dirt of the road, the grit and the stench of life on the road. *Vagabond* is a European riposte to the American myth of individual independence, symbolized by the West and the open road.

Part dystopian road movie, part spiritual quest, Andrei Tarkovsky's *Stalker*, loosely based on the 1971 science fiction novel *Roadside Picnic* by Arkady and Boris Strugatsky, moves through a devastated landscape. Two men, a writer and a professor of science, hire a Stalker, a guide to take them through a mysterious and forbidden terrain, known as the Zone. Within the Zone, they believe, lies a Room which supposedly contains the power to fulfill a person's deepest desire. As they set off on the journey, the Stalker informs the men that the problem with the Zone is that it is a sentient landscape: the land itself senses their presence and lays dangerous traps for them. The Stalker's role is to find a safe route to the Room.

The film treats landscape in an interesting way. The Zone is shot in color, often with a strong emphasis on blues and greens, which contrasts with the rusty red of some of the industrial detritus that lies around. The Zone is compelling; its ruined beauty is seductive. Although there is only one brief moment in which Tarkovsky shows us the sentience of the Zone's terrain, we believe in it right from the beginning of the journey. Most of the other scenes are high-contrast sepia, giving a sense of timelessness. "The Zone doesn't symbolise anything, any more than anything else does in my films; the Zone is a zone, it's life, and as he makes his way across it, man may break down or he may come through."[29]

EXERCISES AND DISCUSSION QUESTIONS

Exercise 1

Consider different kinds of landscape, including the industrial landscape discussed in Chapter 3's section on Antonioni's *Red Desert*. Watch any of the following suggested films of different genres—or choose your own—and note the different ways that the visual appearance of place dramatically affects the mood and drives the story. Consider the "landscape of the mind" and how landscape settings serve as outward manifestations of characters' inner subjective states. Can landscape in cinema or art ever be neutral? Why or why not?

The Last Frontier (1955), dir. Anthony Mann, DP William Mellor

Kes (1969), dir. Ken Loach, DP Chris Menges

Get Carter (1971), dir. Mike Hodges, DP Wolfgang Suschitzky

Eraserhead (1977), dir. David Lynch, DP Frederick Elmes

The Deer Hunter (1978), dir. Michael Cimino, DP Vilmos Zsigmond

Beau Travail (1999), Claire Denis, DP Agnès Godard

Once Upon a Time in Anatolia (2011), dir. Nuri Bilge Ceylan, DP Gökhan Tiryaki

Dead Man's Shoes (2004), dir. Shane Meadows, DP Danny Cohen

The Last King of Scotland (2006), dir. Kevin MacDonald, DP Anthony Dod Mantle

Or choose a road movie:

Central Station (1998), dir. Walter Salles, DP Walter Carvalho

Y Tu Mamá También (2001), dir. Alfonso Cuarón, DP Emmanuel Lubezki

Children of Men (2006), dir. Alfonso Cuarón, DP Emmanuel Lubezki

Las Acacias (2011), dir. Pablo Giorgelli, DP Diego Poleri

Exercise 2

Brazilian director Walter Salles (who studied film in the US) has made road movies that explore the landscape of South and North America.

In 2004's *The Motorcycle Diaries*, and in 2012's *On the Road*, Salles and DP Eric Gautier, depicted two iconic journeys: respectively, Ernesto Che Guevara's South American odyssey toward politicization, and Beat writer Jack Kerouac's account of the chaotic, emotional road trips he and his friends made across the US. Watch both films and compare the way Salles and Gautier depict each journey and their approach to visual storytelling. Compare their depiction of landscape and how each shapes the film's story and characters.

DISCUSSION QUESTIONS

1. On the National Gallery website (www.nationalgallery.org.uk) you can see two paintings called *The Watering Place*—one by Pieter Paul Rubens made about 1615–1622, the other made around 1777 by Thomas Gainsborough. How are they similar? How are they different? What mood does each evoke?

2. Do you think the 1969 counterculture film *Easy Rider* is a western? Many critics and scholars do classify it as a postmodern western. Why? Thinking about the film's use of landscape, and heroic identity, can you see ways that *Easy Rider* can be classified as a western?

WHY
LANDSCAPE?

BEAUTIFUL,
PICTURESQUE,
OR SUBLIME?

THE AMERICAN
LANDSCAPE AND
THE AMERICAN
WEST

CASE STUDY:
THE ROAD
MOVIE

**EXERCISES,
DISCUSSION
QUESTIONS,
AND FURTHER
READING**

FURTHER READING

Andrew Wilton, *American Sublime* (Tate, 2002)

Elizabeth Mankin Kornhauser, *The Hudson River School* (Yale University Press, 2003)

Malcolm Robinson, *The American Vision* (Octopus, 1988)

Nils Buttner, *Landscape Painting: A History* (Abbeville Press, 2006)

David Melbye, *Landscape Allegory in Cinema: From Wilderness to Wasteland* (Palgrave Macmillan, 2010)

Graeme Harper and Jonathan Rayner, *Cinema and Landscape* (Intellect Books, 2010)

Steven Cohan and Ina Rae Hark, *The Road Movie Book* (Routledge, 1997)

NOTES

1 Robert Hughes, "Watteau," in *Nothing If Not Critical* (Penguin, 1990).
2 Joseph Addison in *The Spectator*, issue 489, September 20, 1712. Quoted in *The Sublime: A Reader in British 18th-Century Aesthetic Theory*, ed. Andrew Ashfield and Peter de Bolla (CUP, 1996), p. 69.
3 Horace Walpole "Alpine Scenery: The Grande Chartreuse," in *English Prose: Vol. IV. Eighteenth Century*, ed. Henry Craik (Macmillan, 1916).
4 Discussed in Angela Dalle Vacche, *Cinema and Painting: How Art Is Used in Film* (University of Texas Press, 1996).
5 Jeremi Szaniawski, *The Cinema of Alexander Sokurov: Figures of Paradox* (Columbia University Press, 2013).
6 Jürgen Müller, *Movies of the 90s* (Taschen, 2001).
7 Felix W. Tweraser, "Images of Confinement and Transcendence: Michael Haneke's Reception of Romanticism in *The Piano Teacher*," in *The Cinema of Michael Haneke: Europe Utopia*, ed. Ben McCann and David Sorfa (Columbia University Press, 2013).
8 *Art Quarterly*, Autumn 2014, p. 96.
9 Quoted in Barbara Novak, *American Painting of the Nineteenth Century: Realism, Idealism, and the American Experience* (Oxford University Press, 2006), p. 41.
10 Malcolm Robinson, *The American Vision* (Octopus, 1988)
11 The term "Indian" will be employed here despite its being inaccurate. The North American aboriginal peoples were not "Indians," but the term became established and was used during the period under discussion. It is not normally used to describe Native American people today.
12 George Catlin, *Letters and Notes on the Manners, Customs, and Condition of the North American Indians* (Wiley and Putnam, 1842), available on archive.org.
13 Bruce Watson, "George Catlin's Obsession," *Smithsonian*, December 2002.
14 George Catlin, *Letters and Notes on the Manners, Customs, and Condition of the North American Indians* (Wiley and Putnam, 1842). Available on Archive.org.

15 "Picaresque" is defined as "the adventures of a rogue or lowborn adventurer (Spanish *pícaro*) as he drifts from place to place and from one social milieu to another in his effort to survive." (*Encyclopaedia Britannica*)
16 The first known picaresque story is Homer's *Odyssey*, as the hero Odysseus traverses the Mediterranean, trying to get home. Joseph Campbell indicates the even older myth of the hero's journey: *The Hero with a Thousand Faces*, 3rd ed. (New World Library, 2008). Other significant picaresque stories include *Don Quixote*, published 1605 and 1615, subject of a 1955 ink drawing by Pablo Picasso and several paintings by Charles Coypel (1751) and Honoré-Victorin Daumier (1855); Voltaire's philosophical novel *Candide* (1759); and W. M. Thackeray's *Barry Lyndon* (1844), which was filmed by Stanley Kubrick (1975).
17 Many of the insights in this section are taken from the essays in *The Road Movie Book*, edited by Steven Cohan and Ina Rae Hark (Routledge, 1997).
18 Steven Cohan and Ina Rae Hark, introduction to *The Road Movie Book*.
19 Barbara Klinger, "The Road to Dystopia: Landscaping the Nation in *Easy Rider*," in *The Road Movie Book*.
20 *Ibid.*, p. 181.
21 Kuras interview in *No Subtitles Necessary: Laszlo and Vilmos*, directed by James Chressanthis (Cinema Libre Studio, 2012).
22 Kovacs interview in *No Subtitles Necessary: Laszlo and Vilmos*.
23 *Ibid.*
24 Portraiture dominated painting in Louisiana, for example.
25 Sidra Stitch, *Made in the USA: Americanization in Modern Art, the 50s and 60s* (University of California Press, 1987).
26 Ian Dejardin and Sarah Milroy, *From the Forest to the Sea: Emily Carr in British Columbia* (Goose Lane Editions, 2015).
27 Kate Stables, Review of *Meek's Cutoff*, *Sight and Sound*, May 2011.
28 Roger Ebert, Review, *Chicago Sun-Times*, May 11, 2011.
29 Andrei Tarkovsky, *Sculpting in Time: Reflections on the Cinema* (University of Texas Press, 1989).

CHAPTER SEVEN HEROES AND HEROIC ACTS

Heroic depictions of mythical characters and history paintings that visually recounted great deeds and significant events were considered the highest achievement in art. History painting has always been about heroic acts, crucial battles, and momentous events. Though the heroes change, the heroic body and gesture are endlessly repeated and are instantly recognizable across visual culture. History painting was reinvigorated by its encounter with landscape, starting with Poussin and Rubens, but most notably in the paintings by American artists. In the western movie, a uniquely American genre, landscape and hero meld together in dynamic narratives that echo the oldest myths, yet offer something completely new and different.

HISTORY
PAINTING:
VICTORY,
VIRTUE, AND
THE HERO

HEROISM AND
THE WESTERN

CASE STUDY:
SUBVERTING
THE HEROIC
GENRE

EXERCISES,
DISCUSSION
QUESTIONS,
AND FURTHER
READING

HISTORY PAINTING: VICTORY, VIRTUE, AND THE HERO

Heroic Characters

The ideal "hero" model was established in earliest antiquity, in the ancient epics of Gilgamesh, the *Iliad*, and the Norse sagas. Joseph Campbell in *The Hero with 1000 Faces*[1] shows that similar stories of heroism are present in all societies, at all times in history. It is not a surprise to see that from early times artists have sought to portray heroes and heroic acts. Heroes in paintings are not meant to be realistic; they are heroic.

Heroic characters are central to human culture. They always appear; only the outward trappings change. Carl Jung proposed the idea of archetypes, or "primordial image" that we are all born with and that shape human behavior. The hero archetype is one of these. In painting, Greek mythical characters were by far the most favored, although biblical heroic characters such as David also appear frequently. The problem with biblical characters as heroes is that the most heroic Christian character, Jesus, does not conform to the hero stereotype. In this respect, Greek mythology was a far more reliable source of painting ideas. Ever popular Hercules, the impossibly strong man, recurs in art from Greek friezes and vases through early Renaissance paintings right up to present-day cinema.

We've already seen Titian's painting of Perseus and Andromeda, with the hero in mid-plunge into the sea to rescue the woman from the monstrous sea serpent. The important thing about the hero character is that the hero is mortal, or at least half-mortal, and so his or her feats are particularly remarkable. The difference between a Greek god and a heroic character is that the god is expected to be great and powerful, so therefore is not really heroic but simply doing what gods are supposed to do. The hero, on the other hand, has to *become* heroic.

The old-fashioned notion of hero was taken up immediately by cinema, particularly during Hollywood's golden age. The appeal of the heroic character endures: some of the most popular include Indiana Jones, Ripley in the *Alien* films, and Neo in the *Matrix* films. Neo's partner in *The Matrix*, Trinity, performs a role similar to the Greek goddesses who help (and often become lovers to) heroes like Odysseus, Perseus, and others. Trinity also has elements of the powerful goddess Diana the Huntress (Greek Artemis), a popular subject in Greco-Roman sculpture. Wearing a tunic and carrying weapons, Diana seems quite dangerous (see the *Diana of Versailles* from 200 AD, in the Louvre), but later paintings tend to show her nude and sexualized (Titian's *Diana and Actaeon*, 1556).

FURTHER VIEWING

Some paintings of the exploits of the hero Hercules throughout history:

Antonio del Pollaiuolo, *Hercules and the Hydra* (1475)

Gregorio De Ferrari, *Hercules and Antaeus* (1690s); another version was made by Lucas Cranach the Elder (1530).

Hendrick Goltzius made an engraving, *The Great Hercules* (1589) and a later painting, *Hercules and Cacus* (1613).

Rubens made several Hercules paintings, including an amusing depiction of *The Drunken Hercules* (1611).

A late interpretation, *Hercules Freeing Prometheus* (1819), by Friedrich Heinrich Fuger, also shows the Romantic fascination with the defiant hero Prometheus (Mary Shelley's *Frankenstein* was subtitled "A Modern Prometheus").

Real People Portrayed as Heroes

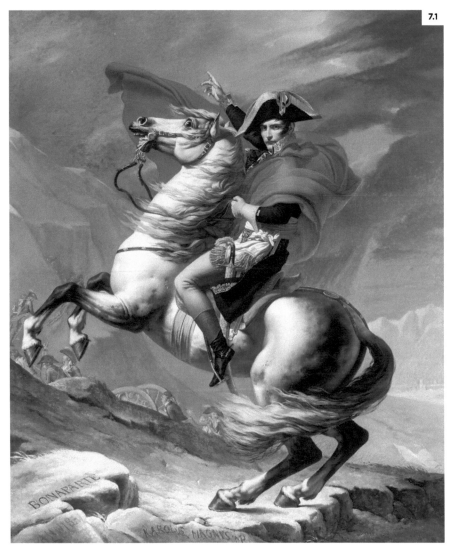

7.1

7.1
Napoleon Crossing the Alps
***(Napoleon at the Saint-Bernard Pass)*, 1801**
Artist: Jacques-Louis David (1748–1825)
David made five versions of this painting of
Napoleon crossing the St. Bernard Pass.

Jacques-Louis David was a staunch
supporter of the French Revolution,
even its most extreme faction. *The Death
of Marat,* one of the most important
paintings of the French Revolution,
shows the murdered revolutionist—a
good friend of David—lying dead in
the bath. However, when the extreme
faction was defeated and Napoleon took
control, David switched allegiances.
Once Napoleon consolidated its power
and proclaimed himself emperor,
David became his official court painter
and painted Napoleon's coronation.
One might think that David would be
disgraced after the fall of Napoleon,
but in fact the restored King Louis
XVIII offered to keep David on as court
painter. The artist refused, remaining
true to his revolutionary principles.

Apparently Napoleon actually crossed
the Alps on mule, a far more suitable
animal for this kind of tricky and
difficult journey. However, this
wouldn't do for heroic painting, so
David has portrayed the general not
only on a horse, but on a splendid horse
rearing up on the edge of a precipice.
The staunch general maintains his
composure, looking directly out of the
canvas and pointing upward, toward
victory and triumph. In the background
the army pushes forward: we can see the
war machines being transported up the
side of the mountain and the *tricoleur*
in the lower right. The structure in the

HISTORY
PAINTING:
VICTORY,
VIRTUE, AND
THE HERO

HEROISM AND
THE WESTERN

CASE STUDY:
SUBVERTING
THE HEROIC
GENRE

EXERCISES,
DISCUSSION
QUESTIONS,
AND FURTHER
READING

picture is striking: Bonaparte is center and is upright, while the horse and the mountain are on a strong diagonal running from top left to bottom right. It is the diagonal arrangement that immediately catches the eye, creating a strong sense of drama and danger. The sensation of wind coming from the rear is shown in the billowing cape and also in the mane and tail of the horse, indicating the harsh alpine winds that confront the army. Yet look at the wind direction: these winds are themselves propelling the general, the horse, and the army forward toward victory. David is indicating that even the gods are behind Bonaparte.

This is a genuinely heroic portrait, and it is obviously, deliberately unrealistic: it would have been difficult for the horse to rear up like that, and Napoleon is wearing an elegant ceremonial uniform. Almost fifty years later, Paul Delaroche made a realistic version of *Bonaparte Crossing the Alps* (1850). Delaroche's mule-riding Napoleon is reflective and knowing, as if he can foresee his Waterloo even in the moment of triumph.

The painting established the persona of Napoleon as a heroic and extraordinary leader. About a year after David's painting, the Haitian revolutionary Toussaint L'Ouverture was depicted in a French print in a similar way, astride a rearing horse in a ceremonial uniform, in this case with his sword held high. David's portrait—reproduced widely in prints, including caricatures—created a popular image for the archetype of the hero. The image retains its power: in 2004, British artist Kimathi Donkor painted his own version, *Toussaint L'Ouverture at Bedourete*, an oil painting reminiscent of David's equestrian portrait.

DAVID AND "NEOCLASSICAL"

David is often labeled "neoclassical," but what does that mean? The late eighteenth century saw the first serious attempts at archaeology, and Greco-Roman artifacts affected artistic style and the development of taste. Neoclassicism interpreted ancient art as having defined lines, sober colors (they incorrectly believed classical sculpture to all be white), shallow space, and strong horizontals and verticals that render the subject matter timeless. Contemporary subjects should "look classical." Neoclassical was associated with moral certainty, heroism, virtue and rectitude, moderation, and rational thinking.

But is David's *Napoleon* really all that neoclassical? Is it moderate and rational? How useful is the concept of "neoclassical"? How can we use it?

FURTHER VIEWING

Films about Napoleon Bonaparte: how "heroic" is he?

Napoleon (1927), dir. Abel Gance, DP Jules Kruger; one of the greatest history films, owing much to both David and Delaroche

Désirée (1954), dir. Henry Koster, DP Milton R. Krasner; a different approach, focusing on the relationship between Bonaparte (Marlon Brando) and Désirée Clary (Jean Simmons)

Waterloo (1970), dir. Sergei Bondarchuk, DP Armando Nannuzzi

David was not the first artist to show that portraying real-life people as heroes involves exaggeration and theatricality. David knew that this is not how Napoleon crossed the Alps, but he understood that in order to create a painting with the highest impact to deliver the propaganda message of Napoleon's overarching genius, strength, power, and glamour, it was necessary to create a powerful, glamorous painting. This problem is at the heart of biopics that attempt to show the core character in a heroic light. Much of the true story and extraneous detail has to be removed, and any act or gesture made by the central character needs to be reinterpreted as heroic. One of the best examples of this in recent cinema is Mel Gibson's 1995 film *Braveheart*, which puts a completely new gloss on the true story of William Wallace. Wallace was a real person who did rebel, but under circumstances rather different from those shown in the film. The film tries to capture historical detail, but there's no question that it was glamorized for dramatic effect.

7.2

How important it that art be accurate? Everybody who saw Napoleon's portrait already knew that he was a military tactician of great talent and that he was extremely powerful. Painting doesn't need to tell us this: the painting simply reinforces visually what we already know. Likewise, *Braveheart*'s story of thirteenth-century William Wallace is not a history lesson; it is an entertaining film that was meant to tell an exciting story of independence and individual resistance to oppression. Yet art can be more powerful than that: David's portrait of Napoleon informed the depiction of the black leader L'Ouverture, both then and now. *Braveheart* may have started the trend for nationalistic face painting at sporting events; the film has even been credited with reviving popular interest in Scottish nationalism.

7.2
Toussaint L'Ouverture at Bedourete, 2004
Artist: Kimathi Donkor
Here Donkor is employing the archetypal heroic composition and gesture established by David and also referencing David's use of color. But the political intent is completely different: L'Ouverture was the leader of a slave rebellion in Haiti, inspired by the ideas of the French Revolution. However, Napoleon sent troops to the island to quell the rebellion, and L'Ouverture was arrested and imprisoned. He remains a key figure in black history.

HISTORY
PAINTING:
VICTORY,
VIRTUE, AND
THE HERO

HEROISM AND
THE WESTERN

CASE STUDY:
SUBVERTING
THE HEROIC
GENRE

EXERCISES,
DISCUSSION
QUESTIONS,
AND FURTHER
READING

Symbolic Heroes

Delacroix's *Liberty Leading the People* depicts the Paris uprising of July 1830, which overthrew Charles X, the king who was restored after Napoleon's defeat. Delacroix did not participate in the uprising; he was in the Louvre helping to protect the collection from the chaos. Though he depended on commissions from institutions and members of the royal family, Delacroix had republican sympathies. Perceiving the uprising as a suitable modern subject for a painting, he started to paint this dramatic scene of the crowd breaking through the barricades, led by the female symbol of Republican France, "Marianne" or Lady Liberty. It is a cinematic and romantic vision, seeking to achieve immediate emotional impact.

The painting has a pyramid composition: the base, strewn with corpses, serves as a pedestal supporting the victors as they push forward, and the pyramid is crested by the lovely Marianne. In her, Delacroix combines classicism, Romanticism, and realism. Liberty's dress is draped in the classic manner, and her face has a Grecian profile with classical straight nose. But her upraised arm reveals the underarm hair that was so vulgar that no painter dared to represent it. She holds a real gun in her left hand, the 1816 model infantry gun with bayonet. She is half-naked, but not sexual. The bare-breasted, fierce image of Marianne leading the battle had appeared in the French revolutionary propaganda of the 1790s; Delacroix revives it, but here makes it romantic, full of color and life, yet also real. The other figures in the painting are as real yet as symbolic as Marianne, as Delacroix faithfully reproduced the style of dress worn by different sectors of society at the time. The man to the right of Liberty in the

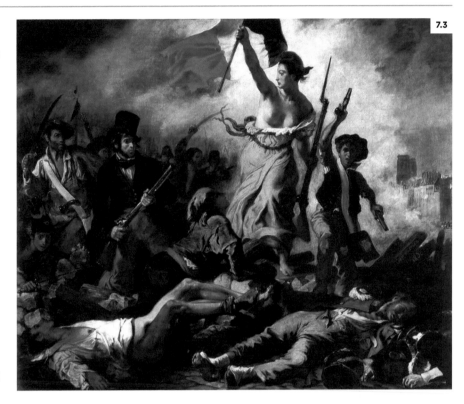

7.3

7.3
***Liberty Leading the People*, 1830**
Artist: Eugène Delacroix (1798–1863)
"Although I may not have fought for my country, at least I shall have painted for her," Delacroix wrote in a letter to his brother.[2] It is not only Lady Liberty who is shown in a heroic pose; so are the men fighting alongside her. This is one of the first actively political works of modern painting.

black beret (worn by students) is a symbol of youthful revolt. The man with the sabre on the far left is a factory worker. Elsewhere in the picture we can see that Delacroix has depicted other workers and peasants realistically. The figure with the top hat may be a self-portrait, or one of Delacroix's friends. He represents a bourgeois or fashionable urbanite making common cause with the ordinary people.

Delacroix's *Liberty Leading the People* was a key inspiration for Eve Stewart, production designer for the 2012 film of *Les Misérables*,[3] which is set during the 1830 events.

The 1830 uprising did not end in a new republic but in a substitute king, and it took several more revolutionary events before France finally became a republic. As one of the most dramatic, persuasive, and stimulating images of revolutionary action, *Liberty Leading the People* was dangerous. The painting was hidden away from public view in 1863. Today it is one of the most popular paintings in the Louvre.

Liberty Leading the People is one of the most cinematic paintings of the nineteenth century and continues to serve as a matrix for crowd scenes, and for the inclusion of symbolic character types within the composition. However, the active heroic female figure, which owes something to the athletic dynamism of the Roman goddess Diana, is only rarely presented in cinema. In recent years female action heroes have become more common, but with the exceptions of the characters Sarah Connor in the *Terminator* films and Ripley in the *Alien* films, it is rare to see female action heroes who are not sexualized. Delacroix's Liberty is bare-breasted to emphasize her femaleness, but she is not using her femaleness to be sexual.

FURTHER VIEWING

Theodor Géricault's *Raft of the Medusa* (1819). Géricault (1791–1824) was Delacroix's teacher. His *The Charging Chasseur* (1812) reinvents David's *Napoleon* portrait as a romantic adventure. The *Raft of the Medusa* is a political work, depicting a recent scandal: the aftermath of a shipwreck in which the captain had left the crew and passengers to die.

HISTORY
PAINTING:
VICTORY,
VIRTUE, AND
THE HERO

HEROISM AND
THE WESTERN

CASE STUDY:
SUBVERTING
THE HEROIC
GENRE

EXERCISES,
DISCUSSION
QUESTIONS,
AND FURTHER
READING

Heroic Bodies

Ford Madox Brown was inspired by two people: he admired William Hogarth, who created pictures with social comment and immediate relevance, and philosopher Thomas Carlyle, who emphasized the nobility of labor, believing that work should be a rewarding experience worthy of respect. Brown wanted to paint the "nobility of labor." His central character is a young workman, holding his shovel at a right angle to his body, his muscles taut and rippling impressively. Brown is doing something similar to Napoleon's horse rearing up: an unrealistic position to create an image of heroism. The young workman is the hero of the picture, with a strong, classical body. He is a modern Hercules, in a heroic pose.

Again we see the pyramid composition, but here Brown subverts the pyramid. He puts the aristocracy (on the horses), who occupy the top of the social hierarchy, at the top of the pyramid, but he recedes them into darkness. The principal subject, the young worker with the shovel, he places slightly off center, and makes space around him, so that the eye is naturally drawn there. Unusually for a painter, Ford wrote a comprehensive explanation of all the details in the picture, including the symbolic meanings of every single subject, which was published in the catalog essay.[4] Philosopher Thomas Carlyle (a "brain worker") appears in the picture, in the hat on the far right.

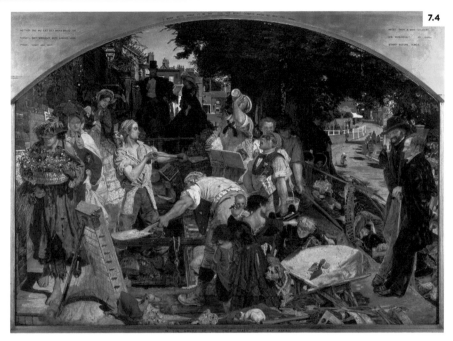

7.4

Brown's painting is an interesting example of an artist trying to employ traditional visual motifs to express very modern, even radical ideas. He offers us very different ideas about what a "hero" is, but he uses heroic gestures derived from traditional art.

7.4
Work (1852–1865)
Artist: Ford Madox Brown (1821–1893)
Ford Madox Brown is not among the ranks of "great artists," but he is useful and important because the wide dissemination of prints of his *Work* entered the popular consciousness. Brown's paintings and murals tend to be didactic and moralistic, and *Work* is no exception. Apparently, as Brown was walking down the street one day, he noticed a group of workers digging a drain, putting in London's vast sewer system. He decided to paint them right there on the street, in order to capture the precise details of light, color, and form.

But the heroic body can also be a site of critique, with the image of heroism undermined through the body. For example, Ernst Kirchner's *Self Portrait as a Soldier* (1915), shows the soldier, the consummate hero, wounded and disabled; Horace Vernet's *The Wounded Trumpeter* (1819) likewise shows an incapacitated warrior. Many filmmakers have used the physicality of the heroic body and its suffering as core images in films dealing with war. Clare Denis's *Beau Travail* (1999) makes the warriors' bodies a site of suffering, not just from the conditions of the desert but also from homoerotic longing. In Kathryn Bigelow's *The Hurt Locker*, the body of bomb disposal expert William James (Jeremy Renner) is often encased in armor that renders him like an alien or a powerful insect; when he emerges from this carapace, he falters, and we see his confusion and weaknesses. In the western *Django* (1966, Sergio Corbucci), the hero's hands are crushed and mutilated before the climactic battle.

7.5

7.5
The Hurt Locker, **2008**
Dir. Kathryn Bigelow, DP Barry Ackroyd
The tension in this story of a three-man bomb disposal team, shot on location in the Middle East, is heightened by the concealing armor they wear.

HISTORY
PAINTING:
VICTORY,
VIRTUE, AND
THE HERO

HEROISM AND
THE WESTERN

CASE STUDY:
SUBVERTING
THE HEROIC
GENRE

EXERCISES,
DISCUSSION
QUESTIONS,
AND FURTHER
READING

HEROISM AND THE WESTERN

John Ford was aware that he was in the business of making myths. In one of his most important films, *The Man Who Shot Liberty Valance*, a character says, "When the legend becomes fact, print the legend." This is what Ford wanted to do. He often said that while his films were historical, he was not married to history. Ford was a friend of Wyatt Earp in the gunfighter's later days, when he served as a consultant on early silent westerns. In *Stagecoach*, Ford tried to show the complexities of the American West—the conflicts between the Natives and the white settlers, who in turn had conflicts with outlaws, lawmen, and gunfighters. Ford's westerns were highly influential and made it a successful genre worldwide, spawning imitators in many countries. At the

core of the western genre is a tension between the idea of valorizing Nature and the "noble savage"—whether it be the Native or the cowboy living in the "natural" life—and the "civilizing mission" ideology of settlement. Most of the painters discussed earlier in the chapter could be seen as championing Nature. But John Ford believed in the civilizing mission, and until his latest films (*The Searchers*, 1956), his moral compass was clear, as were his heroes.

Yet later directors who address the western genre, such as Robert Altman in *McCabe and Mrs. Miller* (1971) and Dennis Hopper's *Easy Rider* (1969), not to mention the whole subgenre of "spaghetti" westerns initiated by Sergio Leone (*A Fistful of Dollars*, 1964),

question even the idea of civilization, never mind heroism. In Leone's films, the beautiful western landscapes of John Ford are replaced by bleak, inhospitable desert landscapes (even though Leone filmed part of *Once Upon a Time in the West* (1968) in Monument Valley, he refused to make it picturesque). In Sergio Corbucci's original *Django* (1966), the frontier town is always muddy, dreary, and filthy, with permanently hurtling wind. The protagonists of these films are only heroic by default; they do not seem heroic, rather mysterious, asocial, and amoral.

CASE STUDY:
SUBVERTING THE HEROIC GENRE

The western was the film genre that brought the heroic figure together with the overwhelming yet splendid landscape. This case study looks at a subversion of that cinema genre through an unlikely relationship: English portrait and landscape painter Thomas Gainsborough (*Blue Boy*, 1770) and American filmmaker Quentin Tarantino (*Django Unchained*, 2012).

Quentin Tarantino has often been referred to as the archetypal "postmodern" filmmaker. His films bear the hallmarks associated with postmodernist approaches: appropriation of ideas, images, and texts from different sources; referencing other movies, books, and art; pastiching established genres; conflating popular culture and high culture. In his later films, Tarantino subverts existing genres, including established trash and schlock genre forms, and through the process of subversion seeks to make a serious point.

Thomas Gainsborough, the eighteenth-century portrait and landscape painter, could not be further apart from Quentin Tarantino at first glance. Yet Gainsborough was subversive in many ways. Like Tarantino, he broke new artistic ground and challenged established artistic forms. However, until *Django Unchained*, it would have been ridiculous to imagine a comparison between Gainsborough and Tarantino, or even to discuss them within the same sentence. But in that film, Tarantino and his design team (J. Michael Riva and Sharen Davis)

appropriate a key element of one of Gainsborough's most popular and most widely distributed paintings, *The Blue Boy*. It is from this starting point that we will look at this case study of *Django Unchained* and Gainsborough's *Blue Boy*.

The *Blue Boy* was painted before Gainsborough moved to London. Born and raised in a lower-middle-class family in rural Suffolk, he moved to the spa town of Bath as his portrait practice developed. The problem for Gainsborough was that he preferred landscapes. He liked painting people—skin tones, drapery, and costume—but, with the exception of certain female clients, he disliked painting portraits of the type of people who commissioned him. We know this because in his letters he complains about his rich, arrogant, empty-headed clients, and says many times over that he wishes he could just go to the countryside and spend the rest of his life painting landscapes and common folk. (His own favorite was *The Woodsman*, 1788, a portrait of a poor forest worker.)

It is not unusual for people to dislike their day job and wish to be doing something else. But Gainsborough's ability to create real likenesses of his subjects made him successful. He rejected the current fashion of painting his subjects dressed up as mythological beings; he wanted to paint people in their own clothes, looking as they would if you met them. One of the trendiest fashions in mid-eighteenth-century England was to be painted wearing the court costume of the previous

century, in the style of Dutch painter Anthony Van Dyke at the court of King Charles I. Van Dyke's paintings were widely copied; all decent painters understood that they should be able to make a Van Dyke to order. Van Dyke painted his aristocratic subjects wearing elaborate silk and lace suits, one of the most influential being *Lord John Stuart and His Brother, Lord Bernard Stuart* (1638). In the painting, Bernard Stuart is wearing a fabulous pale blue satin suit, though most of it is obscured by a heavy silver cape.

Normally this is the kind of portrait that Gainsborough would have scoffed at replicating. But two years previously he had been elected a founder member of the Royal Academy of Arts. It was never an easy relationship; Gainsborough felt like an outsider with something to prove. He decided to challenge the claim of the Academy's head, Sir Joshua Reynolds, that blue colors should be used only as accents, not in the main mass of the picture. He painted a mass of blue, an exercise in color and light reflecting on silk, using layers of different blue pigments: lapis and indigo, cobalt and turquoise, together with charcoal and creamy white, and sent *The Blue Boy* to the Royal Academy's 1770 Salon. But who was the blue boy? He was not an aristocrat or theater celebrity who would normally command an Academy-level portrait. He was Jonathan Buttall, a good friend of Gainsborough and an iron merchant in London. It was not a commissioned portrait: Buttall posed

HISTORY
PAINTING:
VICTORY,
VIRTUE, AND
THE HERO

HEROISM AND
THE WESTERN

CASE STUDY:
SUBVERTING
THE HEROIC
GENRE

EXERCISES,
DISCUSSION
QUESTIONS,
AND FURTHER
READING

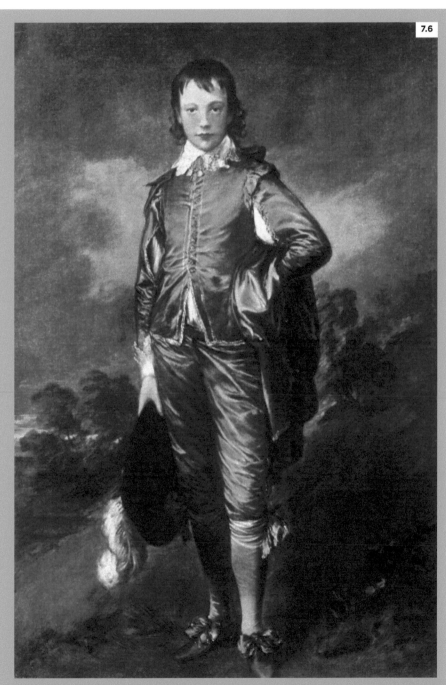

7.6

for Gainsborough as a friend. Buttall was far outside the circles of power; he could never have worn court dress. Therefore, *The Blue Boy* is a subversion. It is not only a painting of an eighteenth-century man in seventeenth-century dress; it is an aristocratic portrait that portrays a middle-class man.

The painting became the talk of the Academy, and its success spurred the painter to move to London two years later. He was commissioned by the royal family, and his success enabled him to take more time out to paint his beloved landscapes. But it was not that simple. Soon after arriving in London, Gainsborough fell out with the Royal Academy and spent the rest of his life in rivalry with Joshua Reynolds. He would probably be surprised to know that *The Blue Boy* remains his most popular and most influential painting—though not his best—while to him, it was a caprice. While Jonathan is not portrayed heroically, he stands for the bourgeoisie, excluded at that time from political power and influence, which was still in the hands of the aristocracy. Dressing him in Van Dyke costume must have been a bit of a joke, a subversion to slip into the heart of the Establishment, the Royal Academy.

By the late nineteenth century, *The Blue Boy* was an internationally popular print and is said to have inspired the 1919 film *Knabe in Blau* by F. W. Murnau (now thought to have been lost). Quentin Tarantino and costume designer Sharen Davis likely first came in contact with

7.6
The Blue Boy, 1770
Artist: Thomas Gainsborough (1727–1788)
Gainsborough painted his friend Jonathan Buttall in seventeenth-century court dress.

7.7

the picture as a kitsch print; it was ubiquitous throughout the 1970s, appearing in many inexpensively printed versions. *Blueboy* was also the name of a US gay porn magazine of the 1970s.

Tarantino, like Gainsborough, started as a rank outsider. He has talked many times about his lack of any insider connections to the movie business, his total lack of power or influence when he started his career. It was hard. "Pauline Kael used to say that Hollywood is the only town where people 'can die of encouragement' and that kind of was my situation,"[5] he says. Like Gainsborough, Tarantino has to date shown no intention of following an established career path. Despite his love of popular culture, he has not made a studio franchise picture. He regularly takes a drubbing from critics, who decry his unabashed love of trash cinema, and those who criticize his films for violence.

Django Unchained is in part a road movie; as production designer J. Michael Riva says, it is Django's psychological journey, but it is also a geographical journey through landscape.[6] Django and Schulz arrive in Tennessee and head to a haberdashery, where Django is invited to pick out a costume in order to play the part of Schulz's valet.

The next shot is of Django wearing a bright blue suit, styled in a vague pastiche of seventeenth-century fashion, the archetypal Blue Boy. The connotations are rife: *The Blue Boy* is a well-known kitsch print, but the painting resides in the important Huntingdon Museum in Los Angeles. "Boy" was a condescending term used to address all African American males regardless of age, particularly in the South.

We first see Django in his blue suit from the side, riding a horse through a landscape, a cotton field. The composition of this shot is itself a nod to the subgenre of the equestrian portrait. Van Dyke made a famous equestrian portrait of Charles I, which was repeatedly copied, and Gainsborough made variations on Van Dyke (as exercises, or simply to pay the bills). And the David portrait of Napoleon is an equestrian portrait. Equestrian connotes aristocrat and hero. But in that costume? Not yet.

7.7
Django Unchained, 2012
Dir. Quentin Tarantino, DP Robert Richardson
Django rides majestically through the cotton field as the pickers look at him in astonishment.

HISTORY
PAINTING:
VICTORY,
VIRTUE, AND
THE HERO

HEROISM AND
THE WESTERN

**CASE STUDY:
SUBVERTING
THE HEROIC
GENRE**

EXERCISES,
DISCUSSION
QUESTIONS,
AND FURTHER
READING

The blue suit makes Django stand out, command attention, and is ineffably striking. Riva notes that "color is a really important to me, it's a mood establisher."[7] The intense blue (much brighter than *The Blue Boy*'s silk) acts paradoxically as a red flag to the white supremacists he encounters. But both Jonathan Buttall and Django are in costume; Jonathan could never dress like that to do his daily business as an iron dealer. Django soon equips himself in what Riva calls "warm nicotine colors," in more practical—and stereotypically "western"—garb.

The Blue Boy motif is incongruous in a western. Yet, as Tarantino points out, "One of the things that's interesting about Westerns in particular is there's no other genre that reflects the decade that they were made and the morals and the feelings of Americans during that decade than Westerns. Westerns are always a magnifying glass as far as that's concerned."[8] He notes that

"Westerns of the '50s definitely have an Eisenhower birth of suburbia and plentiful times aspect to them. . . . the late '60s has a very Vietnam vibe to the Westerns leading into the '70s, and by the mid-70s, you know, most of the Westerns literally could be called Watergate Westerns because it was about a disillusionment and tearing down the myths that we have spent so much time building up."[9] Django is a western that subverts the dominant white male hero in a wish fulfillment revenge fantasy that forces the audience to confront race and slavery. It is probably too much to consider *The Blue Boy* as a wish fulfillment class fantasy. Perhaps we should consider *Django Unchained*'s *Blue Boy* motif to be a parody, with its political connotations, while Gainsborough's *Blue Boy* is an apolitical pastiche. Yet Gainsborough's own letters bear witness to his private discomfort with the upper class.

Tarantino and Gainsborough share the status of being both insider and outsider. Neither man belonged to an influential coterie or was a member of an art or film dynasty. Both gained success on their own terms, even if Gainsborough sometimes whined about his clients.

You don't actually need to know anything about the Van Dyck paintings or Gainsborough to appreciate *Django Unchained*. But understanding the art historical provenance of the costume, with its many underlying connotations, can help you see why it is so effective, and how art can be so influential that it manages to be replicated in unexpected places, while continuing its original message.

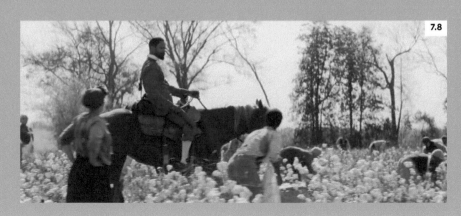

7.8
Django Unchained, 2012
Dir. Quentin Tarantino, DP Robert Richardson
Django is on his way to becoming a hero, but he has to get rid of the blue suit to make it really happen.

EXERCISES AND DISCUSSION QUESTIONS

Exercise

Watch several exciting action films that involve heroic characters doing extraordinary things. Note the kinds of "heroic poses" that the characters use to reinforce their heroic status (freeze-framing or making screen captures can help here). This might involve analyzing camera angles and lighting as well as looking at the actor's body language. How do these freeze-frames compare with the "heroic" paintings discussed here, or with other paintings you have found in books or online?

DISCUSSION QUESTION

Django Unchained subverts many things, including genre. What other examples of genre subversion can you find in art and cinema that use visual motifs?

HISTORY
PAINTING:
VICTORY,
VIRTUE, AND
THE HERO

HEROISM AND
THE WESTERN

CASE STUDY:
SUBVERTING
THE HEROIC
GENRE

**EXERCISES,
DISCUSSION
QUESTIONS,
AND FURTHER
READING**

FURTHER READING

Malcolm Robinson, *The American Vision* (Octopus, 1988)

Gerald Peary, ed., *Quentin Tarantino: Interviews* (University of Mississippi Press, 2014)

Jami Bernard, *Quentin Tarantino: The Man and His Movies* (Harper Collins, 1995)

Jack Lindsay, *Gainsborough: His Life and Art* (Harper Collins, 1982)

NOTES

1 Joseph Campbell, *The Hero with 1000 Faces* (Fontana Press, 1993).
2 Delacroix in a letter of October 28 to his brother, quoted in *Journal 1822–1863*, ed. André Joubin (Plon, 1996).
3 Cathy Whitlock, "Les Miserables Movie Set Design Slideshow," *Architectural Digest*, http://www.architecturaldigest.com/ad/set-design/2012/les-miserables-movie-set-design-slideshow.
4 Ford Madox Brown, *Exhibition Catalogue: An Exhibition of Work and Other Paintings by Ford Madox Brown at the Gallery, 191 Piccadilly (opposite Sackville Street)*, 1865, available at http://www.manchestergalleries.org/assets/files/ford-madox-brown--exhibition-catalogue-.pdf.
5 Transcript, NPR *Fresh Air* interview by Terry Gross, January 2, 2013.
6 J. Michael Riva, quoted in *Django Unchained* DVD (Extra Sony Pictures Home Entertainment, 2013).
7 *Ibid.*
8 *Fresh Air* interview.
9 *Ibid.*

CHAPTER EIGHT
MODERN MOVEMENTS

In his enormous and influential study of twentieth-century art, *The Shock of the New*, the eminent art critic Robert Hughes does not mention cinema at all. While it is understandable that he would not try to provide a whole history of twentieth-century film alongside the history of twentieth-century art, the fact remains that cinema is the "elephant in the room" during any discussion of visual art and culture since the beginning of the twentieth century. Yet the relationship is difficult, and not always easy to unpick. Histories of art almost always eschew any discussion of cinema. In Chapter 2 we noted that at the end of the nineteenth century, the modernist impulses and concerns of painting diverged profoundly from the populist impulse of cinema. The familiar categories of "high" culture (painting, theater, classical music) and "low" culture (cinema, music hall/vaudeville, jazz) that operated for most of the twentieth century were born.

Cinema was always intended to be a mass medium, aimed at attracting large numbers of people to sit together in a darkened room for an emotional, collective audiovisual experience. Since its beginning, cinema has embedded itself in visual culture, dominating it completely through its unabashed mass appeal. To do justice to the relationship between the moving image and visual art of the twentieth and twenty-first centuries would be a book in itself, and this chapter can merely indicate a few possible directions to explore.

This chapter will look at the small selection of modernist influences, principally from the twentieth century, that developed in parallel with the development of the moving image. Perhaps more important, it is in the modern period that we see for the first time the significant influence of art from "beyond the West." The case study will look at Japanese art and cinema and its profound reciprocal influence on Western art and cinema.

"I WANT TO EXPRESS MY FEELINGS RATHER THAN ILLUSTRATE THEM."
**Jackson Pollock, *Jackson Pollock 51*
by Hans Namuth 1951**

CULTURE OR
MASS CULTURE?

EXPRESSIONISM ABSTRACTION ABSTRACT
EXPRESSIONISM MINIMALISM GOING "BEYOND
THE WEST" CASE STUDY:
HOKUSAI TO
DISNEY EXERCISES,
DISCUSSION
QUESTIONS,
FURTHER VIEWING,
AND FURTHER
READING

CULTURE OR MASS CULTURE?

Cinema is the totalizing artwork, the *Gesamtkunstwerk* or synthesis of all the arts that Wagner talked about but never lived to see happen. Cinema combines visual art with drama and music; it is meant to be experienced by many people, to share an emotional as well as intellectual experience.

At different times in history, visual art has had this aim and effect. As we have seen, the Catholic art of the Counter-Reformation was deliberately aimed at attracting the mass of the population and reinvigorating Catholicism through the persuasiveness of dramatic imagery, which was combined in churches with music and ritual. History paintings could inspire the thrill of battle and provide visual manifestations of values and virtues. Even the Victorian "moral" paintings so derided by modernists were meant to communicate and reinforce widely held ideas and codes of conduct through dramatic appeal to the popular imagination.

But for a variety of reasons, painting embarked on new directions in the early part of the twentieth century. Even before the cataclysmic experience of the First World War tore all European frames of reference asunder, artists were challenging the representative nature of European art history. New ideas began to filter into the artistic intelligentsia: ideas about the human mind through the psychological research of Sigmund Freud; ideas about man and machine, the result of the increasing industrialization of daily life. Urbanization created mass culture, and as a result, it became possible and viable to mass-produce products as never before: cheap novels, comic books, records, newspapers, and popular magazines. Cultural critics looked on appalled at what they considered to be degraded, cheap, intellectually deficient, and artistically weak materials. At the same time, wealthier people were increasingly interested in collecting art and founding or contributing to museums and collections that bore their names. Visual culture in the twentieth century begins to recognizably split into "mass" visual culture and "high art" visual culture. Artists did not necessarily accept this frame of reference, and particularly in the period

after the Second World War, many artists agonized over the relationship between "art" and "life," trying to find solutions to the perceived separation between their work and the quotidian world. In the 1960s, "Pop" artists sought to appropriate and incorporate images of everyday life into their artwork in a kind of give-and-take with the everyday world around them, a move away from high art elitism.

Since the end of the nineteenth century, all artistic activity has been under the constant influence of the moving image. Everybody watches films; most people watch television. Artist, mechanic, professor, president, prince, schoolteacher, policewoman—no matter who you are or what role you occupy, whether you ever set foot in an art gallery or open an art magazine, you watch television and movies. There is no artwork in the twentieth century that can be exempted from the influence of the moving image. This is not to say that the influence can necessarily be read directly in the artwork, only that all artwork is made within the context of the dominance of the moving image, just as the art of the Italian Renaissance was made in the context of the dominance of the Catholic Church.

EXPRESSIONISM

Dating the watershed moment of "the modern world" is impossible, but we could take 1889 as a credible starting point, with the completion of the Eiffel Tower in Paris, a marvel of engineering and design with no discernible practical function. Over the next decade and a half, the world saw the introduction of the automobile, the movie camera, the "flying machine," the electric light. Crucially, all of these new inventions were aimed not at the delectation of elites, but at the masses. Although it took time for mass automobile use, mass flight, and the installation of electricity in everyone's home, the die was cast. What followed was an unprecedentedly accelerated rate of change that seemed to promise a new order of things—in short, a new world. Yet the human self remained as stubbornly unsatisfied, complex, and neurotic as ever. It was this inner world of the self that artists like van Gogh painted, expressing his own sense of isolation in the world—in short, human subjectivity. The attempt to depict subjectivity came to be called Expressionism. If the Impressionists had sought to depict perception, the Expressionists sought to depict perception through psychology, wrapped up in an overwhelming sense of self.

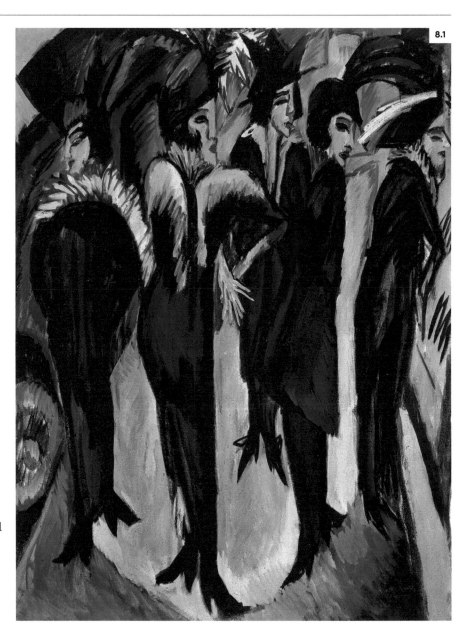

8.1

8.1
Five Women on the Street, c. 1913
Artist: Ernst Ludwig Kirchner (1880–1938)
In Kirchner's group of five women in a Berlin street, we can see the symbolic expression of an inner experience. The forms and shapes of the women are reduced to angular strokes, expressing the artist's subjective feelings. Kirchner ignores the traditional rules of perspective and academic proportion; even the color, applied with sweeping spontaneous brushstrokes, is used mainly to express emotion. This is the first of a number of paintings Kirchner made of street prostitutes, and all appear to betray his fear of them; despite their slender, birdlike shape, they are depicted as predatory.

CULTURE OR
MASS CULTURE?

ABSTRACTION

ABSTRACT
EXPRESSIONISM MINIMALISM

GOING "BEYOND
THE WEST"

CASE STUDY:
HOKUSAI TO
DISNEY

EXERCISES,
DISCUSSION
QUESTIONS,
FURTHER VIEWING,
AND FURTHER
READING

EXPRESSIONISM

Expressionism remains to date the only recognized and sustained art movement that fully incorporated both cinema and visual art. The Surrealist Group, discussed in Chapter 3, made a few films which, though very significant in terms of cinema history and their influence on later filmmakers, did not reach a mass audience. Later movements occasionally combined art and cinema, such as the Pop Art films of Andy Warhol, but their achievements were not as seamless or as profound as that of Expressionism. Expressionist style and its derivations[1] dominated European art and cinema in the 1920s and early 1930s and, after the rise of Nazism, crossed the Atlantic with the artists and filmmakers who fled fascism for America.

While Paris remained the artistic fulcrum it had been throughout the nineteenth century, in the early twentieth century newly unified Germany began to be an influential center of artistic innovation. Germany was rich, industrial, vigorous, and outward looking. It attracted artists like the Norwegian Edvard Munch and the Russian Wassily Kandinsky, as well as a number of German artists, particularly in the southern city of Munich and the eastern towns of Weimar and Dresden. Although never quite as bohemian as Paris, the German cities felt more comfortable and artistically exciting than any in Britain or America.

Artists formed groups, such as Die Brücke ("the Bridge"). Oriented around painter Ernst Ludwig Kirchner and his friends, the group was named "the bridge" because they wanted to assert a connection between the future and the traditional visual culture of Germany.

They admired medieval German woodblock printing, for example, and venerated the newly appreciated Isenheim Altarpiece, sculpted and painted by Matthias Grünewald. Later moving to Berlin, Kirchner embarked on a series of *Großstadtbilder* ("city paintings") showing the underbelly of Berlin, with its streetwalkers distortedly illuminated by gaslight amid the crowded, thronging streets of the capital.

By 1910, the angular, emotional, and often wildly distorted pictorial style associated with Expressionism was established. Robert Hughes calls it "German Gothic without the religious content."[2] Painters and illustrators turned to woodblock printing techniques or charcoal drawing that resembled woodblock's chiaroscuro style. One of the principal centers of Expressionist activity was Berlin. By 1911 it was established as a significant artistic city: a big, imposing and thoroughly modern metropolis. Unlike Paris and London, which had been major cities since early medieval times, Berlin was new and modern; it transformed quickly from a backwater in the far northeast of Germany into a huge, cutting-edge industrial city.

Politics were progressive, and culture was experimental and exciting. At the same time, the city was thrilling and more than a little frightening compared to genteel places like Munich or Cologne or quiet towns like Dresden.

Expressionism portrays psychological states; it seeks to express outwardly what is on the inside. Expressionism appeared not only in visual art, but in literature and theater, poetry and cabaret. Expressionist works sought to portray a kind of secular agony or suffering—secular despair. Taking as their model the gaunt, tortured body of Grünewald's Christ, expressionist artists and writers sought to depict physical and emotional suffering, but made it secular. One of the most important early works associated with Expressionism is Edvard Munch's painting and lithograph *The Scream*, from the late 1890s, which embodies many of these impulses: it depicts a personal, individual agony and despair. The rest of the world (represented by the top-hatted figures walking away and the boats on the lake far in the background) is impervious to the agony and terror of the central subject.

FURTHER VIEWING

Erich Heckel's (1883–1970) 1913 woodcut print *Two Men at a Table* and the 1912 painting in the Kunsthalle Hamburg. The image was conceived as an illustration of Dostoyevsky's Brothers Karamazov.

**"I PAINT THE LIGHT THAT
EMANATES FROM ALL BODIES."
—Egon Schiele[3]**

Expressionism and the Nude

In the more conservative imperial city of Vienna, the young artist Egon Schiele (1890–1918) began to redefine the nude in a radical and controversial way that invited accusations of "pornographer." Rather than traditional poses, Schiele's figures adopt striking body language, with unnatural poses such as squatting, crouching, or lying in unusual positions. Schiele's figures are far from ideal male or female forms. One self-portrait shows Schiele with distorted anatomy: a long torso and an exposed spine, rendering himself something between man and insect, yet profoundly human.

His figures have prominent genitals, with bursts of coarse dark pubic hair. Saying "erotic works are also sacred," Schiele sometimes only painted the body parts (*Male Lower Torso*, 1916). This is a complicated eroticism, nonnaturalistic and controversial, with the genitals prominent, often placed (following the rule of thirds) where the eye is naturally drawn into the picture. Schiele uses clothing to reveal sexuality, the models deliberately lifting their clothing to expose their genitals. In Schiele's work, the body itself is the tool of expression; it expresses vulnerability and fragility, but conversely also its strength and sinew, and the body's secret, usually hidden powerful places.

However, even if suffering in the modern world was secular, not religious, mysticism was popular in the late nineteenth and early twentieth centuries. Partly a reaction against nineteenth-century materialism, the tendency was influenced by the writings of Dostoyevsky and the philosophy of Schopenhauer. Many artists and intellectuals were also strongly influenced by the Theosophical movement, which attempted to synthesize various Eastern and Western spiritual thought into a new, postreligious spiritual system, free from the strictures of traditional European churches.

It soon became clear that Expressionism, which had already permeated Germany's visual art and theater, was also going to dominate the emerging art form of cinema. Berlin's Babelsberg Studios was founded in 1912 and is still active today, making it the world's oldest working major studio. The producers and directors working in Babelsberg devised innovative films created by talented writers and using the skills of Germany's fine artists.

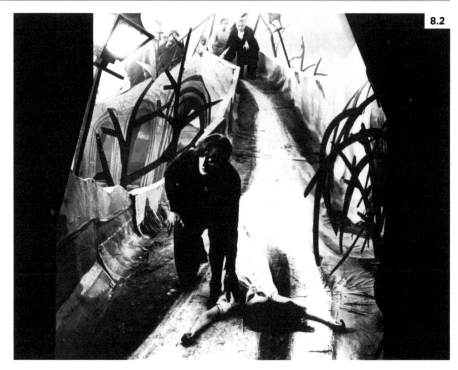

8.2

8.2
The Cabinet of Dr. Caligari, 1920
**Dir. Robert Wiene (1873–1938),
DP Willy Hameister**
Director Wiene employed designer Hermann Warm and painters Walter Reimann and Walter Röhrig; together they took the craft of scene painting to new heights of imagination and innovation. The artists painted light and shadows directly onto the walls of the sets, creating a world of pure theatricality, which was then brought to life through the clever camera work of Willy Hameister.

CULTURE OR
MASS CULTURE?

ABSTRACTION

ABSTRACT
EXPRESSIONISM MINIMALISM

GOING "BEYOND
THE WEST"

CASE STUDY:
HOKUSAI TO
DISNEY

EXERCISES,
DISCUSSION
QUESTIONS,
FURTHER VIEWING,
AND FURTHER
READING

EXPRESSIONISM

Expressionism and Cinema

Expressionism is dramatic, and high drama was exactly what the silent screen needed. The great period of German expressionist cinema comes after the First World War, arguably lasting up to the implementation in the 1930s of Nazi policies that brought most artistic expression in Germany to

FURTHER VIEWING

Sometimes Expressionist painters sought to explore the territory between the inner and the outer world by portraying figures wearing masks. The mask is an interesting motif in painting; we have already seen Roberto Longhi's use of the mask in his paintings of eighteenth-century Carnival Venice. The expressionist masks of Emile Nolde and James Ensor, and the later adoption of the mask in Picasso's *Demoiselles d'Avignon*, were at least partly inspired by the recognition that the traditional European culture of masked revels had passed away, merged with a new awareness of so-called "primitive" art and artifacts brought from the Americas, the South Sea Islands, and Africa and displayed in museums and at fairs.

Emil Nolde (1867–1956), *Mask Still Life III* (1911)

James Ensor (1860–1949), *Death and the Masks* (1897) and *The Intrigue* (1890)

a shuddering end. The German artists after the First World War, like Otto Dix, George Gross, and Max Beckman, are sometimes classified as belonging to the New Objectivity movement (the title of a 1925 exhibition), combining Expressionism with political critique. John Willet says that Expressionism was "an intense, all embracing movement which so swept Central Europe immediately before, during and after the first world war that much of the reaction away from it in the later 1920s still looks more or less expressionistic."[4] And so it proves in the cinema: little connects *The Cabinet of Dr. Caligari*, Fritz Lang's science fiction *Metropolis* (1927), and Josef von Sternberg's *Blue Angel* (1930) other than being made at Babelsberg in Germany. Yet artistically the influence of Expressionism can be traced in each film. Through these films, we can see how *Caligari* links us to Hitchcock, *Metropolis* to Kubrick, and von Sternberg to Rainer Werner Fassbinder. The thread of Expressionism may be slender, but it has never left cinema, and it periodically revives in visual art.

Robert Wiene's 1920 film about madness and murder, *The Cabinet of Dr. Caligari*, is one of the key works of high Expressionism. As well as virtually every frame of the film resembling an expressionist painting or woodcut, it is the first film to use the cinematographic technique of the so-called Dutch ("Deutsche") tilt. The camera angle is deliberately slanted to one side, and Wiene and his DP Willy Hameister use it to create a sense of unease and disorientation, visually emphasizing the film's theme of madness. Fritz Lang's *Nosferatu* (1922), though principally following Gothic and romantic tropes, contains key expressionist moments,

particularly the lighting and the use of the vampire's distorted shadow. Expressionism was part of Alfred Hitchcock's tool kit: as well as admiring Murnau and Lang, he worked on English-German coproductions at Babelsberg before returning to London in 1926 to make *The Lodger: A Story of the London Fog*, clearly under the influence of Expressionism.

But Expressionism found its way into other genres too: see Walther Ruttmann's extraordinary "expressionist documentary" *Berlin: Symphony of a Great City* (1927), which depicts the rhythms of one day in the life of the city. Berlin here is not just a setting, it is the character: the people, machines, and landmarks that populate are its features and expressions.

Expressionism continues to influence visual art and cinema up to the present. Certain techniques used extensively by expressionist filmmakers, such as "Dutch" angles, were widely used in American film noir, ambivalent low-budget dark dramas about human emotion and damaged psychologies. Expressionist image techniques were also used in more substantial films such as Carol Reed's tense and atmospheric Cold War drama *The Third Man* (1949), shot on location in postwar Vienna by DP Robert Krasker.

ABSTRACTION

Expressionism put forward the idea that what mattered was not imitating nature, but expressing feelings. If that was the case, then surely it was possible to ask if feelings or even ideas could be expressed without figurative subject matter. That is, instead of having to express feelings and ideas via a subject, such as a landscape or a portrait, could these be expressed more explicitly through forms and tones? These ideas form the beginning of a radical departure from the Western tradition of painting, moving through Cubism to abstraction, minimalism and conceptual art.

The abstract impulse comes out of many of the same impulses as Expressionism: reacting against the materialism of the industrial age and its plethora of products and objects transforming not only the landscape but the rhythms of daily life. But even early in the history of cinema, images that seem abstract were found in natural history films, using microphotography to reveal the world of insects, plants, and simple life-forms. To the Swiss Paul Klee (1879–1940), the biomorphic abstractions contained within his paintings may not directly represent things perceived in the real world, but hint at their possibility.

What is abstraction? At its most basic, it means taking away the representative elements. Instead of depicting things, abstract painting presents forms and shapes or colors that express, or obliquely represent, things. But not only things: they may represent or express ideas, feelings, passions, principles. Or perhaps they only express or represent themselves.

There was precedent. Turner's late works, such as *Rain, Steam and Speed—The Great Western Railway* (1844), are so indistinct as to often be considered almost abstract. We have already seen that the Impressionists wanted to depict perception, and Expressionists wanted to present the inner world outwardly. Abstraction sought to consider the image outside of the confines of figurative depiction, moving even further away from representation.

Unsurprisingly, much of the impulse behind abstraction was spiritual anomie, caused by the industrialized world of simplistic materialist signs created for the masses. Russian painter Wassily Kandinsky is sometimes considered the grandfather of the abstract. Kandinsky, born in Moscow in 1866, studied law at the University of Moscow and didn't even begin to study art until he was 30. He went to Munich and spent several years studying, not always successfully. He formed an artist group and began a fruitful program of exhibiting and teaching. One can imagine that his age and obvious intellectual ability probably furnished him with some kind of authority within the Munich art scene. His early works are not particularly remarkable, but he was interested in Russian folk art, colorful evocations of peasant life, pagan peasant rituals, and icons. Meanwhile, the younger painters Kazimir Malevich and Natalia Goncharova, studying in Moscow, were also exploring the visual culture of the previously despised Russian peasants.

What set Kandinsky apart from most of his peers was that with his lawyer's mind and training, he could think and write well. When he turned his attention to writing about art, he was able to convey his ideas as persuasively as any barrister. In 1912 he published *Concerning the Spiritual in Art*, in which he made some grand claims for painting: he believed that great works of art "can at least preserve the soul from coarseness; they key it up, so to speak, to a certain height, as a tuning keep the strings of the musical instrument."[5] Note how Kandinsky is linking painting to the more abstract form of music, not unlike James Whistler and his *Nocturne* paintings. But Kandinsky went further than Whistler: he collaborated with composer Arnold Schoenberg and tried to compose avant-garde operas himself.

Kandinsky was trying to understand how art might simultaneously be a product of spirituality, expresses spirituality, and be itself spiritual. These ideas about spirituality in art were unusual and exciting to Western European ears. They offered a development from romantic ideas, which were grounded in the notion that Nature is sacred. However, nineteenth-century science (Darwin) and philosophy (Nietzsche) posited that either there was no God or God was dead. Kandinsky was also involved with Theosophy, founded by the Russian Helena Blavatsky. Russian mysticism, Orthodox Christianity, Russian folk culture, and Theosophy merged in Kandinsky and helped to formulate a set of strangely attractive ideas about art.

CULTURE OR
MASS CULTURE? EXPRESSIONISM

ABSTRACTION

ABSTRACT
EXPRESSIONISM MINIMALISM

GOING "BEYOND
THE WEST"

CASE STUDY:
HOKUSAI TO
DISNEY

EXERCISES,
DISCUSSION
QUESTIONS,
FURTHER VIEWING,
AND FURTHER
READING

Kandinsky was able to gather around him a set of like-minded artists, writers, and musicians to form Der Blaue Reiter (The Blue Rider), which published a book, *The Blue Rider Almanac*, in 1912. The blue knight (rider) is a representation of St. George, constantly slaying the dragon of materialism in the service of spirituality. It was an eclectic publication bringing together contemporary art with folk art, medieval woodcuts, and a whole range of Asian and African art, together with music scores by Webern and Berg, essays, and Kandinsky's own "color opera" *The Yellow Sound* (which was never performed).

At the outbreak of the First World War, Kandinsky returned to Russia in time for the Russian Revolution. At this point he came together with the younger Bolshevik artists such as Malevich and El Lissitzky, but by 1920 he had already begun to fall out with these more radical artists. After brief stints as the head

of psychology in the Russian Academy of Aesthetics, Kandinsky returned to Germany, where he was invited to join a completely new kind of university, the Bauhaus. The Bauhaus was a radical school of art, architecture, and design established by the pioneer modern architect Walter Gropius, initially at Weimar, Germany, in 1919. Instead of traditional classes, the school aimed to create a community of artists working together, aiming to bring art back into contact with everyday life. It is through Kandinsky's work with the Bauhaus that his ideas became much more widely disseminated, as the Bauhaus in turn influenced all aspects of art and design, particularly architecture, not only in Europe but in America.

In short, Kandinsky's main contribution to abstract art was to intellectualize it and imbue it with a sense of a higher calling, to see it as a valid spiritual challenge to boring, soulless everyday

materialism. Even more important, he apotheosized the "true artist" as a spiritual genius: "one man, and only one. His joyful vision cloaks a vast sorrow. Even those who are nearest to him in sympathy do not understand him. Angrily they abuse him as charlatan or madman."[6] Kandinsky's ideas about color, which were themselves largely based on the German philosopher Goethe's theory of the emotional effect of color, became influential largely because they were useful, even if they were not based on anything objectively "real." As we saw in Chapter 1, Kandinsky's ideas about color continue to be influential and useful—we used them ourselves when discussing color in painting and cinema.

Through looking at abstraction, we can consider the relationship between cinema and painting outside of the familiar confines of figurative depiction. We can think about how both use pure form, and color.

The Blue Rider Almanac, edited by Wassily Kandinsky and Franz Marc (MFA Press, 1965), is a widely available facsimile of the original edition.

ABSTRACT EXPRESSIONISM

The idea of a link between spirituality and abstract painting established by Kandinsky lived on, particularly in the postwar work of the American Abstract Expressionists. As we have seen, American landscape painting owed much to ideas about the sublime, but also to American Transcendentalism. This was also an antimaterialist philosophical movement, grounded, at least in part, on the actual experience of Nature.[7] As one of its principal thinkers, Ralph Waldo Emerson wrote in 1836, "Standing on the bare ground,—my head bathed by the blithe air, and uplifted into infinite space,—all mean egotism vanishes. I become a transparent eye-ball. I am nothing. I see all. The currents of the Universal Being circulate through me; I am part or parcel of God."[8] But the American landscape painters were interested in painting the uniqueness of the American landscape. America was filled with the grandeur and mystery of its own landscape, with overwhelming places like the Rocky Mountains, the Mojave Desert, and the Grand Canyon as well as the almost limitless broad sweep of the Atlantic and Pacific oceans.

Though Americans began to fall under the spell of European abstraction, they didn't want to accept it, and didn't want to copy it. During the First World War, the United States had witnessed Europe fighting a monstrous war of attrition and dragging much of the known (colonized) world along with it, almost into self-annihilation. America had reluctantly become involved in that war, and retreated into a position of isolation after the war. Yet American artists were still conscious that in terms of art history, theirs was a juvenile nation, and the most interesting and exciting visual art was still coming from Europe.

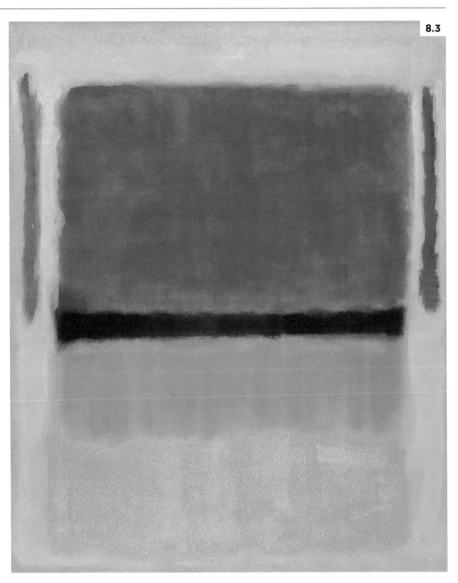

8.3

8.3
***Untitled (Violet, Black, Orange, Yellow on White and Red)*, 1949**
Artist: Mark Rothko (1903–1970)
In the late 1940s, Russian-born American painter Mark Rothko turned to complete abstraction, painting huge canvases consisting of saturated, soft-edged areas of color. The painting depicted here measures more than two and a half meters in height. Rothko explained that they "have no direct association with any particular visible experience, but in them one recognizes the principle and passion of organisms."[9]

CULTURE OR
MASS CULTURE?　　EXPRESSIONISM　　ABSTRACTION　　ABSTRACT
EXPRESSIONISM　　MINIMALISM　　GOING "BEYOND
THE WEST"　　CASE STUDY:
HOKUSAI TO
DISNEY　　EXERCISES,
DISCUSSION
QUESTIONS,
FURTHER VIEWING,
AND FURTHER
READING

This was true even of cinema. Although Hollywood was established in 1912, until war forced the Europeans to largely shut down filmmaking, there was no reason to suspect that America would become the dominant film culture. Even after the war, the most innovative work in cinematography and lighting was coming from Germany. France produced one of the most monumental pictures of the first half of the twentieth century, Abel Gance's *Napoleon* in 1927, as well as the poetic realism of Jean Vigo. Surrealist films were made by Jean Cocteau, Germaine Dulac, and the Spanish team of Salvador Dali and Louis Buñuel. In the 1930s Jean Renoir, the son of Impressionist painter Pierre-Auguste Renoir, directed the brilliant war picture *The Grand Illusion*. Meanwhile, in Moscow, the Soviets were redefining film editing.

It was not until the rise of totalitarianism in Europe that American domination of cinema became not only possible, but probable. Artists, technicians, and filmmakers fled the Nazis, not only in Germany but in Austria and all the lands the Nazis occupied. Many, like Austrian-born Billy Wilder, initially tried to settle in France, but soon realized that America was the last port of call. Hollywood was suddenly stuffed with talent and ability as never before or since. American art as a whole benefited not only from the exodus from Nazism, but from successive waves of immigration beginning at the end of the nineteenth century. Some, like the great Italian-born painter of industrial America Joseph Stella, were never completely sure where they best fitted, back in Europe or in the US.

Abstract Expressionism was the name given to a loose and barely affiliated group of painters based in New York after the Second World War. But the roots of Abstract Expressionism may lie further away, in revolutionary Mexico. Mexican revolutionary painters, led by Diego Rivera, David Siqueiros, and Jose Clemente Orozco, began a tradition of creating large-scale murals in public space; these murals had dramatic nationalistic, social, and political messages expressed in bold, striking colors. The idea was to emulate the populist yet passionate art of the Church to deliver a revolutionary and nationalistic message to the masses. The idea of public murals was taken up in the United States by Roosevelt's Federal Art Project, part of the New Deal meant to combat the depredations of the 1930s Depression. The project employed large numbers of artists to produce public murals presenting socially accessible "American" imagery for the masses. The idea behind it was to create appealing American alternatives to European communism and fascism.

Jackson Pollock and Mark Rothko both worked on the Federal Art Project and admired Mexican muralism. After the Second World War, they moved away from the pictorial tradition of muralism and became completely abstract painters, yet kept the muralist's sense of size and drama. The role of Expressionism in their large-scale abstract paintings is more a matter of the influences than anything that can be seen directly on the canvases. Both were interested in mysticism, spirituality (though not specifically religion), and human tragedy, and were influenced by

psychoanalysis and classical mythology. Both were strongly affected by the philosophical question "What is modern Man, and what is his fate?"[10]

Their methods of painting, however, were strikingly different. Jackson Pollock became famous as "Jack the Dripper": he would lay his huge canvas on the floor and use brushes, or more commonly sticks, to drip the paint onto the canvas as he moved constantly around it. A 1951 film of his method shows the sheer physicality and energy involved in making the works: huge surfaces vibrating with color, made up of complex lattices and webs of dripped paint.

Rothko would soak his unprimed canvases in layer after layer after layer of paint, laying it on in horizontal lozenges. Many of the paintings appear to offer a sense of a horizon; Robert Hughes links them to the tradition of American landscape, saying that landscape "was there, in an oblique way, through scale"[11] and intensity of color. Rothko wanted the viewer to be in the painting, not standing looking at the painting, so he made the huge fields of color enormous, overwhelming.

The critical world responded, and this is where we see the next important aspect of twentieth-century art: the domination of the critic. In this case, it was writer Clement Greenberg, who decided to champion the Abstract Expressionists as urgently important artists expressing something completely new and definitively American. More recently, research has come to light demonstrating how Abstract Expressionism was promoted as part of the pro-American cultural message so important during the Cold War. It was bold, it was expressive, it was certainly American, and most important, the pictures themselves didn't say anything specific at all. Abstract Expressionism was not critical and political like European art, and it was certainly not communist like Soviet Socialist Realism.

Pollock and Rothko also obligingly fed themselves into American popular mythology, though they probably didn't intend to, and so entered the popular romantic myth of the artist as the "troubled outsider" battling his demons, portrayed so often in films. By 1956 Pollock was established and admired; unfortunately, he was also a heavy drinker and he crashed his car while drunk, killing himself and one of his passengers. He died a legend, the rebel artist overcome by his demons. Rothko's final major work was a set of huge paintings for the interior of a nondenominational chapel in Houston, Texas. The Rothko Chapel paintings are enormous and dark, in colors ranging from black to deep plum-red. Rothko intended them as monuments to the depths of human tragedy. He committed suicide not long after, before the paintings were hung in the chapel in February 1971. Dominique de Menil,

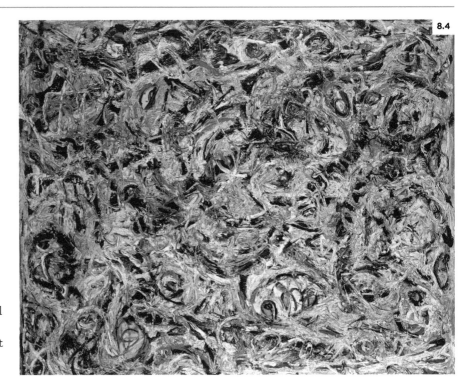

8.4

who commissioned the chapel, said that the work was "the expression of an artist deeply moved by the tragedy of the human condition. They are an endeavor to go beyond art. They are an attempt to create a timeless space."[12]

8.4
Eyes in the Heat, 1946
Artist: Jackson Pollock (1912–1956)
Named "Jack the Dripper" by the press, Jackson Pollock was the first American artist to become truly famous, with these seemingly spontaneous eruptions of paint on canvas. In fact, Pollock exerted absolute control over the effect he wished to create, often touching up a drip with the paintbrush.

FURTHER VEIWING

See *Pollock* (2000), directed by and starring Ed Harris, who did all the paintings in the film, following Pollock's method. The film was not authorized by Pollock's estate.

CULTURE OR
MASS CULTURE? EXPRESSIONISM ABSTRACTION **ABSTRACT
EXPRESSIONISM** MINIMALISM GOING "BEYOND CASE STUDY: EXERCISES,
 THE WEST" HOKUSAI TO DISCUSSION
 DISNEY QUESTIONS,
 FURTHER VIEWING,
 AND FURTHER
 READING

Abstraction in Cinema

Of all the influential modern movements in art, abstraction is probably the most difficult to connect to cinema. The same impulse that was at work in painting, to explore the world of forms and shapes instead of taking on the responsibility for creating representations of things, was also influential in cinema. Movie cameras were taken up and explored as tools for the creation of images, including abstract images. In 1920s Germany, several painters, including Hans Richter and Walther Ruttmann, established a group dedicated to what they called "absolute" film. They joined Kandinsky in desiring to create what they called an "absolute language of form": abstracted geometrical images analogous to music—that is, images without images. Ruttmann's work in particular, such as *Lichtspiel: Opus IV* (1925), is compelling, as are the experimental abstract films of the multidisciplinary Bauhaus artist László Moholy-Nagy (1895–1946). Ruttmann and Moholy-Nagy also made documentary-style "city" films, in which they applied what they learned from their exploration of light and shape in their abstract films to the real world.

Other experiments produced delightful and quirky films such as Len Lye's *A Colour Box* (1935). This abstract film was made by painting colorful patterns directly on the film itself and synchronizing them to a popular jazz dance tune. The film was aimed at the popular audience and was sponsored by the British General Post Office. Generally speaking, however, abstract films remain the preserve of experimental artists and were not aimed at mass audiences. Stan Brakhage's *Mothlight* (1963) is an example. Brakhage took moth wings and small pieces of plants, placed them between two strips of 16mm film, and then made a contact print. Projected, it was an abstract film of strange unearthly beauty made without a camera.

Michael Leja, in *Reframing Abstract Expressionism: Subjectivity and Painting in the 1940s*, makes a strong connection between what he calls the Mythmaker paintings of the New York Abstract Expressionists and film noir. Both, he says, are "grounded in the presumption of a complicated subjectivity under stress, suffused in (primitive) terror and tragedy." Both the paintings and the films, one seen as highbrow and the other as mass entertainment, "engaged crucial materials in the culture—fear, anxiety, the sense of helplessness, disillusion and doom—materials that needed representing."[13] This is an important study because it demonstrates how painting and cinema can be compared beyond (but not excluding) figurative content.

Abstraction is rarely used on its own in cinema. However, it can be used productively within films. As discussed in Chapter 3, Gaspar Noe uses abstraction to connote the afterlife in the opening sequences of *Enter the Void* (2010). In *Inland Empire* (2006), David Lynch's handheld digital images often dissolve into an abstraction of softly blurred colors and indistinct images. In Bernard Rose's realist film *Boxing Day* (2012), the Colorado winter landscape as seen from the interior of the car is abstracted, mysterious, serving as a symbol of the characters' incomprehension and lack of self-knowledge: as the view becomes more abstracted, the greed of the protagonist (Danny Huston) becomes as inexorable and as barren as the frozen landscape. In *Locke* (2013), cinematographer Haris Zambarloukos makes extensive use of *bokeh*, a shallow focus technique that creates images with prominent out-of-focus regions, principally myriad reflected light sources as the film is entirely set on a highway at night.

8.5
Locke, 2013
Dir. Steven Knight, DP Haris Zambarloukos
The abstract effect of *bokeh* as it floats among the metallic sheen of the cars and their mirrors and windows, and across Locke's face, renders the world of the highway alien and unreal.

MINIMALISM

As well as rejecting any form of representation, Minimalists wanted to remove suggestions of Expressionism from the artwork, as well as suggestions of illusion or transcendence. They rejected symbols or metaphors of any kind. According to one writer, "Minimalist painting is purely realistic—the subject being the painting itself."[14]

Minimalists concentrated on simple geometric forms, deliberately pursuing the appearance of factory-produced industrial objects. Minimalist sculptors like Carl Andre and Donald Judd designed their pieces and then, instead of making them by hand, had them created by professionals in industrial workshops. Minimalist painters were interested in the simple act of putting the industrial product, paint, onto canvas, board, or other surface. They frequently used industrial paints, although Agnes Martin often used fine material such as gold leaf.

Minimalism in fine art was often seen as an aggressively male stance; a number of female artists who are classified with the minimalist movement rejected the label. Agnes Martin, for example, stated that she preferred to be considered an Abstract Expressionist.

The Swiss architect Peter Zumthor notes that the silence of Minimalism is a reaction against the "noise" of twentieth-century life. "That plainness has such impact bespeaks the excess of noise that has invaded the landscapes around us."[15] In an era overwhelmed with images and sounds, reduction or filtration ends up being an emphatic form of presence. Donald Judd said, "If my work is reductionist, it's because it doesn't contain the things people think it ought to contain."[16] Seen in this way, Minimalism is less an artistic style than a way of dealing with the world. Less is more.

Minimalism has its roots in the Russian Revolution and the emergence of a group of young artists, the Constructivists, who felt called upon to make a "new art" that shed the corruption, decadence, and injustice of the past. Like Kandinsky, Kasimir Malevich (1879–1935) was initially interested in the Russian peasantry, the embodiment of the mystical "Russian soul," and created stylized simplified forms such as *The Mower* (1911–1912). But only a year or so later he produced *Black Square* (c. 1913–1915), and in 1920 *White Suprematist Cross. Black Square* is simply a black square on a white background, nothing more and nothing less. *Black Square* brings to an abrupt end centuries of representation in art and could be said to mark a "zero hour" in modern art. Malevich enthusiastically termed this new direction Suprematism. He claimed it as the beginning of a new culture. Art, he said, can only happen "when the forms in his picture have nothing in common with nature. Our world of art has become new, nonobjective pure. . . . Everything has disappeared; a mass of material is left from which a new form will be built."[17]

"IT ISN'T NECESSARY FOR A WORK TO HAVE A LOT OF THINGS TO LOOK AT. TO COMPARE, TO ANALYZE ONE BY ONE, TO CONTEMPLATE. THE THING AS A WHOLE, ITS QUALITY AS A WHOLE, IS WHAT IS INTERESTING. THE MAIN THINGS ARE ALONE AND ARE MORE INTENSE, CLEAR AND POWERFUL."
—Donald Judd (*Specific Objects,* 1965)

FURTHER VIEWING

Following are some significant minimalist artists to look up. Their works are held in many major collections, such as the Museum of Modern Art and the Tate.

Painters
Frank Stella
Agnes Martin (1912–2004)
Robert Mangold

Sculptors
Donald Judd (1928–1994)
Dan Flavin (1933–1966)
Carl Andre

CULTURE OR
MASS CULTURE? EXPRESSIONISM ABSTRACTION ABSTRACT
EXPRESSIONISM GOING "BEYOND
 THE WEST"

CASE STUDY:
HOKUSAI TO
DISNEY

EXERCISES,
DISCUSSION
QUESTIONS,
FURTHER VIEWING,
AND FURTHER
READING

MINIMALISM

The Constructivists wanted to make "pure" proletarian art, to support revolutionary socialism. They wanted art to be instrumental and wanted it to be applied to textile design, ceramics, public murals, anything that could be experienced and appreciated by the ordinary worker. However, they forgot that most people, especially the proletarians, wanted figurative images. Multiple millennia of experience had developed communication through figurative images, and the new language of pure form proved inadequate. This new art proved useless as communication. In this instance, Joseph Stalin (who also wanted art to be instrumental) was correct to claim that Constructivist art was useless to advance the necessary cause of socialism. By the late 1920s Malevich returned to figurative painting, making rural scenes again, as well as portraits of his family and friends. In the 1930s the Soviet regime established Socialist Realism as the officially supported authorized style.

It is interesting to see how, during the Cold War, this Soviet revolutionary idea of pure forms stripped of accretions of meaning was taken up and asserted as a revolutionary new *American* art movement. This demonstrates that we need to appreciate that both linear and parallel developments exist in art and cinema, and that the influences that form artistic works, and even whole movements, are complex.

For example, American Minimalists liked to see themselves as part of a new, clean, American art world. Donald Judd believed that this new American art was "more advanced" than European art, because it offered simple material facts. However, we can trace a direct link from early-twentieth-century European Bauhaus as well as Soviet Constructivism to American Minimalism. We can also see strong influences from Japanese art and Zen Buddhism, which is even older.

But Minimalism is not simply rooted in influence from Constructivism or other experiments by modernist artists. Minimalism is connected to a much older impulse, a quest for "purity" that recurs throughout Western art and culture at different times. Neoclassicism is another example of a desire for "purity." Zumthor's remark that minimalism is a response to "maximalism" in the real world was also true in the eighteenth century. To artists, politicians, architects, and philosophers, the sun-bleached whiteness of classical ruins, and the sensible, rational philosophy of the ancient world, represented an opportunity for purification. In his book *Chromophobia*, David Batchelor points out that to Aristotle, art is about line; all the rest, he said dismissively, is ornament.[18] So, neoclassical architects created the US Capitol building to echo the magnificent structures of ancient Rome, ignorant of the fact that Roman structures were actually brightly painted, as were the noble statues. Fashion changed and dropped its frills and wigs. Minimalism is about getting rid of noise, but it is also to some extent about discipline—disciplining the body, disciplining the emotions. As Carl Andre said of Frank Stella, "Stella is not interested in expression and sensitivity. He is interested in his necessities of painting."[19]

**"I KNEW A WISEGUY USED TO MAKE FUN OF MY PAINTING, BUT HE DIDN'T LIKE THE ABSTRACT EXPRESSIONISTS EITHER. HE SAID THEY WOULD BE GOOD PAINTERS, IF THEY COULD ONLY KEEP THE PAINT AS GOOD AS IT IS IN THE CAN. AND THAT'S WHAT I TRIED TO DO. I TRIED TO KEEP THE PAINT AS GOOD AS IT WAS IN THE CAN."
—Frank Stella (1964 radio interview, quoted in *Chromophobia* by David Batchelor)**

Minimalism and Film

Once again, although Minimalism in art may look different from Minimalism in film, the philosophical link is there, even if the process is different. In a sense, minimalist cinema is the direct opposite of minimalist painting and sculpture. In the quest to be absolutely "material," minimalist art tries to avoid expression and sensitivity, whereas minimalist film's quest for absolute honesty seeks exactly the purest distillation of expression and sensitivity.

Although there is not an actual minimalist movement in film, there have been different movements in cinema that we can relate to Minimalism. The *nouvelle vague* of late-1950s France is a minimalist movement. Filmmakers, many of them completely inexperienced and from outside the film industry, acquired cheap military surplus cameras and film. There was little to stop them from making films and sharing their films with a postwar generation eager for something fresh and different. Although the *nouvelle vague* films never approached the success of Hollywood movies, they were influential, particularly on the emerging directors of the new Hollywood of the late 1960s and 1970s. Italian neorealism similarly took a minimalist approach: shooting in the street and in "real" locations, using nonprofessional or semiprofessional actors, and choosing simple yet emotionally charged plots that did not depend on twists or fortuitous events.

In film, a minimalist approach means to be *more* human, and purge the film of artifice. This was taken to extreme conclusions with the Dogme movement of the 1990s. This was a project started by the established Danish filmmaker Lars von Trier and the emerging

filmmaker Thomas Vinterberg, who published the "Dogme 95 Manifesto" in 1995. The manifesto contained the deliberately named Vow of Chastity. The religious connotations are both tongue-in-cheek and absolutely serious. The idea was to purify film of its accretions of effects and technology, stars and celebrity, and "tricks of the trade," and concentrate on the core "classical" values of story, performance, and theme.[20]

Dogme 95 was a deliberate provocation, but it also acted as a challenge to inspire the independent film movement in Europe and America to make high-quality low-budget dramas. Even the creators of the manifesto themselves soon abandoned the rigidity of the

Dogme principles. But the Vow of Chastity remains a valuable and valid disciplinary tool to nurture the filmmaker and test his or her mettle.

Unlike minimalist art, which was claimed eagerly by the elitist art world (something Carl Andre, for one, has never been particularly comfortable with), minimalist films remain associated with the independent sector. They are usually low budget and less commercial. Some filmmakers such as Steven Soderbergh, who started his career with the minimalist *Sex, Lies, and Videotape* (1989), have managed to continue to make minimalist films alongside higher-budget commercial movies.

THE POWER OF "PURIFICATION"

Although the most controversial of the Dogme 95 films is Lars von Trier's *The Idiots*, the most gripping examples of the power of "purification" are in Thomas Vinterberg's *Festen* (*The Celebration*, 1998) and Lone Scherfig's *Italian for Beginners* (2000). Scherfig's film is often billed as a "romantic comedy," and one of the DVD editions even has a pink cover, but the film is quite dark, dealing uncompromisingly and directly with death, addiction, parental rejection, and sexual dysfunction.

See Richard T. Kelly, *The Name of this Book is Dogme95* (Faber & Faber, 2000).

FURTHER VIEWING

Below are five key minimalist films released since Dogme95:

Shane Carruth, *Upstream Color* (2013)

Apichatpong Weerasethakul, *Uncle Boonmee Who Can Recall His Past Lives* (2010)

Kelly Reichardt, *Old Joy* (2006)

Miranda July, *Me and You and Everyone We Know* (2005)

Suzanne Bier, *Open Hearts* (2002)

CULTURE OR
MASS CULTURE? EXPRESSIONISM ABSTRACTION ABSTRACT
 EXPRESSIONISM

MINIMALISM

GOING "BEYOND CASE STUDY:
THE WEST" HOKUSAI TO
 DISNEY

EXERCISES,
DISCUSSION
QUESTIONS,
FURTHER VIEWING,
AND FURTHER
READING

American Visions:
Rauschenberg and Rockwell

Steve McQueen's first feature film, *Hunger* (2008), which explores the imprisonment of IRA member Bobby Sands, can be considered minimalist in its filmic style and method, but it also deliberately echoes compositions inspired by minimalist art. For example, some scenes frame one character (the prison guard Lohan or the protagonist Bobby Sands) against a blank backdrop, and the movements of both camera and actor are minimal: the action slows down, the story pauses, and the elements in the frame become elements of the greater tragedy that McQueen wants to address. Steve McQueen had a successful career as a fine artist before embarking on feature film directing.

Joanna Hogg's 2013 film *Exhibition* is set in an architecturally minimalist house. Both this and her earlier film *Archipelago* (2010) are essentially minimalist in approach. While minimalist art has often been seen as a "male" category, minimalist cinema has attracted many female directors, including Hogg, Scherfig, and others.

How do artists inspire and influence filmmakers? There is no easy answer; it depends on many factors, including personal taste. Remember that a film is made by a team of people, so the director, cinematographer, production designer, and costume designer can all bring their own artistic influences into the project. In this section we will look at two very different American artists who have been cited as inspiring some of the most significant filmmakers of the late twentieth century: popular painter and illustrator of "everyday life" Norman Rockwell (1894–1978), and Robert Rauschenberg (1925–2008), one of American art's greatest innovators.[21]

The DP of *Taxi Driver*, Michael Chapman, was inspired by New York artist Robert Rauschenberg's arrangement of objects and color on the canvas, created by collaging together different materials with paint in bright primary colors. Chapman, talking about the ending of *Taxi Driver*, said that he wanted the composition to look "like a Rauschenberg."[22] Rauschenberg sourced the material for his work from the real world, scouring his neighborhood for

detritus to incorporate into the artwork using a technique known as *assemblage*. He created what he called "combines," works using detritus as the raw material. In *Bed* (1955), he dripped and splashed red paint across a quilt, then displayed it on the wall as a painting, thus juxtaposing the strangeness of a vertical bed with a picture of a bed. There are many inferences at work: illness, childbirth, nightmares, sexuality, murder.

Later work involved collecting diverse images and creating silkscreen collages combining the images. His later combines addressed the Vietnam War, racism, sexuality, politics, and ecology. Rauschenberg took the bits and pieces of everyday life, including the stuff we throw away without thinking, and reconfigured it into art. His work both reflects and critiques the postwar American culture of productivity and waste, and the democracy of objects, but also invites us to re-treasure what we have discarded. To cinematographer Michael Chapman, the arrangement of the objects on set needed to be as dynamically charged as

8.6

8.6
Taxi Driver, 1976
**Dir. Martin Scorsese, DP Michael Chapman,
art director Charles Rosen**
The arrangement of the elements in the frame are inspired by Rauschenberg's "combines," or assemblages. The bed recalls the artist's 1955 piece *Bed*, which is in MoMA and can be seen on their website, www.moma.org.

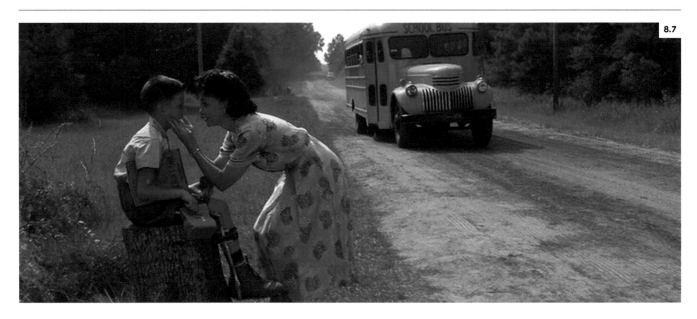

8.7

8.7
Forrest Gump, **1994**
Dir. Robert Zemeckis, DP Don Burgess
The innocent, wholesome world of Forrest
Gump's childhood is deliberately modeled on the
idealized image of small town America depicted in
Rockwell's *Saturday Evening Post* covers.

the arrangements that Rauschenberg created in his combines—not only aesthetically and compositionally, but meaningfully as well. However, though the Rauschenberg inspiration can be seen clearly in the composition of the scene, the strong color was lost. Chapman notes that in order to keep the R rating for cinemas, the colors in the final shootout were desaturated in postproduction, against the wishes of the cinematographer: "Before they desaturated it the overhead shot looks like a Rauschenberg. I meant it to look like a Rauschenberg where the colors are incredibly vibrant."[23]

"I imagined Norman Rockwell painting the baby boomers," said film director Robert Zemeckis of his 1994 multiple-award-winning film *Forrest Gump*.[24] Rockwell was a well-loved illustrator whose work appeared in popular magazines. He specialized in homespun realistic renderings of ordinary American life elevated to mythic status.

From 1916 to 1963, Rockwell made the cover images for the *Saturday Evening Post*, a mass-market popular magazine that offered articles and fiction. During the Second World War his hopeful magazine covers, such as *Hasten the Homecoming* (May 26, 1945), uplifted worried families. Rockwell even invented a character, Willie Gillis, a "typical GI," and followed his military career during the course of America's involvement in the war over eleven magazine covers and a painting. Private Gillis was depicted from induction through discharge, but he was never shown in battle.

FURTHER VIEWING

Rockwell's *Saturday Evening Post* covers can all be seen on the *Saturday Evening Post* website, http://www.saturdayeveningpost. com.

CULTURE OR
MASS CULTURE? EXPRESSIONISM ABSTRACTION ABSTRACT
EXPRESSIONISM GOING "BEYOND CASE STUDY: EXERCISES,
 THE WEST" HOKUSAI TO DISCUSSION
 DISNEY QUESTIONS,
 FURTHER VIEWING,
 AND FURTHER
 READING

MINIMALISM

As well as somewhat idealized scenes of ordinary American life, often infused with humor, Rockwell also included social critique. For example, in 1961, at the height of the American civil rights movement, Rockwell painted *Golden Rule*. It depicts a large gathering of people from all different races, colors, and religions. Text overlays the painting: "Do unto others as you would have them do unto you." The painting was used as a front cover of the *Saturday Evening Post*. Rockwell based the painting on photographs from his own travels, and also real people who modeled for him. Three years later he painted *The Problem We All Live With*, which was featured in *Look* magazine. Again, the civil rights movement framed his subject, a six-year-old African American girl going to attend her desegregated school. As happened in real life, she was accompanied by four US marshals, who are there to enforce the desegregation. The sheer popularity and accessibility of Rockwell's work made his critical commentary on the civil rights movement and the desegregation process unavoidable to middle America.

Zemeckis's film also follows this same trajectory, as we see Gump coming of age into a more troubled America. Gump serves in Vietnam and is inadvertently caught up in many of the key issues of the period such as the Watergate scandal, which shook popular trust in the office of the president. Exposed to the effects of discrimination against disability and race, Gump becomes an everyman, a witness to history.

George Lucas and Steven Spielberg both have Rockwell original paintings hanging in their workplaces, and both contributed their collections for a special exhibition, "Telling Stories: Norman Rockwell from the Collections of George Lucas and Steven Spielberg," at the Smithsonian in Washington, DC, in 2010. In 2014 Lucas donated half a million dollars to the Norman Rockwell Museum. Lucas, Spielberg, and Zemeckis are known for films that, although seemingly heartwarming and affirming, deal with dark and complex problems and situations. It is not surprising that all have been drawn to Norman Rockwell, whose pictures at first glance seem almost sugary but, upon reflection, have much stronger messages to pass on.[25]

Taxi Driver and *Forrest Gump* are films that, however different they are in almost every way, want to tell us something about the America the filmmakers see around them.[26] Rauschenberg and Rockwell are as different as *Taxi Driver* and *Forrest Gump*. Here we can see that each American artist in his own way addressed the issues that American society faced, communicating with their own audience—Rauschenberg with the artistic intelligentsia, Rockwell with "ordinary" Americans. Both in turn provided inspiration to popular and successful films. This process of inspiration and referencing is part of many films, and as you develop your understanding of art, you will develop your ability to discern it, as well as use it yourself.

Modern Movements

Because abstract art departs radically from all previous kinds of art in the Western tradition, it has never been obvious to viewers what they should make of it. Unlike a mythological scene or religious depiction, an abstract picture does not depict and thus reaffirm any well-known story or value. Unlike a realistic picture, it does not attempt to show truths about the world as it is. Instead, abstract art turned to another art form to convey its meaning: words.

There have been instances of artists writing about art: Hogarth's *The Analysis of Beauty* (1753), Vasari's *Lives of the Artists* (1550), and Samuel van Hoogstraten's 1678 Dutch painting manual, *Introduction to the Academy of Painting*, are examples. More commonly, philosophers like Edmund Burke wrote about aesthetics, and there were critics like Charles Baudelaire. Abstract artists, many of whom were educated in other academic subjects, did write about art, their art. Kandinsky (studied law), Robert Motherwell (studied philosophy), and Mark Rothko (briefly studied

liberal arts and sciences at Yale) wrote substantial books. Many abstract artists also gave interviews and participated in documentaries where they were able to explain their ideas. The role of the critic also became much more important, because the art was so subjective. The critic came to be not just an arbiter of fashion and taste but an interpreter, the intermediary between the artist and his or her public. However, we should remember the advice of E. H. Gombrich in *The Story of Art*: "one need not necessarily accepts the artist's theories to appreciate his work." This is as true for art as it is for the writings of Vittorio Storaro. The best way to approach an artwork is directly—experiencing it and forming your own views first.

Criticism also became more academic. Increasingly anchored in universities as well as journals, critical discourse began to appropriate concepts (with varying accuracy) from other disciplines: anthropology, Continental philosophy, psychology, even biology. This intellectualization of art eventually

gave rise to conceptual art, the art of "pure idea." Even before the First World War, French artist Marcel Duchamp had laid the table for conceptual art by criticizing what he called "retinal" art—work that aims principally to engage the eye. Duchamp argued that the idea was primary. However, the problem with Duchamp's position is that, biologically, humans are retinal: vision is our strongest and most primary sense; once the eye is engaged, the other senses and the brain strive to serve vision. To reject the retinal is to force oneself into an unnatural, almost punitive position, groping around for ways to organize meaning.

But Duchamp made us question and examine how we perceive the visual as an image of a thing, and how the relationship between thing and image shifts and changes. Questioning the conceptual arrangement of things and images preoccupied the art of the late nineteenth and early twentieth centuries. By the end of the twentieth century, Postmodernism took these ideas further, questioning the distinction between high culture and mass or popular culture and, like earlier projects such as the Bauhaus, seeking ways to reintegrate art and everyday life. More explicitly, Postmodernism refuses to recognize the authority of any single style or definition of what art should be. As a result, postmodern art is typified by the self-conscious use and mixing together of earlier styles and conventions, often blending different media. We have already seen this in the discussion of Tarantino's *Django Unchained*; the achievement of the film lies in its functioning within the complex visual terms that evolved from modernist and postmodernist ideas.

ART CRITICISM

Here is an example of what a popular museum guide says about the Rothko painting shown in this chapter:

"[Rothko's mature works] . . . metaphorically encompass the cycle of life from cradle to grave, in part by harboring an oblique reference to both adorations and entombments. The stacked rectangles may be read vertically as an abstracted Virgin bisected by horizontal divisions that indicate the supine Christ." (Jennifer Blessing, Guggenheim Museum)

Although the critic's reading may be insightful and help us to enjoy the work, it remains necessarily laden with conjecture and assumption. It cannot say that Rothko's work is a good likeness, or even if it is well painted, as these criteria do not apply.

CULTURE OR
MASS CULTURE? EXPRESSIONISM ABSTRACTION ABSTRACT
EXPRESSIONISM

MINIMALISM

GOING "BEYOND
THE WEST"

CASE STUDY:
HOKUSAI TO
DISNEY

EXERCISES,
DISCUSSION
QUESTIONS,
FURTHER VIEWING,
AND FURTHER
READING

Twentieth-century art, then, is a mass of possible contradictions. Expressionism celebrates subjectivity, highlighting emotional, atmospheric, experiential readings, even as the artist reveals possible neurosis. Abstract art feeds the retina, but provides images outside of the figurative realm for our consideration. Pop art is obvious and inclusive, a celebration of the symbolic and the iconic brand-induced mass-produced culture of the twentieth century. Conceptual art points to the importance of thinking as a primary sense, offsetting the importance of the visual and auditory.

Cinema would have little of this. Cinema, so far, has been able to pick and choose those aspects of art that serve cinema and has largely eschewed the rest. Although film criticism developed in the post–World War II period, it has never gained quite as powerful a hold over the film world as art criticism has done within the art world. There are expressionistic films, films that contain abstraction, even cerebral conceptual movies, but they're all recognizable as cinema and can be experienced and enjoyed as such. Despite Godard's dry assertion that he makes films "for one or two people," films are made for the collective experience, to communicate. The tools of reading the film are almost always there, inside the film. To most moviegoers, a film does not need exegesis, unlike some modern art.

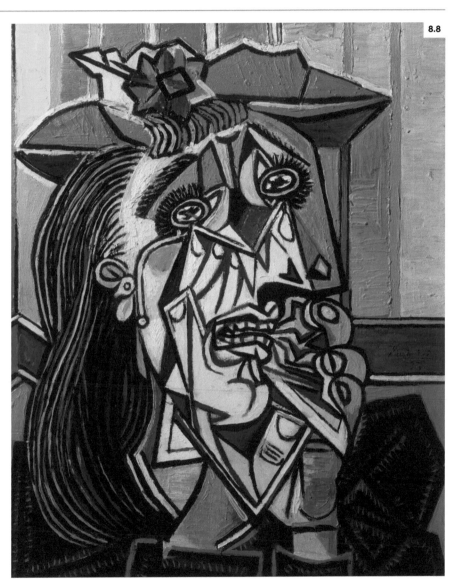

8.8

8.8
Weeping Woman, 1937
Artist: Pablo Picasso (1881–1973)
In the late nineteenth century, African artifacts, masks, drums, and carved statues began appearing in Paris, as a result of French colonial activities. Picasso saw these images as "raw material" and appropriated their forms into his paintings. Picasso's use of African art gave him freedom to alter and distort the human face and body beyond conventional forms of representation.

GOING "BEYOND THE WEST"

European art has always been influenced and invigorated by art from other cultures, and this process is usually reciprocal. Despite wars, imperial conquest, chauvinism, and the acts of regimes and institutions, art has always had a degree of relative freedom and, to a similar degree, has always been porous and open to influence even if not always consciously. We have already seen how European artists like Picasso became inspired by African masks, and how the Blue Rider almanac featured a huge range of global art alongside paintings and drawings by Kandinsky, van Gogh, Natalya Goncharova, Franz Marc, and others. The Blue Rider group did this to make a few specific and direct points: that art is universal; that art is art, no matter where it is produced, or for what purpose; and that European art would benefit from the influence of art from non-European cultures.

However, we have to remain aware that the way "art" developed in Europe was not the same elsewhere. Art had differing functions in different societies. This could lead to problems when Western artists met non-Western art.

European Art Meets the Wider World

We can see historical evidence of the visual culture of Europe embracing diverse elements from other cultures and lands. Consider, for example, *The Adoration of the Kings* (1510–1515) by the Dutch painter Jan Gossaert. Here we see clearly that that the scene is composed of multicultural perspectives, centrally foregrounded. One king is carrying an ornate gift whose workmanship hints at the cultures of the Arabic-speaking world. Look at Vermeer's *Music Lesson*, and notice the richly patterned rug in the foreground. Many of Vermeer's pictures have rugs like this, and they are not Dutch products.

Rugs, porcelain, painted furniture, trinkets, jewelry, and textiles were brought to Europe in ever larger quantities. In almost all cases, these works fall into the category of applied or decorative arts. But for a long period, painting itself was an applied art: it was made for churches or featured on panels. Later it was used to depict important people or events, or to tell a well-known story. The idea of fine art as expressing somehow an artist's "inner feelings" is something born only in the nineteenth century; it is an idea worth questioning because, in retrospect, it is an anomaly in the broader stretch of art history. When we look at art this way, we start to see that the differences between European and non-European art are small.

The influences are fascinating to trace. The Chinese art available in Europe was deliberately created by the Chinese for the export trade and consisted mainly of the delicately painted or drawn pictures on porcelain that inspired the famous Delft potteries in the Netherlands. The Delftware, in turn, created a stronger desire for the color blue, and the increased blue production also benefited artists. Though many travelers brought art back with them to Europe, they did not necessarily understand what it was that they possessed. Many pieces—from Africa or the South Sea Islands, for example—had ritual purposes. It was difficult for many Europeans to accept that an African carving might have a religious purpose not entirely different from that of an icon or crucifix in the Christian church.

Port cities like Venice and Amsterdam were conduits for art and goods from around the world, but trade was so vigorous and lucrative that by the eighteenth century there was scarcely any fashionable house in Europe without a Chinese screen or cabinet, a Turkish rug, and some Indian carved wood. And these made their way into countless European paintings. Later artists consciously sought to incorporate non-European elements into their paintings. The appeal of the Orientalist school of paintings was at least partially due to the portrayal of the rich textiles and luxury goods that made up the "Arabian nights" fantasies of the paintings' buyers. Coupled with the actual textiles and luxury goods, which could also be purchased, the nineteenth-century bourgeois could indulge his oriental fantasies, which included a heavy dose of eroticism.

CULTURE OR
MASS CULTURE? EXPRESSIONISM ABSTRACTION ABSTRACT
EXPRESSIONISM MINIMALISM **GOING "BEYOND
THE WEST"** CASE STUDY:
HOKUSAI TO
DISNEY EXERCISES,
DISCUSSION
QUESTIONS,
FURTHER VIEWING,
AND FURTHER
READING

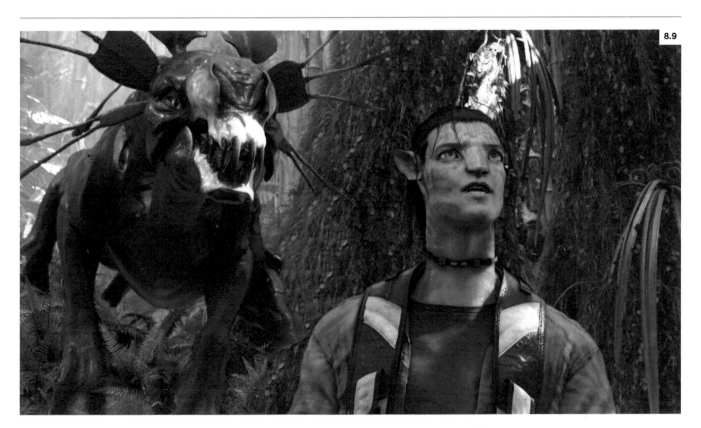

8.9

8.9
Avatar, 2009
Dir. James Cameron, DP Mauro Fiore
The blue-skinned Na'vi live in harmony with nature
and worship a mother goddess. They embody
an enduring Western trope about the lure of a
primitive "natural" life that stands in contrast to
mercantile, industrial civilization. This cultural
longing exists alongside a history of colonial
exploitation—which Cameron's film addresses via
science fiction.

"World" Cinema

Henri Matisse (1869–1954) had a different approach. He was never an Orientalist, but he did spend some time in Morocco and became fascinated with the intricate design of Islamic art. Patterning became a feature of his paintings, and his interest in this continued throughout his life, including his last works, which he created by cutting colored paper into intricate patterns.

European painting was also exported outside of Europe, though aside from the splendid Baroque churches of Latin America, it is unclear how much demand there was for European painting as a product. Most importers sought European technology. However, we do know that European paintings arrived in China and Japan, and they were carefully studied with great interest by Chinese and Japanese artists and scholars.

Sub-Saharan African art was fundamentally misunderstood. Its aesthetics and purpose were little examined, and although it was prized, it was valued for its perceived "primitivism." This interpretation was founded on a myth of "primitive man" that was widely held in Western culture during the period of colonial domination. The concept of "primitive" was dichotomous and contradictory and not based on fact: "primitives" were both demonic and childlike, seen as bestial backward peasants or noble savages. The Western utopian vision of tribal peoples living in harmony with nature has infused cinema, as seen in films such as *Avatar*.

If we turn our attention to cinema, we can see that the adoption of film technology outside of Europe was rapid. Most parts of the world received film technology at more or less the same time. Within a few years, there was a vigorous cinema industry in British-occupied India, led by Indians such as Hiralal Sen, who founded the first production company, and Dadasaheb Phalke, who made the country's first features, based on India's mythological epics, the *Mahabarata* and the *Ramayana*. Indian cinema, particularly Hindi cinema, has continued to borrow from its myths and legends in much the same way that Western cinema continuously borrows from the Greeks. The Indian film industry prospered, and today "Bollywood" produces and exports huge numbers of films, while regional industries serving the country's numerous languages and cultures are also active. Independent Bengali filmmaker Satiyajit Ray learned from Italian neorealism to make significant realist films, including the Apu trilogy *Pather Panchali* (1955), *Aparajito* (1956), and *The World of Apu* (1959), which have in turn become influential to European and American filmmakers.

Egyptian and foreign residents of Alexandria and Cairo also established film companies. In 1927 Aziza Amir produced, codirected, and starred in *Layla*, the first fully Egyptian feature. In 1935 Studio Misr was founded, modeled on Hollywood studios,[27] and Egypt went on to become the hub of regional filmmaking and the main Arab-language cinema producer. Egypt's greatest contribution to cinema has been a particular kind of highly symbolic realism, exemplified by the films of Hussein Kamal. In Chapter 1 we noted his 1971 film *Chitchat on the Nile* (aka *Adrift on the Nile /Tharthara Fawq Alnil*), in which the corrupt elite cavort on a fallen Pharaoh statue. His earlier film, domestic drama *The Impossible* (1966), also uses art, in this case paintings, as a storytelling device. The protagonist, a well-off engineer, is involved with three women; as the characters move through the drawing rooms and bedrooms of their homes, the paintings on the walls create a striking visual comment on the action of the story.[28] Kamal's powerful films also remind us that Egypt has its own painters, its own art tradition; global film cultures are not necessarily engaged with Western art history.

CULTURE OR
MASS CULTURE? EXPRESSIONISM ABSTRACTION ABSTRACT
EXPRESSIONISM MINIMALISM

GOING "BEYOND
THE WEST"

CASE STUDY:
HOKUSAI TO
DISNEY

EXERCISES,
DISCUSSION
QUESTIONS,
FURTHER VIEWING,
AND FURTHER
READING

Toward a Transcultural Hybridity?

It is important to be aware of these developments because many histories of cinema neglect film outside of the Euro-American sphere.[29] What is important is to notice how the European technology soon became a chief tool for non-European storytelling, which borrowed its narratives and its images from its own cultural history.

We should not look at artistic exchange, whether of paintings or films, as a simple binary relationship. It's not possible to really understand it if we see it as a simple "dominant culture versus subordinate culture" relationship. We can't ignore that in many cases there was a colonial relationship, which implies domination and subordination, but the interesting thing about the arts is that they often manage to flow between the cracks in these relationships.

Transcultural hybridity always operates in art, scholarship, and learning. This makes the debate about "Westernization" as a result of adopting Western-originating technologies somewhat redundant. For example, does the adoption of oil paint make Japanese painting less Japanese? Does the use of Indian ink or Afghani lapis lazuli make European art less European? And so with cinema. Remember, if Alhazen had not worked out the science of optics in eleventh-century Egypt, we wouldn't even have the camera.

CASE STUDY:
HOKUSAI TO DISNEY

The most interesting example of reciprocal influence is Japanese art. The following case study explores the influence of a particular strand of Japanese art, *ukiyo-e*, and its eventual manifestation in the first Disney feature film, *Snow White and the Seven Dwarfs*.

There was as much cultural exchange between Japan, China, and Korea as existed among European countries. The East Asian countries were all influenced at different times by Buddhism, Taoism, Shintoism, and Confucianism. When we look at Japanese art, certain themes emerge: the portrayal of nature and animals, portraiture, myth and history, and later, depictions of everyday life. The themes are not much different from those of European art. The Momoyama era (1574–1614) produced energetic paintings of the natural world. *Pine Forest* by Hasegawa Tōhaku (1539–1610) has great subtlety, as the tops of the pines emerge from an almost invisible mist. It is a quiet yet unsettling picture, destined to be influential. This era also commanded splendid equestrian portraits and many scroll handbooks, particularly those offering exciting stories of victories over the Mongols and others. At that time, paintings were often in the form of door panels and screens; they were painted on paper that was then made part of the panel or screen, creating, in effect, a movable mural that was part of the building.

Edo (Tokugawa) Japan and Semi-Isolation

In the period before the 1630s, there was vigorous trade between Japan and other countries. But the new ruler Tokugawa found this threatening. He was probably aware of European colonial activities in other parts of the world, and he wanted to limit the opportunities for interference in Japan. First he forbade Japanese to leave the country: if they left, they could never return. Then he closed the country to all except the Koreans, the Chinese, and the Dutch, whom he confined to small ports. However, the Dutch trade was vigorous, and in 1720 the regime allowed the import of European books on natural sciences, which featured copious drawings of plants, insects, and so forth. Other books of science were also permitted, and books on art and perspective somehow wormed their way in too. So, despite the isolationist policies, Japanese scholars had access to learning about Western art techniques, even if these didn't form a major part of their visual culture.

Japanese Art and Japanese Cinema

That Japanese cinema derives from Japanese art is well documented and is manifested in a number of ways. Narrative cinema probably came quite naturally to Japan because of the long tradition of narrative painting on the hand scroll. These scrolls were often long and complex stories. The historical epic easily lent itself to painting, and some of the greatest Japanese epic films, like 1985's *Ran* (Akira Kurosawa, 1910–1998), are linked visually to the scroll. Although the story of *Ran* is an adaptation of Shakespeare's *King Lear* (just as Kurosawa's *Throne of Blood* is based on Macbeth), the Japanese rendering is manifested distinctively through powerful production design that immediately recalls the *e-makimono* or picture scrolls, particularly those from the Kamakura period of the late twelfth century. One of the most famous is *The Tale of Heiji* (1159–1160), which depicts the rivalry of powerful families and extravagant battles. The paintings in this era were dramatic and detailed, with elements of earthy realism. Similarly, hand scrolls featuring supernatural ghost stories, such as the *Handbook on Hungry Ghosts*, were also important and influential. Well over a hundred of these ancient artworks survived into the twentieth century and remain in Japanese museums and collections, which would have been familiar and accessible to Kurosawa and other filmmakers.

CULTURE OR
MASS CULTURE? EXPRESSIONISM ABSTRACTION ABSTRACT
EXPRESSIONISM MINIMALISM GOING "BEYOND
THE WEST" CASE STUDY:
HOKUSAI TO
DISNEY EXERCISES,
DISCUSSION
QUESTIONS,
FURTHER VIEWING,
AND FURTHER
READING

Kwaidan, 1964

Dir. Masaki Koyabashi (1916–1996)

Koyabashi's portmanteau film of ghost stories combines the art historical tradition of the epic scroll with the art historical tradition of the ghost story scroll. *Kwaidan* is a masterpiece of intertextuality, as it is based on well-known Japanese folktales translated from Japanese to English by US author Lafcadio Hearn. Koyabashi uses an actual Japanese war epic (*gunki monogatari*) in the segment "Hoichi the Earless": he films the painting, and as the narrator tells the story, it comes to life as the scroll's subjects appear in a stylized rendition of the battle. In another segment, "The Woman in the Snow," he uses painting to emphasize the supernatural. The winter landscape is overseen by a huge mysterious eye located in the sky, which creates an eerie and ghostlike image that immediately creates an unsettling sense of wonder and dread, recalling the ghost story scrolls in which oblivious humans share their world with unseen ghosts and demons.

Koyabashi's understanding and appreciation of traditional Japanese art can be seen in every frame of the film; he had initially considered working as an art historian before deciding on a career in cinema.[30] He filmed *Kwaidan* in a vast aircraft hangar, where he was able to build enormous complex sets, especially the huge mural backdrops that largely create the world of the *mise en scène*. The film bankrupted his production company and he was fired by his studio, but he won the Special Jury Prize at the 1965 Cannes Film Festival and was nominated for a Best Foreign Language Film Oscar. Later in life he retired from filmmaking and returned to his first love, the study of Japanese art.

In the eighteenth century, Russian and English traders tried to trade with Japan but were largely rebuffed until 1853, when Commodore Perry essentially forced the Japanese regime to enact trade treaties. This led immediately to energetic export and cultural exchange. This has often been discussed as being revolutionary for the Japanese. Arguably, it was equally revolutionary for European art, which was changed completely by the quality and quantity of its encounter with Japanese art. Japanese art deeply affected all of European painting and illustration, in ways that are simply not covered by the term that was sometimes used, "japonisme."

Ukiyo-e: A Popular Art

Although Japanese painting came in a number of different forms, there was one that stood out during the Edo period as being popular across classes. This was woodblock printing, also known as *ukiyo-e*. Woodblock painting had been known for centuries in Japan, as well as in Europe. But from the late eighteenth century onward, Japanese artists took this technique to unforeseen heights of quality, delicacy, accessibility, and sheer beauty.

Japanese woodblock prints practically exploded onto the European market, where they were avidly collected and appreciated. They were inexpensive mass-produced items that could be found in the curiosity shops of port cities like Le Havre, where Monet, apparently first discovered them. There's another, possibly apocryphal, story that they were discovered in Paris when they were used as packing material for more precious porcelain. European painters wanted to learn from them, and did. James Whistler was one of the first to embrace Japanese composition, and he made a number of paintings in which he dressed his models in Japanese textiles, though the setting was distinctly Chelsea. In terms of its composition, Whistler's *Nocturne: Blue and Gold—Old Battersea Bridge* (1872), which we looked at in Chapter 2, is an almost exact copy of Ando Hiroshige's 1857 print *Riverside Bamboo Market at*

Kyobashi. There's not a great deal of difference in composition between Monet's *Haystacks, Sunset* (1891) and Hokusai's *South Wind, Clear Dawn* (1832). Van Gogh went through an important and fascinating Japanese phase, studying the prints intensively and creating paintings such as *The Bridge in the Rain* (1887); in his portrait of *Pierre Tanguy* (1887), the background is covered in Japanese prints.

The prints were not expensive, and they were barely considered "art" by Japanese intelligentsia. The popularity of *ukiyo-e* was the popularity of the masses. What appealed to Europeans and Americans was the striking balance between similarity and difference in the world portrayed in the Japanese print and life portrayed in Western art.

Arguably, this has always been the secret to Japan's successful reciprocal relationship with the West. Japanese artists and filmmakers have embraced Western knowledge, techniques, and technology and used it to create specifically Japanese art.[31] At the same time, Japanese art and cinema have proven to be largely accessible to Europeans. Japanese films so far have won four Best Foreign Language Film Academy Awards, out of twelve nominations to date, plus many other awards in categories such as cinematography and design. They have also picked up four *Palm d'Or* awards at Cannes and many awards from Berlin, BAFTA,

and others. The achievement of Japanese cinema in the West far outstrips the achievement of any other film culture outside of Western Europe and the United States.

There are essentially three significant *ukiyo-e* artists: Utamaro, Hiroshige, and Hokusai. All deserve closer attention, both for their own intrinsic qualities and for the sheer influence they have had ever since.

Katsushika Hokusai (c. 1760–1849) was an immensely creative artist whose total output is estimated at about 35,000 designs and paintings. One particularly interesting aspect of Hokusai's work is the way in which he combines Japanese interpretation and understanding of Western ideas about perspective with traditional Chinese and Japanese artistic conventions. One of his best-known works is a collection called *36 Views of Mount Fuji*, exemplified by the print "Soruga Street," which shows workmen tiling a roof, with a view of Mount Fuji in the background.

FURTHER VIEWING

Many of Hokusai's works, including all of those discussed here, can be seen online at http://www.katsushikahokusai. org. For Hiroshige, see http:// www.hiroshige.org.uk.

CULTURE OR
MASS CULTURE? EXPRESSIONISM ABSTRACTION ABSTRACT
EXPRESSIONISM MINIMALISM GOING "BEYOND
THE WEST" CASE STUDY:
HOKUSAI TO
DISNEY EXERCISES,
DISCUSSION
QUESTIONS,
FURTHER VIEWING,
AND FURTHER
READING

Ukiyo-e and Everyday Life: Yasujirō Ozu

Koyabashi was influenced by the epic art of imperial Japan, and by ghost stories; Yasujirō Ozu (1903–1963) was clearly influenced by *ukiyo-e*, particularly the scenes from daily life. *Ukiyo-e* began as pictures of the floating world of teahouses, pleasure gardens, and beautiful women, and Utamaro was the greatest creator of these. Later, however, artists such as Ando Hiroshige began to depict everyday life (see *One Hundred Famous Views of Edo*, 1856–1859). Ordinary life, with a salty dose of humor, had been a recurring feature in Japanese art; we can even see it in the epic tales and the ghost story scrolls. Ozu's deceptively simple films about family life in mid-twentieth-century Japan are realist, yet owe much to the *ukiyo-e*. They share a striking visual clarity.

Ozu's color films are as clear and bright as *ukiyo-e* prints. Both visually simplify and declutter the world: the arrangements of the *mise en scène*, the compositions are all designed to be direct and uncluttered. Even Ozu's famous low camera work—he often placed the camera on or close to the floor—and his use of long takes put us in

8.10

8.10
***An Autumn Afternoon / Samma no Aji*, 1962
Dir. Yasujirō Ozu (1903–1963)**
In this bittersweet domestic drama, his last film, we see Ozu's signature floor-based camera and striking composition. Ozu's color films are notable for his use of strong clear color.

mind of the compositions of the *ukiyo-e*. The long take allows us to take in all of the detail, such as the symmetrical arrangement of the figures around a table, the intervention of steam from a cooking pot, a curtain of rain in the background of the shot that frames a crucial conversation. Ordinary domestic life is made important, epic. In *Floating Weeds* (1959), a colorful traveling theater comes to a small town and interrupts the quiet ennui of everyday life. In *Equinox Flower* (1958), a father's liberal views on marriage and fidelity are tested by his own daughter. These are little, intimate human stories. *Ukiyo-e* were also most frequently experienced and appreciated in an intimate domestic environment. People kept the prints in boxes, or pasted them into albums. Sometimes they would stick them to screens or paper sliding door panels inside their homes.

8.11

8.11
***Bathing man*
(woodblock print), 1863
Artist: Utagawa Kunisada
(1786–1864)**
Kunisada's print has elements of the comic; we see the man grimace as the water cascades over him, but we also notice the way his bright, intricately-inked tattoos are echoed by the flourishing foliage growing next to his crouching body as he showers in the open air. Kunisada's striking use of just a few strong colors is typical of the Japanese print, and was a revelation to European painters.

Hokusai's work covers a whole range of approaches, such as naturalistic depictions of nature, embedded within the composition—for example, in *The Netsuke Workshop*. He could also bring forward a strong comic element, as in *Self-Portrait as a Fisherman*, and characters, such as those in *People Crossing an Arched Bridge*. The magical *Rider in the Snow* transports us into a world of myth, history, and wonder. He was also adept in illustrating a story. For example, in *The Waterfall Where Yoshitsune Washed His Horse* (c. 1832), Hokusai illustrates a well-known story about Yoshitsune, one of the greatest and most popular samurai fighters in the history of Japan. However, typically, Hokusai shows not Yoshitsune's fantastic victory, but a tender moment when he washes his horse in the stream. We could say, therefore, that Hokusai was a "cinematic" artist, capturing the "dramatic" moment.

This is exemplified by the print that is often considered to be his masterpiece, *The Great Wave*. Although originally simply one of the series *36 Views of Mount Fuji*, published in 1831, it became the most famous image in all of Japanese art. It depicts a huge wave at sea and two fishing boats caught up in it.

It is a moment of high tension and terror, made tangible by the way in which Hokusai captures the freeze-frame of wave foam. For more than a century after the creation of the Great Wave, no camera had access to the shutter speed that could freeze a frame like this. Yet Hokusai was able to envision that moment. But the moment does not feel like stillness: to the viewer looking at the picture, there's a sense of somehow being in the picture, that the looming wave is about to come crashing down, not only on the ship but on oneself. But the right-hand side of the picture has a large expanse of sky, and in the distance, the serenity of Mount Fuji, the sacred mountain, acts as a beacon and solace. According to Timothy Clark in his study of the picture, Hokusai managed to "transform European naturalistic deep space into something far more symbolic, dramatic and exciting."[32]

CULTURE OR
MASS CULTURE? EXPRESSIONISM ABSTRACTION ABSTRACT
EXPRESSIONISM MINIMALISM GOING "BEYOND
THE WEST" **CASE STUDY:
HOKUSAI TO
DISNEY** EXERCISES,
DISCUSSION
QUESTIONS,
FURTHER VIEWING,
AND FURTHER
READING

8.12
Under the Wave off Kanagawa
(The Great Wave), c. 1832
Artist: Katsushika Hokusai (1760–1849)
The wave takes up the entire left-hand side of the
painting and is enormous, curving into a shape
almost like a beast's claw. The sailors battle to
keep their craft afloat and themselves aboard.

But the reach of *ukiyo-e* was much greater than influencing Impressionism, or even manga. The popularity of these prints, and the general acknowledgment of the brilliance of *The Great Wave*, meant that the entire style of Japanese art became influential and popular. It was copied endlessly, and frequently appropriated. What the Japanese brought was a simplification and refinement that offered fresh possibilities, particularly in the age of the camera. The Japanese prints offered the illusion of depth, not through shading, chiaroscuro, and modeling, but through flatness, clarity, line, and carefully placed detail.

European illustration changed completely through exposure to Japanese graphic arts. This had a huge influence on animation. Early animations, like zoetropes and simple short films, had simple drawings. If we look at Disney's early shorts, the *Silly Symphonies* (for example, *The Goddess of Spring* from 1934), the drawing style is good but quite fussy. It is functional, the animation is clever, and it certainly was an important experimental stage in developing the animation of realistic human figures and creating the illusion of three-dimensionality. But to create an animated feature, something more than technical skill was needed; it needed real artistry.

The kind of sophisticated illustration used in *Snow White* owes a lot to the achievements of *ukiyo-e*, and especially Hokusai. Hokusai was able to suggest three-dimensionality in his compositions, often framing the subjects through foliage. In *Snow White*, the compositions are often framed by branches or flowers, drawn in a style reminiscent of the Japanese. The early scene in which Snow White is gathering flowers in the forest resembles different compositions found in the *ukiyo-e* pictures. Even the Queen's smooth, masklike face owes something to the influence of Japanese Noh theater masks, which were copied by the American mask maker W. T. Benda.[33]

Exposure to Japanese art touched not only the "high" art of the Impressionist paintings, but also the "low" arts of advertising and popular cinema. European art was changed and at the same time invigorated by new philosophical possibilities, with repercussions in every art form, from posters to architecture.

CULTURE OR
MASS CULTURE? EXPRESSIONISM ABSTRACTION ABSTRACT
EXPRESSIONISM MINIMALISM GOING "BEYOND
THE WEST" **CASE STUDY:
HOKUSAI TO
DISNEY** EXERCISES,
DISCUSSION
QUESTIONS,
FURTHER VIEWING,
AND FURTHER
READING

8.13

8.13
***Japanese people* (color woodcut), c. 1830**
Artist: Katsushika Hokusai (1760-1849)
Japan at cherry blossom time is the subject of
Hokusai's print. Typically occurring in late April,
the cherry blossom (*sakura*) season is marked
by celebration and picnics or just resting under
the magnificent trees. The blossoms are richly
symbolic in Japanese culture. *Japanese people* is
typical of Hokusai, who often depicted scenes of
ordinary life. Again, note how limited his palette
is, and his use of outline.

MANGA AND ANIME

After his death, many of Hokusai's sketches were collected
together and published as the *Hokusai Manga* collection.
This found its way to Europe and became influential. The
ukiyo-e are one foundation of what we understand today as
manga comic books. Hokusai's sketches are single images,
although many of them are strongly narrative. Today's manga
comics are a popular version of old Japanese forms like the
narrative hand scroll and *ukiyo-e*. *Anime*, which is simply the
Japanese word for animation, emerges out of this, but was
also influenced by the influx of American animated films after
World War II.

EXERCISES AND DISCUSSION QUESTIONS

Exercise 1
Watch *The Lodger* or *The Cabinet of Dr. Caligari* and freeze-frame the film at random points during the viewing. Compare the frames to pictures by Ernst Ludwig von Kirchner or Eric Heckel, or choose other German expressionist artists. What are the key shared elements of Expressionism?

Exercise 2
What differences can you spot in Minimalism between visual art and cinema? What about minimalist architecture? Can you think of any films that use minimalist architecture as a setting or location?

Exercise 3
You may be unfamiliar with Japanese art, but choose several *ukiyo-e* pictures and imagine stories around them. How do color, composition, and shape organize your experience of the image, and how do they affect your imagined story?

DISCUSSION QUESTION

Picasso painted his lover, the photographer Dora Maar, as *The Weeping Woman*. It does not look like Maar's face at all. What can representations like this convey to us, and how can they be repurposed in cinema?

FURTHER VIEWING

Aside from the Japanese films mentioned in this chapter, the following are worth seeing:

Utamaro and His Five Women (1946), directed by Kenji Mizoguchi, is a fictional biopic of printmaker Kitagawa Utamaro. It is often seen as a thinly veiled autobiography of the director himself.

Chi-hwa-seon or *Strokes of Fire* (2002) is a biopic by Im Kwon-taek about Jang Seung-up (Oh-won), a nineteenth-century Korean painter of humble origins; it won the Best Director prize at Cannes. The film demonstrates many traditional techniques used in Oriental painting.

FURTHER READING

Robert Hughes, *The Shock of the New* (Thames and Hudson, 1991)

Shulamith Behr, *Expressionism* (Tate Gallery Publishing, 1999)

John Willett, *Expressionism* (World University Library, Weidenfeld and Nicolson, 1970)

Christopher Rothko, ed., *The Artist's Reality* (Yale University Press, 2006)

François Truffaut, *Hitchcock by Truffaut: A Definitive Study of Alfred Hitchcock* (Simon and Schuster, 1984)

James Meyer, *Minimalism* (Phaidon, 2010)

Donald Richie, *Japanese Cinema: An Introduction* (Oxford University Press, 1990)

Joan Stanley-Baker, *Japanese Art* (Thames and Hudson, 2000)

Lionel Lamborn, *Japonisme: Cultural Crossings between Japan and the West* (Phaidon, 2005)

Daisuke Miyao, *The Aesthetics of Shadow: Lighting and Japanese Cinema* (Duke University Press, 2013)

Violet Shafik, *Arab Cinema: History and Cultural Identity* (American University in Cairo Press, 2007); an interesting history though the films discussed are often difficult to obtain

Satyajit Ray, *Satyajit Ray on Cinema*; foreword by Shyam Benegal (Columbia University Press, 2013)

Mark Cousins, *The Story of Film* (BCA Pavilion Books, 2004) and his TV series *The Story of Film: An Odyssey* (2012); strongly recommended for the world cinema perspective Cousins gives to his authoritative account of cinema history

CULTURE OR
MASS CULTURE? EXPRESSIONISM ABSTRACTION

ABSTRACT
EXPRESSIONISM MINIMALISM

GOING "BEYOND
THE WEST"

CASE STUDY:
HOKUSAI TO
DISNEY

**EXERCISES,
DISCUSSION
QUESTIONS,
FURTHER VIEWING,
AND FURTHER
READING**

NOTES

1 Scholars disagree whether the New Objectivity (*Neue Sachlichkeit*) movement of the 1920s and '30s should be considered part of Expressionism and if there is such a thing as post-Expressionism. In terms of visual style, John Willett argues convincingly that they are all just different phases of Expressionism. Willett, *Expressionism* (McGraw-Hill, 1978).

2 Robert Hughes, *The Shock of the New*, Episode 6: "The View from the Edge" (BBC, 1980).

3 Quoted in the exhibition *Egon Schiele: The Radical Nude*, Courtauld Gallery, London, October 23, 2014–January 18, 2015.

4 Willett, *op. cit.*, p. 8.

5 Wassily Kandinsky, Introduction to *Concerning the Spiritual in Art*, trans. Michael T. H. Sadler (1916), available at www.gutenberg.org.

6 *Ibid.*, Part II: "The Movement of the Triangle."

7 American Transcendentalism was a philosophical movement that began in the Unitarian Church. Among its projects were diverse unconventional anarchistic and communitarian schemes for living, bound up within an idealistic system of thought based on a belief in the essential unity of all creation and the innate goodness of mankind. Transcendentalists elevated insight over logic and experience as the source of truth, but believed that this insight could be found in communion with nature. Among the adherents were poets such as Walt Whitman. The Transcendentalists also influenced novelists Nathaniel Hawthorne and Herman Melville, and American intellectual life generally.

8 Ralph Waldo Emerson, *Nature: Addresses and Lectures* (James Munroe and Company, 1849).

9 Quoted in Anna Chave, *Mark Rothko: Subjects in Abstraction* (Yale University Press, 1989), p. 102.

10 Michael Leja, *Reframing Abstract Expressionism: Subjectivity and Painting in the 1940s* (Yale University Press, 1997).

11 Hughes, *op. cit.*

12 Dominique de Menil, quoted in rothkochapel.org.

13 Leja, *op. cit.*

14 David Burlyuk, quoted in Edward Strickland, *Minimalism: Origins* (Indiana University Press, 1993), p. 19.

15 Quoted in Anatxu Zabalbeascoa and Javier Rordiguez Marcos, *Minimalisms* (Gustavo Gill, 2000).

16 Quoted in Strickland, *op. cit.*, p. 20.

17 Kazimir Malevich, *From Cubism and Futurism to Suprematism*, quoted in Room 7 of the Exhibition Guide, *Malevich: Revolutionary of Modern Art*, Tate Modern, London, July 16–October 26, 2014.

18 David Batchelor, *Chromophobia* (Reaktion, 2000), p. 29. This is based on ideas expressed in Aristotle's *Poetics* which is widely available and is free on www.gutenberg.org.

19 Quoted in Strickland, *op. cit.*, p. 103.

20 Richard T. Kelly, *The Name of This Book Is Dogme95* (Faber & Faber, 2000).

21 Rauschenberg's achievements included painting, sculpture, printmaking, photography, and performance art. See Catherine Craft, *Robert Rauschenberg* (Phaidon, 2013) and Calvin Tompkins, *Off the Wall: A Portrait of Robert Rauschenberg* (Picador, 2005).

22 Michael Chapman interviewed in *Making "Taxi Driver"* (dir. Laurent Bouzereau, 1999).

23 *Ibid.*

24 Robert Zemeckis quoted by Richard Corliss in "The World According to Gump," *Time*, June 24, 2001.

25 David Savran expands on these points in detail in Chapter 6: "The Will to Believe," in *Taking It Like a Man: White Masculinity, Masochism, and Contemporary American Culture* (Princeton University Press, 1998).

26 Martin Scorsese interviewed in *Making "Taxi Driver."* Zemeckis in an interview says that the film is in part about "grieving the end of the American Dream." Zemeckis interviewed by George Stroumboulopoulos, *Tonight* (CBC), archived on http://www.cbc.ca/strombo.

27 Unfortunately there is no authoritative text on the history of Egyptian cinema; Violet Shafik's *Arab Cinema: History and Cultural Identity* (American University in Cairo Press, 2007) gives a partial account. Ibrahim Fawal, *Youssef Chahine* (British Film Institute, 2001) is an excellent discussion of the prolific and controversial director.

28 Although she does not discuss Hussein Kamal's work, Susan Fellerman addresses the use of art as cinematic and narrative motifs in film in *Art in the Cinematic Imagination* (University of Texas Press, 2006).

29 The recommended text is Mark Cousins, *The Story of Film* (BCA Pavilion Books, 2004) and his accompanying widely available TV series, *The Story of Film: An Odyssey* (2012).

30 Linda Hoagland and Pete Grilli, "A Conversation with Masaki Koyabashi" (1996), reprinted in the 2006 Masters of Cinema collection edition of *Kwaidan*.

31 For a useful and fascinating discussion of the way Japanese filmmakers adopted and used Surrealism, see Mark Schilling, "Japanising the Dark Side: Surrealism in Japanese Film," in *The Unsilvered Screen: Surrealism on Film*, ed. Graeme Harper and Rob Stone (Wallflower, 2007).

32 Timothy Clark, *Hokusai's Great Wave* (The British Museum Press, 2011).

33 There were, of course, other artistic influences at work in early Disney animations. See Van Norris, "Interior Logic: The Appropriation and Incorporation of Popular Surrealism into Classical American Animation," in *The Unsilvered Screen: Surrealism on Film*, ed. Graeme Harper and Rob Stone (Wallflower, 2007).

CONCLUSION: HOW CAN WE USE ART HISTORY IN FILMMAKING?

Whether we realize it or not, there is a relationship between the long history of art and what filmmakers do. Of course, no film is simply the product of its director; a film happens when the director puts together his or her vision of how the film should unfold and how it should look. The director works with the cinematographer, who makes decisions about lenses, lighting, and movement. Meanwhile, the production design team prepares the sets or locations. As we saw with Hein Heckroth and Jack Cardiff, the production designer and the cinematographer use their own knowledge of art to suggest possibilities, creating setups that serve the script and the director's vision. An aspiring director, cinematographer, or production designer should have a basic, straightforward grasp of art history and know that sometimes the best place to get inspiration and ideas is the local art museum.

The most obvious directions to follow when considering the relationship between art and film are art house filmmakers like David Cronenberg, Andrei Tarkovsky, and David Lynch or stylistic visionaries like Michael Powell, Francis Ford Coppola, Stanley Kubrick, Martin Scorsese, and Ridley Scott. However, we also need to consider "mainstream" filmmakers whose broad influence and popular acclaim make them significant generators of visual culture: Steven Spielberg, George Lucas, Sam Mendes, Katherine Bigelow, Robert Zemeckis, Alfonso Cuarón, Christopher Nolan, the Wachowskis, Quentin Tarantino, Michael Mann, and countless others. In fact, any film, and any filmmaker's oeuvre, can be examined in terms of how it intersects with art and visual culture.

It is impossible to separate film from visual art. Film was born when visual art was already almost 50,000 years old. At the same time, after film was invented and disseminated, visual art could not fail to be constantly influenced by the moving image in all its forms. Today, art is inseparable from film. As Kerry Brougher points out, we often experience art through the agency of film: "by the 1930s cinema was no longer borrowing from art, it was converting modern art into popular culture. . . . Surrealism, German Expressionism and abstraction were being converted into languages for mass consumption."[1]

Cinema does more than simply "borrow" from art. We have films that offer artists' biographies; films that refer to, echo, or are influenced by paintings; even films that actually have paintings as part of the *mise en scène*. There many different ways of looking at the relationship between art and film. We can compare a film to a painting; we can seek the influences between the film and a painting; we can seek the deeper relationships, which may be more philosophical than specific. However, when looking at the relationship between cinema and painting, it is just as important to notice the ways that they diverge as it is to notice the ways in which they may converge. Here we present some short case studies that examine convergence and divergence between film and painting, suggesting a variety of different ways that visual art can inform cinema.

EDWARD HOPPER IN FILM

DP Conrad Hall and director Sam Mendes studied the paintings of Edward Hopper for *Road to Perdition* (2002). They used Hopper for inspiration on period, mood, and coloring. Note especially the scene in the diner, with Tom Hanks and Tyler Hoechlin. Though the film is based on the graphic novel, the imagery in the film is quite different from that of the novel.

"Prince of Darkness" Gordon Willis turned to Hopper's sense of color and light when shooting the 1981 musical *Pennies from Heaven*, and actually recreated *Nighthawks* for one scene.

"ONE NEVER FINISHES LEARNING ABOUT ART. THERE ARE ALWAYS NEW THINGS TO DISCOVER. GREAT WORKS OF ART SEEM TO LOOK DIFFERENT EVERY TIME ONE STANDS BEFORE THEM. THEY SEEM TO BE AS INEXHAUSTIBLE AND AS UNPREDICTABLE AS REAL HUMAN BEINGS."
E. H. Gombrich, *The Story of Art* (Phaidon Press Limited, 1995), p. 36

CASE STUDIES
Edward Hopper

Edward Hopper's paintings are often concerned with the use of space within the frame, and his works provide a masterclass in composition. In *New York Movie* the image is bisected, offering a contrast between the cinema space, where the rapt audience sits in semi darkness, and the side-lobby, where the usherette, leaning against the wall, waits for the film to end. Hopper, a keen moviegoer himself, explores this fissure between the dream world which the screen provides (Hollywood was often called the "Dream Factory") and the real world. We can look at the picture in a number of ways. It resembles a "cut" in film, from one scene to another. Or we can see it as a "split screen". See Hopper's use of perspective: the cinema seats in the foreground, and the use of "deep space" to depict the staircase on the right and the cinema screen on the left. Notice how all the people in the picture are "alone" – the cinema-goers are not sitting together.

Curator Stuart Comer has noted that "it is impossible to read the cinema without thinking about Edward Hopper."[2] But Hopper's paintings, though they convey a strong sense of narrative, also convey a strong sense of stillness, status, and inertia, not unlike the stillness in Giorgio di Chirico's paintings. Hopper was interested in Freudian notions of the unconscious, which were coming into common currency in the first half of the twentieth century. We can see the stillness and emptiness in Hopper's pictures as frozen moments in a psychological drama. Hopper is often linked to film noir, but the differences are as significant as the similarities. A number of Hopper's pictures echo the film noir's sense of mood, suspense, and intrigue and the use of the urban

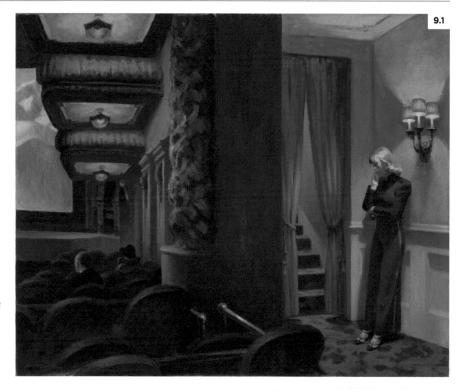

environment, and both often have female experience at the core of the drama. But in the noir films, female experience is seen through the male gaze and is eroticized; in Hopper's paintings, female experience is more often than not female-centered, and frequently is explicitly de-eroticized (see his 1941 painting *Girlie Show* for an example). Film noir—and cinema in general—can often be voyeuristic, and this is something that Hopper's paintings have sometimes been accused of, particularly in the way in which they view people through windows. But it is less voyeurism in the paintings than the unavoidable "casual glance." In the city environment, when we glance around, we are so often surrounded by glass that we are compelled to look through and into. Hopper captures that.

9.1
New York Movie, **1939**
Artist: Edward Hopper (1882-1967)
Edward Hopper's paintings often portray human relations and the city as interactions of light and space. The usherette lingers in the brightly lit cinema lobby, engrossed in her thoughts, while the audience absorbs the flickering and shifting monochrome of the screen. Note the uses of red and blue in the picture.

Hopper offers us strongly colored cinematic drama at a time when drama was almost exclusively portrayed in the cinema in black and white. As we have seen, Gregg Toland believed that color was completely inappropriate for drama. Yet that is exactly what Hopper offers us: intense drama expressed in intense color.

"Thumbs Down!":
Gladiator and Gérôme

Just as film stories constantly repurpose, reedit, and recycle myth, so are visual images repurposed, reedited, and recycled. When the producers of *Gladiator* (2000) approached Ridley Scott about directing the film, they brought him a copy of the 1872 painting *Thumbs Down* (*Pollice Verso*) by Jean-Léon Gérôme (1824–1904), which you can find online.[3] Neither Scott's nor Gérôme's depiction is a true story, but both are based on research into the politics and culture surrounding ancient Roman gladiatorial combat. Gérôme was a very important nineteenth-century "academic" painter, though less well known today. He painted many historical subjects, in particular scenes from classical history and mythology, and was known for his expert coloring and fine brushwork. Gérôme was also well known as an Orientalist. A number of his compositions, such as *Thumbs Down*, have a cinematic quality, but many others show an overly rigid adherence to academic classical rules. Scott does not replicate Gérôme's picture in the film, but rather has absorbed the painter's point of view and something of his visual style.

In *Thumbs Down*, painting condenses the film into a single image. Both *Gladiator* and the painting are hyperreal, based on trying to deliver as much veracity as possible. The question arises, why bother making the movie *Gladiator* when Gérôme's painting would do? Philosopher Walter Benjamin has an answer for this: "The painting invites the spectator to contemplation; before it the spectator can abandon himself to his associations. Before the movie frame he cannot do so. No sooner has his eye grasped a scene than it is already changed. It cannot be arrested."[5] The movie offers movement and development; it tells us who the anonymous gladiator is, and who is the emperor who controls human life. We learn more about the social and political framework under which gladiator combat happened. All of this information was digested by Gérôme and expressed in a single painting; Ridley Scott fleshes it out. Neither is better or more rewarding than the other; they simply deliver the same

material in different ways, and both are available. However, we have to admit that the movie is more immediately rewarding to contemporary audiences than the painting. The film has grossed more than $450 million, which represents many cinema tickets; add to that DVD sales, streaming rights, television broadcast, and so forth. This is a very widely seen and popular film. Theoretically, even more people could see the Gérôme painting because it is available online, and no doubt the success of *Gladiator* made more than a few people discover the painting. But would the film even exist in its current state if not for the painting?

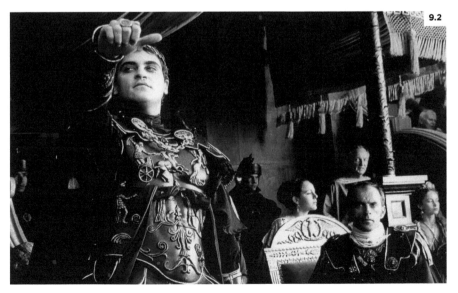

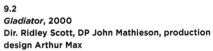

9.2
***Gladiator*, 2000**
Dir. Ridley Scott, DP John Mathieson, production design Arthur Max
The corrupt and amoral Emperor Commodus (Joaquin Phoenix) gives the "thumbs down" (*pollice verso*) signal, indicating that the gladiator should kill his opponent. Mathieson employed multiple cameras filming at various frame rates, creating stop-motion effects for the action sequences. The vast crowds, and ravenous tigers, were rendered in CGI.[4]

Art, Architecture, Film

Artists have long been keen to depict imaginary architecture. The Tower of Babel was a highly popular subject in painting during the sixteenth and seventeenth centuries, particularly in northern Europe. One of the most famous was by Pieter Bruegel the Elder in 1563, but there are well over a hundred known versions of the Tower of Babel painted during this time by different artists. The subject was revived in the eighteenth century, and appeared yet again in Erich Kettelhut's drawings for Fritz Lang's 1927 film *Metropolis*. Lang's film combined the real-world modernism of cities such as Berlin, New York, and Chicago with the art-historical Tower of Babel represented by Bruegel and others. In the following year, M. C. Escher created a woodcut print of the Tower of Babel, and in the early 1960s Salvador Dali essayed an interpretation of the subject.

Architecture appears as a key motif in the films of Christopher Nolan, particularly *Inception* and in the Gotham of the *Batman* films. *Inception* is a psychological film with a series of puzzles at its heart; it is also a film about architecture. Nolan has said that if he were not a filmmaker, he would have become an architect. Appearing in almost every scene are stairs, a maze or labyrinth, a bridge, an arch, a corridor, or a prison (sometimes represented by a cage). *Inception* even

9.3

features a mathematical architectural problem called the "Penrose stairs," which is impossible in real life, but with the agency of art (in this case CGI) the illusion of Penrose stairs can be manifested. M. C. Escher also put Penrose stairs in his 1953 print *Relativity* and in *Ascending and Descending* (1960). Another architectural artwork that appears to belong to *Inception* is Max Ernst's 1934 painting *The Entire City*. In this painting, a city is falling apart; in *Inception*, the ruined dream city crumbles away into the sea.

9.3
The Tower of Babel, **1563**
Artist: Pieter Bruegel the Elder (1525–1569)
Bruegel's tower (based on a story in Genesis 11:4) appears to be a solid and traditional construction, but on closer examination we can see that it is actually an ascending spiral; it is unstable and a few of the arches are already crumbling away.

But the artwork that is most heavily referenced in *Inception* is *The Prisons* (or *Carcieri*) by Giovanni Battista Piranesi (1720–1778). Trained as an architect and as a stage designer, Piranesi was fascinated by the ruins of ancient Rome and spent most of his career drawing them, or fanciful imaginary cityscapes based upon them. *Carcieri* is a series of imaginary prisons, huge vaults with stairs and walkways with impossible perspectives, that seem to lead everywhere and nowhere at the same time.

Piranesi's work is also about architecture as a metaphor for psychology. The "architecture of the mind" is a concept reflected in the drawings of Piranesi and Escher, and the surrealist Max Ernst, and also in *Inception*, which takes place (almost?) entirely in the mind of the main character, Cobb.

In the Magic Hour

The use by director Terrence Malick and his two DPs, Nestor Almendros and Haskell Wexler, of the paintings of American painter Andrew Wyeth in the 1978 film *Days of Heaven* is commonly acknowledged. Wyeth came from a family of artists; his father, N. C. Wyeth, was one of the great illustrators of the American West. Certainly the influence of both Wyeths can be seen in Malick's evocation of the huge rural expanses of the Texas Panhandle, a remote grassland region where the film's story of intense passion and terrible deception is set. Edward Hopper's landscapes are also influential, in particular 1925's *House by the Railroad*.[6]

However, one of the most remarkable things about *Days of Heaven* is that it was shot almost entirely at a particular time of day known as "magic" (or "golden") hour. Magic hour lasts less than thirty minutes; it is that moment of sunset when the sun has gone down but the sky is still light. At the brink of twilight before the darkness begins to fall, luminosity is very soft and rose-tinted.

In 1885 the Anglo-American painter John Singer Sargent painted *Carnation, Lily, Lily, Rose*, a depiction of two little girls in a flower garden bathed in rose-colored light, playing with Japanese paper lanterns. It is one of the most unusual depictions of light in painting. In both the painting and *Days of Heaven*, "magic hour" serves as a metaphor for the brevity of life: fleeting youth, the innocence of childhood, the temporal nature of love, the passing of time, and the aching, unique moment of beauty that—if we are lucky—we may encounter even on an ordinary day.

9.4
Inception, **2010**
Dir. Christopher Nolan, DP Wally Pfister
The normal laws of physics and logic don't apply in the dream architecture of Inception.

9.4

9.5

9.5
Days of Heaven, 1978
**Dir. Terrence Malick, DPs Nestor Almendros
and Haskell Wexler**
Critic Roger Ebert observed that "'Days of
Heaven' is above all one of the most beautiful
films ever made." Because Malick shot almost all
of the film during "magic hour," it took a long time
to make; the original DP Almendros had to leave
the production and Wexler completed the film.

9.6

9.6
Carnation, Lily, Lily, Rose, 1885–1886
Artist: John Singer Sargent (1856–1925)
Sargent painted this outdoors during the magic
hour, in order to precisely capture the quality of
light. Like Terence Malick, it took Sargent quite a
long time to make the work—all of autumn 1885.

Character and Theme

Wes Anderson lifted the image of a woman looking at the world through binoculars from Alex Colville's painting *To Prince Edward Island* (1965, available online) and used it in key scenes in *Moonrise Kingdom* (2012). Unlike the other examples given here, this is a very deliberate use of a specific painting within a filmic composition, not just an influence or inspiration. The painting shows two people on a ferry boat, the woman in the foreground looking through binoculars, while behind her sits the man, his face and body obscured by the woman. Colville has said of the painting, "The woman sees, I suppose, and the man does not."[7] In *Moonrise Kingdom* Suzy (Kara Hayward) stands on top of the lighthouse, obsessively looking at the world through binoculars. When asked about it, she says, "It helps me see things closer. I pretend it's my magic power." She explicitly links seeing through the lens with a kind of magic. It is interesting that Colville's painting and Anderson's film both turn on the idea of a woman controlling her own vision, and being an active user of the tools that enable her to do so. Both can be seen as images of anxiety, but each is of a different kind. It is important to understand the differences between Colville's image and Anderson's. Colville's woman is a mature woman,

9.7

looking directly out of the painting, centered and dominant. Suzy is a girl, still immature, looking idealistically and hopefully at the horizon. Colville's woman has a man behind her, though he is faceless and anonymous; Suzy is alone, looking perhaps for a future companion. The way the painting and the film image play off each other is interesting. Colville's woman is on a boat, definitely going somewhere, and is anxious about that. Suzy is on a lighthouse, connoting isolation but also a sense of stasis, which creates another kind of anxiety.

9.7
Moonrise Kingdom, 2012
Dir. Wes Anderson
Painter Alex Colville once remarked, "Anxiety is the normality of our age." This theme is explored extensively by both Colville and filmmaker Wes Anderson.

The Shared Visual Language of Art and Cinema

Art appears in films; for example, the paintings of Alex Colville are featured in Stanley Kubrick's 1980 film *The Shining*. Jean-Luc Godard frequently features paintings alongside pop cultural artifacts within the *mise en scène* of his films. Curators putting together exhibitions increasingly refer to films: an exhibition of Edward Hopper invited Todd Haynes to create a film program to accompany it; an Alex Colville exhibition discussed his enthusiasm for the Coen brothers, and Wes Anderson's use of his paintings; a Turner exhibition unsurprisingly screened Mike Leigh's *Mr. Turner* (2014). Major galleries and museums have cinemas, where they screen feature films as well as art films. Museums now often offer filmed versions of their major exhibitions. Fine artists become film directors: Katherine Bigelow, Steve McQueen, Julian Schnabel, Sergei Parajanov, and Sam Taylor-Johnson are examples. Artists appropriate film culture: Cindy Sherman, in *Untitled Film Stills* (1977–1980), created a series of self-portraits of herself photographed as generic characters in generic film scenes.

For most of human history, drawing and painting have been the repository of our human culture. For the past century, film has also taken on that role. It is through art that we originally constructed and disseminated our ideas about "What is beauty?" Painting engendered and developed our appreciation for landscape. It carried our ideas about what is worth remembering, valorizing, or commemorating. It demonstrated, through visual communication, our social, religious, and political values. Through painting we can see when and how new ideas and objects entered culture—from the appearance of a new color derived from a scientific invention to the appearance of a Japanese textile in a portrait. Painting is an integral part of human history, and it tells the story of what it is to be human. Cinema is also about telling the human story.

As Kerry Brougher has noted, cinema is "a medium with tremendous powers of absorption and transformation, with the ability to soak up culture, alter it and then represent it to a degree never before seen before the first film projections 100 years ago, at the Café de Paris."[8] Art and film are constantly referring, appropriating, expropriating, and cannibalizing themselves and one another. It is a vital, healthy, and inspirational part of the creative process.

"WE NEED TO MAKE IMAGES; IT'S NOT SOMETHING WE CHOOSE TO DO. WE'VE ALWAYS NEEDED TO DO THIS, TO CREATE IMAGES. BEFORE THERE WERE WORDS, THERE WERE IMAGES . . . DRAWINGS ON CAVES. THAT'S HOW DEEP OUR DRIVE TO DO THIS IS."
—Bill Dill, ASC, cinematographer[9]

EXERCISES AND DISCUSSION QUESTIONS

Exercise 1

Pure observation of light is the first and most crucial step. Recall the lighting exercise you did in Chapter 1. Now pay special attention to the quality of "magic hour." Choose a subject, but this time include a person in the scene. Observe how the color changes and intensifies in a very short period of time. Make notes, but don't take pictures. Think about how the light at magic hour made you feel.

Exercise 2

How can films address characters from paintings? Paintings are full of characters, and we have seen many of them in this book: Lady Liberty, biblical Judith, Millet's peasants, the Dutch guardsmen, and more. But paintings are silent and static, and it is up to the viewer to imagine the characters coming to life. Choose a painting from this book, preferably not a historical character, and write a brief character sketch for the subject of the painting.

DISCUSSION QUESTIONS

1. Among his depictions of modern American urban life, Hopper produced several highly influential paintings of restaurant scenes, which can be seen on http://www.edwardhopper.net/. Look at *Automat* (1927), *Chop Suey* (1929), and *Nighthawks* (1942). What is happening in this frozen moment? Why is a restaurant an interesting setting? How does the painting composition help to suggest ideas to you? Who would you choose to place as the main characters in *Chop Suey*? Compare the three pictures. How is the mood different in each, and how does Hopper accomplish it?

Think of films that have key scenes set in restaurants, and note how the setting is both intimate yet public. Try Yasujirō Ozu's *Equinox Flower* (1958); Quentin Tarantino's *Pulp Fiction* (1994) has two eateries, the Diner and Jack Rabbit Slim's; *I Am Love* (Italy, 2009) dir. Luca Guadagnino; 2003's *Oldboy*, a South Korean neo-noir, directed by Park Chan-wook.

2. History in painting and film. History painting like Gérôme's was considered the highest achievement in painting. What might history painting have to offer to a filmmaker like Ridley Scott? Look at Delacroix's *Liberty Leading the People* or Kimathi Donkor's *Toussaint L'Ouverture at Bedourete*, both in Chapter 7. What do these have to offer the filmmaker?

A number of films use architecture as a motif, regardless of genre. Watch any of these:
In *Playtime* (1967), directed by and starring Jacques Tati, Tati's comic alter ego, the hilariously bumbling M. Hulot, gets lost in the bewildering constructions of Paris's new modern architecture.

Paris's modern suburban architecture features in the social realist drama *La Haine* (1995), directed by Matieu Kassovitz.

Science fiction films often feature powerful architectural themes. *Æon Flux* (2005), directed by Karyn Kusama, was filmed in numerous locations in and around Berlin, Germany.

Batman (1989), directed by Tim Burton, and *The Dark Knight* (2008), directed by Christopher Nolan, interpret the fictional city of Gotham slightly differently.[10]

How does the architecture motif contribute to the overall visual storytelling?

NOTES

1 Kerry Brougher, *Art and Film Since 1945: Hall of Mirrors* (World of Art, 1996), p. 12.

2 Stuart Comer presenting *Double Indemnity: Todd Haynes/Edward Hopper: Todd Haynes with Richard Dyer*, http://www.tate.org.uk/context-comment/video/double-indemnity-todd-haynesedward-hopper-todd-haynes-richard-dyer.

3 Laurence Raw, *The Ridley Scott Encyclopedia* (Scarecrow Press, 2009).

4 Diana Landau, Walter Parkes, John Logan, and Ridley Scott, *Gladiator: The Making of the Ridley Scott Epic* (Newmarket Press, 2000).

5 Walter Benjamin, "The Work of Art in the Age of Mechanical Reproduction" (1936), in *Illuminations* (Schocken, 1969).

6 David Thomson, "Is Days of Heaven the Most Beautiful Film Ever Made?" *The Guardian*, September 1, 2011. See also Emily Smith, *The Terrence Malick Handbook: Everything You Need to Know about Terrence Malick* (Emereo Publishing, 2012) and Nestor Almendros, *Man with a Camera* (Farrar, Straus and Giroux, 1986).

7 Quoted by the National Gallery of Canada for the exhibition *Alex Colville, A Canadian Icon*, April 23–September 7, 2015.

8 Kerry Brougher, *Art and Film Since 1945: Hall of Mirrors (World of Art)* (Monacelli, 1996), p. 21.

9 Quoted in *Cinematographer Style* (2006), directed and produced by Jon Fauer. DVD, color, 86 mins. In English. Distributed by Docurama Films.

10 Read Jimmy Stamp, "Batman & Architecture: The Dark Knight Rises and Gotham's Buildings Fall," *Arch Daily*, July 23, 2012.

APPENDIX

TIMELINE

PREHISTORY
Altamira Cave paintings c. 18000 BC
Lascaux Cave paintings c. 17000—15000 BC

THE ANCIENT WORLD
Nebamun's Tomb paintingsc. 1350 BC
Tutankhamen tomb1333–1323 BC
The Parthenon sculptures Mid-5th century BC
Fayum Portraits.................... 30 BC–3rd century AD
Trajan's Column...............................106–113 AD
Statue of Diana "Of Versailles"200 AD

325 AD
Christianity becomes the official religion of the Roman Empire; 652 Islam conquers Roman North Africa; 718 Conquest of Byzantine Constantinople. These changes broadly affected art.

Alhazen or Ibn Al-Haytham..............c. 965–c. 1040
Discovered the way the eye works; invented the concept of the camera

THE MIDDLE AGES
5th–15th Century
400–1500

Unknown Japanese artists
The Tale of Heiji1159–1160
Unknown Japanese artists
Handbook on Hungry Ghosts12th–13th century
Michael Pacher ..1435–1498
Matthias Grünewald................................1480–1528
Mariotto Albertinelli1474–1515

THE RENAISSANCE
14th–17th Century
1300–1600

Jan Van Eyck...................................... c. 1390–1441
Fra Angelico c. 1395–1455
Antonio Del Pollaiuolo..........................1429–1498
Sandro Botticelli c. 1445–1510
Hieronymus Bosch..................................1450–1516
Leonardo Da Vinci1452–1519
Lucas Cranach The Elder......................1472–1553
Michelangelo Buonarroti1475–1564
Jan Gossaert c. 1478–1532
Raphael ...1483–1520
Titian...1490–1576
Jacopo Pontormo1494–1557
Hans Holbein...................................1497–1543

1517
1517 is the accepted date for the start of the Reformation, which split the Western Christian Church. This has wide implications for the fine arts. The Post-Reformation period, after 1600, includes the Baroque.
Bronzino...1503–1572
Tintoretto...1518–1594
Pieter Breughel the Elder.....................1525–1569
Paolo Veronese1528–1588

Hasegawa Tōhaku 1539–1610
Paolo Fiammingo c. 1540–1596
Hendrick Goltzius..................................1558–1617
Cornelis Van Haarlem1562–1638
Francisco Ribalta1565–1628
Caravaggio..1571–1610
Guido Reni ..1575–1642
Frans Hals ..1582–1666
José De Ribera1591–1652
George De La Tour.............................1593–1652
Artemisia De Gentileschi1593–1656
Nicolas Poussin1594–1665
Johann Liss ..1595–1631
Francisco De Zurbarán.......................1598–1664
Anthony Van Dyck..............................1599–1641
Diego Velázquez...................................1599–1660
The Le Nain Brothers..........................1599–1677
Claude Lorrain1600–1682
Rembrandt Van Rijn..........................1606–1669
David Teniers the Younger.................1610–1690
Salvator Rosa1615–1673
Esteban Murillo....................................1617–1682
Albert Cuyp1620–1691
Jacob Van Ruisdael1628–1682
Pieter De Hooch.................................1629–1684
Jan Vermeer...1632–1675
Gregorio De Ferrari c. 1647–1726
Jean-Antoine Watteau........................1684–1721
William Hogarth...................................1697–1764
Pietro Longhi1700–1785
François Boucher1703–1770
Giovanni Battista Piranesi1720–1778
Sir Joshua Reynolds1723–1792
Thomas Gainsborough.........................1727–1788
Jean-Honoré Fragonard1732–1806
Joseph Wright "Of Derby"1734–1797
John Singleton Copley1738–1815
Benjamin West1738–1820
Henry Fuseli (or Füssli)1741–1825
Francisco Goya.....................................1746–1828
Jacques-Louis David..............................1748–1825
Friedrich Heinrich Fuger.......................1751–1818
John Cozens...1752–1797
William Blake1752–1827
Utamaro ...c.1753–1806
Thomas Stothard1755–1834
Louise Élisabeth Vigée Le Brun1755–1842
Hokusai .. c. 1760–1849
Nicéphore Niépce...................................1765–1833
Sir Thomas Lawrence1769–1830
Caspar David Friedrich1774–1840
James Mallord William Turner1775–1851
Kunisada Utagawa1786–1864
William Etty..1787–1849
Louis Daguerre1787–1851
Horace Vernet1789–1863
Theodore Gericault.............................1791–1824
George Catlin1796–1872
Ando Hiroshige1797–1858
Eugene Delacroix.................................1798–1863
Henry Fox Talbot1800–1877
(Invented calotype process)

Thomas Cole1801–1848
Karl Bodmer1809–1893
Jean Francois Millet1814–1875
Augustus Egg 1816–1863
George Frederick Watts1817–1904
Théodore Chassériau1819–1856
Ford Madox Brown1821–1893
Jean-Léon Gérôme1824–1904
Gustave Moreau1826–1898
Arnold Böcklin...................................1827–1901
Dante Gabriel Rossetti1828–1882
John Everett Millais1829–1896
Albert Bierstadt1830–1902
Eduard Manet1832–1883
Edward Burne-Jones 1833–1898
Felicien Rops.....................................1833–1898
William Morris1834–1896
JM Whistler.......................................1834–1903
Winslow Homer.................................1836–1910
Odilon Redon1840–1916
Claude Monet1840–1926
Berthe Morisot 1841–1895
Jean-Jules-Antoine Lecomte du Nouy . 1842–1923
Ilya Repin...1844–1930
Walter Greaves1846–1930
Elizabeth Southerden Thompson,
 Lady Butler1846–1933
Paul Gaugin1848–1903
John William Waterhouse..................... 1849–1917
Vincent Van Gogh1853–1890
Ferdinand Hodler1853–1918
Unknown Japanese artists
The Eyewitness Account of Commodore Perry's Expedition to Japan in 1854 1854
John Singer Sargent...........................1856–1925
Georges Seurat 1859–1891
Henry Ossawa Tanner.......................1859–1937
James Ensor1860–1949
Gustave Klimt 1862–1918
Edvard Munch...................................1863–1944
Suzanne Valadon...............................1865–1938
Wassily Kandinsky1866–1944
Emil Nolde.......................................1867–1956
Henri Matisse...................................1869–1954
Emily Carr..1871–1945
Aubrey Beardsley..............................1872–1898
Kuzma Petrov-Vodkin........................1878–1939
Kazimir Malevich................................1879–1935
Natalya Goncharova1881–1962
Pablo Picasso....................................1881–1973
Edward Hopper..................................1882–1967
Jose Clemente Orozco1883–1949
Erich Heckel......................................1883–1970
Diego Rivera.....................................1886–1957
Georgia O'Keefe1887–1986
Giorgio de Chirico.............................1888–1978
Paul Nash...1889–1946
CRW Nevinson1889–1946
Egon Schiele1890–1918
El Lissitzky1890–1941
Giorgio Morandi1890–1964
Max Ernst...1891–1976

Dora Carrington1893–1932
George Grosz1893–1959
Norman Rockwell1894–1978
David Siqueiros1896–1974
Nick Eggenhofer............................1897–1985
René Magritte1898–1967
M. C. Escher.................................1898–1972
Jindřich Štyrský1899–1942
Weegee Arthur Fellig1899–1968
Yves Tanguy1900–1955
Mark Rothko.................................1903–1970
Salvador Dali................................1904–1989
Frida Kahlo...................................1907–1954
Francis Bacon...............................1909–1992
Dorothea Tanning..........................1910–2012
Jackson Pollock1912–1956
Agnes Martin................................1912–2004
Robert Motherwell1915–1991
Sidney Nolan1917–1992
Alex Colville.................................1920–2013
Lucien Freud1922–2011
Robert Rauschenberg1925–2008
Andy Warhol.................................1928–1987
Donald Judd1928–1994
Allan D'Arcangelo..........................1930–1988
Richard Estesb. 1932
Lyn Foulkes..................................b. 1934
Paula Regob. 1935
Frank Stellab. 1936
Robert Mangold.............................b. 1937
David Hockney...............................b. 1937
Carolee Schneemannb. 1939
Chuck Closeb. 1940
Valie Export..................................b. 1940
Anselm Kieferb. 1945
Eric Fischli...................................b. 1948
Cindy Shermanb. 1954

Early cinema time line
[covers the less familiar films discussed]
George Melies.................................1861–1938
A Trip to the Moon (1902)
Auguste and Louis Lumière
Auguste...1862–1954
Louis..1864–1948
L'Arrivée d'un Train en Gare de la Ciotat (*The Arrival of a Train at La Ciotat Station*) (1895)
Dadasaheb Phalke............................1870–1944
Raja Harishchandra (1912)
Robert Wiene...................................1873–1938
The Cabinet of Dr. Caligari (1920)
F. W. Murnau....................................1888–1931
Nosferatu (1922)
Jean Cocteau1889–1963
The Blood of a Poet (1930)
Abel Gance1889–1981
Napoléon (1927)
Alfred Hitchcock..............................1899–1980
The Lodger: A Story of the London Fog (1927)
Luis Buñuel.....................................1900–1983
Un Chien Andalou (1929); *Los Olvidados* (1950)

Walt Disney.....................................1901–1966
Snow White and the Seven Dwarfs
Akira Kurosawa1910–1998
Kagemusha (1980), *Ran* (1985)
Masaki Koyabashi1916–1996
Kwaidan (1964)
Satyajit Ray....................................1921–1992
Pather Panchali (1955)
Hussein Kamal1932–2003
The Impossible (1966)
Chitchat on the Nile (1971)

MOVEMENTS
We have to remember that movements are fluid and any dates given are only approximate. Many movements overlap, and many artists combine approaches from different movements. A movement really only indicates a dominant trend, and sometimes only indicates an art-historical classification, which is helpful if you want to look up artists or artworks. Don't take them too seriously.

CLASSICAL...............................5th–4th centuries BC
The Parthenon sculptures..........................c. 438 BC

HELLENIC (including the Roman Hellenic period).................323 BC–500 AD
House of the Mysteries, Pompeii and other frescoes; the Fayum portraits, Trajan's Column Rome

MEDIEVAL...500–1300 AD
Book of Lindisfarne, Northumbria, c. 715; Basilica of San Vitale Ravenna c. 547

RENAISSANCE............Early 14th–late 15th century
Michael Pacher, Jan van Eyck, Sandro Botticelli

HIGH RENAISSANCE...Late 15th–mid-16th century
Leonardo da Vinci, Michelangelo Buonnarotti, Peter Bruegel

BAROQUE.................Mid-16th–end of 17th century
Caravaggio, Vermeer

ROCOCO ..18th century
François Bouchard

NEOCLASSICAL............Late 18th–early 19th century
Jacques-Louis David

"HIGH" REALISM19th century
Jean-François Millet, Paul Delaroche

ROMANTICISM...19th century
Paul Delacroix

PRE-RAPHAELITE.....................................19th century
Dante Gabriel Rosetti, John Everett Millais, William Morris

MODERNISMLate 19th–mid-20th century
Pablo Picasso, Henri Matisse, Wassily Kandinsky

SYMBOLISMLate 19th–mid-20th century
Gustave Moreau, Alfred Kubin, Edvard Munch, Frida Kahlo

IMPRESSIONISMLate 19th century
Claude Monet, Alfred Sisley

POSTIMPRESSIONISM.............End of 19th century
Paul Cézanne, Paul Gauguin, Vincent van Gogh, Georges Seurat

FAUVISM...Early 20th century
Henri Matisse, Raoul Dufy

EXPRESSIONISMEarly 20th century
Ernst Ludwig Kirchner, Emil Nolde, Kathe Kollwitz, Otto Dix, Emily Carr

CUBISM ...Early 20th century
Pablo Picasso, George Braque

ABSTRACTION.............................Early 20th century
Wassily Kandinsky, Piet Mondrian, Joan Miró

ABSTRACT EXPRESSIONISM.....Mid-20th century
Mark Rothko, Barnett Newman, Robert Motherwell, Jackson Pollock, Lee Krasner

MINIMALISM................................Mid-20th century
Agnes Martin, Sol Lewitt, Frank Stella

OP ART ...Mid-20th century
Bridget Riley

POP ART...1960s–1980s
David Hockney, Andy Warhol, Keith Haring, Pauline Boty

CONCEPTUAL ART1970s–present
Marcel Duchamp, Yayoi Kusama, Fluxus, Yoko Ono, Marina Abramović

POSTMODERN ART1980s–present
Damien Hirst, Takashi Murakami, Jeff Koons, Ai WeiWei, Banksy

GLOSSARY

Arcade (architecture)

An arcade is a structure made of a series of arches carried by columns. This creates either a passageway between the arches and a solid wall, or a covered walkway that provides access to other places such as adjacent shops. Arcades were devised by the Romans and were used extensively in Renaissance Italy. Giorgio de Chirico painted eerily deserted arcades. Paris had significant arcades, built in the 1820s, called *passages couverts*, and some are still in use. Louis Malle's 1960 film *Zazie dans le Metro* features scenes shot in the Passage du Grand Cerf.

Avant-garde

The term comes from the military, meaning advance-guard or vanguard, and refers generally to anything that is experimental or risk-takingly innovative. In art, the term first appeared around the 1890s to describe the work of young painters in Paris who seemed to be doing things quite differently from even the generation just a few years older. Generally speaking, the term is used to mean artists or art movements that seem to be opposed to mainstream cultural values and styles. These were characteristic of the twentieth century.

Baroque

The baroque style arose in the period immediately following the European Reformation, and is often associated with Italy and Spain, although major examples of baroque architecture and art appear in Germany and throughout Central Europe. Baroque style is identifiable in compositions that emphasize movement, with complex use of diagonal lines and pyramid structures, dramatic and dynamic lighting, and rich colors, augmented by the dramatic effect of light and shade. This is the era in which chiaroscuro becomes one of the dominant techniques in painting.

Bauhaus

A school of art, architecture, and design established by Walter Gropius, initially at Weimar, Germany, in 1919. Through a community of artists working together, the school's aim was to bring art back into contact with everyday life. Kandinsky, Paul Klee, and artist/filmmaker László Moholy-Nagy taught there. See Moholy-Nagy's films *Gross-Stadt Zigeuner*, a short documentary about Berlin's marginalized gypsy community, and *Lichtspiel Schwarz-Weiss-Grau* (*Lightplay Black-White-Gray*), a fascinating experimental film about light, shape, and form, both 1930.

Chiaroscuro

Chiaroscuro (from the Italian *chiaro*, "light," and *scuro*, "dark") is the use of bold and strong contrast between light and dark, affecting a whole composition. Here light and shadow are used to define three-dimensional objects within the composition, and also to create high drama. Examples: Artemisia Gentileschi (1593–1656); José de Ribera (1591–1652).

Classicism

The classical approach highly values the art and philosophies of classical antiquity from the Western tradition (Greek and Roman) as setting the standard for taste. Classical art typically seeks to be formal, restrained, and rational, always paying attention to the rules laid down by Greek aesthetic philosophy. Example: Nicolas Poussin (1594–1665).

Cubism

Instead of depicting objects from one particular viewpoint, the artist analyzes the subject, breaks it up, and reassembles it in an abstracted form. Cubism depicts the subject from a multitude of viewpoints simultaneously. Cubist paintings appear fragmented and abstracted. This approach challenged and even rejected ideas about perspective established in the Renaissance, emphasizing the two-dimensional flatness of the canvas instead of creating the illusion of depth. The movement was founded in 1907–1908 by artists Pablo Picasso and Georges Braque and was joined by Robert and Sonia Delaunay, Juan Gris, and Jean Metzinger, among others. According to the curator Bernice Rose, it was the artists' interest in film that spurred them to invent a new style of painting that "could meet the challenges of a perceptually re-invented world." See, for example, Picasso's *Portrait of a Woman* (1910), Georges Braque's *Still Life with Harp and Violin* (1911), or Juan Gris's *Glass of Beer and Playing Cards* (1913).

"Dutch" ("Deutsch") tilt

A strongly angled camera shot in which the camera is set at an angle on its roll axis so that the horizon line of the shot is not parallel with the bottom of the camera frame. The angle is so-called because of its popularity in early German ("Deutsch") cinema and was associated with Expressionism, both in visual art composition and film. The technique was brought to Hollywood in the 1940s, where it became a staple of horror and film noir pictures. See John Huston's *The Asphalt Jungle* (1950) and Sam Raimi's *The Evil Dead* (1981).

Expressionism

Expressionism is both an artistic movement of the early twentieth century and an artistic style that continues up to the present. Expressionism involves figurative depiction, not of objective reality but rather of the subjective emotions and psychological states that are aroused within the person. This can be achieved by creating images that are distorted, exaggerated, and combine colors in unusual or irregular combinations, or through vivid, violent, dynamic application of formal elements in the composition. It draws attention to the continued presence of the irrational in a seemingly ordered and rational cosmos. Expressionism is often associated with Germany, where the movement formed around a number of young painters who called themselves Die Brücke ("The Bridge"). After the First World War, painters such as George Grosz and Otto Dix renewed this tendency, but with a far more critical and aggressive perspective. German Expressionism came to an abrupt end in 1933 when the Nazis forbade it as "degenerate art."

Expressionism's dramatic, distorted, and disturbing imagery was a significant movement in cinema, influencing both European and American film, such as Robert Wiene's *The Cabinet of Dr. Caligari* (1920). The expressionist style has influenced cinema up to the present day and continues to be a source of inspiration.

Figurative

Refers to work that is clearly derived from real subjects, and therefore is representational. The term arose only after the advent of abstract art. The majority of the artworks discussed in this book are figurative.

Fresco

The mural painting technique used in ancient times was called fresco, or "fresh": color was applied onto wet plaster, bonding it to the surface. This is a firm and long-lasting technique so long as the building remains intact and is not exposed to too much sun and weather. Some Etruscan underground tomb paintings have been discovered, and the interior murals in Pompeii survive because for most of the last several thousand years they were sealed in volcanic ash.

Futurism

Futurism was founded in Italy in 1909 by the Italian poet Filippo Marinetti. It explicitly rejected the art of the past and celebrated change and technical innovation. The Futurists praised technology, the automobile, and all aspects of speed, power, and movement. This is reflected in paintings by Umberto Boccioni, Giacomo Balla, and Gino Severini. See Giacomo Balla's *Dynamism of a Dog on a Leash* (1912).

In 1916 the Futurists started to experiment with film, and although most of the original films they made have been lost, they were influential at the time. Futurism's greatest influence outside of Italy was in Russia, inspiring painters and filmmakers, including the greatest—Lev Kuleshov, Dziga Vertov, Sergei Eisenstein, Vsevolod Pudovkin— whose work contributed so much to the development of cinema.

Gothic

In art, this usually refers to a long period that lasted from the mid-twelfth century to the fifteenth century, or as late as the end of the sixteenth century in northern Europe. Gothic architecture is particularly striking; one of the best examples is Paris's Notre Dame Cathedral. Painting was mainly of religious subjects, and gold leaf was often applied. Example: the Italian painter Duccio (1278–1319). In the nineteenth century appeared the "Gothic Revival," involving a romanticized version of medievalism, and sometimes a taste for the macabre. Example: Dante Gabriel Rosetti (1828–1882) and William Morris (1834–1896) in art and design; Augustus Pugin in architecture (1812–1852).

Grotesque

Originally, the term *grotesque* referred to paintings and carvings that depicted intricate compositions, combining or interweaving forms of human and animal figures, often with foliage and other decorative elements. Frequently these figures looked strange and even comical; conversely, they could be frightening. A good example might be gargoyles on Gothic buildings. From the eighteenth century onward, however, grotesque increasingly has come to mean anything strange, fantastic, often with an ugly or incongruous appearance. In modern art, the works that appeared in post–World War I Germany by artists such as George Grosz, Max Beckman, Otto Dix, and others are often referred to as grotesque. The grotesque appears in contemporary art and illustration, and in all kinds of genre films.

"Isms"

As has been made clear in the book, movements and "isms" are not to be taken too seriously when we consider the relationship of art and cinema. At least as many artists (and filmmakers) do not adhere to any movement, but continue to flourish. Therefore, although the art history books might say that American art in the 1940s and '50s was dominated by Abstract Expressionism, many realist and surrealist painters continued to work productively. Likewise, film history books often discuss the Italian neorealist movement, but other films were made in Italy at the same time that did not belong to this movement. We have to recall that in any given time, everybody is exposed to all kinds of art, not just whatever the key movement of an era has to offer. Nonetheless, being aware of movements and "isms" can be useful when attempting to understand general directions in the arts.

Mannerism

Mannerism is a movement in late Renaissance art, roughly between the 1520s and 1590s. It questioned the accepted harmonies of classicism and idealized naturalism prevalent in the work of artists such as Rafael, Leonardo da Vinci, and others. Mannerist artists were interested in experimenting with more challenging styles and techniques. The results are stylized paintings that are visually striking but openly artificial, and allegorical subjects were popular. Bronzino's *Venus, Cupid, Folly, and Time* (c. 1544–1545) is considered one of the greatest Italian mannerist paintings. The movement also existed in northern Europe, where it was often darker, even sometimes grotesque. The Dutch painter Cornelis van Haarlem is a good example of a northern Mannerist.

Metaphysical Painting

This is a very short-lived movement, if it can even be called that, as it principally applies to only two artists: Giorgio de Chirico and Carlo Carrà. In the period between 1911 and 1920, de Chirico was studying philosophy and was fascinated by the writings of Friedrich Nietzsche on Italian architecture. This inspired him to create paintings that aimed to present more than what meets the eye, to go beyond the physical representation of a real place, in his case contemporary urban landscapes, and suggest metaphysical ideas—that is, ideas that suggest other things, such as the past, memory, and dreams. The names of de Chirico's paintings, such as *The Nostalgia of the Infinite* (1913–1914), also played a major role in suggesting the metaphysical world.

Mimesis

Mimesis is a basic principle in art, applicable both to painting and to cinema. Plato and Aristotle discussed mimesis as the representation of nature. To Plato, all artistic creation is just imitation of what exists theoretically in a world of ideas. Aristotle was more down-to-earth and stressed that art imitates things that exist in real life. However, in his great work on theater, *The Poetics*, Aristotle also pointed out that to be effective mimesis must be more than copying; it must be very carefully crafted and augmented, with just the right modicum of drama. One of the best ways to think about mimesis is whether, all things considered, what is presented is believable. This means that, given the "rules" by which the world of the artwork is constructed, does it appear believable? This is why we are able to accept a film like *Ratatouille* (Pixar, 2005, directed by Brad Bird), a computer-animated comedy about a rat who is a chef in a fancy restaurant. Logically, we know that the presence of rats in restaurants would bring the health and safety inspectors. Within the rules of the world of the film, we accept it because the psychological complexity and the social commentary of the film are mimetic—that is, they imitate the world that we know. Arnold Böcklin's painting *The Centaur at the Blacksmith's Forge* is not realistic because there is no such thing as a centaur, but within the rules of the world of the painting, there is a centaur, and since centaurs have horses' hooves, we can readily accept that from time to time he'd want to have them shod.

Minimalism

Minimalism was an art movement, principally in the United States, characterized by rigorous stripping down of the artwork into almost pure form. It embraced both sculpture and painting; minimalist painting is also sometimes referred to as hard-edge painting, aiming at anonymous construction of a simple object. *Red Orange White Green Blue*, a 1968 acrylic painting by Ellsworth Kelly, is a good example, being simply made up of stripes in these respective colors.

In cinema, minimalism is also about rigorous simplification; it is distinguished by a stripped-down approach, low budgets, and deliberate avoidance of artifice. The Danish Dogme95 movement is an example of film minimalism.

Modernism

Modernism is a product of the tremendous changes that came about as a result of industrialization in the nineteenth century; it both embraces

these changes, in the constant search for new forms of expression, and rejects them in favor of a newer and better way of being. Art is seen to move away from mass society; the concept of the avant-garde is born.

Often art histories claim painter Édouard Manet as the generator of modernist art, when he broke away from accepted notions of perspective, modeling, and subject matter. However, it might be just as viable to cite J. M. W. Turner's late works, which are almost abstract, as being proto-modernist. See Peter Gay's *Modernism: The Lure of Heresy* (2010), which gives a good general account that includes the birth of cinema as a key part of Modernism.

Naturalism

Naturalism is not an art movement, but an approach to making art. At first glance, naturalism looks very much like realism, since both are concerned with portraying real things as they actually are. But the roots of naturalism are more specific: attempting to represent a scientifically accurate, objectively faithful "slice of life" without reference to inner psychological states or moral qualities. In painting, this developed into a strong concern with accurate depiction of real things, such as the precise rendering of fauna and flora and detailed, accurate representation of the human body.

Neoclassicism

In the late eighteenth century, German archaeologist and art historian Johann Winckelmann (1717–1768) revived a taste for classical art, strongly influencing Western painting, sculpture, and architecture. The aim was strong, simple compositions without frill or fuss and rational use of space, line, and color without obvious manipulation of emotions. Example: Jacques-Louis David (1748–1825), who proclaimed "An artistic genius should have no other guide except the torch of reason."[2]

Pop art

Pop art was principally an Anglo-American movement, starting in the late 1950s, that sought to incorporate elements of popular culture into the subject matter of painting, and sometimes even physically into the art object. Robert Rauschenberg's "combines," collages of detritus picked up in the neighborhood, are part of pop art; Roy Lichtenstein's large-scale painted renderings of comic strips and Andy Warhol's silkscreen of tabloid press photographs are key examples. Michelangelo Antonioni's 1966 film *Blow Up* shows aspects of pop art in a story about a fashion photographer; it is satirized and pastiched in the *Austin Powers* films (1997–2002).

Postmodernism

As with most movements, it's impossible to know when modernism ends or postmodernism starts. But we can identify certain key characteristics of the so-called postmodern. Instead of always looking for the new and original, the postmodern approach sees value in exploring and using the art and ideas of the past, but always doing so critically. Postmodernists don't just accept traditional explanations or truths, nor do they immediately dismiss them and look for new "truth." Instead, they want to examine and question what may be missing, essentially "reading between the lines." Postmodernists appropriate ideas, images, and so on, but transform them into something else, conveying different messages. Postmodernism is difficult to identify precisely, but its influence can be seen in all aspects of contemporary culture. One aspect of postmodernist art may be a kind of pessimism about the possibility of escaping from borrowed imagery into "authentic" experience. This is explored by the Wachowskis in *The Matrix* (1999).

Realism

Realism in art has several meanings. The first is simply mimesis, the attempt to portray real-world things—that is, nature and everyday life—as truthfully as possible, rejecting imaginative idealization in favor of close observation of appearances. Examples of realist painters include Jan Vermeer and Caravaggio.

In the middle of the nineteenth century, painters began to reject drama and Romanticism in favor of a truthful and accurate depiction of nature and contemporary life. Painters like Jean-François Millet and Gustave Courbet wanted to paint frank reality, to show real peasants and laborers and the local character of landscapes, emphasizing the simple and ordinary aspects of life.

This kind of aggressive insistence on depicting the lives of ordinary people didn't enter cinema in earnest until after the Second World War with Italian Neorealism, notably the films of Vittorio De Sica (*Bicycle Thieves*, 1948) and Roberto Rossellini (*Rome, Open City*, 1945). This was very broadly influential, going on to inspire movements such as the French nouvelle vague (*The 400 Blows*, 1959, dir. Francois Truffaut), the new Hollywood of the late 1960s and

1970s (*Alice Doesn't Live Here Anymore*, 1974, dir. Martin Scorsese), and British social realism (*Kes*, 1969, dir. Ken Loach). It remains a strong force in cinema up to the present.

Rococo
The term *rococo* refers loosely to a highly decorative style of painting and design. It derives from the Baroque of the seventeenth century, but by the eighteenth century the style becomes much lighter in color, with far less use of dramatic lighting effects, more informal compositions, and quite often a delicately veiled eroticism. The style originated in France, some of the greatest exponents being the painters Antoine Watteau, François Boucher, and Jean-Honoré Fragonard, but it was influential in Italy and elsewhere. Fragonard's *The Swing* (1767) is one of the great exemplars of the rococo. However, some art histories deny that rococo applies to painting, seeing it purely as a design tendency.

Romanticism
Romanticism in art can be seen as a reaction against the rationalism and materialism that had come to dominate Western European culture, but it was also part of a desire to explore the world in a new way. Instead of continuing the great traditions inherited from the ancients, imbued with reason and rational thought, the Romantics advocated the primacy of emotional, personal expression. Romantic art is based on the real, but makes it more emotional and dramatic. Example: Eugene Delacroix (1798–1863).

Sfumato
Whistler's *Nocturne: Blue and Gold* uses an old painting technique called sfumato. Sfumato (deriving from the Latin for "to smoke") is fine shading that produces soft, imperceptible transitions between colors and tones. This means that there are no distinct outlines: areas blend into one another through miniscule brushstrokes, which makes for a subtle rendering of light and color. Leonardo da Vinci developed and perfected sfumato; see his *Mona Lisa*. The opposite of sfumato is chiaroscuro.

Sublime
In art, the sublime happens when an artwork has the power to provoke a kind of ecstasy, approaching the limits of the mind's strongest emotion. Dramatic landscapes or frightening yet beautiful images invoke the sublime. Edmund Burke wrote that "whatever is in any sort terrible or is conversant about terrible objects or operates in a manner analogous to terror, is a source of the sublime."[1] In a sense, the sublime cannot be absolute; it involves the experience of the individual experiencing horror, destruction, and awesomeness simultaneously with beauty. J. M. W. Turner's *Snow Storm: Steam-Boat off a Harbour's Mouth* (1842), Henry Füssli's *The Nightmare* (1781), and American painter Frederick Church's *Twilight in the Wilderness* (1860) are all good examples. In cinema, most thrillers attempt to create the sublime. A good example is Henri-Georges Clouzot's *The Wages of Fear* (1952).

Surrealism
Surrealism started with poets and became a movement encompassing all aspects of the visual arts, literature, theater, and cinema. Surrealism was articulated in the early 1920s, particularly through the surrealist manifesto written by poet André Breton, the self-appointed leader of the movement. The Surrealists were interested in invoking the unconscious mind and, whether through writing or visual art, representing the contents of the unconscious. Like the Expressionists, the Surrealists embraced the irrational but had a much more positive aim: they believed that if they could set free the human mind, a broader and more positive freedom for human society would inevitably follow. Surrealism was very widespread, with adherents across Europe, including Britain, as well as in North and South America. Surrealism also strongly influenced cinema, and though there are few purely surrealist films (see the work of Jan Svankmajer), many filmmakers invoke surrealism in the creation of dream or fantasy sequences where the content of a character's mind is explored on the screen (*Eternal Sunshine of the Spotless Mind*, directed by Michel Gondry, 2004).

Symbolism
Symbolist artists shared the romantic value of "emotional truth" and subjectivity of experience, but went even further. Rejecting the need for realistic depiction, symbolist painters believed that art should reflect an emotion or idea rather than try to represent the natural world and instead used symbols—often hybrid oeuvres mixing Greek myth, biblical stories, and mythological characters. Examples: Gustave Moreau (1826–1898); Paul Gauguin (1848–1903).

Tenebrism
Tenebrism (derived from the Latin *tenebrae*, "darkness") is the "spotlight" effect, the extreme contrasts of dark and light, used in figurative compositions

for dramatic effect. Some of the masters of tenebrism are Caravaggio and also the Spanish painters Francisco Zurbarán (1598–1664; see *Saint Francis in Meditation*, c. 1635–1639) and Jusepe de Ribera (1591–1652; see *Saint Jerome*, 1652), French painter Georges de La Tour (1593–1652; see Dice-Players, c. 1651), and the Dutch painters Gerrit van Honthorst (1590–1656; see *St. Peter Released from Prison*, c. 1616–1618) and Hendrik Terbrugghen (1588–1629; see *Esau Selling His Birthright*, 1625).

Trompe l'oeil

Trompe l'oeil, or "fool the eye," is a kind of illusionist painting that depicts an object so exactly as to make it appear real. This idea began with the ancient Greeks and was also popular with Roman muralists. European painters sometimes employed this technique, creating window-like images suggesting actual openings in the wall or ceiling. A good example is *A Trompe l'Œil with a Garland of Flowers and a Curtain* (1658) by Frans van Mieris (1635–1681). Caravaggio's *Basket of Fruit* (1599) is a good example of *trompe l'oeil* in a small painting, but it is more common in murals, ceiling paintings, and, of course, in theater set design and matte painting, where scenes are painted on glass panels mounted in front of the camera (as discussed in Chapter 3's case study of *Black Narcissus*).

Trope

Tropes are commonly recurring devices and conventions that are already familiar to the audience. At their best, they can create a kind of familiarity that indicates a signature style. At their worst, they are clichés. It is not uncommon for a film director to develop certain themes, tropes, and character motivations common to that director's style. Tropes can be story-based or visual, but in all cases should feed into the film's theme. For example, Christopher Nolan can be said to employ several storytelling tropes, including nonlinear narrative, characters undergoing identity crises, and ambivalent endings. Genres employ tropes: the 1940s film noir femme fatale often smoked, while the ingénue rarely did. Horror movie tropes include the dark, mysterious cellar or attic.

Vanitas

Vanitas in art derives from the biblical verse *Vanitas vanitatum omnia vanitas* (Eccl. 1:2;12:8): "vanity, vanity, all is vanity." It normally includes a skull or skeleton amid objects from everyday life, thus suggesting that all human achievements are transient and ultimately futile. See Harmen Steenwyck, *Still Life: An Allegory of the Vanities of Human Life* (c. 1640). *The Ambassadors* (1533) by Hans Holbein the Younger combines vanitas with portrait. Both are in the National Gallery, London.

Vorticism

Very few significant artistic movements have arisen in England, and many claims have been made for Vorticism, which flourished briefly from 1912 to 1915. It was the brainchild of writer/painter Wyndham Lewis and, like many similar modernist movements, vehemently rejected the art of the past. It openly embraced machinery and industrialization, and visually it owes a great deal to Cubism and Futurism. Although the output of Vorticism was a mere footnote in art history, the painting *Bursting Shell* (1915) by C. R. W. Nevinson is a particularly evocative piece of war art. Although Nevinson was associated with both the Futurists and the Vorticists, he never formally belonged to either.

ONLINE RESOURCES

Online Collections
BBC: Your Paintings
http://www.bbc.co.uk/arts/
yourpaintings (all the paintings held in
the national collection across the UK)

The Frans Hals Museum, Haarlem
http://www.franshalsmuseum.nl/en

The Louvre, Paris
http://www.louvre.fr/en

The National Gallery, London
http://www.nationalgallery.org.uk

The National Gallery, Washington, DC
http://www.nga.gov

National Gallery of Canada
www.gallery.ca

Prado Museum, Madrid
https://www.museodelprado.es/en

The Rijksmuseum, Amsterdam
https://www.rijksmuseum.nl/en

The Tate Gallery, London
http://www.tate.org.uk/art

The Wallace Collection, London
http://www.wallacecollection.org/
thecollection

Some modern artists, whose work is
mostly in private collectors' hands, have
their own websites:

Alex Colville
http://alexcolville.ca

Edward Hopper
http://www.edwardhopper.net

Andrew Wyeth
http://www.andrewwyeth.com

Some contemporary artists are difficult
to find online, but their work can be
found in the books mentioned in the
Further Reading sections at the end of
each chapter. Artnet.com can also be a
useful resource.

Online Art Libraries and Film Archives
These are commercial art libraries that
provide licensed images, but you can
look at the collections for free.

BFI Screen Online has many articles
and stills about British cinema
http://www.screenonline.org.uk

The Bridgeman Art Library
http://www.bridgemanimages.com

Scala Archives
http://www.scalarchives.com

Additionally, http://www.wikiart.org has
a vast collection of paintings that are in
the public domain.

Books and DVDs
Documentary films are also useful;
following are a few of the best.

Andrew Graham Dixon, *The Art of Spain*
(BBC, 2010)

Waldemar Januszcak, *The Impressionists*
(BBC, 2013)

Tim Marlow, *Great Artists Vols. 1 & 2*
(Seventh Art Productions, 2001): an
entertaining, multipart series that
covers almost everything you ever
wanted to know about traditional art
history

Simon Schama, *The Power of Art* (BBC,
2006): a six-part documentary about six
major artists

NOTES
1 Edmund Burke, Section VII: "Of The Sublime,"
 in *A Philosophical Inquiry into the Origin of
 Our Ideas I Sublime and Beautiful* (1757),
 available at gutenberg.org.
2 Quoted by the J. Paul Getty Museum
 catalogue entry for "Jacques-Louis David,
 1748–1825."

PICTURE CREDITS

COVER IMAGE: The Art Archive / Museum of Modern Art New York / Superstock

0.1: Silver Screen Collection / Getty Images

0.2: De Agostini Picture Library / Getty Images

0.3: PIERRE ANDRIEU / Getty Images

1.1 *Roma* (1972) / Dir. Federico Fellini / Les Productions Artistes Associés / Ital-Noleggio Cinematografico (Italy), United Artists

1.2: DEA PICTURE LIBRARY / Getty Images

1.3: DEA PICTURE LIBRARY / Getty Images

1.4: Columbia / RPC / Hemdale Film / The Kobal Collection

1.5: DEA / M. CARRIERI / Getty Images

1.6: IWM / Getty Images

1.7: *Jacob's Ladder* (1990) / Dir. Adrian Lyne, DP Jeffrey L. Kimball / Carolco Pictures / TriStar Pictures

1.8: DEA / G. DAGLI ORTI / Getty Images

1.9: 20th Century Fox / Dreamworks / The Kobal Collection

1.10: The Art Archive / Museum of Modern Art New York / Superstock

1.11: © Dedalus Foundation, Inc./VAGA, NY/DACS, London 2015

The Art Archive / The Solomon R. Guggenheim Foundation / Art Resource, NY / Solomon R. Guggenheim Museum, New York. Gift, Agnes Gund, 1984

1.12: MGM / The Kobal Collection

1.13: Heritage Images / Getty Images

1.14: Heritage Images / Getty Images

1.15: Paramount / The Kobal Collection

1.16: Paramount / The Kobal Collection

1.17: The Art Archive / National Gallery of Art Washington / Superstock

1.18: DEA PICTURE LIBRARY / Getty Images

1.19: Allarts/Erato / The Kobal Collection

1.20: Contentfilm International / The Kobal Collection

2.1: Print Collector / Getty Images

2.2: Imagno / Getty Images

2.3: *Gone With the Wind* (1939) / Dir. Victor Fleming, DP Ernest Haller, production designer William Cameron Menzies / Selznick International Pictures, Metro-Goldwyn-Mayer / Loew's Inc.

2.4: Print Collector / Getty Images

2.5: Columbia / Frank Cronenweth / The Kobal Collection

2.6: The Art Archive / Musée du Louvre Paris / Gianni Dagli Orti

2.7: Print Collector / Getty Images

2.8: DEA PICTURE LIBRARY / Getty Images

2.9: Woodfall / Kestrel / Michael Barnett / The Kobal Collection

2.10: Mosfilm / The Kobal Collection

2.11: Frozen River Pictures / The Kobal Collection

2.12: Heritage Images / Getty Images

2.13: DJ Films / Isle Of Man Films / BFI / Pinewood Pictures / The Kobal Collection

2.14: DEA PICTURE LIBRARY / Getty Images

2.15: The Art Archive / Courtauld Institute London / Superstock

2.16: DEA / G. NIMATALLAH / Getty Images

2.17: United Artists / The Kobal Collection

2.18: Diagram of the Camera Obscura / Nazir Tanbouli

2.19: DEA / M. CARRIERI / Getty Images

2.20: Heritage Images / Getty Images

3.1: The Art Archive / Wallace Collection London / Superstock

3.2: DEA PICTURE LIBRARY / Getty Images

3.3: DEA PICTURE LIBRARY / Getty Images

3.4: © ADAGP, Paris and DACS, London 2015. The Art Archive / Private Collection / Gianni Dagli Orti

3.5: Athanor / The Kobal Collection

3.6: The Art Archive / DeA Picture Library / G. Cigolini

3.7: *The Red Desert* (1964) / Dir. Michelangelo Antonioni, produced by Antonio Cervi and Angelo Rizzoli / Rizzoli (USA)

3.8: *A Matter of Life and Death* (1947) / Dir. The Archers / The Archers and J. Arthur Rank / Eagle-Lion Films (UK), Universal Studios (US)

3.9: *Black Narcissus* (1947) / Dir. The Archers, produced by Michael Powell and Emeric Pressburger / General Film Distributors

4.1: DEA PICTURE LIBRARY / Getty Images

4.2: The Art Archive / Musée du Louvre Paris / Gianni Dagli Orti

4.3: The Art Archive / Musée des Beaux Arts Nantes / Collection Dagli Orti

4.4: Print Collector / Getty Images

4.5: DEA / V. PIROZZI / Getty Images

4.6: DEA / G. DAGLI ORTI / Getty Images

4.7: Heritage Images / Getty Images

4.8: The Art Archive / National Gallery London / Superstock

4.9: DEA / G. NIMATALLAH / Getty Images

4.10: Warner Bros / The Kobal Collection

4.11: Mondadori Portfolio / Getty Images

5.1: DEA PICTURE LIBRARY / Getty Images

5.2: The Art Archive / The Solomon R. Guggenheim Foundation / Art Resource, NY / Solomon R. Guggenheim

5.3: Heritage Images / Getty Images

5.4: DEA / G. DAGLI ORTI / Getty Images

5.5: *Pan's Labyrinth* (2006) / Dir. Guillermo del Toro, DP Guillermo Navarro / Tequila Gang, Estudios Picasso, Telecinco Cinema, Sententia Entertainment, Esperanto Filmoj / Warner Bros. Pictures (Spain), Picturehouse (US)

5.6: Imagno / Getty Images

5.7: Legendary Pictures / The Kobal Collection

6.1: DEA / E. LESSING / Getty Images

6.2: DEA PICTURE LIBRARY / Getty Images

6.3: Frozen River Pictures / The Kobal Collection

6.4: Heritage Images / Getty Images

6.5: The Art Archive / Gift of Carman H Messmore / Buffalo Bill Center of the West, Cody, Wyoming / Buffalo Bill Center of the West / 16.60

6.6: The Art Archive / Gift of Mrs Sidney T Miller / Buffalo Bill Center of the West, Cody, Wyoming / Buffalo Bill

6.7: The Art Archive / Buffalo Bill Center of the West, Cody, Wyoming / Buffalo Bill Center of the West / 2.66

6.8: United Artists / Ned Scott / The Kobal Collection

6.9: Columbia / The Kobal Collection

6.10: Film Science / The Kobal Collection

6.11: Evenstar Films / The Kobal Collection

6.12: Evenstar Films / The Kobal Collection

6.13: DEA / G. DAGLI ORTI / Getty Images

6.14: *Stalker* (1979) / Dir. Andrei Tarkovsky / Mosfilm

7.1: Heritage Images / Getty Images

7.2: © Kimathi Donkor, 'Toussaint L'Ouverture at Bedourete'. 2004, oil paints on linen, 136cm x 183cm

7.3: UniversalImagesGroup / Getty Images

7.4: The Art Archive / DeA Picture Library

7.5: First Light Productions / Kings Gate Films / The Kobal Collection

7.6: Print Collector / Getty Images

7.7: *Django Unchained* (2012) / Dir. Quentin Tarantino, DP Robert Richardson / The Weinstein Company, Columbia Pictures

7.8: *Django Unchained* (2012) / Dir. Quentin Tarantino, DP Robert Richardson / The Weinstein Company, Columbia Pictures

8.1: DEA PICTURE LIBRARY / Getty Images

8.2: Decla-Bioscop / The Kobal Collection

8.3: The Art Archive / The Solomon R. Guggenheim Foundation / Art Resource, NY / Solomon R. Guggenheim

8.4: The Art Archive / DeA Picture Library

8.5: *Locke* (2013) / Dir. Steven Knight, DP Haris Zambarloukos / Shoebox Films, IM Global / A24

INDEX

INDEX

ACKNOWLEDGMENTS

Thanks firstly to the many students I have taught at SAE Institute and other institutions.

I am grateful to the always-helpful staff and librarians at the British Film Institute and the Westminster Library Art and Design Collection.

I am indebted to the many talented artists and filmmakers with whom I've worked as curator and friend, whose lively conversation led me to explore this subject.

Special thanks to Lynsey Brough and James Piper at Bloomsbury Publishing.

The publishers would like to thank Doreen Bartoni, Mairi Cameron, Rob Edgar-Hunt, Larry Engel, Angela Giron, Suri Krishnamma, Robert Murphy, Lewis Paul and Kimberly Radek.